D0390744

The Girl with the Gallery

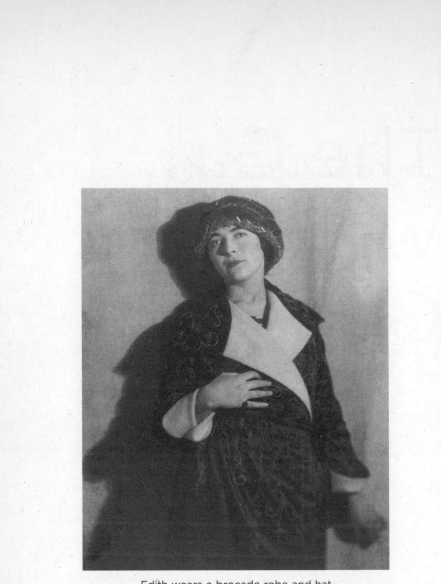

Edith wears a brocade robe and hat
in a photograph taken by her husband's friend,
photographer May Ray, in the early 1920s.

The Girl with the Gallery

EDITH GREGOR HALPERT AND THE
MAKING OF THE MODERN ART MARKET

Lindsay Pollock

PublicAffairs : New York

Published in the United States by PublicAffairs™, a member of the
Perseus Books Group.

PublicAffairs books are available at special discounts for bulk purchases
in the U.S. by corporations, institutions, and other organizations. For
more information, please contact the Special Markets Department at the
Perseus Books Group, 11 Cambridge Center, Cambridge, MA 02142,
call (617) 252-5298, or e-mail special.markets@perseusbooks.com.

Book design and composition by Mark McGarry
Set in Dante with Gotham Display

Library of Congress Cataloging-in-Publication Data
Pollock, Lindsay.
The girl with the gallery : Edith Gregor Halpert and the making of the
modern art market / Lindsay Pollock.
p. cm.
Includes bibliographical references and index.
ISBN-13: 978-1-58648-302-9 (alk. paper)
ISBN-10: 1-58648-302-1 (alk. paper)
1. Halpert, Edith Gregor, 1900–1970. 2. Art dealers—New York
(State)—New York—Biography. 3. Downtown Gallery (New York, N.Y.)
I. Title.
N8660.H28P65 2006 709.2—dc22
[B] 2006023266

FIRST EDITION
10 9 8 7 6 5 4 3 2 1

To Dale, Jim, and Justine Pollock,

My Mother, Father, and Sister

Contents

Introduction

When Edith Gregor Halpert founded the Downtown Gallery on West 13th Street in 1926, there were just a handful of art dealers who dared to sell contemporary American artworks, and none who dared to do so in Greenwich Village. For one thing, there were no museums showing this sort of work; the Downtown Gallery predated the Museum of Modern Art (MoMA), the Whitney Museum of American Art, and the Guggenheim. The Village was a place where artists commiserated in smoky tearooms by night and worked in dingy studio apartments by day. Among the modern painterly set, few could afford to live by art sales alone. Many taught art school, depended on a spouse, or did odd jobs to scrape together the rent. Besides, most critics, curators, and collectors agreed: American art was a second-rate affair. Paris held a monopoly on the art market. New York artists suffered from a chronic inferiority complex, which was not only bad for their egos but bad for sales.

Edith believed none of it. A Russian Jewish immigrant, she was an early and ardent champion of American art, which she believed was original and salable. She devoted her life to this fight. Today, when

Manhattan is the undisputed art capital of the world, and thousands of artists vie for slots in hundreds of galleries, few remember Edith and would think to acknowledge her contributions to the big business that art dealing has become. I certainly had never heard of her. Indeed, after immersing myself in a college art history program that featured virtually no women, I was astounded to see the name Edith Halpert, noted on a simple wall label at a Jacob Lawrence retrospective at the Whitney Museum in 2001. The label identified Halpert as Lawrence's dealer, who had in 1942 successfully sold a series of sixty paintings—filled with potent symbols of a racist America—by the then unknown twenty-four-year-old black artist to two of the most important museums in the country. Who was this Edith Halpert, I wondered, and why hadn't I heard of her?

As it turned out, Halpert had no intention of being unknown. She had donated most of her vast gallery records to the Archives of American Art, part of the Smithsonian Institution. Those records form the backbone of this book. I drew on hundreds of thousands of letters, newspaper clippings, photographs, sales slips, press releases, and other material painstakingly preserved with Halpert's own mania for organization. Rather fortuitously, after I had embarked on writing this book, the Downtown Gallery records were also made available on the Internet, providing me with several years of all-night web-surfing sessions. But Edith wasn't content to let her records speak for themselves. She participated in lengthy interviews and also hired writers to ghostwrite her autobiography. Outlines and notes from these uncompleted books include many of Halpert's most dramatic and compelling stories. She was a master storyteller, and by the 1960s, which coincided with her own sixties, she had refined these tales for all their dramatic potential. I have relied on many of Edith's own stories in retelling her life. I have omitted those that were impossible to corroborate or seemed out of step with the spirit of the woman, but I have included those that seem truthful, revealing, or emblematic of her life.

This book is a truthful attempt to puzzle together events as accurately as possible. It is a pastiche of voluminous archival material layered over with interview memories—those of Edith and the dozens of people I spoke with about her—recalled from decades earlier and shaded by personal vendettas, desires for immortality and glory, and also the plain blurriness of time. I have indicated in my citations whether the source is a document from the archive or Edith's own word. And when I think her word needs to be appreciated but taken with a bit of skepticism, I've indicated as much to the reader.

This book also owes a debt to Dr. Diane Tepfer, who wrote an authoritative dissertation on the Downtown Gallery, focusing on its first two decades. Tepfer's research helped spark my own interest in Edith's story and provided an art historical context and reference by which to measure Edith's achievements and those of her artists. Tepfer also wrote a biography of Edith's first husband, Sam Halpert, which was invaluable to my understanding of him as an artist and man.

Early on in my research, I located the original Downtown Gallery. On a shaded Greenwich Village street lined with modest brick townhouses, one can, at the Spain Restaurant, feast on yellow rice and green-curry shrimp in the Daylight Gallery, Halpert's jewel box backyard addition. The skylight is coated with muddy sludge and the walls are decorated with posters and oil paintings by former employees of the restaurant, but two delicate Art Deco nymphs stare down from a doorway—the one remaining vestige of Edith's time, a sculptural addition by a Downtown Gallery artist in 1930. At the restaurant, which has been at 113 West 13th Street since 1967, none of the waiters or customers, some of whom have been around for decades, had heard of Edith Halpert, her pioneering gallery, or her crusade for American art—that is, until I started popping by to visit.

1

A Samovar in Harlem

"THE ODESSA BUSINESS," said sixty-one-year-old Edith Gregor Halpert, "there's nothing there." The grand dame of New York art dealing exhaled cigarette plumes as she brushed off questions about her birthplace and the city where she had spent the first six years of her life. The interview had begun precariously, with Edith deflecting her interviewer's questions. They were sitting in her art-filled apartment, on the third floor of her brick and limestone mansion at 32 East 51st Street, an address familiar to generations of curators, collectors, artists, and anyone else interested in modern American art. It was she who would chart the course of conversation. It was, after all, her story.

Dr. Harlan B. Phillips, an art historian, had the unenviable task of interviewing the pioneering art dealer. He had been commissioned to do so by the Archives of American Art. In 1957 Edith had given the archives permission to begin microfilming her gallery records. Now, four years later, on April 19, 1962, she and Phillips were convened to record the story behind the more than 200,000 documents (including letters, sales slips, exhibition catalogs, photographs, and press releases)

that she had preserved during her more than thirty-five years at the helm of the legendary Downtown Gallery.

"My idea about this is to do it only in relation to my art life, my life in the art world," said Edith, dictating the parameters of their conversation. "What happened before is prologue." Edith was not interested in rehashing tales about her impoverished youth. It was not that she had anything to hide, though her brassy voice and salty tongue—part Auntie Mame, part Fannie Brice—gave her a cultivated air at odds with her roots. She was well aware that her hardscrabble childhood had helped shape her identity. "I'm very grateful for all the hard knocks I had in my youth because it made a woman out of me," she told Phillips. "I've never been bitter about poverty, or anything. . . . When I began getting things, I appreciated them so much more." There was a more pressing reason for Edith to steer the conversation toward her accomplishments in the art world. She had achieved so much, yet her legacy was in jeopardy.

By the 1950s the art world had moved on, disowning the generation of American artists who had labored between the World Wars. Critics, collectors and museum curators hailed artists such as Jackson Pollock (an artist Edith had refused to exhibit) and Franz Kline, whose oversized canvases appeared to Edith as nothing more than random drips and slashes, born of messy minds and even messier times. By the start of the interview, in 1962, the New York cultural cognoscenti were championing an even newer group, the brash Pop Artists. Edith was incensed that work she deemed technically and conceptually inferior had galvanized attention from the international arts community. These so-called Pop Art purveyors were "commercial artists doing the most vulgar version of commercial art," in Edith's view. Roy Lichtenstein and others were a bunch of Johnny-come-latelies, creating second-class derivations of work that Edith's own Stuart Davis—who painted a tin of Lucky Strike roll-cut tobacco and bottle of Odol disinfectant in the 1920s—had done ages ago.

The fact that American artists were now regarded as the most creative force in the world, celebrated in headlines and museums, was

especially galling to Edith. When she discovered the New York art world in 1915, it wasn't much of a scene. There were only a handful of serious players, and there was certainly no money or fame for buyers, sellers, or makers of American art. Now dozens of dealers and hundreds of artists competed for a place in the spotlight and a cut of the profits. The art world's notoriously short-term memory had already reduced Edith's generation to a footnote.

Here was Edith's chance to set the story straight. She took the task seriously. The Archives of American Art's interviews would allow her to champion an earlier era when the art world wasn't so wrapped up with fame, power, and money. Fifteen interviews later, a transcribed copy of her conversations with Harlan Phillips numbered 819 pages. Edith had talked her heart out, weaving a narrative that she hoped would help seal her place in history. Otherwise, what would become of Edith, her artists, and her gallery once she was gone?

Perhaps Edith considered her childhood mere "prologue" because once her family left Odessa in 1906, they never looked back. They struggled to become Americans, like most immigrants of the era, trading old world identities for the shiny and new. Edith never hid her roots, however, boasting that she served her mother's borscht recipe to her best art-buying client, Abby Aldrich Rockefeller. She retained just a few scattered memories from her childhood, or a few she was willing to discuss. She recalled her prosperous parents, a fourteen-room apartment, watching Tsar Nicholas II's royal procession, and her father's fondness for cocoa.

"We weren't driven out," Edith insisted about her family's decision to leave Odessa. Still, her memories skirted Odessa's dark side: the economic struggles and ethnic tensions that ultimately resulted in the mass exodus of hundreds of thousands of Russian Jews—people who were most certainly driven out. History books reveal Edith's birthplace as a city of stark dualities. Odessa was an oasis of cosmopolitan splendor as well as a backdrop for violence, anti-Semitism,

and upheaval. Edith claimed to have shrugged off the effects of her earliest days. As her life story reveals, however, she was a product of her past.

One of the earliest artifacts in her archive is a photo of Edith and her older sister, Sonia. Edith is seated on a decorative railing, her tiny leather shoes dangling in the air. Sonia, nearly twice Edith's size, stands beside her. A stock fern frond pokes in from the left side, the photographer's attempt to class-up the composition. The girls gaze into the camera, and although neither seems pleased with the portrait

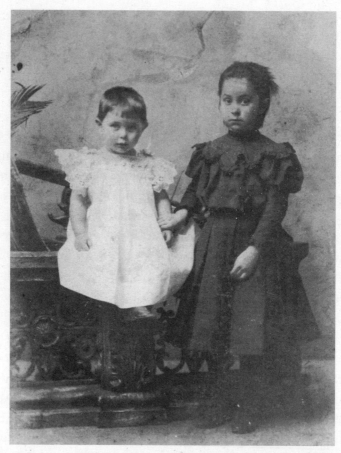

Edith and Sonia in Odessa, circa 1902.

session, the younger sister appears a bit more at ease. The photo was probably taken in 1902 when Edith was two years old. She's already striking, with a round face and wide eyes, topped by a boyish crop of hair. Her long white dress with its frilly lace sleeves suits the daughter of a successful businessman. Edith's gaze is not so frivolous as her frock. Patient and engaged, she is focused on the photographer, calmly staring down the camera lens. Seven-year-old Sonia looks stiff beside her. Her mouth is pinched, her cheeks are plump, and her eyes peer out at an angle as if to say: please finish this business now. She is cloaked in a matronly black dress with a high neck and puffy sleeves, looking like a miniature Victorian spinster. Her hand grips Edith's chubby wrist.

Edith, or Ginda Fivoosiovitch, claimed to be born on April 25, 1900. Her father, Gregor, worked in the grain business, one of the area's dominant industries, run almost entirely by Jews who exported Russia's wheat to the rest of the world.

"I don't know what he was," Edith said. "I've heard so many stories about what he was from my mother and from my family that I don't know, but we lived in very good style." The grain business employed a vast network of middlemen, and Gregor was probably a broker. He had an entrepreneurial flair and ran a spirits shop on the side. His wife, Frances, worked with him in the store. If Gregor was all angles and planes, constructed like a Cubist painting, Frances had a stockier, rounder build, inherited by her older daughter Sonia. Edith inherited her mother's round face, with her father's more delicate nose. Edith recalled that her father was an important man in the community, claiming he belonged to the Duma, the local governing body. Historians contradict Edith's claim, however, noting that Jews weren't permitted to belong to the Duma.

By the 1880s the Russian government had enacted a number of laws to appease the Christian majority, laws that were blatantly discriminatory against Jews. Jews constituted more than one-third of the total population—second only to the Slavs (Russians and Ukrainians)—and dominated the middle classes, but they were required to

live in certain regions and attend certain schools. At the shore, bath-house signs made rules clear: "No dogs or Jews allowed to bathe here." Jews were alternately welcomed and spurned in the city. They were permitted to live there, free from restrictions imposed in the Pale Settlement, a barren swath of land on Russia's western coast where most Jews were required to live. But although the Jews of Odessa were tolerated, they were frequently reminded that Christians were in control.

In spite of this pervasive anti-Semitism, Russian Jews thrived in Odessa, which by the turn of the twentieth century had become one of the largest and most modern cities in Russia. Much of Odessa's good fortune depended on its location. Perched high on pale lime-stone bluffs at the southern border of the Russian Empire, Odessa sat on the edge of the Black Sea and at the confluence of three major rivers. Blessed with a deep harbor, modest tides, and mild tempera-tures (which meant no ice and year-round use of the port), Odessa provided easy access for large ships. The construction of a railroad allowed it to become the trading gateway between southern Russia and the rest of the world.

Odessa was also culturally rich, despite its geographic isolation from Moscow and St. Petersburg, the most advanced Russian cities. Indeed, Odessa aspired to be the Paris of Russia, though the real Paris was thousands of miles away. By the close of the nineteenth century, its broad avenues, laid out on a Cartesian grid system, were paved and lit by gas lamps, and the majority of residents had running water. Noted European architects created the city plan, designing elaborate public buildings, including a stock exchange of Italian marble and Lebanese cedar and an Italian baroque opera house with rooms lined in gold leaf and ceiling murals depicting scenes taken from plays by William Shakespeare. Niches on the opera house façade framed busts of famous writers who had lived and worked in Odessa, including Nikolai Gogol and Alexander Pushkin.

In addition to writers, musicians, and artists, Odessa attracted adventurous and entrepreneurial immigrants from all parts of Russia

and the Ukraine, as well as Europe and Asia. It was a cultural mosaic and certainly the most diverse city in Russia. "The Odessa I knew was a city of poets and sailors, merchants and musicians, Jewish intellectuals and exotic strangers," wrote Bel Kaufman, a writer who was raised in Odessa, just a few apartment buildings away from Edith's home. One could hear the clashing dialects of twenty languages in the streets.

The Fivoosiovitches lived near the harbor, in a three-story apartment house at 48 Rishelyevskaya Street, an address Edith described as "the Odessa equivalent of Park Avenue." A black metal gate swung back, leading to a dark vaulted tunnel that opened onto a central interior courtyard. Windows and small balconies permitted residents to keep watch on the activities below, where pools for children and adults provided a cool summertime respite. The air was scented by acacia trees. Edith befriended a university professor who read on a courtyard bench. He called her "Edyusha," and read her fairytales and taught her addition. She claimed she could tally four columns of numbers when she was just four years old.

"I really was a nasty little kid," Edith recalled. She remembered standing on her balcony, squeezing her arm and head through the metal grill, and pelting a little girl below with flowers. A governess walked Sonia to school, and a German nursemaid, Mona, pushed Edith's pram around town. If Edith misbehaved, Mona would threaten Edith that the bronze statue of the Duc de Richelieu, perched high on a pedestal overlooking the sea, would eat her up. When Edith returned to Odessa for the first time since her childhood, nearly sixty years later, she confronted the statue. "I remembered him vividly, and I thumbed my nose at him," Edith said. "A few people stared at me, but I wasn't afraid of him anymore! I had been. He'd scared me to death."

Together Edith and Mona explored Odessa. There were parks with ice cream stands, and on street corners vendors sold scoopfuls of *semechki* (roasted sunflower seeds). The bustling streets were crowded with sailors in striped shirts, schoolchildren, merchants in

bowler hats and walking canes, and women fashionably dressed in long skirts sweeping the ground. *Droskies* (horse-drawn carriages) pulled passengers along cobblestone streets for half a ruble an hour. Otherwise the *konka* (a horse-drawn tram) transported Odessans down the Zhukovskogo and other broad boulevards. Admirers often stopped Mona to compliment Edith's penetrating blue-green eyes. "People always stop a nurse with a kid . . ." Edith said. "Everybody always remarked about my eyes. I had very blond hair and dark eyebrows."

Though strangers admired Edith's striking features, her mother saw fit to quell any signs of budding vanity. When Edith was four or five, she took to studying her reflection in an ornate gold mirror. She looked at herself not out of vanity, she claimed to Phillips, but curiosity:

> I stood in front of this mirror and I made the most fabulous discovery; that I could move my head this way and that and have my eyes remain still, and this to me was the most incredible idea you could imagine. . . . I was so fascinated I must have been standing in front of this mirror for an hour when my mother said, "What are you doing?" I didn't want to tell her about this discovery—it was private—so I said, "I was looking at my eyes. Aren't my eyes pretty?" She looked at me and said, "No!" I said, "Everybody says they are." She replied, "They lied to you."

After this incident, Edith said she never believed people who told her she was pretty, especially men. "I was a little bit unhappy about it because I really wanted to have pretty eyes," she said. "But after my mother said that they had lied to me, I never believed I had pretty eyes until much, much later when I read Freud, or something, when I decided that maybe I did." Edith did eventually learn to use her physical charms; her large blue eyes and shapely legs helped her get noticed—and get sales.

Edith had conflicting feelings about her mother. She said Frances withheld affection, never kissing Edith until she delivered a peck on her daughter's cheek on the occasion of Edith's wedding. Gregor made up for Frances's frosty behavior by lavishing affection on his daughter, but that was short-lived. When Edith was three or four, she was shocked to see her father lying on the floor. She remembered his lean body, outlined by a white sheet. Like thousands of other Odessians, Gregor had contracted tuberculosis, an epidemic that caused 10 percent of all deaths in the city. "I stood against the door jamb knowing that something dreadful had happened to the only one I really loved," Edith recalled. "From all the whispers and sympathetic pats and pecks [I received I knew] that I would never see him again; [I] tried so hard to cry as I felt it was expected of me, [but] could not succeed."

Gregor's death left Frances to support her two daughters. She tried to run her husband's business, but the grain industry was in a slump. Business had boomed during the first half of the nineteenth century because of a combination of factors, including government-funded upgrades to keep the port modernized, ambitious immigrants who flooded Odessa and worked the docks and railroads, and the bountiful raw grain goods cultivated in the growing hinterland. By the second half of the nineteenth century, the trade had slowed. The United States competed with Russia in grain exports, and Odessa was outmatched. "In Russia, even near the great exporting city of Odessa," said an American agricultural expert in 1905, "the method of buying and handling grain is of the crudest and most primitive kind." Quality control problems in Russia made Russian grain less desirable than that from the United States. "Exposed to dampness when dragged in carts, heaped on railroad platforms, carried in open railway cars, and dumped on wharves, Russian grain often was soaked," according to historian Patricia Herlihy. The Russian government also stopped funding harbor upgrades, and gradually Odessa's infrastructure became dated. Worse yet, in some years the international grain price was so low, it was not worth even exporting.

Since the grain trade accounted for the largest percentage of Odessa's exporting business, when the grain business declined, the whole city suffered.

In 1904, the year Gregor died, there was an additional threat. Russia was at war with Japan, and although that might have caused an increased demand for grain to supply the troops, railroad cars were needed to carry soldiers into battle and were unavailable for transporting grain to the port. According to Herlihy, by 1905 most Russian wheat was left sitting on railroad platforms. With the city already suffering from depression, strikes, and high unemployment, the Russo-Japanese War only made things worse. Brick factories closed, jute and stone quarries laid off workers, and the price of bread spiraled up. Fear spread, along with a rise in theft and burglaries.

In this period of uncertainty and anguish, old ethnic tensions reappeared, and suddenly the Jews were blamed for all that had gone wrong in Odessa. Throughout the nineteenth century, there had been at least five serious anti-Semitic incidents in which Jews has been murdered and their homes ransacked, but what happened now was much more serious. The tension was so severe by October 1905 that Jews formed self-defense brigades in anticipation of attacks or pogroms. Men were instructed to arm themselves with guns, knives, clubs, and whips, and women were advised to prepare solutions of sulfuric acid, which burned skin on contact. On October 9, crowds took to the streets to celebrate news of the October Manifesto—the tsar's hollow political proclamation intended to subdue signs of insurrection. The manifesto called for an elected Duma and some basic civil liberties. Protestors for and against Tsar Nicholas II clashed as Russians began attacking Jews, whom they blamed for the economic troubles and general disorder. Small confrontations escalated into large-scale riots, and by the next day, hundreds of Russians were rampaging in the streets, emboldened by vodka. Violence escalated over the next three days, as Jews were murdered, raped, and attacked, primarily by gangs of non-Jewish day laborers who populated the bottom ranks of Odessa's workforce. The police provided

virtually no protection and were later accused of inciting violence against Jews.

As the port burned and Jewish homes and businesses were ransacked, Edith and her mother and sister huddled at home. The family barricaded themselves inside, hammering wooden slats over the doors and windows. For five days, Odessa burned. In the end, 400 Jews were reported dead and 1,600 Jewish homes, apartments and businesses had been attacked. For Edith, the only serious casualty of the October attacks was her favorite French doll. In the rush to secure the front door, a piece of wood had smashed the delicate porcelain girl into shards.

Jews began streaming out of Odessa. Fifty thousand fled after October 1905. The following year, hundreds of thousands more decided to leave home in search of something better. For Jews looking for opportunity, one destination beckoned above all others: America. Frances had a half-brother living in New York City, and she decided to take her daughters there. Many émigrés had difficulty raising money to pay for the trip, which cost about $34 (equivalent to about $700 in 2006) for the least expensive ticket in steerage class. There were also expenses for traveling to ports, bribing officials, and traversing borders; for an entire family, travel costs amounted to "a small fortune."

Most Jews raised ship fare by selling their few possessions, only to arrive in America destitute.

According to historian Irving Howe, Jews left southern Russia by illegally crossing the Austro-Hungarian border and taking trains bound for Vienna or Berlin, where they traveled in groups to the big ports, such as Rotterdam in Holland. Edith claimed that she and her mother and sister sailed from Rotterdam in a second-class cabin, a world apart from immigrants crammed into steerage bunks, buried deep in the ship's hull. Six-year-old Edith had a memorable trip. She sat in her cabin, gazing out the porthole and studying Robinson Crusoe's adventures in a picture book. Otherwise, she caroused on deck. "I was a pet on the boat because I learned a lot of revolutionary

songs," Edith said. "I was taken over by everybody who was traveling first class, and I would come down with the most wonderful load of stuff. If they offered me anything like chocolate, I would always tell them that I needed two more because I had a mother and a sister." At age six, Edith already knew how to work the crowd.

The immigration process was easiest for passengers traveling in first and second class. Officials from the Hudson River Quarantine Station inspected these passengers before the ship even docked. Steerage passengers were ferried to Ellis Island, where doctors poked and prodded, isolating the sick from the healthy. Edith said she arrived May 6, 1906, though no record of her family appears in the files at Ellis Island. The Fivoosiovitches were part of an immense immigration wave. In 1906, more than 400 Jews arrived each day in America from Eastern Europe, more than 150,000 by year's end. The year of Edith's arrival coincided with the largest Jewish immigration to the United States.

Although many of these Jews headed for tenement slums on the Lower East Side, Frances aimed for something better. Her half-brother was already settled on the west side of Harlem, and that was the part of the city she chose for her family's new home. At the turn of the twentieth century, Russian Jews had begun streaming up to Harlem. They were attracted to the promise of a better life than the noisy, crowded tenements on the Lower East Side. A housing boom made for a ready stock of apartments, which tended to be less crowded and better constructed than ghetto housing, and only slightly more expensive. Those who passed over the Lower East Side for an uptown address included some of the most ambitious new Americans—those with the faith and fortitude to break away from the well-worn path to the ghetto. Harlem was first populated by Irish and German immigrants, but at the turn of the century Jews became the dominant group. By 1910, some 100,000 Jews lived in Harlem.

While the poorest immigrants crowded into railroad flats and tenements east of Third Avenue, France was able to afford an apartment on East 112th Street, between Madison and Park Avenues, a broad

street with sunlight and schools nearby for her daughters. Although not nearly as luxurious as the apartment in Odessa, the Harlem brownstone was still superior to the first homes afforded by most other Russian Jews. Edith's first glimpses of New York would have included some shocking sights: children playing stickball in alleyways—boys in caps and knickers, girls in long skirts and braided hair—newsboys hawking papers on the corner, horse-drawn wagons and cable cars, push-cart sellers, and billowing sheets and shirts clipped to clotheslines overhead.

The first priority was shedding the family's Russian Jewish identity. In Odessa, as Jews and females, their survival had been at risk. They had been outcasts, unwanted by the government and detested by the Slavic majority. There was no choice but to leave. In America, being Russian Jewish females was also not especially advantageous. German Jews had acquired a measure of status in society by virtue of their wealth, education, and assimilation. By contrast, Eastern European Jews, who tended to be poorer, uneducated, and newly arrived, were lumped together at the bottom. The priority for most immigrants was to become Americanized as fast as possible. That meant learning the English language and adopting the habits, dress, and customs of the new land. Men shaved off their beards, while women discovered the wonders of Uneeda Biscuits, Borden's condensed milk, and Gulden's mustard.

Frances understood the importance of reinventing herself and her daughters—they were New Yorkers now, and only by assimilating into their new community would they succeed. If they were destined to be exiled from Odessa, in New York they possessed the power to transform themselves. Frances held onto her old samovar, an urn used for making coffee and an emblem of Odessa, but she let go of most everything else. She stopped speaking Russian and Yiddish and began learning English. She also shortened the family's surname from Fivoosiovitch to Fivisovitch, a modest attempt to make the name more manageable for American tongues.

After getting settled in their new apartment, Frances still had

money left over. Her half-brother suggested she invest her savings and her inheritance from Gregor in a new factory. The factory never opened, however, and Frances' money disappeared. Though Frances was to struggle as a provider for years to come, Edith sensed from the start that America was a land of plenty. It was a lesson she learned shortly after her arrival, when she saw a man sweeping the stairs at the elevated train station, just a half block from the apartment. He was just a worker, but he was eating a banana. In Odessa, Edith had only once been treated to a banana. A rich uncle from Baku paid nearly three rubles, a princely sum in those days, to give his niece the exotic pleasure of the yellow fruit, delicately wrapped in green foil and tied with a ribbon. In America, Edith observed, even men with brooms ate bananas. "That to me was, you know, the symbol of America, the wealth of America," said Edith. "I was terribly impressed with that."

Edith and Sonia enrolled at the local public elementary school, P.S. 159, in the fall of 1906. Each morning the girls, aged six and eleven, walked seven blocks north to 119th Street and east to Third Avenue. It was nearly a half-mile walk past brownstones, tenements, fruit stands, and workers headed for the elevated subway stations. But the walk was not nearly as foreboding as the classroom. Edith's Russian and German language skills didn't mean a thing in New York City. She had no idea what the teachers or students were saying, nor could she make sense of the strange sounds uttered in the streets.

A photograph shows Edith seated in the third row of a classroom, one of fifty schoolgirls tucked behind tilted wooden desks, looking serious and studious and holding open books. She is dressed in a long white smock over a dark billowy dress. Her hair is swept back and braided. An American flag hangs at the back of the room, reminding the immigrant children that they will grow up to be Americans. Edith was still more Russian Jewish than American. Her teachers didn't bother with her new shorter Americanized name, which was still quite Russian and unpronounceable. She was called "Miss Edith."

Even though many of the other students were also foreign-born, it was the newest crop that bore the brunt of the teasing. Edith was taunted in the streets and in the schoolyard and was just one more "greenhorn" schoolgirl for whom everything was strange and new. Her first year was miserable. Five decades later, she still spoke with rancor of the treatment she received from her first teacher, who forced her to wear a pointed dunce cap on her head. "She knew I didn't understand the language," Edith said. "So she put a dunce cap on me. The indignity of it! I stopped crying at the age of six. I never cried thereafter, but that was injustice."

The hurt didn't last for long. Edith resolved to become a real American and also the best student at school. Soon, she wasn't a greenhorn but a regular New York City kid. She roller-skated in the streets, grabbing onto the back of moving trolleys for a tow, and played in nearby Central Park, exploring rock outcroppings and meadows. At school, she first excelled in math and science, subjects that didn't depend heavily on her poor English skills. She was often the teacher's pet, able to complete her work faster and more accurately than other students.

She formed a close friendship with her eighth grade science teacher, who, like the professor in Odessa, recognized Edith's potential and encouraged her interests. On Saturday afternoons, they went to see theater, including plays by Shakespeare and Broadway productions. The friendship motivated Edith to perform in the classroom. She maintained a meticulous science notebook filled with detailed class notes and drawings on subjects such as the pinhole camera, the phases of the moon, and the telegraph. These drawings reveal an innate artistic sense as well as a tremendous talent for observation.

Edith's hard work and enthusiasm in school garnered her "A" grades but few friends. Her classmates didn't always appreciate her success. "Some of the kids didn't like me because I was called on in assembly to recite, to do all sorts of things," Edith said. "Some of those kids who didn't like me started a rumor." Edith's striking coloring—the light-colored hair, blue eyes and thick black eyebrows—

gave her classmates something to pick on. They spread word that Edith's mother painted her eyebrows with the black polish that was used to clean cast-iron stoves. "There was always a sense of injustice that hurt in all those instances," Edith said. "But I really had a very good time at school basically."

During the school day, Edith's mind was stretched and challenged with new ideas. But after school, the reality of her family's poverty was everywhere. There was simply never enough money. Edith tried to help out earning money, a role she preferred to other domestic duties. "I didn't do any housework," Edith said, who later in life depended on hired help to tackle cooking and cleaning. "That she [Frances] couldn't get me to do. I was the business woman."

Edith was more comfortable in the traditional male role of wage earner. Like many other Jewish immigrants, she took in sewing projects. When she picked up rickrack, a zigzag trim, to sew onto teddy bears or children's romper clothes, she said the material was for her mother, but it was really for her. She sewed in the evenings, after finishing her schoolwork. But these odd jobs didn't add up fast enough. After rent and expenses, the family was poor. With any luck, Sonia would find a husband who could save them from sinking into further debt. She did have prospects. Sixteen-year-old Sonia was being courted by Maurice Chase, another Odessa émigré, who worked as an examiner for the Metropolitan Life Insurance Company. Maurice was highly educated for a Russian Jewish immigrant. He had studied medicine in Frankfurt, Germany, and philosophy at the University of Berne in Switzerland. He claimed that he was exiled from Odessa after the 1905 uprisings for belonging to Zionist political parties, and that is what took him to Germany. When he moved to New York, he stayed active in the Zionist movement, and unlike Edith's family, he strongly identified with the Jewish faith. He had retained his old-world beard.

In the meantime, Edith and Sonia mostly depended on Frances as the main source of income, at a time when very few women were the sole breadwinner, even among immigrant families. Most women were

married, and rarely did a married woman work full-time. But with-
out a husband, Frances had no choice. At first, she opened a dry
goods store, but she was not especially skilled when it came to busi-
ness, and the store failed. Finally, she started a small neighborhood
shop selling penny candy, stationery, ice cream, soda water, pencils,
and notebooks. The location was ideal, near an elementary school on
105th Street and Madison Avenue, and sales to students kept the
business afloat. The family lived above the store and their new
address meant Edith was zoned for a different school. Her science
teacher lobbied on her star pupil's behalf, and Edith was permitted to
finish elementary school at P.S. 159.

After school Edith helped out in her mother's shop, watching
schoolchildren decide how to spend a penny, choosing between eight
jelly beans or six chocolate dolls. Later in life, Edith avoided choco-
late, as it always brought back memories of the children's voices, hag-
gling over the few cents that paid her mother's bills. Unlike her
mother, Edith demonstrated an early flair for business. In her notes
for an unpublished autobiography, Edith described a peanut-selling
scheme:

In 1910 a schoolchild could buy a sack of roasted peanuts for
a penny. There were fourteen peanuts to a sack and it was
important to count accurately: one less than fourteen and
you'd lose a customer and probably all his friends as well; one
more and you'd go broke. The display technique consisted
simply of filling the little bags and piling them up in the win-
dow. As a bag was filled you twisted the neck until the paper
was tightly pressed around the fourteen peanuts.

At ten, I introduced a merchandising revolution. After
counting out the fourteen peanuts, I lifted the sack to my lips
and blew, then gave the final twist to the neck of a full inflat-
ed sack. The customers were still only getting fourteen
peanuts, but those bulging, blown-up sacks were much more
attractive than the little twists of brown paper. Our peanut

sales doubled, tripled and kept on climbing. If it had been possible to make a living out of peanuts, our troubles would have been over.

But it was not possible to make a living off peanuts. Marriage allowed Sonia to leave the home and make a bid for a more middle-class existence. On November 29, 1912, she wed Maurice. Edith later expressed jealousy that her sister found men to take care of her. "My sister was the spoiled darling," said Edith. "She was smart, you know, people thought I was smart! Well, I was a dumb cluck because I always worked. She was helpless. She was helpless through two husbands who adored her and took care of her, covered her in jewels and furs."

At the time, twelve-year-old Edith was attending the city's first all-girls high school, the newly constructed Wadleigh on West 114th Street. This towering Tudor edifice was surely a powerful symbol to the immigrant students, reminding them they were beneficiaries of the great city's largesse. Money was not bountiful at home, however, and Edith couldn't afford regulation bloomers for gym class. She sewed her own, inventing a pleated style that she thought was superior to the frumpy pairs worn by her classmates. The gym teacher called Edith to the front of the class, chastising her for the improvised attire. Snickers reverberated across the gym from the other girls. Edith walked out of the gymnasium and never went back. "All the kids were new; it wasn't personal," said Edith. It was the teacher's behavior that had galled her. "Being mocked by an authority figure was a very powerful experience." Years later, when Edith was selling art to scions of the country's richest families, she was never intimidated by wealth. In fact, she always felt slightly more entitled and accomplished because she had earned her own place in the world. "It hardened me in a way, and I think I punished the rich ever after," said Edith. "I really developed for myself esteem, a sense of superiority to compensate for the hurt."

Poverty made life at home and at school a series of struggles, but

Edith found a world where bloomers, blackboards, and penny candy didn't matter. The National Academy of Design, a bastion of culture and education, was located at the top of a hill on West 109th Street and Amsterdam Avenue, across the street from St. John the Divine, the skeleton of a Gothic cathedral, under construction. The academy had moved to 109th street in 1899 as a temporary home, after its original building burned in a fire. The new school had spacious classrooms and well lit studios. It was not far from Edith's home and just blocks from Columbia University's neoclassical buildings and sculpture, much admired by the academy's teachers. But the academy was isolated from the rest of the budding modern art scene. The few galleries that existed in New York were scattered around the forties and fifties, while artists lived and worked in inexpensive studios far to the south, in Greenwich Village.

Eight instructors taught 425 students in day and evening classes, delivering lectures on composition, perspective, anatomy, and the history of painting and architecture. In 1914, Edith plucked the girlish ribbons from her hair, slid into a high-bust corset and tacked a couple of years onto her age. Pretending to be sixteen, older than she really was, she signed up for classes in life drawing and drawing from antique casts, using an Americanized name: Edith Georgiana Fein.

Art school was an escape from a home where Edith wasn't able to indulge her artistic and cultural interests. Frances had no time for such frivolity. The academy classes were populated by talented and ambitious young people, all committed to art, something luxurious and unthinkable for many immigrants focused on survival. Many of the students shared Edith's background; nearly half were foreign-born, and close to a quarter were Russian.

There was another new dimension at the art classes—they included young men. School and home life were dominated by girls and women, but the evening art classes allowed Edith to mix with the other sex, and she soon discovered that her beauty and free-wheeling personality made her popular. After class, she had her pick of suitors willing to carry her portfolio and escort her home. One of the only

disadvantages of being a girl was that she had to sit in the hallway, with the other few female students, during the life drawing classes and work from casts. Men and women weren't permitted to work from a nude model in the same class.

In the summer of 1914, war exploded across Europe. New Yorkers were filled with unease, but Sonia secured an escape from the sweltering summer heat for her mother and sister; a ticket out of New York and the uncertainty of life lived off the slim margins of penny candy. The year before, in 1913, the Metropolitan Life Insurance Company had transferred Maurice to an office in northern Kentucky. Now a department supervisor, Maurice was able to afford an apartment at 110 East 5th Street, in a good part of town. There was room for Edith and Frances.

Covington, Kentucky, was not an utter backwater. The town was just across the river from Cincinnati, where there was a large art museum and art school. Compared to New York, however, Covington was sleepy. The leafy streets were lined with old wooden homes, people spoke with heavy twangs, and blacks weren't allowed in the same schools or on the same trolley cars as whites. The local economy was growing because of heavy industries such as steel and railroads, as well as such regional specialties as meat packing, tobacco warehouses, distilleries, and harness making. There were 60,000 citizens, but just thirty-five Jewish families. Covington boasted dozens of churches, but not one synagogue.

Even if the town was slow-paced, Edith's brother-in-law was a charismatic leader who made news soon after arriving. He helped start a chapter of the Young Men's Hebrew Association, serving as toastmaster for the club's first banquet held at the Odd Fellows' Hall. He also galvanized Jewish families to build the town's first temple. For three years before Maurice arrived in town, Orthodox Jews had attended religious services at the Kentucky Post Hall, borrowing a rabbi from the next town over. In 1913, Maurice helped this congregation raise funds to build their own temple, and in 1916 inaugural services were held at Temple Israel, an elegant neoclassical building.

A long flattering profile in the *Kentucky Post* credited Maurice as the prime force behind the temple and also as founder of the Sunday school where Sonia taught classes. "The story of Chase's transformation from Russian insurrectionist to a peaceful Covington citizen partakes of proportions usually found in story books of the best seller type," extolled the article. The paper recounted the colorful journey of the young political exile who had fled Odessa for Europe, then New York, and finally Covington. "And so among Covington Jewish people Chase is held in high regard. To his scholastic degrees of M.D. and Ph.D they say should be added that of B.E. to stand for Booster Extraordinaire."

Frances had raised her daughters in a secular household. Although she spoke some Yiddish, the family neglected Jewish holidays, and Edith did not attend Sunday school. Edith later said her family overlooked the Jewish holidays because most of the traditions required a man in the household. The fact that Maurice identified so strongly with his faith was probably quite an adjustment for Edith. But Maurice's interest in poetry and collecting curios, artworks, and carved ivories likely intrigued her, given her own growing fascination with all things artistic. Edith found a summer job drawing illustrations and modeling for a hat company in Cincinnati. But this quiet life didn't suit her. She yearned to return to the city even if that meant going back alone.

2

What Shall I Choose?

EDITH SAT IN THE PARLOR of her sister's apartment, smiling politely at her male suitor as the maid placed a bowl of strawberries on the table. She knew she wasn't going to marry anyone in Kentucky. Her brother-in-law Maurice had encouraged his best friend to court the bubbly and attractive fifteen-year-old brunette, but getting married and settling down was not part of Edith's plan.

As soon as Edith had saved enough money, she would escape from Covington. This quiet southern town was no place for a girl with dreams of becoming an artist. And that's what Edith wanted to be. She knew it in her bones. But her dreams of artistic greatness were useless in a town like Covington, where ladies at the local Arts Club focused on social issues such as jail conditions and on planting gardens at the local schools. Nearby Cincinnati, like Odessa, was relatively prosperous and cultured, but it felt remote, isolated geographically and physically from the cities that pushed the world's markets forward, cities such as Paris, London, and New York. Home for Edith was never going to be a second- or third-tier town.

"I left home at 15, with a total capital of $18," Edith said of her

budget equal to $360 in 2006. She may not have had much of a cushion, but Edith's decision to set out on her own, leaving behind her mother and sister, was unequivocal. Having already survived her father's death, the pogroms, and poverty, Edith knew she was strong enough to make it in New York City.

Even though Frances had shown remarkable strength and bravery in abandoning Russia and moving with her two young daughters to an entirely new world, her primary motivation in America was survival. To expect more than that, to dream of intellectual stimulation, power, fame, and fortune, was unrealistic. Middle-class respectability was a perfectly splendid finale for her, as it was for most immigrants, including Edith's sister Sonia, who at twenty years of age had settled happily into marriage and motherhood. Sonia's future was secure, and she was delighted to abandon the hectic, gritty city for a life of comfort and complacency. Not so for Edith. If she wanted artistic glory, she would have to strike out on her own.

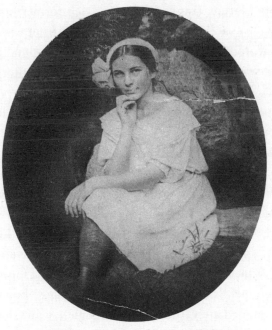

Edith in Central Park, circa 1916.

If Edith had left New York as a girl, she was now returning, at age fifteen, as a young woman. Her blond locks had darkened to a soft brown. In the custom of the day, she let her hair grow long but wore it tied back, either in neatly coiled braids or swept back with a middle part, emphasizing the symmetry of her features. Her beauty had a certain exoticism: the glossy brown hair, wide blue eyes, and full round cheeks.

Edith rented a room in an apartment belonging to distant relatives living at 201 East 58th Street, a block lined with narrow tenements. Now all she needed was a job. Bloomingdale's, a department store catering to lower- and middle-class shoppers, faced Third Avenue, around the corner from where she was staying. The store's quirky tagline, "All cars transfer to the home of the truth," played up its proximity to public transit. Shoppers came by subway and the elevated trains (El), trudging past dingy saloons and tenements tucked into the shadows and clatter of the elevated train tracks. "Bloomingdale's was drab, a series of buildings cobbled together over the years," wrote Marvin Traub, Bloomingdale's former president. "No two floors were exactly alike, and many tilted from east to west and from north to south." Wealthy New Yorkers shopped at the better stores downtown, including B. Altman, Lord and Taylor, and Arnold Constable.

It was common for immigrant girls who had grown up in New York to work as shopgirls or typists. Girls who came to America when they were older had fewer options and were stuck with the less desirable jobs in the garment trade. Edith did not need to look for such "greenhorn" employment. She decided to put in for a job as a Bloomingdale's comptometer operator. "I had at best a very hazy idea of what a comptometer might be," Edith said. "But I knew it had something to do with adding figures and I had always been good at arithmetic." When she arrived for the interview, she found a long line of other job hopefuls. "Standing in line waiting to be interviewed, I figured out immediately that Bloomingdale's wanted experience," Edith recalled. "By the time I got to the head of the line, I'd had two

previous jobs operating comptometers, did it well and liked the work. I was hired."

Edith's story reflected her precocious ability to sell herself under pressure, even if that meant lying. Salesmanship and a certain skill at bending facts to suit her needs would come in handy when she launched herself as an art dealer. Ultimately, the very core of art dealing is selling, both the art and the dealer herself. Knowing what a collector needs to hear converts browsers into buyers. Edith had learned to sell herself from the moment she arrived in New York.

On her first day at work, Edith was directed to one of Bloomingdale's upper floors, where she found a large open room filled with rows of desks and chairs. Each workstation consisted of a chair, a desk, and a strange metal box. A blur of black skirts filed into the room. Edith sat down and glanced at her machine, a bewildering device with eight rows of black-and-white keys, an early incarnation of the modern day calculator. A supervisor distributed stacks of papers to each worker and stood watch at the front of the room. The room vibrated and buzzed as hundreds of fingers punched metal keys at an alarmingly fast rate. Edith tried to keep calm. "I bent over my machine and tried to find out what to do by sidelong glances, covered by a hand on my brow," Edith recalled. "It was useless. On both sides of me, the girls kept their fingers punching the keys, but from the only angle at which I dared to watch, I couldn't tell what keys they were punching." The routine appeared to be a flurry of key punches and a tug on the side lever. Edith studied her box. There wasn't much she could do. She began jabbing at keys and pulling down the lever. The contraption refused to yield any hints. "To hell with the comptometer!" Edith thought.

She began churning through the numbers, adding in her head. After lunch, the supervisor summoned Edith. He told her he had reviewed her work and was impressed with her fast and accurate results. In Edith's recounting of this tale, she makes the astounding— and unlikely, given the speed of the comptometer machines—claim that her mental computations had out-added the other operators.

The supervisor had not summoned Edith to praise her work. He accused her of fakery, lying that she was an experienced comptometer operator. Edith claimed she admitted her subterfuge and was permitted to keep her job, with the proviso she learn to add on the machine. "He also explained that one girl couldn't do more work than the others," said Edith. "It was bad for morale. But he let me keep the job and he showed me how to operate the comptometer, which easily slowed me down to the regular speed."

Slowing Edith down didn't last for long. Aside from the joy of a regular paycheck, the job was sheer drudgery. Though she sat in a room filled with workers, it was essentially a solitary act: one woman, one machine, and endless sales figures in need of totaling. There was little chance for advancement in the comptometer pool, and Edith recognized her talents were not being used.

Edith's own job may have been dull, but working for Bloomingdale's was fascinating. The department store sold millions of dollars worth of merchandise to thousands of customers, and these magical transactions took place just a few floors below the realm of the key punchers. Each day Edith wandered past tables, shelves, and racks displaying mahogany-veneered frames, patent leather boots, and organdy dresses with satin bows. Bloomingdale's was a full-service store, with a pickup wagon available to retrieve soiled blankets for cleaning and a circulating library with 1,000 books, available to borrow for a $1 membership fee. She thrived on the energy and action downstairs, but she wanted a better job at a better store. Luckily for Edith, there were unprecedented work opportunities for women in 1915. Despite concerns over the war in Europe, there was both increased demand for consumer products and inflation, resulting in a boom for retail merchants.

This healthy retail and economic climate, combined with Edith's own talent for draftsmanship, helped Edith earn a promotion to Bloomingdale's art department. She drew advertisements, and although there were strict limits on her creativity, the work united her talent for art and business. It was also evident to Edith, even at fif-

teen years old, that she was out-earning some of the artists she had befriended through the National Academy of Design, much older men who didn't make as much money from their art as Edith made churning out ads for Bloomingdale's.

The promotion did not satisfy her for long. The largest and most dynamic department store in the city lay a mile or so south. Edith went to work for R. H. Macy and Company in Herald Square, sketching fashions. Macy's was not the most fashionable shop, but it had made a name by promising to undersell the competition, a lesson Edith absorbed and would put to practice later on in the art business. Constructed in 1902, Macy's sprawling nine-story building was a model of modernity, with thirty-three elevators, four escalators, and an 18-mile network of brass pneumatic tubing shooting cash and checks around the store. There were 4,000 employees and a public restaurant seating 2,000 customers. Store policy was enforced down to the last detail: black men worked as elevator operators, and store buyers were required to keep current with high fashion by reading *Vogue* magazine. Edith was required to dress in a long black skirt and black shirtwaist a new button-down blouse, favored by working women and modeled after men's shirts. Edith bucked the oppressive all-black rule, sometimes showing up for work in navy. Still, Macy's was regimented. Each morning, she tossed a disc down a chute, like tossing a coin in the subway turnstile. At 8:45 a.m., the chutes closed, and any latecomers had to leave and were docked a half-day's pay.

Macy's and other department stores of the day provided a visual smorgasbord of material comforts for the home and closet, with tables and racks stocked with lace curtains, fur coats, and French linens. The store sold everything Macy's managers could think of, including cutlery, boys' hats, photographic supplies, corsets, and delicatessen foods. Stores exhibited all the material pleasures usually hidden from, and certainly too costly for, most New Yorkers. For newly arrived immigrants, they provided an instant education in what lay on the other side of the large limestone façades on Park

Avenue, a distant world of ease and refinement. The fantasy began on the sidewalk, where women congregated before wax figures posed in the windows, studying the tilt of a hat and the cut of a coat.

Edith joined the foreign office, making drawings from cabled reports describing the latest in European fashions. She was eager to continue her ascent and decided she wanted to be a buyer, a position that involved travel, responsibility, taste, and negotiating skills—and that paid a larger salary. But before Edith could leap on the path to a glamorous career as a buyer, she needed to gain more experience as a lowly clerk. In the meantime, she sought out smaller opportunities for advancement. Macy's had a suggestion box, and employees with the best suggestions received a cash prize. Edith made frequent recommendations, although we don't have any record of what they were, and she later claimed that she won the monthly prize so often, it seemed to come as regularly as a paycheck.

Fearless in her critiques, Edith claimed she brought one complaint directly to the company president. The trouble began in the staff cafeteria, where Edith usually spent her forty-five-minute lunch break. The company offered employees free milk, coffee, and tea, and Edith determined the least expensive and most satisfying lunch was a banana, washed down by a free glass of milk. One day, feeling extravagant, she splurged on a slice of strawberry shortcake. Her second forkful turned up a disoriented cockroach in the whipped cream. Edith was furious. She had noticed the cafeteria seemed dirty, but now the evidence was staring her right in the face. Inspired by the socialist books advocating worker's rights that she read at night, Edith made an appointment to meet with Macy's top executive, Jesse Isidor Straus. Mr. Straus was a formidable presence. Handsome, brown-eyed, and slim, he stood nearly a foot taller than Edith. He was also the Harvard-educated heir to one of the city's most prominent German Jewish families.

When Edith appeared for her meeting, she glanced around Mr. Straus's lavish office and started in. "You have all these oriental rugs and a carved wooden desk," she said, "while your employees eat

roaches." For a young, low-level employee to have had the courage to take such a combative position with the head of her company does seem unlikely, but during her lifetime, Edith never shied away from speaking her mind and found that people in positions of power responded well when she treated them like anyone else. Indeed, she never fawned over her rich and powerful clients, whether Rockefellers or Fords, so there is probably some truth to her retelling of her first encounter with Mr. Straus. Edith said that Mr. Straus took his young worker's concerns seriously. He asked Edith to show him the areas of the store reserved for employees and then ordered conditions cleaned up. Apparently, Mr. Straus was so impressed with Edith that, having learned of her artistic talent, he offered to send her to Europe to study art—as many Americans did during the teens. But when he offered her a trunk of his daughter's used clothing, Edith's sense of pride was offended, and she turned him down flat.

Though she always had a hard time accepting gifts from others, Edith said she did accept Straus's offer to pay her tuition at a progressive midtown art school, the Art Students League, located on West 57th Street. Student records reveal she paid the modest $6 dues for two classes—though there is no indication if that came from Straus.

The league had been founded in the 1870s by a group of young artists dissatisfied with the crusty academic approach offered at the all-powerful National Academy of Design. "It was certainly the radical school," said Marchal E. Landgren in his history of the school's early years. "It had separated from the tyranny of the Academy; it had grown out of a desire on the part of a group of students to better their education; it was student controlled and managed; its integrity could not be, and was not, questioned."

Edith enrolled in the "Evening Life" class, taught by George Bridgman, who was renowned for instruction on figure drawing and anatomy. Students worked from nude models, studying proportion, shape, balance, and shading. Classes were held in top-floor studios where students sat on wooden chairs, arranged in a semicircle, holding large

boards with sheets of paper clipped on top. Burlap covered the windows, protecting the rest of 57th Street from a potentially shocking sight: nude models posing on a wooden box under the studious gaze of men and women—in separate classes—as they studied and sketched.

The league also served a social function, as a meeting spot fo 1,000 students, members, and teachers. The elegant building designed by the architect who would later create the Plaza Hotel included a students' clubroom, and there were lectures, costume dances, and daily penny teas in the lunchroom.

Edith's intense connection and identification with the arts set her apart from the thousands of other immigrant children. She was unlike other Russian Jews, striving on the Lower East Side or in Harlem tenements, burdened with anxieties about food and shelter. But being part of the bohemian artists' circle was not without repercussions. One night, Edith returned home from class and found her portfolio splayed open and her drawings strewn about the parlor floor. Her relatives had discovered charcoal sketches of a young man clad only in a loincloth. They recognized the model as a young man who sometimes escorted Edith home from class. "So that's what you do. You all go naked and draw pictures of each other," stammered Edith's aunt. "The honor of the family was ruined and could only be restored by expelling the erring member. Out I went," Edith said. She gathered up her few belongings and tearfully made her way to the Young Women's Hebrew Association, where she rented a room. Her expulsion was an awakening. "For the first time," said Edith, "I realized that I was involved in a way of life that most people didn't understand, and didn't particularly want to understand."

Edith remained at Macy's for two years, until the early spring of 1917. Even though the man who ran the company was an ally, she was ready to move on. She was supporting herself and her mother, who had by then returned to New York from Kentucky. They shared a modest apartment at 660 Dawson Street in the Bronx, and life had no more frills than Edith's threadbare childhood. But now there was

a difference: Edith was an adult and in a position to improve her lot—she knew there was a better life out there than the one she could afford on her small Macy's salary. She needed more money.

In April Edith found a new job at Stern Brothers Department Store, on West 42nd Street between Fifth and Sixth Avenues. In her new position as assistant to the advertising manager, she wrote copy and designed ad layouts. She wrote to Mr. Straus after she left Macy's, likely explaining her financial circumstances and her desire to have been promoted to a buyer position. Mr. Straus, who had worked his way up in the family business, starting in the receiving department, replied that he thought Edith had made a mistake and invited her to return to Macy's and to continue to train for an appropriate promotion. "As you must appreciate, if you would be a buyer, you must first learn to sell," said Mr. Straus. "Return here and go to work." But even pressure from Mr. Straus didn't persuade Edith to stay. Perhaps she considered her department store work as merely a means to survive, while her real work was done in the studios of art school. If that was the case, her objective would have been to maximize her immediate earnings, not slowly climb the corporate ranks at a company such as Macy's.

By day Edith worked at Stern Brothers, a department store selling fur lined motor coats and Persian rugs to wealthy New Yorkers. On evenings and weekends she sought entrée into the small but lively arts community. Guided by a precocious mind and the gift of resourcefulness, she ferreted out the most authentic, progressive, and influential art dealers, salons, and artists. At the time, the New York art world was confined to a few dozen art galleries, as well as some art clubs. Edith visited the galleries, where she learned about art and the art of the deal. One of her favorite destinations was the Little Gallery, or "291" (located at 291 Fifth Avenue), known as *the* place for progressive modern art, and even better known for the man who ran it. Alfred Stieglitz, who founded the gallery in 1905, had created a modest three-room space with a grand mission: to showcase some of the earliest and most important modern artworks in America.

Stieglitz himself was an eccentric, and he cultivated that image, dressing in a flowing black cape, with a scraggly gray mustache and pince-nez eyeglasses. Artists, wealthy patrons, and writers adored him and promoted the Stieglitz myth. By the time he began dabbling in art dealing, he had already proven himself as a brilliant photographer. "To Stieglitz the emanations of the artistic soul were miracles to be cherished," wrote art historian Milton Brown. "He was willing to act for the artist as a buffer against the unfeeling world. '291' became a symbol of perfection in a vacuum, an oasis in the desert of crass commercialism where the creation of beauty was the sole objective and beauty itself was enshrined."

Photographer Annie Brigman visited the gallery in 1914, around the same time Edith frequented it, and wrote about her experience. Brigman described an "insignificant doorway," leading to a "more insignificant hall," and finally an elevator "about as large as a nickel-plated toast-rack on end, with a six-foot African in command." She asked for the Little Gallery, and "a flash of teeth, a tattoo of huge knuckles, a pull on the rope and we were crawling up inch by inch to Mecca." Brigman followed a narrow hallway and recognized "its drop lights, its gray walls and simple hangings, and the great copper bowl filled with branches of russet oak leaves." The décor was mere backdrop once she saw the exhibit: "I didn't know that these were Matisse drawings, or that those wild riots of color were Marins and Hartleys. It was just a head-on collision to my plain little brain. . . . And those pictures! I couldn't believe my eyes—what did they mean? It was as though I had come from or gone to another planet."

When Edith was still a teenager, Stieglitz was one of the earliest advocates of modern art in America. He was ahead of almost everyone else, championing the modern cause well before the famous and ground-breaking 1913 Armory Show. In April 1908, he exhibited French artist Henri Matisse, the artist's first show in America. Critics were incensed, describing Matisse's female figures as "subterhuman hideousness." Stieglitz didn't mind the controversy. He reprinted the

reviews in *Camera Work* and went on to exhibit many Americans whose works were influenced by the modernist movement in Paris, including John Marin, Georgia O'Keeffe (Stieglitz's future wife), Max Weber, Abraham Walkowitz, and Marsden Hartley, all of whom would eventually exhibit with Edith.

Stieglitz was one of the lone missionaries for modernism in the early teens, but that all changed in 1913. The Armory Show, held that year at the cavernous Sixty-ninth Regiment Armory on Lexington Avenue, cast a spotlight on modern art—canvases with cubist forms and wild colors—which was alternatively mocked and celebrated in hundreds of newspaper and magazine articles. "There is in my bathroom a really good Navaho rug which, on any proper interpretation of Cubist theory, is a satisfactory picture," observed Theodore Roosevelt. The show was organized by American artists (those with modern tendencies and those who favored realism, including Walter Kuhn and Arthur Davies) who hoped to generate publicity and sales. Ironically, it was the French artists, such as Marcel Duchamp and Henri Matisse, who caused the biggest sensation, garnering the most scathing critiques, headlines, and even sales. Of the $44,148 in sales, more than $30,000 went to the Europeans. The Armory Show crisscrossed the country, traveling to Chicago and Boston. Hundreds of thousands of visitors saw it, and thousands more read about it in newspapers and magazines. Modern art and artists were suddenly household names.

But even with the frenzy surrounding the Armory Show, just a year or two later, when Edith appeared at Stieglitz's door, modern art was still the domain of the few. New York had no museums collecting modern art, and just a handful of galleries and collectors even interested in contemporary American art. Most teachers at the National Academy of Design discouraged students from visiting "291," lest they be influenced by radical American painters such as John Marin and Abraham Walkowitz, whose disregard for accurate form and color outraged the traditionalists.

Edith ignored her teachers, realizing Stieglitz had much to offer.

His gallery even looked different from the others. The rooms were stripped down and muted: burlap walls lit by simple metal lamps. It was not much compared to the lavish décor found at other upscale salons, where red velvet upholstery, heavy drapes, and viewing rooms stocked with fine French furniture gave buyers confidence they were acquiring tradition and value. These galleries, specializing in paintings of quasi-realistic landscapes, still lifes, and portraits, tarted-up with gilt frames, provided a psychological edge to the newly wealthy collector. Americans sought out treasures from old Europe: Italian Renaissance madonnas and eighteenth-century portraits of elegant English lords and ladies. These status symbols were preferred by America's wealthiest collectors, including J. P. Morgan, Andrew Mellon, and John D. Rockefeller, Jr. There was no point buying new American art; the stuff was small, incomprehensible, lacking pedigree, and not pleasing to the eye.

Painter Guy Pène du Bois, who noted that "the commercial galleries vied in coldness and aloofness with the museums," mused about those velvet-lined emporia:

Hung in horrible red velvet and a pall of stuffy silence, one was invariably attended in them by an excessively well-mannered gentleman in afternoon clothes who seemed incapable of any strained vision without looking down his nose. Art was unquestionably designed for the captivation of tycoons. The little men were certainly not invited to view it and when they did, which was, Heaven knows, rarely enough, the feeling of intrusion which must have attacked them could not have greatly helped their appreciation of the works shown.

Stieglitz offered none of that Gilded Age pomposity. "For Stieglitz it wasn't primarily about making money," said Sarah Greenough, curator and head of the department of photographs at the National Gallery of Art. "It was about finding a way for artists to earn a living so they could work." Stieglitz didn't consider "291" a business

but a laboratory for a handpicked circle of artists, managed like a museum. He reportedly took no commission on the few sales that did trickle in, instead relying on his own private income and donations from wealthy patrons, the so-called rent fund, to keep the doors open. Stieglitz also cultivated a reputation for refusing to sell his artists' work to anyone who failed to meet his standards.

Edith appreciated Stieglitz's eye and said she visited his gallery regularly, though it's doubtful Stieglitz took note of her until she could be of use to him, much later on. Nevertheless, Edith felt a connection with the fifty-year-old dealer. She loved the adventurous work he presented, so different from the traditional, classic examples that hung at her art schools and at the Metropolitan Museum of Art, the only art museum in town. But she was also confounded by his poor business sense and his insistence on placing his moral principles above his commercial interests. Edith knew what it meant to be poor. None of his artists seemed to have Stieglitz-sized trust funds. Painters such as Arthur Dove and Marsden Hartley were usually desperate for sales. If Stieglitz was a dealer, Edith thought, then he ought to strive to match collectors and artists, buyers and sellers. But that was not his concern. He usually mounted just four or five exhibitions a year—less than half the number Edith would present during her slower years. He professed disdain for any sort of marketing or advertising, frowning on the whole unsavory premise of art dealing, the notion of putting a price tag on the creative output of his handpicked geniuses, a small group he felt were leading a cultural revolution in the United States.

In fact, Stieglitz wasn't nearly the disinterested business man he professed to be. There were occasions when Stieglitz fudged facts and numbers to make it appear that he was selling art for much more than he really was. He experimented with selling to a small network of other New York dealers—Charles Daniel and Newman E. Montross—who then resold paintings and prints to the small pool of willing buyers. Stieglitz's own larger-than-life personality prevented him from making sales directly to customers. His mercurial outbursts and imperious manner turned potential clients away. Ohio mining tycoon

Ferdinand Howald bought hundreds of American paintings, including twenty-eight Marins, which he acquired from Stieglitz through dealer Charles Daniel from 1916 to 1924. Howald never bought from Stieglitz, though the dealer approached him directly, recommending he purchase an O'Keeffe. After Howald borrowed and returned the O'Keeffe, correspondence between the two ceased. "Howald disliked intensely to be told what he ought to admire," wrote E. P. Richardson, director of the Columbus Gallery of Fine Arts, where the Howald Collection was donated. Richardson believed that Stieglitz's "directing and exhorting" cost him Howald's business.

Stieglitz also alienated another important collector, Duncan Phillips, who founded the Phillips Memorial Gallery, a private museum in his Washington, D.C., home in 1921. Phillips bought a group of Marins from Stieglitz in 1927, including *Back of Bear Mountain*, a majestic landscape with washes of plum and cool gray blues, which Stieglitz had priced at $6,000, a record price for any American watercolor. Phillips asked Stieglitz to keep the purchase price a secret—or at least limited to the gallery's inner circle—but the dealer couldn't resist spreading the news. Articles appeared in the *New Yorker* and the *Dial*, where critic Henry McBride remarked, "Such an unlooked-for achievement in finance strikes my mind into numbness and it knows not what to think." Phillips was furious and demanded Stieglitz arrange for a retraction. Stieglitz refused and was unwilling to apologize. Phillips boycotted the Intimate Gallery, the 1920s incarnation of "291," for an entire year.

Even as a precocious teen in awe of the Stieglitz aura, Edith was shocked by his cavalier and condescending attitude toward certain clients and gallery visitors. Unlike Stieglitz, who was born into a wealthy household, she had learned early on that money meant freedom and power, and only hard work and daring could bring these rewards to someone starting at the bottom.

Edith claimed to be more impressed by Newman E. Montross, proprietor of the Montross Gallery. He was also from an older gen-

eration, born in the mid-nineteenth century, and like Stieglitz, he had adapted to the twentieth century. Although his gallery appeared more traditional than "291," showcasing American Impressionists William Merritt Chase and John Henry Twachtman in a plush salon, Montross grew attuned to modern art. Following the 1913 Armory Show, he was among a handful of dealers who began exhibiting contemporary art, reorienting his gallery's program with shows by young American radicals such as Charles Sheeler and Europeans such as Matisse, Pablo Picasso, and Duchamp.

Montross had more modest beginnings than Stieglitz. He had started out as a clerk in an artist supply shop, moved on to open his own store, and gradually began selling art alongside paintbrushes. Artists were known to mock Montross's imperious affectations, and painter John Sloan pegged him as "soft and suave." By the time Edith visited Montross, he presided at 550 Fifth Avenue, a prestigious address, and was considered one of the most reputable dealers in town, with clients including the eccentric Pennsylvania collector Dr. Alfred Barnes, later famous for his museum filled with dozens of Renoirs and Cézannes. Fifteen year-old Edith first visited the Montross Gallery in about 1915, and though she says it was a pivotal occasion, she also says she only visited once. During that visit, Montross impressed Edith by treating her seriously. He invited her into a private salon reserved for important clients and propped dark moody paintings by nineteenth-century American artist Albert Pinkham Ryder on velvet-backed easels, rhapsodizing over them with such a passion that Edith was wholly captivated. She later claimed Montross had the biggest influence on her as a dealer for teaching her the fundamental principle of art dealing: show what you love.

Aside from the clutch of commercial galleries, there were other places progressive art-minded New Yorkers gathered. Regular exhibitions were held at the Whitney Studio "Club," a three-story building at 8 West 8th Street, funded by society sculptor Gertrude Vanderbilt Whitney. Exhibitions started in 1914 and soon included younger artists such as sculptor William Zorach, later associated

with Edith's Downtown Gallery. As compared to the artists champi-
oned by Stieglitz, those supported by Whitney and her director
Juliana Force worked in the realist vein. Whitney's own taste ranged
from John Singer Sargent's portraits of society figures to the brushy
renderings of street urchins and common folk by the so-called Ash-
can artists such as John Sloan and George Luks. The Whitney Studio
continued presenting exhibitions with a view to helping artists gain
exposure and possibly dealer representation from Kraushaar Gal-
leries, Macbeth, or one of the handful of established dealers who han-
dled American contemporary art.

In 1918, Force and Whitney expanded their enterprise, founding
the Whitney Studio Club, a gathering place for member artists offer-
ing not only exhibition space but also a squash court, a library lined
with art books, a salon with blue satin curtains, and a billiards room.
A sketch class with live models at twenty cents per session provided
artists with an affordable and social venue, and many artists later
associated with the Downtown Gallery partook in the impromptu
sketching sessions: Peggy Bacon, Stuart Davis, "Pop" Hart, Kather-
ine Schmidt, and Yasuo Kuniyoshi. Other members included Mar-
guerite and William Zorach, Robert Laurent, and Samuel Halpert.

Edith later regaled clients and artists with raucous Whitney Stu-
dio tales, recounting parties where painter George Luks pinched fan-
nies—including Edith's—and razzed Mrs. Whitney during dinner.

Edith said she went "wherever artists could be found, seen, or
respectfully heard, and attended every meeting that was free." She
discovered a lively group of artists and critics who gathered on Fri-
day nights and called themselves the People's Art Guild. John Weich-
sel, founder of the guild, was a psychologist, activist, and art lover
who opened up his home at 918 Cauldwell Avenue in the Bronx for
weekly dinners and discussions. The guild started up in January
1915, initially as a group of Jewish painters and sculptors surround-
ing Weichsel, who were concerned about the "prevailing art condi-
tions in our ghetto." Its mission was to bring art to the masses, and
in two years, members organized more than fifty exhibitions in

churches, cafeterias, Lower East Side community centers, and settlement houses.

Edith joined the guild in 1917. "I was made mascot of the People's Art Guild," she said. These meetings served as a social network for Edith, where she met many of the artists whom she would later represent, including Elie Nadelman and Max Weber. Edith felt at home among the Weichsel artists. She was comfortable with flamboyant ragtag bohemians, who operated against all cultural grains, but she could also hold her own within the structured confines of an office job. Edith straddled these two worlds easily but identified most with the artists. Indeed, they shared a common background: most were Eastern European Jewish immigrants, raised in poverty in New York, and determined to survive as artists.

In addition to a sense of instant community, the guild provided Edith with a moral imperative she would carry with her for the rest of her life. "He [Weichsel] sponsored lectures and he provided a place for artists to meet with each other and with a wider public than 57th Street at the time dreamed of," Edith recalled. "Art to this doctor was somehow a part of general social progress. It was right for the people to know about art and artists, to see new work and perhaps live with it. It was equally right for artists to get acquainted with the workers, small merchants and impoverished intellectuals." Edith would always believe art was for everyone, whether rich or poor, educated or not. She learned the lesson of low prices from the guild exhibitions and the commonsense practice of keeping evening hours to accommodate working people. Unlike the snobbery that had infiltrated the Stieglitz circle— where it was assumed the working class couldn't understand modern art anyway—Edith was democratic. She always said she cared most about the "little guy," the collector from Brooklyn buying on the installment plan. Ironically, her business ultimately flourished not because of the middle-class buyer, but because the Downtown Gallery was the art source for some of the richest Americans.

Edith was not just a pretty mascot. At seventeen, she was selected as the guild's treasurer. She quickly proved her worth. The guild held

its largest exhibition at the Forward Building, the Lower East Side offices of the city's Yiddish newspaper, in May 1917. "The crowds who came to the opening were so great, it became necessary to call the police," said Yiddish writer David Igantow. A poet slated to speak during the opening ceremonies couldn't get past the crowds and was forced to climb in through the window. Lectures were held during the exhibition, and at one such event, Weichsel plucked Edith out of the audience and handed her a plate to solicit donations. Edith claimed she pulled in the most donations ever collected at a guild event.

Edith's striking looks meant she attracted attention from some of the male artists. According to Edith, Mr. Weichsel's wife did her best to make sure the artists didn't get too friendly with the young girl, though Edith didn't mind the lingering glances at all. She went eagerly along to poet Robert Frost's studio and to parties at painter Ben Benn's loft on 23rd Street. "It was a time for sitting at the feet of the talkative and important," Edith recalled.

One evening, she met a handsome, thirty-three-year-old painter with gentle blue eyes, powerful broad shoulders, and a stocky frame. Although his features were pleasing, he was short—only five feet, three inches tall—and his head seemed disproportionately large on his small body. Edith liked him instantly and accepted his invitation for drinks at the posh Astor Hotel in Times Square.

Sam Halpert appeared to Edith as the pinnacle of sophistication. She was thrilled to be courted by a well-known artist, far more mature and sophisticated than the boys she flirted with in art school. She also appreciated the intellectual tenor of their conversation. Though she had a frivolous side, Edith liked to be taken seriously, especially as an earnest young woman still sorting out her identity. At the time, she wanted to let any prospective beau know that she was no ordinary girl. She preferred discussing Sigmund Freud and Albert Einstein to gossiping about film star Rudolph Valentino. Sam shared Edith's intellectual curiosity and was also a father figure who, though nearly as short as Edith, was elegant and worldly. He wore crisp suits,

lace-up boots, and usually a tie. Edith admired the gray hair on his temples.

Edith claimed she experienced a terrible disappointment in her painting career soon after meeting Sam. Apparently Leon Kroll, Sam's friend and an instructor at the National Academy of Design, told Edith she didn't have the talent to become a great artist. Edith had taken her art training very seriously. She faithfully attended classes, lugged her easel to Central Park or Fort Lee, New Jersey, for Sunday afternoon sketching, and sacrificed dinners to afford a palette so large it gave her thumb a callus. Now Kroll told her she was destined to be a second-rate Sunday afternoon dauber, something she couldn't and wouldn't tolerate. She went home, gathered up all her art equipment—the paints, brushes, turpentine, palette, sketches, portfolio, and paintings—stormed down to the basement and tossed it all into the furnace. More than forty years later, sixty-one-year-old Edith admitted, "It hurt for so many years."

With the legacy of her art student days reduced to ash, she threw herself into her love affair with Sam. In the fall of 1917, Edith penned maudlin love poems and short stories, inspired by her adolescent emotions, caught up in the whirl of romance. For all her pretenses of intellectual sophistication, when it came to men, Edith lost restraint. She wrote "I Am Afraid I'm in Love" in October:

> . . . *It seems to me*
> *That this same world*
> *Has thrown a veil aside,*
> *And in her naked glory*
> *Here before me stands.*
> *She offers me her boundless fruits*
> *And bids me to partake.*
> *But Life [sic] is short.*
> *What shall I choose?*
> *Oh, I'll take love, just love* . . .

Love aside, Edith was certainly attracted to Sam's stature in the art world. Artists and dealers from Manhattan to Paris knew Sam Halpert as a talented and serious painter who was also a generous and kind man. Sam had devoted his life to art, for art had rescued him from the ghetto. Sam was born in Bialystok, Russia, in 1884. When he was five years old, his family had immigrated to New York. Unlike Frances, who hoped for a better life in America, Sam described his own father as disinterested in the earthly. "My father, a religious dreamer, always gave more thought as how to increase his and our spiritual baggage for the 'next world to come' and paid little attention to our earthly necessities for which he left us to provide at an early age while he remained our spiritual guide," Sam said. "We lived from hand to mouth."

Elias Halpert's preferred activities were studying the Talmud and attending synagogue services. He and Masha, Sam's mother, lived in the Lower East Side on Eldridge Street, along with their nine children: Joseph, Benjamin, Samuel, Jacob, Hyman, Ida, Yetta, Irving, and Jack. Art ultimately saved Sam, providing him with an opportunity to avoid the path chosen by several of his younger brothers, who grew up to be criminals in the Jewish mafia.

As a public school student, Sam had shown talent for drawing. He studied at a Jewish community center, the Educational Alliance, where he met teachers who encouraged his artistic training and sent him uptown to study art at the Metropolitan Museum of Art. Unable to afford art materials, he stole to pay for tubes of paint. He continued studying at the Educational Alliance, where he befriended a teacher, Henry McBride, who went on to become an important art critic for the *New York Sun* and would later be a staunch supporter of Edith's gallery.

In 1899, at the age of fifteen, Sam worked days assisting a commercial artist and spent his nights drawing plaster casts at the National Academy of Design. "It wasn't long before I began to feel the emptiness of this Academic instruction which made me look for help in other directions," Sam wrote to Weichsel. Like many of the

most ambitious artists of the day Sam boarded a ship bound for Paris, a mecca for most modernists, from Claude Monet to Matisse. With a $200 donation raised by teachers at the National Academy, he spent two years abroad, studying first at the stodgy École des Beaux-Arts and then at the more progressive Académie Julian. Sam experimented with the fashionable styles, meeting various artists and trying out new modes of making art. He toyed with the brushy bravura of the Impressionists, a style his New York teachers had warned him against as "the fad of the day." He tested out the bold unnatural colors used by Henri Matisse and a group called the Fauves, painting mustard-colored trees and violet mountains. When the Fivoosiovitches were nailing their doors shut in Odessa in 1905, Sam had three paintings accepted in the Salon d'Automne, a prestigious Parisian annual art show for artwork defying traditions of the academy.

Sam traveled back and forth between Europe and America over the next decade, taking part in important exhibitions on both continents. He made friends among the artists and critics in New York, including Stieglitz. He learned to speak French fluently and to cook the indigenous cuisine. American painter Abel Warshawsky visited Sam's Paris studio on Rue Moulin-de-Beurre and joined Sam on an early spring sojourn around Rouen, where Monet had painted the façade of the cathedral. They also toured Italy. "My new friend Halpert was congenial company," said Warshawsky. "A stocky blue-eyed, sociable man with sandy-colored hair, he seemed always loaded down like a pack mule with paint boxes and gear. At least that's the way I remember him best, carrying more equipment around even then [sic] other painters (perhaps because he carried so many extra clean brushes)."

Sam's tranquility was rattled when war broke out in 1914. He chose to remain in Europe, shuttling between London, the south of France, and Portugal. Even with the war raging, he was reluctant to return to New York, a town less supportive of his sort of art. In the fall of 1914, Sam reminisced to Stieglitz about an evening in 1909, a

farewell celebration for painter Max Weber, one of the first Americans to experiment with cubism. Weber was returning to New York, and a group of artists had gathered in a café to bid him adieu. They fell into a discussion of modern art in America. "The conversation naturally turned to the subject as to what sort of a reception was reserved for the New Art movement in America. The prospects looked hopeless . . . and in the stress of such discouraging outlook and despairing conclusions we looked for consolation in our ideals as we drifted away in the speculations as to what sort of a free center might be created for the younger generation (us) for the manifestation of the New Art."

Sam struggled to support himself with sales to patrons, including John Weichsel. "Your money order of 5th March is an agreeable surprise, as I figured that we were 'financially square,' when I received your previous installment, and was hereafter in the hopes that you will nevertheless keep on writing with the same regularity as when you were sending me your financial aid," Sam wrote Weichsel from Saint-Tropez, France. "Since I last wrote you Mr. Daniel [dealer Charles Daniel] sent me 120 dollars which puts me on my feet again."

Despite Sam's misgivings about America, he returned to New York in 1916 and dedicated himself to finding those pockets of the art world receptive to modern art. He found this support in the same places Edith visited, including select galleries, the Whitney Studio, and the People's Art Guild. When Edith met Sam, she sensed an opportunity to help his career. Sam had achieved a certain amount of recognition, but he was not among the most original or recognized artists of the day. With Edith's influence as muse and marketer, perhaps Sam would paint better paintings, exhibit at more galleries, and achieve higher critical regard. If Edith wasn't fated to achieve great heights as an artist herself, perhaps she could create that success while someone else held the paintbrush.

"Edith was very aggressively seeking him out," recalled Sam's niece, Myrna Davis, who said Edith usually angled for dinner invita-

tions on Friday night when Masha was cooking. "Edith thought she was going to lead a fine bohemian life," said Davis. "But Sam wore a shirt and tie. He was not a crazy bohemian." Sam did, however, have a weakness for seductive, beautiful women. The following spring, exactly one month after Edith turned eighteen, they wed. "I married with the feeling I had married American art," Edith said.

For the first few years of their marriage, their lives revolved around Sam's needs. They lived on 106th Street, near Sixth Avenue. Edith spent her days at Sterns, while Sam focused on painting cityscapes, still lifes, and interiors, often featuring Edith as a model. These canvases depicted the sweeping geometries of city life, featuring bustling districts from Times Square to the blocks surrounding the Flatiron Building. Sam's domestic compositions were of tranquil homes decorated with flowers, African sculpture and a figure—usually Edith—making a bed or sewing a dress. Although Sam's overall compositions evoked a harmonious and elegiac mood, his figures of women—and Edith—tended to be stiff and never quite settled within these imaginary worlds.

"It is very worthwhile for the public to see Mr. Halpert's exhibition," said *New York Times* critic Elisabeth Luther Cary of Halpert's one-man show at Daniel Gallery in 1919. "If only to note how possible it is for a man to break with the conventions and still keep to the great traditions, to be individual without becoming eccentric, to play in the same garden with other modernists and maintain sanity and a muscular style." Cary was a conservative critic and not wild for most modern art. Yet she liked Sam's work; it was safe and didn't till much new ground. Sam's canvases suggested a dabbling with the avant-garde, the thick black outlines and earthy palette of plums, emerald greens and golden yellows, but ultimately Sam's work portrayed recognizable subjects in a recognizable style.

Early into their marriage, Edith realized that she would be the bread winner. During his most profitable years as an artist, Edith claimed Sam earned around $800 a year, amounting to no more than a deduction on Edith's tax returns. Though she had no college or

business school degree, Edith was able to discern employment trends and to predict where she could use her skills. She noticed a growing demand for "systematizers," later called "efficiency experts," and became an early version of a management consultant. At the age of eighteen, she left Stern Brothers to work in this emerging field. From 1918 to 1920, she worked for two garment manufacturers—Cohen-Goldman and Fishman & Co. Edith was a quick study, but her career path at Fishman was cut short when her boss surprised Edith by unbuttoning his shirt, placing her small hand on his silk underwear and exclaiming "Feel!"

During the summer, Edith and Sam moved temporarily to Lake Mahopac, New York, a rural resort village just 55 miles outside the city, where they rested and refreshed themselves in the outdoors, swimming and hiking. Sam stayed busy churning out pretty paintings of fruit bowls and the sweeping green and gold of the countryside. For Edith, country living was not nearly so relaxing. Each morning she walked a mile to the train station, followed by a two-hour commute to the city. At the end of the day, she had another two-hour ride to get home. Though she had been married for only two years, Edith had already begun to resent her husband.

Seeking escape from her amorous boss, Edith placed an advertisement in a New York newspaper, looking for work as a statistician and efficiency expert. She claimed she received more than a dozen replies, most of which she threw away. One of the few which caught her eye came from a famous investment bank, S. W. Straus and Company. Straus's zippy slogan, "Thirty-nine years without loss to an investor," appealed to Edith. She studied mortgages, bought tortoise-rim glasses to appear older than twenty, and barreled through her job interview. Feeling confident, Edith asked for a $50 weekly salary, and after some negotiation, Straus agreed.

Edith was initially hired to manage the correspondence department, some sixty female typists who created and mailed thousands of sales letters and brochures targeting prospective bond buyers. She made decisions that dramatically improved the firm's organization.

She managed ad campaigns and streamlined the mailings. She also found ways to analyze the sales data and vast mailing lists to eliminate waste. Edith also adopted new technologies to help the firm operate more efficiently. On her recommendation, Straus was one of the first companies to install a Dictaphone system. Edith even arranged for the installation of soundproof ceilings to muffle the clatter reverberating from the typists. Mrs. Halpert, as she was known at Straus, was so successful that she gave lectures on efficiency at the Astor Hotel and was put on the cover of a business magazine as one of the only women executives on Wall Street. She was even appointed to Straus's board. Straus's management also rewarded Edith with promotions and raises. By 1925, she was earning a $6,000 salary with a $10,000 bonus, which paid for many comforts at home. Edith and Sam moved into an apartment at 148 West 57th Street, near the Russian Tea Room, Carnegie Hall, and the Art Students League. Edith's salary paid for a maid as well as tailored suits and hats. She also paid for Sam's art supplies, studio time, and models.

Edith's hard work at Straus brought her respect in the business world, but her efficiency expertise meant little to the artists with whom she and Sam socialized. The orbit of New York's art world was minute. There were a few buyers for American modern art, and most artists' wives supported their husbands by teaching or doing other low-paying jobs that allowed their families to scrape by. Edith out-earned all of the other artists' wives, but that didn't bring pleasure to Sam or to her. Sam had trouble sleeping, plagued by a ringing in his ears. Edith didn't have much sympathy. She claimed he had even spent their wedding morning sitting in a corner, groaning. "I was very unhappy, naturally" Edith later recalled. While Edith's salary allowed Sam to concentrate on his artwork, he was no longer a young hopeful. At forty years old, Sam still had not achieved his artistic breakthrough. He had an audience who respected his work, but he was not considered a pioneer. It seemed as if he was destined to be a minor figure, and that was not enough for Edith.

By 1924, their relationship was so strained, Sam began psycho-analysis to try and save the marriage. His analyst suggested he was becoming emasculated by Edith's success. The recommended pre-scription was for Edith to quit her job and for the Halperts to travel to Paris, where Sam had always felt at home. Sam was not convinced of the wisdom of this plan. "My only possession is hope," Sam wrote his friend, painter Leon Kroll. "When I return from Europe I shall be entirely broke. I had to choose between going to Paris or losing my wife. . . . Edith has given up her job for good. (Perhaps that is better for both.)"

Edith agreed to the plan, excited by the prospect of her first trip to Europe. It also offered her a way to exit the business world. She was exceptionally talented at her job, but it is likely she wanted to find a way to blend her passion for art with her talent for business. Edith quit her job in April 1925. Two months later, with two $140 second-

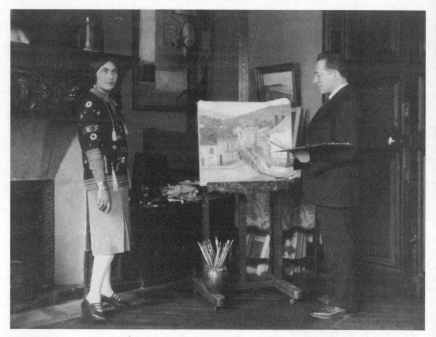

Edith and Sam Halpert in their flat in the Maison Watteau, Paris, 1925.

class tickets (equal to $1,620 in 2006), Sam and Edith boarded Hamburg American Line's *Resolute*, a 620-foot steamer equipped with a pool, café, gym, and botanic garden for the eight-day journey.

It was Sam's first trip to Paris since the end of World War I. When they arrived, a group of fifty artist friends threw a surprise party, welcoming back their old friend and his new bride. Edith's savings provided much more luxurious accommodations than Sam had been able to afford during his earlier visits. They rented a Montparnasse flat in a historic house, the Maison Watteau, once the studio of Jean-Antoine Watteau, the eighteenth-century French painter famous for his murals of bonneted damsels frolicking in lush gardens. By the 1920s it was home to architects and art dealers sharing Modernist sensibilities. In addition to the mahogany paneling and grand fireplaces, Edith was impressed by the bidets in the washroom. For the next four months, Sam worked at a wooden easel placed beside a fireplace as tall as Edith. He stored his brushes in a ceramic jardinière and stacked his canvases in a corner. Meanwhile, Edith, dressed in skirts skimming the bottom of her knees—exposing her white stockings and trim legs—wandered the city streets.

They fell in with an illustrious art crowd, hosting costume balls and raucous cocktail parties for their artist friends. Sam introduced Edith to Claude Monet, who was finishing a series of water lilies paintings, and writer and collector Gertrude Stein. One of the biggest events of the summer of 1925 was the Exposition Internationale des Arts Décoratifs et Industriels Modernes, which launched the design rage for Art Deco. Between French lessons, Edith also toured the art galleries, shocked by the crowds. The dealers seemed to be actually selling artworks, unlike those in the sluggish New York galleries. European art was very expensive, yet European and American buyers clamored to make significant purchases. Edith spent time talking with French dealers, including the famed Ambroise Vollard, who promoted major French artists such as Edgar Degas, Pierre-Auguste Renoir, Paul Cézanne, and Pablo Picasso. Vollard made a big impression on the young American.

In spite of the romantic setting and Edith's abandonment of her role as the family breadwinner, Sam's masculinity did not return, and his ears continued to ring. Edith grew bored with the role of model and muse. She was not content to sit around posing for Sam and enjoyed the role of the coquette. "We had little difficulties because in Paris everyone was overt about making passes," Edith recalled. "I couldn't help it. . . . we would sit in a café, and Sam always wanted to knock somebody down because he would make a remark."

Sam suspected Edith had met another man and was plotting to have an affair. When she announced she would be leaving for a week-long job at a department store in Lille—accompanied by a dashing Swiss advertising man with "patent leather hair"—to bring some of her American efficiency expertise to the French, Sam went into a jealous rage. He chased her to the train station, threatening to hurl himself onto the tracks. Edith claimed friends had to restrain him.

Edith returned to Paris with a large check for her services and lessons on the discreet convenience of adjoining hotel rooms. Once Sam accused her of cheating, whatever remained of their marriage crumbled. "Everything evaporated," said Edith. "Finis." They had nearly run out of money anyway, and so they headed home to New York. Paris had not improved their marriage, nor had it made Sam a better artist. It had given Edith a chance, however, to think about her own future. She wasn't certain whether she wanted Sam to be part of that future, but she was certain she wanted it to include American art.

3

The Girl with the Gallery

OGUNQUIT, Maine's craggy coastline, was certainly a long way from Paris. As Edith plucked flowers from a neighbor's yard and bargained for a discount hen at the grocer, that distance seemed even more pronounced. Edith and Sam had come to Ogunquit, a popular artists' colony, during the sweltering summer months of 1926. Since their return from Paris the previous fall, Edith had fitfully attempted to be the Mrs. Halpert featured in her husband's paintings: the reserved, domestic heroine of Mr. Halpert's making. It wasn't working.

Sam and Edith followed a steady stream of artists who fled New York City when the summer heat made life in brownstone tenements unbearable. Since the teens, groups of New York artists with modernist inclinations had boarded trains for the day-long trip to York Beach, Maine. A seven-mile carriage ride over dirt roads conveyed dusty and stiff painters such as Marsden Hartley, Bernard Karfiol, Yasuo Kuniyoshi, and the future director of the Whitney Museum of American Art, Lloyd Goodrich, to a cove with gray shingled fishermen's shacks and wooden dories. This remote seaside community called Perkins Cove, home to fishermen and farmers, was the unlikely setting for one of the liveliest early American art colonies.

New England artists had begun anchoring their easels on Ogunquit's rocks as early as the 1890s. In 1898 painter Charles Woodbury opened a summer school focusing on painting and drawing from nature. Dressed in knickers and plimsolls—so as not to slip on the rocks—Woodbury exhorted his students, "Don't draw what you see of the wave—you draw what it does!" Ogunquit soon became a destination for wealthy maiden ladies from Boston, who sketched, sipped tea, and paraded around town, much to the amusement of the local fisherman, who dubbed them the "Virginal Wayfarers."

In 1906 a wealthy New Yorker and enthusiastic art patron, Hamilton Easter Field, began buying fishermen's shacks around Perkins Cove, aiming to start a second art school and colony devoted to more avant-garde art. The local Mainers didn't know what to make of the stuttering high-strung bachelor, but Field ingratiated himself by paying for the installation of running water and electricity and the construction of an icehouse to store fish. He outfitted the shacks with rockers, decoys, and Windsor chairs—rustic and attractive furnishings he found in local junk shops.

These primitive objects had an appeal not unlike the African art admired by American and European modernists and the children's art displayed by a few galleries, including Stieglitz's "291." Artists who rented these shacks discovered the charm and originality of the folk style. Yasuo Kuniyoshi, Elie Nadelman, William Zorach, and others followed Field's lead, buying up rustic Maine mementos, and the influence of the flattened perspective, simple lines, and rough-hewn surfaces filtered into their own art. "They too began to cull the nearby antique shops, garrets, and barns for works of folk art which were then obtainable at prices even artists could afford," Edith later recalled. "In these unconventional, direct statements they found a kinship with their own esthetic aspirations."

Artists who came to Ogunquit to Field's summer school were unabashedly modern. "Ogunquit was an experience of the kind of teaching which was more . . . lined up to modern art," recalled Lloyd Goodrich. "More emphasis on emotion, color, the institutive style of

painting." Field was a champion of modern art, and naturally his school attracted artist friends who were also partial toward experimentation, including Niles Spencer, Katherine Schmidt, Wood Gaylor, Max Weber, and others who later formed the core of the Downtown Gallery's earliest roster. By the time Edith and Sam made their way to Perkins Cove in 1926, artists with sketchpads seemed to outnumber lobstermen.

The contrast between artists of the Woodbury group and the Field circle was noticeable: "They just went their separate ways," recalled Field's grandson, John Laurent. "The Field school seemed to have a younger, fun-loving group who took to dancing a Valentino tango or just playing the latest records. Whereas, the Woodbury-ites seemed older, quieter, and more sedate." While the Woodbury students focused on their academic studies of the landscape, Field's acolytes trained their gaze on the human figure. "One day a young European countess who modeled for at least one summer at Field's school, jumped up from a nude pose, grabbed an Oriental kimono," said John Laurent, "and, dashing across the little rickety bridge to the other side of the Cove, flung herself nude on the steps of Woodbury's studio and proceeded to sunbathe."

When Field died of pneumonia in 1922, Robert Laurent, his adopted son, inherited his properties in Maine and Brooklyn. Laurent was a dashing figure, with a shaggy mane of black hair, a narrow mustache, and vestiges of his French boyhood, including espadrilles and blue-and-white-striped fishermen shirts. Instead of "Mr. Laurent," he preferred the less formal though distinctly French pronunciation of Robert, "Row-bear." After Field's death, Robert continued to rent fishing shacks to artists, using the income to support his wife and two children.

That hot summer of 1926, Edith and Sam rented from Robert, sharing their shack with a painter friend, Louis Ritman. The artists painted in the morning and whiled away afternoons and evenings with rounds of golf at the Cliff Country Club, outdoor amateur theater at the Village Studio, dances at the Sparhawk and the Lookout

resorts, and silent pictures starring Mary Pickford and Douglas Fair-banks, screened at the Fireman's Hall.

Edith enjoyed the social aspects of summer in Ogunquit, with its endless circuit of picnics and parties. She befriended most of the artists and met a handsome man from the Newark Museum named Holger Cahill, whose easy wit and smile caught her eye. Ogunquit's physical charms were not enough to buffer the desultory mood at home, however. Ritman was depressed over a love affair that had recently dissolved, and Sam was still suffering from lingering health problems—cold sweats, insomnia, voices, and the ringing in his ears.

Edith was more dissatisfied than ever now that she had given up her job. While other artists' wives tended to their children, Edith had none of those maternal responsibilities—nor any desire to have children of her own. She didn't mind children but preferred them at a distance.

Sam knew that Edith was restless at Perkins Cove. At an artists' colony, the most important activity is making art. Edith's dreams of being an artist were long over, and being Sam's wife simply wasn't enough. Her frustrations added to his own anxieties. His wife was young, beautiful, and brimming with zest and energy. His love wasn't enough—she wanted more, and the things she wanted, Sam couldn't offer.

The accommodations were also not up to Edith's standards. Their house was filthy and lacked electricity, and the furnishings consisted of a rocker, a wooden box, and a kerosene lamp. Water needed to be pumped from the well, and worst of all, using the outdoor privy was an ordeal because of Edith's fear of mice. She was hardly relieved to find that it wasn't mice who took shelter in the privy—it was a slith-ering snake. In an effort to spruce up the shack, Edith sewed calico curtains. It was hardly the Maison Watteau. For a time, Edith tried to make the best of a bad situation. Even though she had little money, she was determined to make a feast. She scrounged for old vegetables, traded bottles of homemade beer for fish, and bought leftovers from the grocer. After three days of chopping and simmering, Edith's stew

had stewed. "Boys, this is a gala evening," Edith ordered. "Let's be gay!" She donned one of her favorite dresses and served dinner. Ritman sat on the rocker, lurching to and fro. Sam crouched on the wooden box cracking his knuckles. Edith felt desperate for some conversation. "Please someone say something," she cried. Ritman perked up for a moment and declared, "Do dat's dat," before closing his eyes and falling asleep. Edith stepped outside, shaking with hysterical laughter that soon turned into tears.

The meal had failed to galvanize the men, but it provided Edith with a flash of insight: there would be no more three-day stew escapades. When Edith was a successful businesswoman, she was accused of emasculating her husband, but working meant a large apartment near Carnegie Hall and, more than that, an outlet for her energy and talents. Now that Sam was fueling the family coffers, she was back to immigrant striving all over again. She wouldn't live this way. Edith decided she had no choice but to go back to work. After all, it was the middle of the 1920s, and opulence, wealth, and hedonism were in the air. Back in Manhattan, the stock market was soaring, skyscrapers carved out a new cubist skyline, and magazine covers celebrated the flapper: women cut loose from Victorian restraint, dancing the Charleston, bobbing their hair, and abandoning the corset and petticoat in favor of shorter skirts with lower waistlines. In addition to powdering their noses, ladies now dusted talcum on their knees.

Edith kept her brown hair long, wearing it rolled into neat semicircle buns on the sides of her head. But she had the heart of a flapper, rejecting all the old rules. She smoked cigarettes, drank bootleg liquor, wore scarlet lipstick, and spoke her mind. But for Edith, freedoms weren't opening up fast enough, especially for women. She rejected the prevailing notion that women should stay at home and become mothers. She wanted her own career and her own life, without the heavy bonds of marriage or children. Although her attitude was not so radical within Edith's own bohemian circle, it was unheard of in the rest of the country, where motherhood and

marriage were a lady's primary role. It was only at the start of the decade, in 1920, when women were given the constitutional right to vote in the United States.

Edith quietly plotted her return to New York City and work. At first she considered opening a Russian tearoom, but after some more thought, Edith realized what she really wanted to do—and what would capitalize on all her years in and around the art world: she wanted to open a gallery. It was the perfect solution, really. She had some experience steering Sam's career; she could apply her business savvy; she had firm relationships with many artists; and, perhaps most importantly, she was passionate about art. She decided to focus on the artists who had surrounded her for over a decade, the American moderns who populated the Halperts' circle of friends. With so few opportunities—just a handful of dealers even daring to sell American moderns—there was an urgent need for a capable ambassador. Also, Edith had been inspired by the heady art shopping she had witnessed the previous year in Paris. She had been shocked to see collectors lining up to buy art and artists who seemed as prosperous as bankers. Claude Monet's estate in Giverny, landscaped with a Japanese water garden, bore no relation to New York artists' cluttered, vermin-infested apartments, where they lived and worked in cramped quarters.

There was certainly a need for her services, Edith thought. In New York, collectors and museums ignored the American modernists, preferring the Europeans. The Metropolitan Museum of Art, the lone Manhattan art museum, had a distinctly European outlook. Just five years earlier, in 1921, it had mounted an exhibition of the most contemporary art ever shown there, "Loan Exhibition of Modern French Painting," which introduced Post-Impressionists such as Paul Gauguin and Vincent van Gogh to American audiences. Two decades would pass before American modern art hung on those same walls. "Like most years since Dickens," Edith said, "1926 was the best of times and the worst of times. It was a good year for horse-players, stock-players and jazz piano players. For American Art, 1926 was

bad." Edith believed that the Americans were as talented as the Euro-
peans, but few shared her conviction.

Edith's strong, controlling personality was not suited to a part-
nership, but she needed an investor to start the gallery. She befriend-
ed Berthe Goldsmith, the older sister of Leon Kroll, one of Sam's best
friends. Bee expressed eagerness at going into business with Edith.
She was at her own crossroads. At thirty-three, Bee had married Her-
bert Goldsmith, a lawyer whom her family didn't consider to be espe-
cially smart. The marriage was further blighted when their one son
fell out a window and died. Bee took the unusual step of divorcing
her husband. Now she needed to find a way to earn money and also
to rebuild her life. Edith agreed they might work together, likely sat-
isfied that the mild-mannered and older Bee—twenty-four years
Edith's senior—would allow Edith to take charge and remain a silent
partner. Meanwhile, Edith claimed that Sam was unhappy about the
gallery—it certainly pulled her focus off him, both as an artist and as
a husband.

Edith and Bee decided to name the venture "Our Gallery," sug
gesting the gallery welcomed all—an egalitarian slant on a usually
elitist business. "I wanted to make it an intimate thing," Edith
recalled. "So that anybody could come in at any time, day and
evening." While most of the city's other galleries were uptown, Edith
looked to Greenwich Village—a long way away, both geographically
and psychologically. Downtown real estate was far cheaper, and
Edith felt it made sense to open a gallery near where the artists lived.
The gallery could function as a neighborhood gathering place for
artists. It would also save on transportation costs because artists
could carry their work over from nearby studios. But Edith wanted
to be sure that uptowners, especially the wealthy art collectors who
rarely ventured south, would be able to find the gallery. Many of the
streets in the Village deviated from the numbered grid pattern, and
Edith was determined to locate the gallery on one of the numbered
streets to help people remember and find her address.

She found a three-story brownstone for sale at 113 West 13th

Street, a wonderfully simple and memorable address, just west of Sixth Avenue. The block was easily accessible, flanked by the Sixth Avenue El—the elevated subway—to the east and the IRT underground subway on Seventh Avenue to the west. With a home for wayward girls down the block and a funeral home across the street, the location was decidedly Left Bank. On that narrow street, lined with red brick townhouses, the only structure worth noting was the Village Presbyterian Church, a hulking white Greek temple-like building that added a whiff of respectability to the surroundings. Number one hundred and thirteen was typical of the block. Lacking ornament or

Exterior of the Downtown Gallery,
113 West 13th Street, circa 1939.

architectural flourish, it was a simple townhouse originally intended for a mid-nineteenth-century family of modest means. Each of the eight windows on the front was topped by a simple white block, and the doorway was flanked by a pair of flat columns. A set of ten steps, with a simple metal railing, led up to the front door. To the left, three steps led down to a basement level. The basement would be suitable for a gallery. Upstairs were four apartments where Bee, Edith and Sam, and two tenants could live (just as Frances had lived above her shop), with the rental income subsidizing the gallery's rent.

The building cost $40,000, paid for with $31,000 in mortgages, with Edith and Bee each investing $5,410. Edith's money came from her Straus bonuses, money her old boss had urged her to keep for herself and not share with Sam. Mortgage payments came from rental income: Bee rented the parlor floor for $125 a month; the third-floor apartment was also rented for $125 a month; and the top floor was divided into two smaller apartments, one that was rented for $70 a month and one that was let to Edith and Sam for $40. Rent on the gallery worked out to about $100 a month.

Edith planned to open the gallery in November 1926, which gave her two months to prepare from the date of the closing. As the founder of the first modern-era art gallery in Greenwich Village, Edith didn't have to compete with the uptown establishments. She could shape the venture to suit its environs. Edith turned away from examples set by other dealers of the day. She wanted to create the antithesis to art dealer Joseph Duveen's Fifth Avenue mansion, with its intimidating neoclassical exterior and pompous showrooms lined in rich velvet. Duveen catered to only the wealthiest clients, and he had devised a setting suited to the aspirations of his buyers, as well as to the price tags on his Raphaels and Rembrandts.

Edith would do the opposite. Here was her chance to invent a new sort of gallery, a space that would welcome art patrons, artists, and browsers looking for affordable art—not intimidate them with fancy trappings. Drawing inspiration from the egalitarian spirit of Dr. Weichsel, the folksy warmth of the Whitney Studio Club, the

simplicity of Stieglitz's "291," and the retailing lessons she had learned at the department stores of the day, Edith created a new sort of commercial environment, one that blended community, education, and commerce.

In designing the gallery, she was influenced by the sleek modernity she had discovered the previous summer in Paris, when she visited the Exposition Internationale des Arts Décoratifs et Industriels Modernes. In addition to introducing modern design to the masses, the exposition was one of the first times decorative arts and furnishings took the spotlight, which was usually reserved for painting and sculpture. That was not lost on Edith, who designed her gallery as a sort of domestic installation so clients could imagine the art in their own homes. She hung paintings on the walls and placed sculptures around the rooms, featuring Elie Nadelman's rustic sculpture of a seated woman on a carved wooden chest. Sculptures by Zorach sat on bookshelves, and the marble fireplace mantel was topped with small statues.

Edith included artworks by artists working in different media, including ceramic plates with earthy glazes by potter Henry Varnum Poor, ceramic animal figurines by Carl Walters, and metal lamp sculptures by Frank Osborne. Inexpensive decorations from New England, including milk glass, ironstone pottery and duck decoys, and simple old American tables, chests, and chairs (all bought for $5 to $10) added to the homey effect. The back room was designated as an area where visitors could linger over a cup of coffee and conversation.

The Village already had a legacy of bohemian experimentation by the time Edith opened her gallery, garnered during the teens when long-haired sandal-clad radicals—artists, poets, suffragists, socialists—loudly proclaimed their objection to anything midwestern, bourgeois, and middle-class and their devotion to free love, birth control, socialism, Freud, women's rights, and self-expression. It was the perfect home for painters and sculptors, who socialized in Greenwich Village tearooms and gathered in artists' studios. Art had hung in the Village before Edith's gallery, but not in a commercial sense. In 1917, Polly Holladay, proprietress of Polly's, a popular restaurant at

The opening exhibition at Our Gallery, November 1926.

5 Sheridan Square, had hung art on her walls and dubbed the enterprise the Sheridan Square Gallery. Exhibits of paintings by customers like a young unknown Stuart Davis attracted a few lukewarm reviews, but that was the extent of Edith's competition.

Edith knew the Village had already lost much of its bohemian authenticity. Compared to the early teens, by the mid-1920s, it was already a tourist destination. But the area remained home to the avant-garde. Just down the block from the gallery, at 152 West 13th Street, were the offices of the *Dial*, one of the most influential of the so-called little magazines, publishing poetry, short stories, and art by T. S. Eliot, Georgia O'Keeffe, and Pablo Picasso. Just a few blocks south, on Eight Street, heiress Gertrude Vanderbilt Whitney had converted a stable into a sculpting studio and maintained a gallery for exhibits of the unpopular artists she supported, those like John Sloan, George Luks, and Stuart Davis, who painted the city in a realist style

unacceptable to the National Academy of Design, where the Gilded Age reigned supreme. Gertrude Whitney didn't sell. The gallery was merely an exhibition space, a precursor to the Whitney Museum of American Art, which she would found in 1931.

Speakeasies also dotted the area, serving up illicit alcohol, prohibited from sale since 1920—a law that only seemed to have increased the demand for liquor and tolerance for illegal behavior. Edith's block was notoriously wet; she claimed there were twenty-one speakeasies and that many of her first customers wandered into the gallery thinking they had stumbled on a speakeasy in disguise. Although the gallery was strictly downtown and her artists radical, the bohemian identity only went so far. "The only thing that I did not do was that I did not wear dresses, and I did not wear long earrings," recalled Edith, who dressed in elegant suits and hats. "I made it very much uptownish in my attire, but very downtownish in the functioning and the whole idea of having people meet, having collectors see the artists—that was terribly important."

Drawing on her talents from her days at S. W. Straus, Edith wrote letters inviting artists to show at Our Gallery and enclosed stamped reply cards to ensure a fast and easy response. From the start, she lined up an impressive mix of artists, many of whom she knew from Ogunquit and others she had met in New York. They included painters Walt Kuhn, Yasuo Kuniyoshi, Katherine Schmidt, Niles Spencer, Max Weber, George Ault, and Marguerite Zorach, as well as sculptors William Zorach, Robert Laurent, and Elie Nadelman. For the most part, they were established names, artists with exhibition histories at the Whitney Studio Club and New York galleries. But none had achieved any sort of real stability. They depended on their spouses for income or other employment to survive.

Edith printed her aesthetic mission on sheets stacked in the gallery: "Our Gallery has no special prejudice for any school. Its selection is directed by what's enduring—not by what is in vogue." Reactions about the new gallery ranged from strongly positive to the quizzical. "You are opening a gallery of American art?" her friend,

the dealer Newman E. Montross, exclaimed. "Good Lord! And you had such a good job, with such good pay!"

Edith also used the fact that she was just "a little girl from Odessa"—her own ironic description that she delivered with her hands on her hips and a shimmy—in approaching other dealers to borrow artworks for shows. Because Edith was a woman, the wife of a well-known artist, the other dealers didn't consider her a professional threat. There was only one other female dealer of any stature: Marie Sterner, wife of noted portrait artist Albert Sterner, who had joined Knoedler and Company in 1912 and set out on her own in 1920. She exhibited American and European artists from her 57th Street outpost until her retirement in the 1950s. Edith acknowledged Sterner as her lone female predecessor.

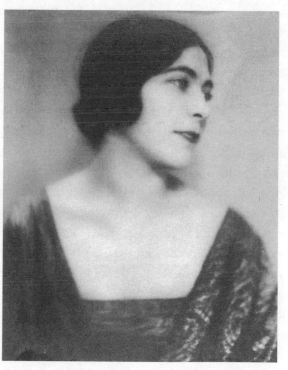

Edith Halpert in the 1920s.

She visited other galleries to ask dealers questions about the basics of gallery operation: how they made sales, what sort of receipts they used, and how they obtained insurance. The dealers were not especially forthcoming, but she assumed it was because they didn't have systems themselves. The little girl from Odessa was now the girl with the gallery, and her uptown competitors didn't think they had much to fear.

Edith decided to operate on a consignment basis, accepting artworks for sale—with prices set by the artists themselves—with Edith retaining a 33 percent commission, undercutting competitors like Charles Daniel of the uptown Daniel Gallery, who kept 50 percent of sale proceeds. Daniel also offered certain artists stipends in exchange for all their output, operating like the Parisian dealers. Edith considered that arrangement rapacious as the dealer alone benefited in the long run when artists' prices rose. Also, she feared artists would not be inspired if they were merely painting to fill quotas, like assembly line workers at the Ford Motor Company. She also broke with tradition by paying exhibition costs for invitations, catalogs, and opening party cocktails. She did charge the artists for framing, but most other galleries deducted all expenses from an artist's profits.

Edith was also unique among dealers in that she included buyers' names on the artist's payment receipts. Most dealers kept buyers' identities secret—afraid an artist might go directly to the customer, cutting out the dealer's commission.

On November 6th, 1926, Our Gallery officially opened. Edith paid herself a $25 weekly salary, a fraction of her old pay at S. W. Straus. The "Opening Exhibition: Small Works by Leading American Contemporary Artists" allowed Edith to fill her walls and keep prices low. Our Gallery was to be a place to find high-quality artworks, but not at high-quality prices. The gallery was to be a democracy, with prices set for the average person and—unheard of in a gallery—flexible payment plans. Edith applied the new principal of installment plans, recently made popular for iceboxes and motor cars, to art. She aimed to create a new sort of gallery and a new locus for the art market—a place where she would be at the very heart of it all.

Edith issued a lengthy gallery announcement, which made it clear that Our Gallery would be more than a place to buy art:

In the homelike atmosphere of OUR GALLERY will be found a wide choice of paintings, sculpture, etchings, drawings, pottery, and allied arts; all of dimensions proper to the modern home.

In addition, there will be a fine display of antiques, and a comprehensive assortment of books.

To enable all to possess works of art, OUR GALLERY has made the following arrangements:

Any of the fine art objects can be secured through extended payments.

For a moderate monthly rental, you may have in your home one of the pictures or sculptures.

To create a meeting place for the artists of OUR GALLERY, the Coffee Room will be open to them evenings, after dinner.

This invitation is extended as well to the patrons of OUR GALLERY upon purchase of one of the "specific collections" of fine arts.

Edith focused on promotion. She understood the power of mailings from her days at Straus but lacked funds to buy a mailing list. Instead she made her own, culling the telephone directory and creating a list of names and addresses from the most expensive neighborhoods in the Village. "Do you know that there is an Art Gallery in your neighborhood—away from the traditional fifties and Fifth Avenue?" went her form letter. "Do you know that a large number of leading American artists live in this vicinity, perhaps on your very street? You may recognize the name of your neighbor in the list of Our Gallery exhibitors." She placed small ads in seven newspapers and received flattering reviews in many of the dozens of New York dailies, including the *New York Telegram*, *Herald Tribune*, and *New York American*, where she was identified as the wife of a well-known painter.

"Could an address be manufactured better to stick in the memory?" asked the *New York Evening Post Literary Review*. "It is under the management of Mrs. Edith Halpert and presented so attractive an appearance that one reviewer found it hard to leave." The same reviewer called Edith's exhibit "a real embarrassment of artistic riches." A reviewer at the *Christian Science Monitor* also emphasized the setting, noting that "art will be found arranged in home-like fashion and a genuinely cordial welcome to come in and enjoy the combination of good art and old-fashioned hospitality."

Although Edith succeeded in promoting the gallery name, sales remained elusive. And so Edith invented an idea for her next show, borrowing a principle from her days in retailing. Since the holidays were the busiest season for department stores, retailers made a practice of advertising bargains, hoping that once the people were in the door, they might be tempted to spend more. Edith decided to use the same technique to sell art. "We didn't give away silk hosiery or dishes, but you had to attract them with ideas," said Edith. "The Christmas show was a puller-inner. . . . They'd come in, they'd look around and they'd see a print, a lithograph or something and for twenty bucks they could give someone a gift and prove that they were really cultured."

She mimeographed the artists' biographies and gave them to customers so that they would feel important for having bought "art." Edith never used pretense or a sense of exclusivity to sell her artists, but she did understand that there was something magical and transformative about buying art. "Very few people really gave away what they bought at the Christmas show," she said. "They kept them, but that was a great experience—you know, having a genuine, a real piece of art, does something to a few people." She mailed out invitations to a tea for the opening of the "The Christmas Exhibition, $10–$50 (equal to about $110–$569 in 2006)." She promoted the gallery's shopper-friendly hours: open Monday through Saturday from 10 a.m. to 6 p.m. and 8 p.m. to 11 p.m. and Sundays from 3 to 6 p.m. Edith also mounted an annual show of etchings, lithographs,

and woodcuts around the holiday season, organized by a group of artists who called themselves the Society of the American Print Maker. Prices ranged from $10 to $20.

These promotions got to the heart of Edith's life-long sales strategy. Like circus impresario P. T. Barnum, she knew she needed to do whatever it took to get bodies in the door. "The idea was to keep the character in the gallery long enough so the picture grew on him," she later explained. "Or tell an anecdote about that specific picture which he would remember, and it would make an impact. It was the only way to function when you had material that was completely unpopular. You know, most of it looked crazy as hell to these people. They didn't know what it was all about. The drawing was out of shape."

Edith predicted her Christmas show would appeal to new art buyers of modest means, but it was the rich who responded. William Preston Harrison (who went by Preston), a distinguished Los Angeles collector, whose wealth came from family-owned real estate and newspapers in Chicago, where his father had served five terms as mayor, saw an advertisement for the Christmas show and immediately wrote the gallery. Harrison had been a devoted buyer of American paintings since 1919, focusing on Impressionist canvases by artists such as Childe Hassam and grittier urban scenes by artists such as Robert Henri and George Luks. By 1926, Harrison had already stopped buying the Americans and had moved on to French art, hoping to ultimately donate his art collection to the fledgling Los Angeles Museum of History, Science, and Art (in 1961 a separate art museum, the Los Angeles County Museum of Art, was established) which had only a handful of pictures in its collection. Compared with the prices he had paid in Paris, Edith's prices for American art were irresistible.

"From the work listed, you can readily judge that we are doing something new in the line of art," Edith wrote Harrison. "The attitude of the artists of Our Gallery, together with the fact that our overhead in this locality is literally a fraction of other galleries, makes this possible."

Harrison responded that he was "quite keen about 'modernists'" but concerned that American artists were "mere copyists" of the Europeans. His fears were typical of the prevailing attitude. Edith not only needed to promote her artists—she needed to promote the worthiness of American art itself. And so she defended American art, explaining why artists were sometimes forced to become copyists. When they traveled to Europe for teaching and inspiration, she said, they absorbed the famous European styles, falling under the spells of the "isms" of the day, from Impressionism to Cubism.

Edith suggested that if there were respect for American artists and if their works were exhibited abroad, it would give American artists a chance to be inspired by their own homegrown aesthetics. "If those men who are responsible for the choice would broaden their scope in arranging an exhibition for some European country, Americans abroad would not turn away from their own art, to plunge into French art—i.e., art sold in Paris—the home of the best artists in salesmanship insofar as galleries are concerned. . . . Don't you think that if some of our younger men were represented in these shows, American [sic] would have something more vital to say?"

Harrison became one of Edith's most faithful early customers, deciding to assemble a collection of modern American watercolors. He bought Charles Demuth, George Ault, and William Zorach, usually on an installment plan. One of his first purchases was a $200 tempera by Sam Halpert. Edith decided to waive her usual 30 percent commission because it is "rather embarrassing to collect commission from one's husband," she wrote Harrison. Edith even managed to sell Harrison a watercolor by a young unknown artist desperate for funds. She offered him a Stuart Davis watercolor titled In Cuba, of a man on a horse leading a cow across a river. A couple of days later Edith sweetened the deal, knocking the price down to $75. Harrison accepted.

Edith maintained a cross-country correspondence with Harrison for nine years. He wrote Edith long letters about his art world travails, and Edith cultivated him as a collector from afar, without the

benefit of speaking to or seeing her loyal customer. Over the years Edith's warm and humorous—though always firm—letters would help her sell to a much wider network of buyers than just New Yorkers. From the start she pursued adventurous art appreciators across the country. When Harrison and his wife finally came to New York and invited Edith to dinner, she was nervous he would be shocked to discover how young she was, considering the "very learned" letters she wrote him, where "I had to throw my weight around." She had a bonnet made to cover her dark hair and borrowed a frumpy dress for dinner at the Brevoort Hotel—a posh establishment on Fifth Avenue and 8th Street—hoping to appear older than she really was. Harrison was fooled; his wife was not.

The Harrisons were among a steady stream of the affluent who made their way to the gallery. Edith soon decided her out-of-the-way location was an advantage because it distinguished her from the other New York dealers. In 1927 sculptor William Zorach suggested she take a new name. "After all," Zorach told Edith, "the other galleries are all uptown. Why not call it the Downtown Gallery?" Edith agreed and commissioned sculptor Hunt Diederich, who worked in animal motifs and metal, to design a sign. His creation, with two intertwined serpentine creatures and the gallery's address, encapsulated the energy, whimsy, and optimism embodied by the Downtown Gallery. Edith hung the sign, which looked most of all like an urban riff on a rural form—the traditional barn-topping weathervane. The sign was a perfect blend of the modern and the folksy aspects of American art—a relationship that Edith would package and sell for decades to come to some of the richest families in the country.

4

Art for the Electric Icebox

THE GALLERY'S downtown coordinates were a source of amuse-
ment for Edith's customers. Whenever a production of Puccini's *La
Bohème* came to town, Edith received offers for tickets from her
wealthier clients. They knew she lived in an exciting world of artists,
bootleggers, and nightclubs, and many ventured downtown for a
glimpse of it themselves.

Edith loved escorting uptown types to Julius's, a nearby
speakeasy, or bringing a flask of martini mix to meet an out-of-town
customer at the Drake Hotel. It was all for the shock value. She
would walk clients and museum curators around the corner to
painter Yasuo Kuniyoshi's 14th Street studio, scandalizing visitors by
leading them through the street-front lingerie shop, filled with girls in
short skirts and stairways cluttered with garbage cans. Edith Wet-
more, a Newport heiress whose father had been governor of Rhode
Island, adored cruising downtown in her roadster to the land of
smoky tearooms and long-haired artists. On her first visit to the
gallery, Wetmore asked to see a particular painting in natural light.
Edith carried the oil outside and leaned it up against a garbage bin,

all the while describing the line and the brushstrokes. Wetmore soon returned, accompanied by two men in raccoon coats. "This is the gallery where they show pictures leaning against garbage cans," Wetmore chirped delightedly to her friends, before making the first of many acquisitions.

The Village was a vibrant district that offered Edith—and her customers—a lively parade of sights and smells. Edith loved the Sullivan Street pushcarts with cheap fresh fruit hawked by Italian vendors and was especially fond of Romany Marie, a teahouse operator across the street, who not only read the future in tea leaves but fed poor artists such as Marsden Hartley by bartering food for paintings.

In her early days Edith envisioned the gallery as a sort of salon, in addition to a commercial venue. She asked writer Ford Madox Ford to organize a series of lectures named for poet Williams Carlos Williams, who was friendly with some of the artists. Speakers included architect Buckminster Fuller, but the lectures came to a halt when Ford invited poet Ezra Pound to speak, whose fascist politics offended Edith. She refused to host Pound, reminding an angry Ford, "I own the joint!"

Still, the Village was a destination, and Edith was not satisfied waiting to be discovered. She had aims to go national and take art out of the gallery. In 1927, she organized an exhibition at the Wanamaker department store's Venturus Gallery, launching a practice she would continue for decades, eventually showing art at Macy's, Gump's, Neiman-Marcus, Frost's, and dozens of other stores around the country. During the 1920s, department stores used art and decorative art exhibitions and avant-garde window displays in an effort to attract more shoppers.

Edith was assisted in her ventures by Holger Cahill, the handsome Newark Museum curator she had been attracted to in Ogunquit. There was romantic tension between them. Cahill was newly divorced and Edith's relationship with Sam was essentially over. Even though extramarital affairs were considered outré for most Americans—it was illegal for hotels or landlords to let rooms to unmarried

couples—the rules were different in Edith's free-loving Greenwich Village.

Cahill had first become part of the artists' circle working as a publicity writer for the Society for Independent Artists, a group founded in 1917 by adventuresome artists looking for a way to exhibit outside the conservative academy. Like Edith, Cahill was an outsider who had reinvented himself. He was born Sveinn Kristján Bjarnarson in a small rural town in North Dakota in 1887. His father was drunken, violent, and abusive and eventually abandoned his wife and two children when Sveinn was about eleven. His mother suffered a nervous collapse, and a neighbor took in the children, but Sveinn was eventually sent to another family, where he did farm work in exchange for a room. Eventually he ran away and spent the next decade between Canada and the United States, working for a cattle rancher in Nebraska, selling books and insurance, washing dishes in a hotel, and attending some night school along the way. Finally he rode the rails to New York and took writing and journalism classes while working nights as a short-order cook. He went on to journalism jobs at the *Bronxville Review* and *Scarsdale Inquirer* and in 1919 married Katherine Gridley, whom Stuart Davis described as a short, hard-drinking Irish woman. Their daughter, Jane Ann, was born in 1922. Along the way, he changed his name to Edgar Holger Cahill; friends called him Eddie. In 1922 he went to work at the Newark Museum in Newark, New Jersey, where he remained for eight years.

By the time Edith and Cahill met, he was a handsome older man (about Sam's age) with an elegant mustache, the hint of a dimple in his chin, and the dreamy eyes of an intellectual. Though Cahill had learned plenty about art working at the museum, he considered himself a writer first. His first novel, *Profane Earth*, was published in 1927.

Also in 1927, Sam had accepted a job as head of the department of painting at the Art School of the Society of Arts and Crafts in Detroit, Michigan. It was a welcome change. Edith had grown uncomfortable with the way Sam used the gallery as a place to fritter away afternoons playing cards and checkers with Bee's husband,

Portrait of Holger "Eddie" Cahill Inscribed: "To Edith, with dearest love on the eve of her expedition to conquer the world, from 'Eddie."

while the two puffed on cigars. She was concerned about how it appeared to customers, and she suspected it was highly unprofessional. Sam and Edith's marriage continued to be strained as Edith devoted herself increasingly to that which she cared about, the gallery, and withheld her attention from her lesser priority, her husband. Sam's new job allowed him a steady paycheck, time to paint, and distance from his decaying marriage. For Edith, it meant the freedom to pursue her career and to indulge in the freewheeling parties of her beloved Greenwich Village.

One of the most freewheeling characters in Edith's circle was painter Jules Pascin, originally Jules Pincas from Bulgaria. He befriended Edith in 1927 when he came to New York from Paris to reestablish his American citizenship. He stayed with Robert Laurent and Yasuo Kuniyoshi in Brooklyn Heights and was a popular figure, with his trademark derby hat and outlandish drunken antics. In Paris,

Pascin had lived in the Montmartre district and was a regular at Café du Dôme. In New York he preferred the Downtown Gallery, where he visited regularly, attracted by Edith's dynamism and strength.

Pascin's fleshy female nudes were his stock and trade; his idol was Henri de Toulouse-Lautrec, and in Paris prostitutes were among his favorite companions. One day he asked Edith if she would sit for a portrait. Edith, who had modeled countless times for Sam, agreed and went to his studio. She pulled out her hairpins, letting loose her long brown tresses, and stripped down to her bloomers. Pascin arranged a pose with her leg raised. "Now take your clothes off," he called out from behind the easel. "It's too cold," Edith replied. "You prude," he charged, slashing the canvas with the end of his brush. Pascin stormed out.

The next time he appeared in the gallery, Pascin kissed Edith's cheek and asked for help buying bootleg booze for a party he was throwing in Brooklyn. Evidently their fight had been forgotten. Edith, who entertained regularly and always kept a supply of liquor at the gallery, was familiar with methods for avoiding Prohibition restrictions. In exchange for her help, she received an invitation to the soirée: "Carlo Restivo, champion accordionist of the world, will play. You to dance this Saturday at Pascin's 110 Columbia Heights." The invitation, with a sketch of an accordionist and dancing couples, specified, "No costumes but head make-up." Edith wore a towering white Marie Antoinette–style wig and set off for Brooklyn. "The party was in full swing," said Edith. Pascin took his revenge: "There were big drawings of me naked all over the walls. The legend said 'Poses taken from life.'"

Back in Paris two years later, Pascin, depressed and alcoholic, slashed his wrists and smeared the name of his married lover in blood, killing himself. For most of the artists, this hard living didn't exact a toll for decades. It wasn't easy painting and sculpting day-in and day-out for an audience so limited, so broke, and so pathetically powerless. Edith refused to be discouraged. She kept fighting and believing in the American art cause. It was her relentless persistence

that ultimately alienated many of her early supporters, but this same persistence brought her some of her biggest prizes, like the raffish young painter who lurked around jazz clubs and painted what he heard and felt. Without her dogged pursuit of equitability for the Americans, what might have happened to artists like Stuart Davis?

In the gallery's early days, Edith had the challenge of finding the right artists to exhibit—those established names who could pull in other artists. She had no trouble roping in her acquaintances for group shows. That was the best way to introduce artists to the gallery and entice buyers to come for a look. To launch her fall season in 1927, she mounted a group show of twelve artists who worked in Ogunquit, including Stefan Hirsch, Katherine Schmidt, Leon Kroll, Robert Laurent, the Zorachs, and Sam Halpert. Earlier in the year, she had given one-man shows to artists she admired, including lithographs by Walt Kuhn—who had helped organize the 1913 Armory Show—and drawings and watercolors by the little-exhibited George Ault. Though she wasn't given paintings to exhibit for the one-man shows—more expensive and more prestigious—Edith was willing to take whatever made sense. There was an element of trust and faith that went along with the dealer and artist arrangement, and for a new dealer it took time to store those up.

Because she aimed to make her artists roster the best in town, Edith didn't mind chasing an artist she really wanted, and the one she really wanted was Stuart Davis. Davis later recalled that he had met Edith through Sam, who had sketched with him at the Whitney Studio Club. By the time Edith approached Davis, he was thirty-four and had been working as a professional artist for fourteen years with little commercial success to show for it.

Edith and Davis were born eight years apart and belonged to the same artistic generation. Both had been influenced by artists such as Robert Henri and John Sloan, who melded an Impressionist's brushwork with subjects lifted from the city streets, focusing on the lives of

average New Yorkers and rejecting the tradition of artists who took inspiration only from the lives of the very rich. Edith and Davis shared a passionate belief in the talents of American artists and the necessity of independence from the Europeans. In fact, Davis was one of the few American modernist artists who had not yet traveled to Europe to absorb vibrations from the hallowed Parisian painters. Despite his obvious talent, Davis could hardly sell a picture. He was a commercial flop, but all Edith cared about was that he was an untainted homegrown genius.

The 1920s, the decade that marked and molded Edith's aesthetic and political sensibilities, was characterized by a rise in American nationalism and pride—against and away from the infatuation with Europe that had colored the first two decades of the twentieth century. Political forces stirred this post–World War I nationalist resurgence and rise in isolationism. Senators voted to not participate in the League of Nations, and immigration quotas were slashed. Art historian Abraham Davidson describes the period as "a time of self-absorption, self-congratulation, complacency, and, concomitantly, disentanglement from the affairs of Europe." This nationalist fixation gave rise to some unfortunate episodes, including a Red scare from 1919 to 1920 and the rise of the Ku Klux Klan.

For Edith and the rest of the American art scene, the nationalism of the 1920s and 1930s infiltrated their art and ideas. Edith always sought to play up the American angle. Before one of her summertime trips to Europe, she told Walt Kuhn she was sailing on a ship named *America*, "to keep up the native tradition," and assured him her patriotism wouldn't wilt abroad. "No doubt I shall return with an American flag wrapped around me, singing the 'Battle Hymn of the Republic.'"

Edith's obsession, heightened by her own immigrant story, was typical of the period. "American intellectuals and artists sought to identify what was uniquely American and what constituted the quintessential American experience," wrote Barbara Haskell, the Whitney Museum of American Art's curator of prewar art. "Artistically, the

nationalist agenda found a highly productive outlet in the search for indigenous subjects and forms of expression."

Many of the artists Edith identified with, those whose work stirred something inside that let her know she could find a way to make it sell, were focused on creating a modern American vernacular. Stuart Davis was among the most articulate and brilliant of the bunch. His lifelong motto was, "I paint what I see in America. I paint the American scene."

Davis was a slim man with a sketchbook perpetually tucked in his jacket pocket. A cigarette dangled from one side of his mouth. He spouted tough-guy talk from the other. He had always been a bit of a social misfit, awkward at parties and the small chitchat, but brilliant with big ideas and addressing large crowds. His isolation, working in a crowded, stuffy studio, with only the company of a radio blasting jazz music and a bottle of liquor, exacerbated his oddities. When Edith came calling, he had only just begun to receive any sort of professional recognition. He had been the youngest artist included in the 1913 Armory Show, and among his earliest champions were Mrs. Gertrude Vanderbilt Whitney and Juliana Force, who included his early realist efforts in group shows nearly every year starting in 1915. In 1926 they offered him a one-man show at the Whitney Studio Club, which included about thirty paintings dating from 1911 to 1926. The work ranged from Davis's earliest and most realistic paintings to his later, more experimental works, including his Cubist *Lucky Strike* from 1921, a painting of a tobacco package.

Davis's paintings were inspired by the modern industrial city, influenced by advertising, and used space in a whole new way. He filled up his canvases, using an economy of color and line to achieve a maximum striking effect. There was no one else doing anything like it. Davis wrote in his journal while working on a revolutionary series of product-inspired artworks: "I do not belong to the human race, but am a product made by American Can Co. and the *New York Evening Journal*."

Critics' reactions to the Whitney show were mixed. Although one

critic felt Davis displayed a "genuine talent for painting," another found the jumble nothing more than "laboratory work." Juliana Force was convinced of Davis's talent. She arranged for a $100-a-month stipend from Mrs. Whitney, which supported Davis for the following year. The stipend changed everything for Davis. He could now focus on his art.

Davis had been born into art. His father was the art editor at the *Philadelphia Press*, a newspaper that used a fleet of illustrators who went on to become some of the most important American artists of the early twentieth century, including John Sloan, George Luks, and William Glackens. Davis's mother studied art at the Philadelphia Academy of Art and was a sculptor. In 1901, when Davis was nine years old, his family moved from Philadelphia to East Orange, New Jersey, where his father worked as an art editor and cartoonist at the *Newark Evening News*. After one year at East Orange High School, Davis dropped out and began studying painting with Robert Henri in New York City. Davis's art school days were memorable for the "big accent on the saloon," Davis admitted. "Beer mostly." It was around this time he discovered McSorley's Old Ale House on East 7th Street, one of the many spots he regularly patronized. Davis also indulged in his passion for music—he loved playing the piano—which would be a lifelong interest and major influence on his own painting. Davis's father, who was originally from the South, had taught him an appreciation for black music, and Davis began visiting the colored saloons in Newark to hear pianist James P. Johnson and other ragtime musicians.

In 1912, after three years of art training, Davis rented a studio with another artist in Hoboken and was recruited by John Sloan to make drawings for the leftist magazine the *Masses*, where illustrations served a political agenda, mocking the rich and self-important and celebrating bums, whores, and working stiffs, a group usually ignored by artists and polite society. Davis also made cartoons for *Harper's Weekly* and later served as a cartographer in World War I.

The year Edith offered Davis his first solo show at a commercial gallery was a pivotal one in his artistic development. That same year, 1927, Davis had begun one of his most important experiments. With financial security provided by Mrs. Whitney—but lacking studio space—Davis made use of what was around him. "I nailed an electric fan, a rubber glove and an eggbeater to a table and used them as my exclusive subject matter for a year," Davis later explained. He sketched out his compositions, first making pencil drawings on graph paper and color studies in gouache. Davis described the paintings as "an invented series of planes" and modestly credited his "working on a single still life for a year, and not wandering the streets," as key to his breakthrough. What eventually emerged made history. Davis completed four abstract paintings known as the Egg Beater Series, with interlocking blocks, wedges, and swathes of greens, creams, browns, reds, pinks and grays and a couple of areas with vaguely discernable forms like the fingers of a glove. Davis later explained his purpose was "to strip a subject down to the real physical source of its stimulus," concluding, "everything I have done since has been based on that eggbeater idea."

In November 1927, Edith gave Davis's new abstract paintings their first public outing. She hung the 1927 *Egg Beater* along with *Matches*, *Percolator*, *Cigarettes*, and other recent radical creations. The exhibit, "Stuart Davis Exhibition: Recent Paintings, Watercolors, Drawings, and Tempera," also included some of Davis's earlier, more recognizable works, including the watercolors *Gloucester Wharf* and *Sea Gulls*.

"People wanted to break windows," Edith later recalled with her usual flair for the dramatic. "They would come in from the street and scream—you know 'This is indecent, having these crazy pictures.'" Edith did her best to reason with visitors and critics and to provide a context for Davis's experiments. She relied on the artist's own words to argue his case for modern art. In the gallery publicity release, she quoted Davis at length:

The type of subject I am interested in representing is character-ized by simple geometrical solids. That many of the younger artists are similarly interested in various ways probably indi-cates that this type of form has greater contemporary aesthetic utility than other types. From this it follows that people who are up to date in their clothes, automobiles, apartments and love affairs must buy this type of picture in order to be consis-tent. In fact it is the only kind of picture that will look well in modern surroundings. . . . The paintings of Rembrandt will always be good art, but they will not look well with an electric kitchenette and an electric ice box. . . . In short, the point I want to make is that the type of picture I am doing is not made to confuse art critics and befuddle layman in general, but on the contrary, is made with particular adaptability to the houses and offices they live in.

Edith's and Davis's efforts to explain new modern art for the new modern age didn't find many takers, even among the supposedly most sophisticated of all audiences: the art critics. "Quite incompre-hensible," was the verdict of the *New York Times* reviewer. Even *Art News* preferred *Sea Gulls* to *Egg Beater*: "It is perhaps our own lim-itation that Mr. Davis' conscientious abstractions make a very limit-ed appeal. Often interesting and decorative in their color, the geometric deductions of his 'Percolator,' and 'Matches,' leave us rather cold and as for the abstract of the rhythm of 'Egg Beater' we were equally puzzled. Perhaps the most amusing composition in the show is 'Sea Gulls' where pure geometry is mitigated with the con-crete pleasure of a red gas station and the sea."

Edith did not discuss the critical response with Davis. As would be her practice as an art dealer, Edith never commented to an artist about his or her work or offered any sort of feedback or criticism other than some friendly innocuous support. She had made up her mind to do so based on her own experiences at art school. When teacher Leon Kroll had begun correcting her drawing, "I screamed

like hell," Edith recalled. "I said, 'you can make corrections on the side. Don't you touch my drawings.'" Her feeling was that any artist willing to have his or her work influenced by others wasn't worth exhibiting. "I will never sell anything I don't think is good goods," she said. "My taste may stink. I may be wrong—whatever, but unless I feel that a picture is something. . . ." If she felt one of her artists was in a slump or in a transitional phase and making lousy art, she made up excuses not to exhibit his or her work.

Often her artists—and aspiring gallery artists—came to her seeking approval. If one of her artists brought a painting by the gallery, Edith would study the work carefully, then glance away, uttering something along the lines of: "Do you think it's going to rain today?" Her artists knew the routine. Many years later, when she was inundated with requests from artists eager for Downtown Gallery representation, Edith would review work but refuse to comment, frustrating some artists who felt entitled to a professional analysis. Edith offered but one response: I am not an art critic.

Davis and other artists generally appreciated Edith's support, which often extended into other areas of their lives—helping with landlord referrals, finding doctors, and helping locate affordable schools for children. Though Davis was to become highly dependant on Edith for many areas above and beyond his art making—later on his drinking would seriously affect his health and productivity— they had a somewhat awkward relationship. Their dealings were not nearly as warm as Edith's friendships with other artists such as Charles Sheeler, Bernard Karfiol, and the Zorachs. Edith and Davis were both strong-willed, stubborn, suspicious people who shared a dark sense of humor. They clashed regularly.

Not surprisingly, at Davis's first 1927 show, Edith didn't make a single sale. She wasn't deterred, however, nor were Davis and his tiny band of fans, including the 57th Street dealer Valentine Dudensing, who included Davis in group shows in 1926 and 1927 and gave him a two-man show in 1928. Juliana Force continued her support as well, including Davis in the thirteenth Whitney Studio Club annual of

up-and-coming artists, along with Charles Sheeler, Sam Halpert, and others, in 1928. Davis submitted *Egg Beater, No. 4,* but soon after the opening, he appeared at the club with another painting tucked under his arm. "I'd like to change that picture," he told the club's secretary, pointing to the *Egg Beater* painted in flat tilting planes of mustard, green, red, and white and hanging in a narrow space between two windows. "Change it?" she asked. "Why, you can't imagine how much favorable comment it has had. Mrs. Whitney liked it and so did Mrs. Force. And I don't know how many others."

Davis was adamant. "That's good, but it doesn't look right," he said, offering to exchange the *Egg Beater* for the painting he had brought with him of a landscape with a port, ship, and trees. The secretary said she preferred *Egg Beater.* "It fits so nicely between the windows," she explained. "Why don't you like it?" she asked him. Davis leveled with her. "Well, to tell you the truth. You see I painted it the other way around, longways, and your committee has hung it upright. Somehow I don't think it looks proper that way, even though every one likes it so much." Davis was persuaded to leave *Egg Beater* on its head.

His acquiescence paid off. Mrs. Force bought two oil paintings (*Landscape* and *Trees and Water*) from a concurrently running exhibit at the Valentine Gallery. That exhibit also received more appreciative notice from critics who were willing to admit Davis was on a worthwhile course. He packed up his *Egg Beater* series and used the fresh funds to make his first trip to Paris, where he made paintings and prints inspired by his new surroundings. He mailed Edith lithographs rolled up in tubes, jumpy black-and-white cityscapes of distorted buildings and winding streets, unpopulated and anonymous except for the odd sign, noting hotel here and "VIN" there. They were like stage sets for a play set in a cardboard world of Davis's own making. "Are you planning to stay in Paris indefinitely?" asked Edith. "Every once in a while we hear some rumor about your returning to this country. Is there any truth in it?" She signed off with regards to the artists who gathered daily at Café du Dôme to gossip,

drink, smoke, and flirt. "Please remember me to the Dome'ites," wrote Edith.

In 1929, Davis married Brooklyn-born Bessie Chosak and returned to New York, renting a one-room apartment at 43 Seventh Avenue, just half a block from the Downtown Gallery. Edith had included Davis's work in five group shows in 1928 and 1929 and presented his Paris paintings in a one-man exhibit, "Hotels and Cafés: Exhibition of Recent Paintings by Stuart Davis," in 1930. Edith offered Davis a two-year contract so he could keep working and not worry about sales—like his stipend arrangement with Mrs. Whitney. But whereas Davis decided to give Mrs. Whitney *Egg Beater No. 1* as a gift for her patronage, his contract with Edith bound him to hand over virtually his entire output; a minimum of fifteen oil paintings and ten watercolors each year, in exchange for $50 a week. They signed the contract October 1, 1930, an arrangement that Davis would later describe as "a very brutal arrangement" and would lead Davis to resent his dealer. Edith typically resisted this sort of arrangement, the French method. She preferred to take art on consignment directly from the artist because it seemed more equitable, allowing both dealer and artist to profit as prices rose. But Davis was a special case. He needed money, and sales seemed unlikely until the buying public caught on to what a few critics, artists, and Edith already knew: Davis was the future.

5

The Richest Idiot in America

A WHITE-HAIRED man ducked into the gallery in search of a drink. With so many speakeasies on the block—many disguised as legitimate businesses—it was no wonder he first thought the artwork was merely a front. Indeed, many future clients wandered into Edith's rooms by accident. There were no other art galleries in the area, and Edith didn't mind the fact that she met these accidental clients under false pretense. She only minded when someone who had already consumed a few too many gimlets stumbled in and delivered a slurred, rambling art critique. In those instances, Edith dashed to the nearby garage to summon the attendant, who moonlighted as Edith's bouncer.

This man stuck around even when it became apparent that art, and not bathtub gin, was the main attraction. He seemed to like the unpretentious, appealing display. In the back room, he admired two oak benches and inquired if one was available. He explained he was an architect and needed just such a bench for a client. Edith would have preferred selling him art but was not about to turn away a sale or a new customer. She offered to have the bench replicated. The man introduced himself as Duncan Candler and ordered the $80 bench,

asking that it be delivered directly to his client's home at 10 West 54th Street. The address didn't mean much to Edith, but as she was soon to discover, it was home to one of the richest families in the country.

Candler became a regular customer at the Downtown Gallery. He not only designed homes for his clients but also advised them on their art purchases. Though he was over 70 years old, and well-established both in the New York society and with a client list that included some of the wealthiest families in America, Candler developed an easy, warm friendship with Edith. When Edith traveled abroad in 1928, Candler gave her a $50 draft—$25 to spend on lithographs for Candler and the other half for Edith to spend on herself.

Over dinner one night at a Village speakeasy, Edith mentioned her latest idea, an exhibit of American landscapes. Her aim was to pit old-guard artists, those whose works hung in museums and who were irrefutable anchors of the art canon, against her new generation of painters, who were untested and unknown. She planned to mix both groups and let people decide for themselves how the current crop— John Marin, Joseph Stella, Max Weber, William Zorach, and Bernard Karfiol among them—held up.

During the gallery's first year, Edith had faithfully mounted shows by living American artists who were testing the bounds of modernism. No Europeans and no dead artists had found a spot on the walls of the Downtown Gallery. The mix of exhibits reflected the range of Edith's interests, coupled with whatever she could cajole artists to lend. Whereas other dealers merely rotated stock, sometimes mounting a show for a particular artist, Edith came up with unifying themes and innovative ways to present new work.

For the landscape exhibit, Edith had borrowed a Marin, but she needed more examples from the established names. She hoped to find works by George Inness, Albert Ryder, and Winslow Homer. Knoedler and Company had refused to lend a Homer and "kicked me out quick," Edith told Candler. She borrowed a Hassam, worrying that "I am sleeping with the Childe Hassam that I can't afford to

insure. But where will I get a Homer?" Candler said he knew of a Homer that Edith could borrow. "Will it be insured?" Edith asked. "Or will I have to sleep with the Homer too?"

True to his word, Candler delivered the Homer, *Shark Fishing*, a shimmering blue watercolor. Edith hung it in an alcove between two watercolors by innovators John Marin and William Zorach. She had decided to mount the thirty works so that old and new hung side by side in stark contrast.

Critics, collectors, and the merely curious made their way to the show, which opened in January 1928. "Landscape Experiment," ran the *New York Times* headline, as critic Edward Alden Jewell declared, "Modern and Early Work on Friendly Terms." Other critics felt Edith's younger artists more than held their own. "It is sad, in a way, but in this exhibition of American Landscapes, painted by Americans of the last 25 years, the older artists do not shine," said another reviewer in the *New Yorker*. "Inness, Blacklock, Hassam, Wyant, Robinson—their soft and edgeless canvases fade into nothingness besides the bright impacts of the newer men."

Despite the critics' admiration for the newer artists, the Homer was constantly singled out, praised in articles as "great," "vibrant," and "brilliant." Customers agreed. One of them, bedazzled by the Homer, shocked Edith with his offer of $14,000 for the painting. At the time, most anything in Edith's inventory could be had for a few hundred dollars. She relayed the exciting news to Candler, marveling at the commission she would earn on such a sale. "No," Candler replied. "The owner wouldn't want to sell."

One afternoon a lady arrived at the gallery. She stood in front of the Homer and its two modern sidekicks. Meanwhile, Edith studied the woman. She had made a practice of sizing up her visitors, though she had learned a valuable lesson: it was dangerous to judge a person's wealth from his or her clothes.

One time a woman had wandered into the gallery. Edith's immediately pegged her by her démodé ensemble—a frumpy black wool suit and black stockings—when a woman with any flair and means

swore by sheer silk stockings. Dowdy though she was, the woman was charming and keenly interested in looking at pictures. She spent hours studying canvases side by side with Edith. Edith was always thrilled to meet an enthusiastic art lover, but she hardly suspected this pleasant, round-faced lady, who looked more like a schoolteacher than an heiress, might be a serious buyer. The lady asked Edith to hold two paintings aside for her husband. Edith knew all the standard brush-off lines from people trying to make a dignified exit, but she decided to indulge the woman and kept the pictures on hold.

The next day, a Rolls Royce pulled up outside the gallery. Children in the street ran alongside, trying to glimpse the millionaire inside. Cornelius Sullivan, prominent lawyer and art patron, made his way to Edith's basement gallery. His wife, Mary Quinn Sullivan, had asked him to come by, he told Edith. Mrs. Sullivan had indeed been a public high school teacher before marrying Mr. Sullivan. Together they had assembled a well-known avant-garde collection, including works by Amedeo Modigliani, Cézanne, Picasso, all daring and bold choices of the day. A few years after Mrs. Sullivan first stepped into the gallery, she became one of the founders of the Museum of Modern Art, which opened in November 1929. Edith never forgot the lesson she learned from Mrs. Sullivan. "It's the person who looks least like a client that you should play up to," she later advised her employees. "It's a little, simple, poor-looking little person, and in most instances they turned out to be the collectors, not the swishy, well-dressed people."

The elegant woman now studying Homer's watercolor, flanked by the Marin and Zorach, was neither frumpy nor swishy. She preferred understated though beautifully constructed French clothes and ordered custom suits, coats, and dresses from Parisian couturiers Worth and Patou. She chose the quiet opulence of long strands of pearls over the glitter of diamonds and usually left her gemstones at home in a safe. From her wide-brimmed hats blocked by French milliners to the corsets cinching her broad hips, she enjoyed quality clothing as much as she enjoyed shopping for art. Her face was

pleasant, with an angular jaw, pointed nose, and soft eyes. She was no beauty, but she had great presence and an undeniable air of warmth. She was about 5 feet, 2 inches tall, like Edith, but at least twenty years older than the twenty-eight-year-old dealer. Unlike the other wealthy collectors who wished to buy the Homer, this lady asked about the Marin and the Zorach. "They are not for sale," Edith boomed. "Why?" asked the woman. "Because," said Edith, "I am holding them for the idiot who refused to sell the Homer for so much money."

"I am the idiot," the woman replied. She introduced herself as Mrs. John D. Rockefeller, Jr., client of architect Duncan Candler and lender of the Homer. She proceeded to buy $1,000 worth of art ($750 for the Marin and $250 for the Zorach).

Edith had founded her gallery with dreams of making art available to buyers at all price levels, but she undoubtedly understood the significance of having Abby Aldrich Rockefeller as a client. The Rockefeller name was legendary, branding the most prominent, wealthy, and sometimes controversial family in the land. Even before Mrs. Rockefeller met the shy Brown college student John D. Rockefeller, Jr., she was already rich and privileged. Her father, Nelson Wilmarth Aldrich, was a leading Republican senator for thirty years, and he had used his influence and power to multiply his wealth. *Time* magazine said Senator Aldrich "practically ran the country from 1897–1905" and "was probably the richest man ever to enter the Senate." Aldrich was an ambitious young man who had started out as a grocer and made his fortune with investments in banking, sugar, rubber, and public utilities. Although he had been born into an old, distinguished family, his parents did not have the wealth to match. Aldrich married his social equal, Miss Abby Pearce, who traced her lineage right back to the Mayflower. By the time Senator Aldrich died in 1915, he had amassed a $30 million fortune, equal to $552 million in 2005.

Abby Aldrich was raised in a three-story mansion in Providence, Rhode Island. She was exposed to all the upper-class traditions,

including French lessons, debutante balls, and a European grand tour, a privileged upbringing that bore no resemblance to Edith's hardscrabble Harlem girlhood. Yet the two women formed an almost immediate bond. There was something about Edith, a gutsy, young, independent businesswoman who was unafraid to speak her mind and advocated for unpopular art, that resonated with Mrs. Rockefeller. Though she was from an older generation, Mrs. Rockefeller was often drawn to younger women who had more freedom than she herself had known. She made a habit of aligning herself with such talent, including a dynamic woman whom she hired to run a rooming house for young women (funded by Rockefeller money), as well as a brilliant landscape architect, Beatrix Farrand, who was one of the few females in the field. "I like the looks of the young women I meet," Mrs. Rockefeller said in 1927, in a speech to a group of

Abby Aldrich Rockefeller in her trademark pearls, 1922.

women. "Being naturally frank myself, I am not shocked by the lack of reserve that one notices in their conversation. I am delighted that [they] are having a chance to express themselves."

Such behavior was consistent with her personality. She adored the tactile, the evocative, and all that was beautiful. "Abby was extremely sensuous," said Mrs. Rockefeller's biographer, Bernice Kert. "She had sex appeal and was open to passion." She shared these qualities with Edith, who also had a strong effect on most men. Sculptor William Zorach said Edith always had "sex appeal." (Once her gallery got successful, Zorach told her she also had "checks appeal.") Edith and Mrs. Rockefeller were both aware of their feminine charms and used them to their advantage—it was one of the few ways women wielded power. Mrs. Rockefeller's sensuality kept her marriage passionate for decades; Edith used it to curry favor and attention in an all-male business world.

Mrs. Rockefeller certainly wasn't stuffy, but in deference to the circumstances of her high-profile husband, she was forced to rein in her naturally exuberant personality. John D. Rockefeller, Jr., was far more introverted. On a trip with her husband, Mrs. Rockefeller wrote one of her children, "Your father is afraid that I shall become too intimate with too many people and will want to talk to them, so generally we eat in what I call the old people's dining-room where he feels I am safe." Indeed, Edith probably reminded Mrs. Rockefeller of herself as a young woman, an extroverted, curious, and vivacious person, whose marriage into the Rockefeller dynasty had forced her to curb these traits. Edith was about the same age as Mrs. Rockefeller's own daughter, Babs, who had rejected her mother's interest in the arts. During a two-week European art tour in 1924, Babs was moody, irritable, and "bored stiff" in museums. Meanwhile, galleries filled with African art, French Gothic miniatures, and contemporary German Expressionist artwork left Mrs. Rockefeller insatiably curious and hungering for more. Bernice Kert, her biographer, has suggested that with Babs's disappointing rejection of her mother's interests, Edith was the perfect surrogate daughter, an

able partner with Mrs. Rockefeller in exploring this exciting new world.

Mrs. Rockefeller may have had other reasons for supporting Edith. She had a history of championing the rights of young women, as well as Jews and blacks. "One of the greatest causes of evil in the world is race hatred or prejudice," she told her sons in 1923. "The two people . . . who suffer the most in this country from this kind of treatment are the Jews and the Negroes." Patronizing a gallery run by a young Jewish woman and her black assistant would have appealed to Mrs. Rockefeller.

Edith hired her assistant in 1928, once sales had picked up and she had tired of doing everything herself. She realized the best thing to do was to hire a man to work as a porter and secretary and figured out she could pay him $15 a week. Since she could only afford to pay one employee, she decided the most logical thing to do was to hire a man who could help with the packing and shipping and hanging of exhibitions, as well as attend to her correspondence and secretarial needs. (Edith loved dictating letters but hated typing them. She also hated her messy handwriting. It didn't conform to her mania for order.) Edith went to the National Urban League, an organization that helped blacks find educational and employment opportunities, and asked for a referral. The league recommended Lawrence Allen, who had recently arrived in New York after schooling in Virginia. Lawrence was charming, well-spoken, and a hard worker. Edith hired him and placed him at a desk by the front door, signaling to visitors that this gallery did not pay mind to the color line. At other businesses, black workers were relegated to low-level, behind-the-scenes jobs. Not so at the Downtown Gallery where Lawrence would welcome all visitors.

But Mrs. Rockefeller's patronage didn't depend just on altruism. By the mid-1920s, Mrs. Rockefeller had begun to seek out art for the gargantuan Rockefeller homes in Manhattan, Pocantico Hills in Westchester County, and Mount Desert Island in Maine. At first she dabbled in areas her husband admired, buying Asian sculpture and

Chinese porcelain from Yamanaka and Company and costly Duccios, Goyas, and Chardins from the Duveen Brothers, who also sold the Rockefellers a $10,000 Gothic chimney piece, later donated to the Metropolitan Museum. These Old Masters, particularly the religiously themed, appealed especially to Mrs. Rockefeller's husband John, who was raised in a strict Baptist household and remained faithful to his roots, running a weekly Bible study group at the Fifth Avenue Baptist Church. While Mrs. Rockefeller preferred the company of lively artists and friends, John used their 54th Street mansion as a meeting place for Baptist ministers. The early Italian pictures from Duveen not only suited Mr. Rockefeller's taste but were in vogue for many of the newly wealthy men of the day, including J. P. Morgan and Andrew Carnegie. These wooden panels, flecked with gold, hung in ornate Fifth Avenue mansions, conferring instant taste, status, and culture upon their owners.

The nine-story Rockefeller mansion, with its squash court, rooftop gymnasium, and floors for servants, was nearly twice as tall as all the other buildings on the block and certainly impressive to anyone invited within its towering limestone walls, anyone except Edith. She found the décor terribly old-fashioned—heavy and grim—best described using one of her favorite expressions: beyond ghastly. To the less critical eye, it was merely the style of the day, with ponderous crystal chandeliers, acres of Oriental carpets, and traditional English Chippendale and eighteenth-century French gilt furniture—a blend of antiques and less-costly reproductions—reflecting Mr. Rockefeller's efforts to economize.

The second-floor drawing room was decorated in neoclassical style, filled with columns, pilasters, and arches. John D. Rockefeller's prized collection of famille-noire Chinese vases sat on pedestals and nearly every other horizontal surface. These porcelains were one of Mr. Rockefeller's few indulgences. In 1915 he had implored his father, founder of Standard Oil, to lend him more than a million dollars to buy a selection of black-ware porcelains from Duveen, who had acquired J. P. Morgan's collection. He told his

The opulent Edith would say, "beyond ghastly"—living room of
the Rockefeller mansion at 10 West 54th Street, circa 1937.

father the vases would certainly hold their value and that they were
the lone extravagance dear to his heart ("A fondness for these porce-
lains is my only hobby," he wrote John, Sr.) His father eventually
gave him the money. When Mr. Rockefeller fell in love with some-
thing, he didn't let frugality hold him back. He was reported to have
paid $1.2 million for a set of Gothic tapestries known as the *Hunt
of the Unicorn*. Another time a blue Chinese rug caught his eye at
auction. It was expected to fetch around $2,500. He wound up pay-
ing $15,400.

Though their home décor was clearly ornate—and expensive—the
Rockefellers didn't follow most rules dictated by high society. They did-
n't attend society balls, preferring the privacy of their own company.
They shunned displays of wealth, and aside from lavishing money on
their pet causes and their homes—Candler designed a $500,000 play-
house in Pocantico modeled on a French medieval townhouse—they
preferred not to spend. While Mr. Rockefeller was in college, stories

about his frugality flew around campus: the son of a man worth more than $200 million [in 1901] soaked two-cent stamps apart, trimmed his frayed cuffs, and pressed his trousers under his mattress. His thrift and stringent morals were fashioned by his stern and controlling father, a wildly wealthy yet thin and ascetic oil baron. "Save your pennies, work eight hours a day, write down how you spend every penny you receive, make a budget at the beginning of each year and live within your budget, and don't run an automobile unless you can afford it," Mr. Rockefeller told 197 congregants on November 12, 1922, during his weekly sermon given to the Young Men's Bible Class of Park Avenue Baptist Church. Monday morning, his advice wound up on the front pages of the *New York Times.*

Mrs. Rockefeller shared her husband's sense of thrift. "Mrs. Rockefeller, Jr. gives all but a mere pittance of her income to charity," wrote gossip columnist Cholly Knickerbocker (a pseudonym for Maury Paul) in his column in the *New York American.* Another journalist sketched her lack of pretense with a few observations, namely that she loved gardening; she had remained in the same home for twenty-five years; she knew the names of all her servants; and she drove an old model motorcar. Mrs. Rockefeller shared her husband's distaste for extravagance, rooted in her New England upbringing, but unlike him, she was receptive to new types of art.

Before Mrs. Rockefeller met Edith, she had limited exposure to modern art, but she had begun exploring the terrain by the mid–1920s. She made her first purchase, a $500 German expressionist watercolor titled *Landscape* by Erich Heckel, during her 1924 European art tour under the guidance of William R. Valentiner, director of the Detroit Museum of Art. The fact that Mrs. Rockefeller bought an inexpensive watercolor, rather than a painting, was consistent with her future collecting. She preferred buying smaller works and in bulk, in part because of her innate frugality and in part because she viewed her collecting as a form of patronage. She was able to support many more artists by regularly buying inexpensive works, instead of buying fewer, expensive paintings.

For a brief time before she met Edith, Mrs. Rockefeller relied on painter Arthur B. Davies, who was more gifted as a promoter than as a maker of art. One of the organizers of the event that launched modernism in America, the 1913 Armory Show, Davies himself was no modernist, preferring to paint gauzy romantic paintings laden with symbolism and historical references. Still, he championed the new. He steered several wealthy heiresses, including Abby Rockefeller, toward the moderns. Upon Davies's death in 1928, she wrote his son a heartfelt condolence note. "I had the deepest admiration for him, and although I had known him only for a few years, I felt a real affection for him," she wrote. "I feel that I owe to him a very great deal, because he inspired me and encouraged me to acquire modern paintings, and without the confidence which his approval gave me I should never have dared to venture into the field of modern art."

If Valentiner and Davies primed Mrs. Rockefeller's interest in modern art, Edith helped transform this burgeoning interest into a full-blown obsession. Edith always repeated the story about the Winslow Homer in describing her first encounter with Mrs. Rockefeller. There is evidence, however, suggesting that Mrs. Rockefeller first visited the Downtown Gallery before February 1928. Mrs. Rockefeller brought Nelson, one of her five sons, to visit some of her art destinations during his winter break from Dartmouth College in January 1928. Nelson Rockefeller, the second eldest, was the most gregarious and social of all the offspring and the one most like his mother. He was keen to learn about art, and his mother was overjoyed to accommodate him. "Dear Ma," he wrote in a letter, "You don't know how much I enjoyed our two trips to Mr. Davies and the visit to the Downtown Galleries [sic], I feel as if I had been introduced to a new world of beauty, and for the first time I think I have really been able to appreciate and understand pictures, even though only a little bit. I hope to continue this when I am in New York and maybe do a tiny bit of collecting myself."

Mrs. Rockefeller's purchase of the Marin and Zorach at the Downtown Gallery launched a buying spree. Captivated by a dealer

who was filled with boundless enthusiasm for her artists and appeared trustworthy and invested in the art business because she cared about the art—not just the profits—Mrs. Rockefeller quickly became the gallery's biggest customer. She appreciated Edith's discretion. When buying on her behalf, Edith kept her client's identity a secret; letting a seller know the prospective buyer was the richest woman in the country had obvious drawbacks when demanding a discount. Mrs. Rockefeller was never willing to pay top dollar, and Edith often pressed sellers for a lower price, or switched vendors—such as framers or art restorers—to find someone skilled but cheaper. Edith was always diligent about letting Mrs. Rockefeller know that she wasn't one to waste Rockefeller funds—and coming from a woman who had grown up poor and understood the value of a dime, Mrs. Rockefeller believed her.

Meeting Edith wasn't the only reason Mrs. Rockefeller accelerated her buying. For years, she had relied on her own family trust funds, supplemented by small infusions from her husband, and the odd $1,000 gift from John D. Rockefeller, Sr., to make her art purchases. But in 1927, John sidestepped his distaste for modern art and wrote his wife a note informing her of a new art budget. He gave her $25,000 in three lump installments drawn from his Banker's Trust account, "hoping this will facilitate the carrying out of your desires, I am affectionately, John." This sum was large enough to support many artists, and a few galleries, but it was only a tiny fraction of Mrs. Rockefeller's husband's wealth. He was already worth an estimated $1 billion dollars (plus $500 million more in family trusts), as a result of gifts given by his father.

Mrs. Rockefeller had no trouble dispensing her first allocation, buying at four galleries: Kraushaar, Keppel, Knoedler, and Montross. By December 31, 1927, $317.36 was all that remained in the account. John evidently noticed how much his wife enjoyed collecting. In 1928, he nearly doubled her budget to $40,000—the same year she became a serious client at the Downtown Gallery. By the end of 1928, Mrs. Rockefeller had spent $67,000 on art, tacking on inter-

est and probably making up the rest from her own private trust account; $22,855 of that wound up in the coffers of the Downtown Gallery. She bought widely and deeply, usually opting for a watercolor or print, with most purchases ranging from $20 for a print to a few hundred for a painting. Artists she bought included Leon Kroll, Peggy Bacon, Walt Kuhn, Charles Sheeler, Abraham Walkowitz, Max Weber, and both Marguerite and William Zorach. The most expensive piece was a $3,000 painting by Walt Kuhn titled *Dorothy*, of a somber-looking lady of vaudeville, one of the chorus girls working for a famous movie theatre promoter, Samuel Rothafel, or Roxy.

Although Edith and Abby maintained formalities, addressing each other as "Mrs. Halpert" and "Mrs. Rockefeller," certain boundaries slowly came down. Edith usually worked or socialized until late at night, rising around 10 a.m. and slowly making her way downstairs to the gallery. Mrs. Rockefeller, however, preferred an earlier start. The morning after the auction of the estate of Arthur B. Davies, Edith was startled awake by the sound of her bell ringing. Since it was only 9 o'clock, she ignored it for a while before finally coming out on the landing in her nightgown and shouting down, "Who is it?"

"This is Mrs. Rockefeller."

The third-floor tenant was out on his landing, as his bell had also been rung. "So's your old man!" he called out. Edith raced back into her apartment, hiked up her nightgown, and tied the ribbon belt so it would stay up. She rolled on stockings, tossed a dress over her head and dashed out the door and down the stairs. They loaded more than a dozen pieces into the car, and Edith joined Mrs. Rockefeller for the ride uptown. They drove to 54th Street, where the butler and other servants helped them unload. Edith, sleepy and frazzled, asked for a cup of coffee. They reviewed the bill, and Edith couldn't resist telling Mrs. Rockefeller that she had noticed her normally stone-faced driver, Valentine, had cracked a smile that morning. Mrs. Rockefeller said she knew the reason why: he wasn't used to seeing a lady racing around with the hem of her nightgown dangling below her dress.

If Edith made Valentine smile, she didn't have the same effect on

Mr. Rockefeller. To the shy, reserved man who battled depression and low self-esteem with regular rest cures and visits to sanatoriums, Edith was a troubling force. For one thing, artists weren't known for their sober morals or actions. Rockefeller disapproved of nearly everything Edith stood for, from her incomprehensible art to her smoking. (He so disapproved of smoking that he promised each of his children a $2,500 reward if they refrained from the habit until the age of twenty-one. Only a couple actually got the reward, and Edith thought it was short-sighted for the Rockefeller heirs to hold out for a few thousand bucks; one day they would all inherit millions.) Edith claimed Mr. Rockefeller gave her a talking to after she arrived in Pocantico to deliver some artworks, having made the grave mistake of sitting in the front seat of her Hupmobile with her driver, who was actually just a gallery employee. "It's very embarrassing for us to see that," Edith recalled being chastised during lunch. "After all, you passed the garage man, the gate man. It just isn't done."

Even though her husband had serious doubts about Edith, Mrs. Rockefeller remained devoted. She even asked Edith to take Nelson on an art tour of Greenwich Village. The pair stopped in at Romany Marie's, where the young Rockefeller could meet some of the artists whose work they had been viewing. Edith introduced "Mr. Nelson," a name she'd been using all day to "avoid riots," to Marie, who offered to read his fortune. She stared into a cup of tea leaves, was baffled by what she saw, and called for a second cup. The results were the same. Edith pressed Marie to reveal the mysteries of the leaves. The leaves indicated that "Mr. Nelson" would one day be the owner of "piles of gold, all heaped up" and also the leader of millions of people. Edith later said she remembered Marie's prophecy when Nelson Rockefeller became governor of New York.

Mrs. Rockefeller, like her son, wished to have as normal a life as possible. Though she lived uptown in relative isolation, cloistered by the Rockefeller fortune and the watch of her controlling husband, she was intrigued by Edith's world. Having heard all about the rage for speakeasies, she yearned to see one of these places firsthand but had

not dared. In 1920, the Eighteenth Amendment to the Constitution outlawing the sale of liquor went into effect. The Rockefeller family had a history of leading the dry fight. As early as 1883, John D. Rockefeller, Sr. gave $10,000 to support the Woman's Christian Temperance Union's campaign for prohibition. Nearly two decades later, he continued to rail against the evils of alcohol. "I am an old man, but I am glad to say I never touched whiskey," he said in 1908, at the age of sixty-nine, during an interview in Augusta, Georgia. He considered it "a good thing to keep liquor away from Negroes and lower classes of whites." John, Jr. inherited his father's crusade, and by 1926, Rockefeller father and son topped the list of donors to the Anti-Saloon League of America, having contributed $20,000 in a year and a half.

Enforcement of Prohibition was impossible, and soon saloons were replaced by illegal speakeasies, some 32,000 in New York City alone. Bootleg booze was a significant stimulant for the 1920s antics in Greenwich Village. Excess was the norm, later tragically born out when many social drinkers turned alcoholic. It was also an ethos and subconscious mindset, a push to upend Victorian and early twentieth century mores. Drinking was common in artistic circles, but it would have scandalized Mrs. Rockefeller's high-minded teetotalling husband.

As she became a regular visitor to the Downtown Gallery, Mrs. Rockefeller discovered that West 13th Street was far better known as a destination for drinkers than for art lovers. One day she mustered her courage and asked Edith if she might visit one of these places. Edith often entertained clients at speakeasies, but with Mrs. Rockefeller she wasn't so sure. She was concerned that Mrs. Rockefeller might feel compelled to tell her husband if they went to a speakeasy and that Mr. Rockefeller would then feel obligated to notify the police and have the place closed down. These raids happened regularly, and the owners and the customers were all tossed in jail. But Mrs. Rockefeller promised to keep their visit a secret. "She was just bursting to see how the other half lived," Edith said.

Around 4 p.m. on the appointed day, a Rolls Royce rolled to the curb outside the gallery. Edith had decided on a late afternoon visit, when the speakeasies were relatively quiet and patrons relatively sober, to avoid exposing Mrs. Rockefeller to too raucous and shocking a scene. They left the Rolls in front of the gallery at Edith's suggestion—she though it unwise to let Valentine know where they were headed—and hailed a taxi to take them to Julius's, one of Edith's favorite Village watering holes. "Don't worry about it," Edith told Mrs. Rockefeller. "You don't have to drink. I'll order a ginger ale for you. I'll order something else because I've been there frequently and they'll think it very odd if I don't drink." The taxi pulled up on Waverly Place, in front of a long narrow alley. Edith had chosen Julius's because of the whimsical decor, thinking Mrs. Rockefeller would appreciate its humor. Inside, brass basset hounds decorated the foot rails, lights were mounted on wagon wheels, and wooden beer barrels served as seats.

They didn't make it that far. As they neared the front door, Mrs. Rockefeller reached out and grabbed Edith's arm. "I don't know what happened to me! This is the most ridiculous thing!" Mrs. Rockefeller turned and dashed back down the alley toward the street. "It would make the front page of the paper," she gasped to Edith, once they reached the corner. "Somebody would recognize me—the cook, the dishwasher, somebody, and the next day there would be this big story in the 'Mirror' that Mr. and Mrs. Rockefeller were dragged out drunk from a speakeasy." Edith tried to convince Mrs. Rockefeller that no one would recognize her, but there was no calming her down. It's true that the newspapers were filled with news from the wet beat. A raid on Julius's during the summer of 1928 had indeed made the papers, with reports that just after midnight, detectives corralled forty-nine customers—including fifteen women—and hauled them off to the Charles Street Police Station.

Edith found another taxi, and they returned to the gallery. Mrs. Rockefeller was still shaken and asked Edith to accompany her uptown. They stepped into the back of the Rolls, and Mrs. Rocke-

feller pulled the panel dividing them from Valentine. She sat back and burst into tears, frustrated with the limitations of wearing the Rockefeller name. She was envious of Edith, she said, who could do whatever she pleased. "No one would believe you," said Edith. "I am supposed to envy *you*." Once they reached the Rockefeller manse, they settled in for a soothing cup of tea. Soon John appeared at the door, glanced at the two women, and asked, "What are you girls up to now?"

6

One Very Wide-Awake
Art Operator

THE FIRST YEARS of the Downtown Gallery were defined by Edith's grand ambitions for her gallery and her artists. She landed the biggest collector in the country, Mrs. Rockefeller, but that didn't slow her down or lessen her drive. She devoted much time and energy to wooing other wealthy collectors willing to dabble in adventurous art. Early converts included Duncan Phillips; Hamilton College professor Edward Root, whose father was Secretary of State Elihu Root; Santa Barbara collector Wright Ludington; and *Vanity Fair* editor Frank Crowninshield. There were a number of lesser known figures as well, such as B. D. Saklatwalla, an executive and scientist at the Vanadium Corporation in Pittsburgh, Pennsylvania, who visited the gallery once a week for years and dined with Edith every Wednesday night before taking a late train back home.

Though her sales volume continued to rise, Edith's average sales figure was quite small. In addition to paintings and sculptures costing a few hundred dollars, she sold dozens of $10 to $20 prints, affordable purchases for artists, a few museums, and clients with all sizes of budgets. Edith encouraged her artists to make prints, and she

was one of the few American dealers to insist that the prints be limited to edition sizes indicated on the print and signed by the artist.

Edith toyed with the notion of moving uptown, near the other big-stakes dealers, to assert her status as an important player. If she were uptown, she might be able to make bigger sales. In the late 1920s and early 1930s some of her biggest sales were not her own Americans, but paintings by French artists Henri de Toulouse-Lautrec and Odilon Redon, which she scouted in Europe for Mrs. Rockefeller. These works commanded upward of $4,000 and netted Edith a bigger sales commission, funds she urgently needed to help pay the gallery bills. But how could she leave downtown? Perhaps it would be wiser to invest her earnings to upgrade the existing gallery.

Buoyed by the depth and strength of her artist roster and by Mrs. Rockefeller's steady purchases, Edith searched for ways to add stature to her gallery. She continued to stage compelling monthly exhibits at the gallery, aimed at bringing in press and clients. She felt American artists needed and deserved an extra push, and she was ready to propel them as far as possible.

During her summertime trips to Europe Edith made a study of the Parisian galleries, and especially Picasso's dealer—and one of the most successful art dealers of the day—Ambroise Vollard. She had noticed art books placed strategically around his gallery. Vollard, like other European dealers, hired writers and published books on his artists, a practice that both appealed to his artists' vanity and underscored the historical importance of their work. It was not a money-making venture, but one aimed at shaping art history.

The practice of publishing art books did not exist in the United States. Art galleries might print up a sheet or a pamphlet for a show, as Edith did for her monthly exhibits, but not a full-fledged catalog or book with any lengthy text or reproductions. Edith felt books about her artists would elevate their stature and also establish the reputation of the gallery. Why not publish ten monographs on her most important artists? That idea was quickly scaled back. No publisher was interested in publishing books on contemporary art—there

had been only a handful, including Max Weber's *Primitives*, printed by Spiral Press in 1926. If no one was willing to publish Edith's artist series, she would do it herself.

For the first book, she selected one of her highest-profile artists, sixty-year-old George Overbury Hart, better known by critics and his worldwide admirers as "Pop." Hart's images of his travels to Tahiti and Mexico found wide appreciation from critics and collectors. By the time Edith began selling his paintings, watercolors, and prints in 1927, he had shown sporadically with dealers Knoedler and Company and Weyhe and exhibited at the Brooklyn Museum and Art Institute of Chicago. He was also the president of the Brooklyn Society of Etchers. His watercolors were among the best of the 1920s, a period especially rich for this medium. Over and above these credentials, the press lapped up the carefully cultivated "Pop" persona, chronicling up his exotic adventures, playing up on his start as a sign painter, and regaling readers with tales of his romantic adventures riding the rails, hoboing across the country, and hobnobbing with Mexican princesses. Mrs. Rockefeller happened to be one of Pop's biggest fans, swooping up dozens of prints. (Not surprisingly, her husband disapproved. "I showed Papa the Hart pictures," Mrs. Rockefeller wrote her son Nelson, "and he thinks they are terrible beyond words.")

Edith decided to publish two editions devoted to Hart, one priced at $2, and a deluxe smaller edition at $10 that included a signed etching. She began plugging subscriptions to her clients, selling fifteen by July. The book would be written by Holger Cahill and include twenty-four watercolors and lithographs, borrowed from gallery clients such as Duncan Candler, Abby Rockefeller, and Preston Harrison. "We are also giving the name of the owner in each case, as well as the medium, title and date painted," Edith wrote Pop of her plan to flatter collectors' egos. "Nothing like giving them their money's worth, eh?" She estimated the book would cost $1,000 to print but hoped the gallery wouldn't have to shoulder the entire amount. Mrs. Solomon Guggenheim—wife of the founder of the future Solomon R. Guggenheim Museum and aunt of future art patron Peggy Guggen-

heim—offered to chip in $500. Bee Goldsmith, who was involved with the print sales and helped raise funds for the Hart book, wrote Mrs. Guggenheim explaining that the gallery would fund the other $500 and lamenting that "New York publishers are still hesitant about 'art books' as a business proposition."

Edith made sure the Pop Hart book got an appropriately high-profile launch. She convinced one of Hart's biggest enthusiasts, Mrs. Rockefeller, to throw a tea party to celebrate the publication of the book. On December 7, 1928, from 4 to 7 p.m., socialites, journalists, and artists arrived at 54th Street and were ushered to Mrs. Rockefeller's own private art gallery, on the top floor of her mansion. The rooms, formerly a nursery, had been converted to an exhibition space now that her six children were grown. They served as an intimate refuge where Mrs. Rockefeller could store and admire her growing collection, away from her husband's disapproving eye. Edith had helped decorate Mrs. Rockefeller's "Topside Gallery" with material from discount fabric shops. The gallery was making its public debut along with Hart's book.

"The afternoon was drizzly, blustery and bleak," wrote *New York Times* art critic Edward Alden Jewell, "but indoors all was snug, and before an open fire in the room where tea was served one found the artist himself—he who has warmed himself before so many fires all up and down the world in his adventurous years of vagabonding." Jewell described the tea as "a delightful coming-out party" and praised the simple hardbound book as "attractively prepared" and "with an admirably sympathetic introduction by Holger Cahill." Jewell, who usually wrote flattering reviews of Edith's shows, went so far as to describe Hart, who was certainly talented but no pictorial trailblazer, as a genius: "There is no more sincere artist at work in this country today," Jewell wrote near the end of his article. "So long as we have men like 'Pop' Hart we need never be troubled when Europe raises an eyebrow, inquiring, 'Where are your geniuses?'"

Edith's own accounts of the tea party, retold and likely embellished over the years, dramatized the clash between the downtown artist and

the uptown dames. "The project [the party] called for new clothes for Hart, and a long soak in a turkish [*sic*] bath, and the removal of many layers of grizzle and spittle. Hart was still asking questions about etiquette when he arrived clean, pressed, and sparkling. Mrs. Rockefeller said, 'I'm so pleased to know you, Mr. Hart,' and he replied, 'You don't know me. This ain't the way I look in Fort Lee.'" Even though there was nothing stronger than tea on tap, Hart quickly warmed up, Edith recalled, and was soon taking liberties with the society ladies like Mrs. Percy Hitchcock, slapping her on the back—"a very low altitude slap"—and calling them "baby."

The party was not only Hart's coming-out party: the public learned that Mrs. Rockefeller, formerly associated with the conservative tastes and morals of her husband, harbored a serious interest in modern art. "Although not widely known as a collector on her own part," said the *Herald Tribune*, "Mrs. Rockefeller has formed a choice lot of watercolors, lithographs and color etchings." According to her biographer, Bernice Kert, the Hart show introduced Mrs. Rockefeller as a proponent of the modern. "Abby, whose forays into the world of modern art had begun quietly," writes Kert, "was now perceived, to the surprise of a public who had assumed her to have a conventional outlook, as an adventurous collector of unpredictable and original opinions."

Edith considered her first foray into publishing a success. She followed up two years later with a monograph on painter Max Weber, one of the most radical artists showing with the Downtown Gallery. The elegant book, with thirty-two reproductions and a forty-five page introduction by Cahill, was timed to coincide with a Weber retrospective held at the Museum of Modern Art in April 1930. (Stieglitz, with whom Weber had feuded, wrote Edith a long angry letter stating that the book was plagued with falsehoods perpetuated by Weber.) Edith sold the book in her gallery and also tried to convince a French publisher to print a translated version for Parisian audiences. She found no takers for a Max Weber export, and with that second volume, the monograph series came to an abrupt halt.

Publishing books was indeed a money loser, and Cahill's health problems—intestinal and otherwise—terminated the book project as well as a short-lived venture into magazine publishing. *Space*, a quarterly magazine devoted to contemporary art, debuted in January 1930, with Cahill as editor-in-chief, B. D. Saklatwalla as president, artist Stefan Hirsch as vice president and business manager, and Edith Gregor (who had temporarily dropped the Halpert in name, as she had done in life) as treasurer and secretary. Subscriptions were available for $1 and came with a free Kuniyoshi print, clearly an Edith-style inducement to increase readership. Other artists on the masthead included painter Max Weber and sculptor Robert Laurent, whose apartment at 110 Columbia Heights served as the magazine's office. The June issue of *Space* featured contributions from the Downtown Gallery circle, including collectors Duncan Phillips and Preston Harrison and artists John Sloan and Stuart Davis, as well as illustrations by seven other artists connected to the gallery.

Harrison described the humiliation of his first art modern purchase: "My acquaintances at the time jeered and hooted, some advising me to hang it upside down to get the best effect, others suggesting to place it face side to the wall, nobody as I now recall having a kindly word to utter in its behalf. Artists in particular went so far as to rage and rave, much to my embarrassment and wounded pride."

Stuart Davis argued in his article that in the future, the moving picture would replace paint as artists' favored medium: "The moving picture camera is already at a point where it can take over the functions of visual art and perform them better than they have ever been done. Anyone who contends that movement in an object is not more interesting than immobility should reconsider before so contending." Davis did qualify his position by still advocating for picture sales. "But again let me say that the above cannot in any way be construed as an argument against buying pictures. Present day picture buyers cannot wait fifty years for the better and less dusty art. If at that day they have any aesthetic interest left, it will probably be confined to the art of embalming."

By summer, Cahill was hospitalized with appendicitis and could no longer serve as editor. Edith was also alarmed when the critics, artists, and collectors she had depended on for free articles started asking to be paid. She halted the operation immediately. Three issues of *Space* had been published, and a fourth never went to press.

Edith searched for other ways to improve the reputation of contemporary American art. She was particularly chagrined that there was no museum venue exhibiting or collecting contemporary American art in New York. Others felt the same way. In December 1927, A. E. Gallatin, a banking heir and New York University trustee, installed his modern art collection in three rooms at the university, just a few blocks from the Whitney Studio Club and the Downtown Gallery. But in terms of institutions with the power to shape taste, the Metropolitan Museum of Art was the only art museum in town. Curators and trustees at the Metropolitan were not interested in contemporary art and had a special dislike for anything provincial and American.

Though she continued to pummel curators at the Metropolitan with suggestions they dip into their deep coffers and help artists who were still alive, Edith got little response for nearly six years. Finally, in 1932 she managed to sell the museum two paintings, and even then it took a monumental effort and the strategic yanking of some important coattails. Edith turned to Mrs. Rockefeller's son, twenty-four-year-old Nelson Rockefeller, who had been named to the museum's board—the youngest ever in the museum's history and the only crust-free soul of the lot. Though young, Nelson Rockefeller's opinion carried weight. The museum selected two paintings, a Bernard Karfiol and a painting of a speakeasy by Glenn Coleman. Both works were figurative and relatively conservative, but a sale was a sale was a sale. "All the artists are very enthusiastic about the new trend of the museum's purchases," Edith told Bryson Burroughs, the Metropolitan's painting curator, optimistically suggesting the museum would be buying more, and soon. Her enthusiasm was premature. The museum just wasn't interested in the new and untested, nor did the cura-

tors feel any special obligation to support the fledging local gallery scene.

In February 1932, Edith also contacted William Ivins, the museum's print curator, a man respected for his scholarship but known as "Ivins the Terrible" and "Poison Ivins" behind his back. She proposed that the museum buy a set of Glenn Coleman's prints, especially now that the artist was dead. Her suggestion that the museum buy, rather than accept, the prints unleashed a torrent from Ivins, who told the dealer he was shocked at the audacity of American artists who expected the museum to pay for their works. "I have never been able to see why an American artist who makes prints should not make a very cheap and easy contribution to the Museum by giving it impressions from his coppers and stones." The cost to the artist is "almost nil," he noted, and thusly is "no sacrifice" on the part of the artist. Ivins lectured Edith that the value of having a work at the museum outweighed the necessity of having the museum pay for it. "If the museum never bought a single print by a living artist, all the living print-makers would be nevertheless under the greatest debt to the museum." After all, getting admitted to America's most exclusive arts club was tantamount to "a seal of approval."

At the end of his letter, Ivins softened a bit and said he would offer $100 for the Coleman set, in view of the fact that the artist had recently died and he supposed that executors had legal obligations to settle the estate. Edith accepted his offer of $100 with the caveat that he "mention the price to no-one" because others who had paid more would be upset. She understood that the art market is largely based on perception, and she couldn't have the news that her prints were cheap running rampant in curatorial circles. She conceded to Ivins that there was considerable value to being included in the museum's collection but still found a way to politely stand up for artists, stating their case loud and clear: "Artists would ordinarily be delighted to give examples of their works to museums," she said. But with the Depression and collectors' "non-buying psychosis," said Edith, "the artist depends on museums for their [sic] livelihood." That was quite

an admission. The museums certainly weren't dependable, and least of all the one in Edith's hometown.

Rather than stew in frustration, Edith took action. She was not only an innovative thinker but also brilliant at making things happen and translating grand ideas into tangible action plans. She wrote up a museum proposal for Mrs. Rockefeller. "I shall not go into the needs for such a collection in our metropolis—the logical art center of this country," Edith wrote Mrs. Rockefeller. Her plan was simple and straightforward and depended on the power of women. She suggested that a committee of ten women art collectors each donate $10,000 annually to a fund used to buy art by "LIVING AMERICAN ARTISTS." The money would be allocated by the committee, and the art would be displayed in a room at the Metropolitan Museum. Edith hoped her plan would be "small enough to be experimental, yet important enough to serve as a solid groundwork for future development."

It is significant that Edith shaped her scheme around the involvement of women. Although society expected women to be focused on family and defer to their husbands, Edith had noticed that many of her own top collectors were women (Edith Wetmore, Mary Sullivan, Abby Rockefeller). She believed in the power of women to fight for change and to make a difference. "To me it seems fitting that women should foster this plan. Tradition points to greater courage in women towards reform and new ideas. Women are privileged to 'change their minds,' and therefore have that advantage in making new experiments. Women have more time to devote to the arts as can be judged from the attendance at all art functions."

Edith was not the only person lobbying for a contemporary art museum, nor the only person likely to have been pursuing the matter with Mrs. Rockefeller, but by the end of the year, her dream was put into action. In early 1929, while traveling in the Middle East, Mrs. Rockefeller met up with wealthy heiress Lillie Bliss, and they briefly discussed the possibility of starting such a museum. The following spring, the two ladies, along with Mary Sullivan, began meeting reg-

ularly to discuss opening a museum or gallery devoted to modern art. The three women wished to have a man in charge and asked Conger Goodyear, a collector and former museum director from Buffalo, New York, who was known to be sympathetic to modern art, to head up the effort.

By this time, Edith's role as Mrs. Rockefeller's art adviser was well known. It did nothing to win Edith friends among other dealers, who were jealous of the influence wielded by a twenty-eight-year-old woman who had owned her gallery for less than two years. Edith claimed some of these dealers wrote letters to Mrs. Rockefeller, accusing Edith of unwholesome living and loose morals. After all, not only did she not have children, but her husband resided halfway across the country, and she was known to keep company with her artists and Holger Cahill. If that weren't bad enough, she was one of the very few married working women—about 8 percent of American married women worked in the 1920s. Even well into the 1930s, most people believed married women should not work. To top it off, Edith's career fell outside the traditionally female domain. Single women, and those who absolutely had to work, were usually in domestic service, labored in factories, or possibly did clerical work or teaching. Art dealing was not even on the charts. Finally, her competitors accused Edith of charging Mrs. Rockefeller exorbitant commissions. They said Edith borrowed artwork from one dealer and then marked it up and resold it to Mrs. Rockefeller, who was stuck paying two commissions. Edith said that Mrs. Rockefeller never confronted her directly about the accusations but that her secretary, Anna Kelly, shared the letters with Edith and explained that neither she nor Mrs. Rockefeller believed them. All this did nothing to improve Edith's opinions of her competitors, but only fueled her desire to be as successful as possible.

By this time, Edith's role as the eloquent voice of the American artist was recognized by influential art journalists—doubtlessly infuriating her competitors, nearly all older and male. She manufactured opportunities to be in the news. In October 1928, she held an exhibit

called "Americans in Paris," to show her artists' original and exciting creations—which were still by American citizens—even if they were made within walking distance of the Dôme. The show received a flurry of write-ups. An article in the *Chicago Post*, headlined "Current American Paintings Salable," quoted but one dealer: Edith. "'The result,' says Mrs. Samuel Halpert, the very wide-awake operator of New York's little Downtown Gallery, 'is that we are coming more and more to depend on the American market and American artists. Our youngsters over here are doing just as good things as the young artists of Paris. More and more picture buyers are realizing this, and more and more eagerly are they scanning American shows to grab off the best of the new pictures as they are produced."

The Downtown Gallery had achieved a reputation among the converted and the cognoscenti, but Edith wanted to pull in new American art pilgrims. She desperately wanted to tell the rest of the folks—those millions outside the inside set—that Paris didn't have some sort of monopoly on art making. She could continue to thrust her innovative shows on Village audiences for years and years, but what she really needed was a bigger platform—a major show featuring the best in contemporary American art. There were, however, some serious obstacles. Other dealers tended to be protective of their clients and artists, competitive, and generally not team-spirited. Each gallery was run like a fiefdom, and sharing customers—and the limelight—didn't come naturally.

Still, Edith realized that a large exhibition might be a way to call attention to American art. It had been effective before. Certainly the 1913 Armory Show was successful in promoting modern art, even if it failed to ignite interest in the home-grown examples. In 1917, another artist-organized group, the Society for Independent Artists, came together in opposition to the academic art societies. Those older societies used an antiquated jury system to exclude artists working in more progressive styles from their exhibits, or if they did allow such

work, they displayed it in the least appealing spots. This system left the younger artists with crushed egos, and it wasted valuable time and money. As a result, those excluded adopted a mantra, "no jury, no prizes," and held monster exhibits at the Grand Central Palace, stocking the place with an overwhelming 2,500 artworks by 1,200 artists. Five year later, Salons of America offered another twist on the no jury–no prizes strategy, mounting regular exhibits by members in exchange for an $8 fee that paid for gallery rental, advertising, and attendants' fees.

These events were organized by the artists themselves. Edith realized she could use her flair and business savvy to improve on their efforts. One day, such an opportunity appeared. Louis E. Stern, a businessman and art collector and head of the fledgling Atlantic City Art Association, came to Edith with a proposal. Atlantic City had recently constructed a massive new beachside convention hall, including an auditorium with the world's largest stage, a 5,000-seat ballroom, twenty conference rooms, two bathhouses, and the world's largest pipe organ and switchboard. Stern had convinced the mayor that art exhibitions might bring a little class to the enterprise. He asked Edith to organize a show.

Edith was ready to seize any opportunity to draw attention to her ever-neglected contemporary American artists and to expand her domain beyond 13th Street. She accepted the assignment for a $1,000 fee. Edith enlisted Holger Cahill to help her select the art and write an introduction to the show program, which would expound nationalistic themes. "American art has definitely arrived," wrote Cahill. "Heretofore our artists and collectors have looked to Europe as the center of world art, but today there are signs that the center is shifting westward."

Other American art dealers grumbled that the show would be just another gimmick for the pushy Edith Halpert to promote her artists, but Edith tried to counter that perception—which did have more than a grain of truth, of course—taking great care to solicit artworks from other galleries. Lenders to the show included Edith's regular crowd,

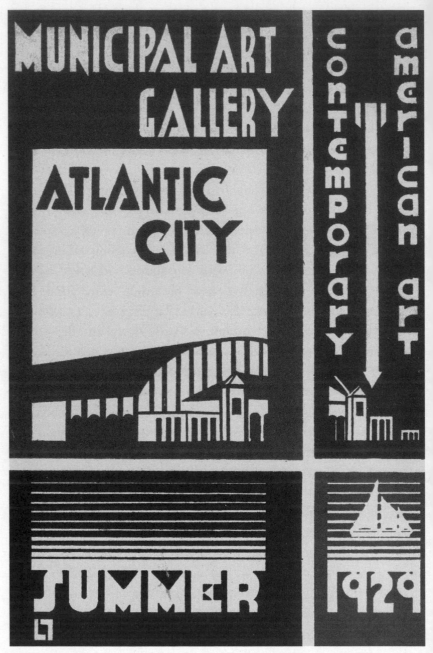

Catalog Cover for Edith's ground-breaking Municipal Art Show,
Atlantic City, New Jersey, 1929.

Mrs. Rockefeller, and B. D. Saklatwalla as well as Duncan Phillips, Frank Crowninshield, *New York Sun* art critic Henry McBride, and sculptor Robert Laurent. She also borrowed from the Newark Museum and from dealers and galleries, including Daniel Gallery, Antoinette Kraushaar, Robert Macbeth, J. B. Neumann, Frank Rehn, Alfred Stieglitz, Marie Sterner, and Erhard Weyhe. "You will see that this answers completely once and for all—any hint of criticism that this is a Downtown Gallery exhibit," Edith wrote Stern.

Edith and Cahill selected some seventy artworks representing the very best of American art of the moment. Artists included Max Weber, Leon Kroll, Yasuo Kuniyoshi, Charles Sheeler, Georgia O'Keeffe, Marsden Hartley, Edward Hopper, Charles Burchfield, and Stuart Davis.

With the show just a couple of weeks away, Edith was overworked and temperamental. Her diplomatic skills had vanished. "I have been put to a great deal of trouble and annoyance in collecting these works from rival galleries, and I am afraid that you have little, if any, realization of just how much time, [and] effort this exhibition has cost me," she told Stern.

Trust didn't come easily to Edith, and when she got worried, she became overly defensive. "I feel terribly hurt at the tone of it [your letter]," Stern wrote back. "So far as I can see it serves no useful purpose. . . . I fully realize the value of your services and I have considered it a piece of good luck to have you become associated with this exhibition. . . . I shall give your letter the most charitable construction and that is, that you have worked too hard and lost your temper."

If Edith was needlessly severe with Mr. Stern, the extent of her work on the show was no exaggeration. Her involvement went far beyond selecting and installing the show. She was responsible for every aspect of the event, from assembling an honorary committee of influential art people to give the show credibility and panache (the list included Frank Crowninshield, Duncan Phillips, and Preston Harrison), to printing catalogs and generating publicity. In her usual

fashion, she wrote up press releases, and soon articles about the upcoming "Boardwalk Luxembourg" (after the Parisian Musée du Luxembourg, which showed nineteenth-century progressive French art) peppered papers from Massachusetts to Missouri, mostly echoing the lively language in Edith's own publicity materials.

Edith also created a radical design for the show, a sleek modern interior to match the modern art. She hired a progressive young designer named Donald Deskey, whose line of furniture with tubular steel frames was inspired by Marcel Breuer and the Bauhaus but manufactured in Grand Rapids, Michigan. Deskey's sinuous steel chairs would become emblems of modernity by the following year. Edith was avant-garde down to the last detail: she tracked down an experimental "x-ray light," which simulated daylight, and constructed gray modular partitions to hang paintings and divide the cavernous space into discrete areas.

In some cases, the décor got as much notice as the art. Deskey's outrageous tubular steel furnishings puzzled *New York Times* critic

Interior of the Municipal Art Galleries.

Edward Alden Jewell: "The chairs look a little like the letter U lying on its side. There are no legs, but instead there is just one pipe of metal on each side, running along the floor and curving up to form the front. . . . They are comfortable, but whether they are really beautiful as chairs is a question. Painted a pale green, this metal furniture somehow reminds one of a hospital."

Jewell didn't love the chairs, but he declared the overall effect of the gallery a grand success, noting "much thought has gone into the enterprise and art might search far without finding a more congenial setting." Indeed, a year later, in a *New York Times* article about the current vogue for mixing modern décor and artworks, the Atlantic City show was credited as the forerunner: "The Municipal Art Galleries of Atlantic City pioneered in this worthy combination of furniture and paintings in their exhibition last Summer, metal furniture by Donald Deskey serving as a foil for paintings on the wall."

Edith invited a group of artists and critics to attend the show for free. Using lessons she had learned in business, she made the trip to Atlantic City as easy as possible so her chosen guests simply couldn't say no. Just as she always included a self-addressed and stamped postcard in her correspondence, she thought of everything. Buses transported artists and critics to Atlantic City, where they were given free hotel accommodations and a banquet dinner. "I must tell you again how much I enjoyed my visit to Atlantic City," painter Max Weber told Edith. "Meeting the nice people and seeing the exhibition, which is a great credit to you. Men of many years' experience and discernment could not possibly have done better."

The exhibit solidified Edith's position as a leader among American art dealers and as an organizational wunderkind, able to unite all the competing dealers under one mission and one roof.

Edith readied for her annual summer trip to Europe, where she planned to travel with her sister Sonia. Cahill went to New Mexico to visit his daughter. Meanwhile, Sam Halpert decided to spend his

summer holiday in Ogunquit, where he could paint and spend time with his old friends. It was clear that Sam and Edith's marriage was not to be salvaged. At the start of 1929, Edith had asked Sam for a divorce, but he wouldn't agree, and Edith wasn't shy about sharing her plight with their circle of friends. But although Edith's version of the story cast Sam as the disgruntled lover, he defended his position and said he was ready to divorce but legally could not. He needed to wait until the fall to file on grounds of desertion, the strategy recommended by his attorney. Though divorce wasn't social suicide in the bohemian Village, in most of the country it was very uncommon. From the 1900s to 1920s, just eight of every 1,000 marriages ended in divorce.

Sam expressed his concern to his close friend Max Weber that Edith was misrepresenting his feelings to their friends, making him out to be a possessive husband, unwilling to let go. "Edith knows very well that I am willing to grant her a divorce," Sam wrote Weber on February 3, 1929.

> The fact that Edith withheld this information from you makes me think that she wants others and herself to feel that she is a martyr to a cruel husband who doesn't want to let her free. The fact is I'm no less anxious to be free myself. Time heals everything and miracles do happen—I can be happy without Edith. . . .
>
> Since she wishes no alimony both our interests will be well protected. And also since she doesn't intend to remarry—at least not so soon—then she won't mind waiting.

Sam hoped that after the matter of their divorce was settled, they could become friends. "After that [the divorce] Edith and I can be friends, and as she wrote me in a note 'mutual admirers.' I have nothing against her and believe I will like her much better when she will be my wife no longer."

Edith sailed for Bremen and toured German cities in quick succession, including Berlin, Dessau, Leipzig, Dresden, and Carlsbad, where Sonia took a rest cure at a spa. Sonia, like Edith, was recovering from a failed first marriage. Now a mother of a son and a daughter—Howard and Nathaly—Sonia would divorce Maurice Chase the following year, in 1930, and marry Dr. Michael Watter, a wealthy businessman from Philadelphia.

Sonia tried to persuade Edith to remain at the spa, hoping for some company, but Edith had no desire to spend her holiday resting. She had planned a busy itinerary. "I have been having an art feast daily," she wrote Mrs. Rockefeller. "I have been traveling like a chorus girl on one-night stands," she wrote to Preston Harrison, using a bit more color than in her report to Mrs. Rockefeller.

She kept in contact with her clients, writing Saklatwalla from Paris, "August is rather dull from an art standpoint. All the galleries where life exists are closed and one naturally sees only the head liners exhibited. Blue Picassos, Cubistic Picassos, brown Derains, yellow Derains, and so on down the line, as you wish." Edith remained a booster of all things American. She observed to Zorach, who whiled away the summer chipping his rocks in Maine, that Europe appeared to be under the American influence. "Everywhere, the spirit of the U.S.A. prevails. There is no native music, even in the small Czech villages. 'I Can't Give You Anything But Love, Baby,' is the national anthem in each country. Women have their hair bobbed, and wash silk undies with Lux, gargle with Lavoris, and sip Chocolate Sodas." The question was, when would American art arrive?

While Edith's reputation and fortune continued to rise, Sam did not find the same success. His paintings weren't selling, and he had trouble being optimistic when so much was going wrong all around him. Though he was well regarded in Detroit, president of the local Society of Independent Artists, he was unhappy much of the time. "As for

myself," he wrote to painter Leon Kroll in January 1930, "I'm plunging along with spirits more often low than high." Although Sam was a kindly man, he couldn't help but have resentment over Edith's meteoric rise in fame and fortune. While he was exiled in the Midwest, Edith was in the heart of the art world, making a name with the biggest artists and collectors. The only casualty of the venture appeared to be their marriage. In a letter to his friend Max Weber, he caustically referred to Edith as "Lady Duveen" and admitted his marriage had changed him for the worse. "If Leon [Kroll] thinks I was a 'nice fellow' before I married Edith, he may discover that I again changed into a nice fellow after I am unmarried from Edith." Despite the tension, Edith continued her efforts to promote Sam's work, mounting a one-man show for him in 1928. In early 1930 she delivered the good news that she had convinced the Albright Art Gallery (now the Albright-Knox Art Gallery) to give Sam a one-man show later that spring. She urged him to ship her more canvases.

Sam was in no position to paint. "I am writing you this note sick in bed," Sam replied on March 25. "Have been laid up with the 'flu' and an acute earache that had to be lanced, so you can see I'm not feeling so strong." Sam had been unable to paint for over a month. Doctors' bills had used up most of his teaching wages from the Detroit Society for Arts and Crafts. He also noted that he had stopped receiving payments on paintings Edith had sold to her ex-brother-in-law, Maurice Chase. "I'm sorry you weren't able to buy yourself a new coat however that old one was very becoming to you. And also look at all the glory you have now as an important art dealer." He signed off, "your old friend, Sam."

At the end of March, Edith and Sam's divorce was granted, and their connection was legally severed. Within days Edith was suddenly summoned to Detroit, where Sam was a patient at Harper Hospital. His inner ear was badly infected, and the infection had spread. On Saturday, April 5, forty-five-year-old Sam Halpert died. The death certificate described the cause as "streptococci meningitis; contributing: acute otitia media." This diagnosis suggested that all Sam's

headaches and head ringing and pain might not have been rooted in psychological difficulties after all but a rotting inner ear.

The following week, Edith received a letter from the lawyer who had granted their divorce. He told Edith that Sam had visited his office in February. "I could see at once that Halpert was both in despair and in love," the lawyer wrote Edith on April 9, 1930. "He never spoke an unkind word of you. The one fault, that you did not love him, was one for which he often said he could not blame you."

Given the tragic timing of Sam's demise, coming just a week after their divorce was finalized, the lawyer sought to ease Edith's mind. "I think I make no mistake in assuming that the divorce which I provided is not very significant. I simply feel that I must regard you as he did—his wife." Edith Gregor Halpert, divorcée and widow, retained the Halpert name for the next forty years of her life.

Even before Sam's death, his family blamed Edith for much of Sam's unhappiness. She was rumored to have been unfaithful to the most famous member of the Halpert clan, an artist respected from Paris to Detroit, described as "a nationally known painter," and "an especially gifted teacher" in his *Detroit News* obituary. From their perspective, Edith had shirked her duties as a wife and had abandoned their kind and gentle Sam. She had used Sam for his art world contacts and then moved on when he wasn't useful to her any longer.

The Halpert family were not only furious with Edith but determined to strip her of any connection to Sam's only legacy, the paintings he had left behind. The family lawyer demanded an accounting of the Halpert paintings in Edith's possession (thirty-one paintings and eleven lithographs). They consulted Edmund Gurry, head of the Society of Arts and Crafts. "I made it very clear to the lawyer that they would be doing a great injustice to the memory of Halpert, and it might endanger the value of his paintings to in any way slight or embarrass you," Gurry wrote Edith, ". . . as you were a person of recognized opinions when it came to presenting the work of American painters and I felt that whatever personal animosity the family might have towards you would be most unwise."

The family did not heed Gurry's advice. Benjamin and Irving Halpert, two of Sam's brothers, arrived at the Downtown Gallery with no intention of negotiating. The brothers, who worked for the mobster Dutch Goldberg, showed Edith their guns and announced that the family would be taking charge of Sam's estate. Edith, usually a stoic and thick-skinned person, was terribly shaken.

Despite all this, she had already been considering ways to honor Sam. She had offered to pay for an annual scholarship at the Society for Arts and Crafts in Detroit, where Sam had taught. In April 1931, she helped organize a memorial exhibition of thirty-one Halpert paintings at the Albright Art Gallery in Buffalo. It was the show Edith had originally suggested to Sam, refashioned as a retrospective. The introduction described Sam as an "outstanding younger man of special promise."

That was the last Halpert show Edith worked on. The Halperts withdrew Sam's estate from the Downtown Gallery and turned over representation to the Milch Gallery. Benjamin Halpert locked the rest of Sam's paintings away in a warehouse, where they remained until the 1960s when the estate was sold to another dealer. Today, Sam Halpert's paintings occasionally hang in the American galleries at major institutions such as the Brooklyn Museum of Art and the Metropolitan Museum of Art. The paintings, filled with Sam's quiet scenes of Paris and New York and images of Edith-like figures, acting out the part of the dutiful and domesticated wife, reveal Sam's vision of a world that haunted his easel but not his life. Edith was unable to be a traditional nurturing wife—she was a modern working woman, decades ahead of her time.

7

Packaging the Primitives

THE STOCK MARKET crash of October 1929 had an immediate and crushing affect on most American businesses, but Edith was determined not to let it intimidate her. She even found a way to use the Depression as a sales angle. "You do not have to worry about payments on these pictures," Edith wrote Los Angeles collector Preston Harrison, about several paintings she was recommending from her summer exhibit of works priced $100 and less. "This is really an 'after the crash' show and it was planned to tempt those who were not in a position to go in for any heavy purchases at this time."

Her efforts were unsuccessful. Like his contemporaries, Harrison was not in the mood to spend his shrinking fortune. "The truth of the matter is that I have no funds available, and what is worse unless conditions improve quite soon," he wrote, "I will be about the cheapest imitation of an art collector in the United States."

At least Edith had her annual European summer pilgrimage to look forward to. As was the custom, the Downtown Gallery would close for the months of July and August, when art collectors and artists fled the city for cooler climates. The only thing that dimmed

her excitement over the trip was the fact that Eddie would stay behind, convalescing. He was beset with digestive troubles and would be admitted to a hospital over the summer. But Edith knew she had to get away, and that meant Europe. She asked Esther Coons to join her instead. Esther had accompanied Edith on earlier visits and was an old pal from art student days. Though they shared a passion for art, they had different notions about how to while away a holiday. They stayed at the Palace Hotel in Paris, where Edith visited art collectors, galleries, and museums, while Esther remained in bed nursing a hangover. They went to the theater, to Café Select, and out for dinner, but Edith avoided alcohol. She had had several appendix attacks, and a French doctor had forbidden drinking.

Edith also had work to do. At Mrs. Rockefeller's request, she was searching for "première classe" paintings by French artists Pierre Bonnard and George Rouault. A dealer offered her a collection Edith thought Mrs. Rockefeller might consider buying, paintings considerably more expensive than the American prints and drawings by Downtown Gallery artists. These "great bargains," as Edith described them in her letter, included a $5,000 painting by Toulouse-Lautrec and an $18,500 Renoir. "I cannot find appropriate adjectives, and if you think that I have been affected by the French atmosphere or salesmanship, it is not so in connection with these paintings," she wrote Mrs. Rockefeller. "I am rather familiar with the tactics in Paris, and was very suspicious of the good fortune." Edith mailed photos of the paintings and suggested Mrs. Rockefeller cable payment if she was interested. The seller was only making these works available because of the sorry state of the French "bourse," and Edith had been given just a two-week option for the purchase.

Mrs. Rockefeller, like Preston Harrison, was not in a mood to spend. With the spiking unemployment rate and shantytowns springing up around New York, there was something unseemly about dropping money on art. Unmoved by Edith's urgent plea, Mrs. Rockefeller wrote back that she already owned similar works and was making a sincere effort to stay within her budget. "The fact is I am trying very

hard not to run over my appropriation for this year any more than I already have done for I don't want to get in the habit of borrowing," she wrote. "I do not think it is wise and it involves so much thought and trouble."

Mrs. Rockefeller's financial prudence cost Edith some big sales. The American stock crash had hurt the European art market, causing a sudden withdrawal of American buyers. Suddenly French dealers were willing to accept slower payment and paid more attention to the young American dealer, offering her important pieces to broker. "I have seen millions of pictures," she wrote Eddie, "and have been cabling the hard boiled customers to buy, buy, buy." Unfortunately, Edith's clients were suddenly unwilling to be tempted, even those so rich that they were insulated from the Depression.

Edith borrowed a typewriter from the hotel so she could type letters to Eddie. She loathed her own messy penmanship. "Don't you think this separation is good for us, dear? I feel so wretched of late because I was in such bad shape myself and could not cater to your nervous condition. I felt mean, nervous and small," she wrote. "The financial worries for the gallery at a critical time, and the general antagonism on all sides—for which I am sufficiently to blame—it was too much for me. The Detroit affair [Sam's death] completely unbalanced me—and then your illness, and so far away, with all my necessary responsibilities. When I looked at myself in the glass on the boat, I was horrified. My hair has turned so grey, and my face looked scared and old."

Eddie evidently wanted a bit more sympathy from Edith. In a later letter, she suggested he get help from a doctor and improve his attitude. "You must not be impatient. Please, dear, do listen to your mamma. And don't think that noone [sic] appreciates what it is to be in physical and mental agony. I am terribly unhappy about you, and your lack of personal strength. You must develop a new philosophy—and don't think that it is easy to make recommendations when one is well," Edith wrote. "I rarely luxuriate in self pity and therefore I don't appear sensitive nor as unhappy as I actually am."

Just as Edith had been the provider in her marriage to Sam, she was already assuming responsibility for Eddie. Eddie considered himself a novelist, not an arts professional; though as time went on, Eddie's writing about the arts, including books and essays written for the Downtown Gallery, was far more skillful and compelling than his forgettable fiction. Edith encouraged Eddie's novel writing, nonetheless, just as she had championed Sam's painting. Even as she struggled with her own business, she was compelled to take care of her 43-year-old lover, and offered to subsidize his creative efforts: "As soon as you feel better, try to get started on your novel," she wrote. "Perhaps something can be managed to make it possible for you to continue writing. . . . I am sure I can manage something for you."

That was optimistic. There were no sales during the summer, and Bee and Edith were unable to draw salaries from the gallery. "No one pays bills, and we are in a terrible state," Edith wrote Eddie on July 5, 1930. Edith was also frustrated with Sam's family as they tried to settle his estate. Sam had died without a will. "If only that damned Lieberman [the Halpert lawyer] would stop writing to me."

Edith returned to New York to spend the month of August preparing for the fall exhibitions. As she plunged back into work, the summer heat and her own frantic pace landed her in the hospital. Within days of her return, she was diagnosed with acute appendicitis and scheduled for an operation. Mrs. Rockefeller, realizing Edith would have no one to care for her after the surgery, arranged for Edith to convalesce at the Rockefeller estate in Pocantico. She and Mr. Rockefeller would be in Maine, but Edith would be able to relax, eat, take warm baths, and struggle to finish reading *Ulysses*—an attempt to impress Eddie.

By September, Edith was back at the gallery, dreaming up ways to increase business. She packaged traveling exhibitions and shipped them off to regional and university museums, sending works to the Berkeley Museum of Art and Princeton Museum, among others, that fall and winter. Edith was a forerunner in packaging traveling exhibitions, something that many museums wouldn't initiate until much

later on. Meanwhile, more and more collectors dropped out of the buying game. "Unfortunately we are in no position to buy anything at present and I am sending back paintings by [Stuart] Davis and [Pop] Hart," wrote Washington, D.C., collector and museum founder Duncan Phillips. "I like both of them well enough to acquire but must be extremely careful just at present."

Even Edith's letter-writing campaigns failed to produce results. She wrote a man in Kentucky who had visited the gallery and expressed interest in the work of a particular artist, Bernard Karfiol, a painter of languorous female nudes who was considered one of America's top talents by 1950 but was later forgotten. "I do not ordinarily go in for writing 'sales letters' but this is such a special cas [sic]—the canvas is a superb example of contemporary painting—that I could not resist writing to you." Karfiol had recently completed a new work that Edith had seen during a visit to the artist's studio, and she offered the "important" painting for $700. She even offered to exchange the work if the collector bought the painting and later decided he preferred another work. Her arguments fell on deaf ears. The client replied that he was out of the picture-buying market.

Despite these setbacks, Edith presented a gay outlook to clients, writing Preston Harrison, "There has been a good deal of activity in New York in spite of the depression, and we are very cheerful. 'You can't hold good art down' is our motto." With close friends, she described an altogether less optimistic atmosphere. Even venerable dealers seemed to be on the verge of bankruptcy. Dudensing, a posh 57th Street gallery that exhibited Matisse and other European artists, seems "to be in financial difficulties and as is for most of the dealers these days, he is supposed to be in a state of bankruptcy," she wrote a dealer friend in Paris. Even the Daniel Gallery—where Charles Daniel had shown Max Weber, Yasuo Kuniyoshi, Charles Sheeler, Sam Halpert, and Man Ray—ran out of money. In the fall of 1930, Daniel painter Preston Dickinson begged Edith for a loan: "Frankly I have got to change dealers," he wrote from Spain. "Daniel has sent me almost no money and I've been worried for well over two months and

now my need is desperate. I need money to return to the States and damn quickly." Weeks later, Dickinson became ill. Penniless, the thirty-nine-year-old painter died of pneumonia. Edith was so alarmed by his sudden demise that she wrote up a proposal for an artists' loan organization that would allow artists to use their artworks as collateral. Edith proposed soliciting funds from people interested in "native art" and asking dealers and artists to contribute 1 percent of their gross sales. She presented her idea to Mrs. Rockefeller, and although nothing came of this plan, Edith did institute a welfare fund for Downtown artists so there would be money available in the case of an emergency. Drastic times called for drastic measures.

As for Charles Daniel, he couldn't sustain his gallery much longer. By 1932 he was unable to pay his rent, and marshals seized his inventory and padlocked the door. His problems directly benefited Edith because a number of Daniel's artists migrated to the Downtown Gallery.

Other galleries struggled to stay solvent. Harry Braxton, a Hollywood dealer to whom Edith regularly consigned prints, filed for bankruptcy. Edith was "shocked" at this misfortune, she wrote the dealer, and "if sympathy means anything, you have plenty of it from me." But what was he going to do about the $956.31 that he owed her, and what about the 124 prints and watercolors she had sent him on consignment?

One day desperation hit even closer to home. Edith's purse was stolen from the gallery. "Occasionally I feel that educating the masses is a very expensive matter," she wrote Harrison about the incident. She was also having difficulty in her role as a landlady. The heating was broken in two of the rear apartments, and she was worried about losing the rental income from a tenant who threatened to leave. The bedroom and bathroom in Edith's own apartment were so cold, she had trouble sleeping.

As a consummate survivor and problem solver, Edith scrambled to find solutions. She urged her wealthy customers to support artists. For instance, she convinced Mrs. Rockefeller to commission a young

discovery, Ben Shahn, to paint a portrait of her favorite horse at Pocantico and to commission Charles Sheeler to draw a landscape of Central Park from the window of her midtown home. Mrs. Rockefeller also supported the gallery with regular purchases from artists who needed the money most (Marsden Hartley, Glenn Coleman, and others), but her most generous act of patronage was commissioning Marguerite Zorach to make a tapestry of the Rockefeller family at their home in Seal Harbor, Maine.

Mrs. Rockefeller invited the Zorachs and their two children to visit her in Maine, where she would discuss the terms of the deal with Marguerite. "We went up and had a very nice visit—went sailing and for a buggy ride and watched a horde of gardeners preserve the wild aspect of Mt. Desert by removing all the undesirable weeds and leaving the desirable weeds," Marguerite reported back to Edith. "Mrs. R. said she wanted to talk business with me and with fear and trembling I sat down." Mrs. Rockefeller quizzed Marguerite on the details of Edith's commission and the price of the tapestry. She never spent her money casually or frivolously and was concerned that Edith's commission would cut into the Zorach's urgently needed funds. Mrs. Rockefeller fundamentally trusted Edith, but she also knew that Edith was a hard-boiled businesswoman out to make a buck. She was both impressed and annoyed by Edith's hard bargaining over the tapestry. Edith had originally priced the tapestry at $15,000, but Mrs. Rockefeller ultimately agreed to a stipend of $500 a month, eventually totaling about $18,000 over three years, a sum that allowed the Zorachs to continue their work as artists and also provided for their two young children. Mrs. Rockefeller told Marguerite that Edith ought to open a print shop on Wall Street, where she could ply her prodigious sales skills on tired businessmen heading home after work.

In April 1931, Edith traveled to Holicong, Pennsylvania, to preview a country auction of furnishings and decorations belonging to Juliana

Force, who in addition to her role at the helm of Gertrude Vanderbilt Whitney's artistic endeavors, which included the newly founded Whitney Museum of American Art, was also known for her superb taste in interior decoration. Force and her husband had bought and restored Barley Sheaf Farm, an eighteenth-century farmhouse and barn, set on 60 acres with a tennis court and swimming pool. Force had always had bigger social aspirations than her income and that of her late doctor husband warranted. Now she needed to divest herself of some items.

In the 1920s, Force's urge to possess had been stoked by the tastes of the artists hanging around the Whitney Studio Club, who admired the early American primitives.

"Portraits by self-taught limners, theorem paintings on velvet copied by schoolgirls, fanciful etchings of historical incidents, vernacular furniture fashioned by a local artisan or whittled by a tramp who happened to be passing through, quilts, whirligigs, cigar-store Indians, hand-carved toys, the odd article of homely whimsy—Juliana had an eye for it all," writes Avis Berman, Force's biographer. "Such things were all around her in the antiques shops and secondhand stores of rural Pennsylvania, and because no one else prized such cast-offs, they were cheap and plentiful."

Force decided to prune her collection with the 1931 auction. Edith didn't attend the auction after her initial preview, but sent Eddie to bid on thirty items for Mrs. Rockefeller's Pocantico home, including two Victorian sofas, a maple desk, and iron lawn furniture. In all, Edith billed Mrs. Rockefeller $925.10 (including a 10 percent commission for Eddie). Earlier in the month, Mrs. Rockefeller had turned down Edith's offer to buy a dramatic portrait of art dealer Joseph Brummer by the self-taught French painter Henri Rousseau—a $35,000 value, Edith claimed, available for just $15,000. But Mrs. Rockefeller wasn't interested. She preferred spending small, and the Force sale was just right. Her purchases included $5 iron door stops, $20 chalk-ware roosters, and a $5 tinsel painting of flowers. "Some

f the paintings you may want to include in your collection of Primitives," Edith wrote Mrs. Rockefeller after the sale, "as they are very ine examples in spite of the very low prices."

That such simple, well-constructed relics of America's past—bjects chosen by the famous Force eye—could be had for so little ignaled an opportunity. Relative to their beauty and historical mportance, as the first generation of indigenous American art, Edith uspected these "primitives," or "crudes," as they were called, were eriously undervalued. When Edith had first opened her gallery, she ised such inexpensive antiques as furnishings and of course also ffered them for sale. She sold a chalk-ware figure of a deer to Mrs. Rockefeller in 1929, an inexpensive piece to adorn a shelf in a guest oom. Edith felt a visceral connection to this art—she didn't love it he same way she loved her modern works—but she thought it had lenty of appeal, and plus, it was cheap.

Edith may also have felt a kinship with the primitive artists who were self-taught geniuses, lacking academy training, and forced to find heir own way using ingenuity and creativity. Edith, whose education had ended with high school, was the consummate self-taught dealer.

Edith's interest in the primitives was also linked to her relationship with Eddie. Eddie's enthusiasm for early Americana stemmed from his years at the Newark Museum, under the stewardship of museum director John Cotton Dana, who took a democratic and unorthodox approach to his exhibits, showcasing wallpaper and other lowly materials with high design. After Dana died in 1929, Eddie quit the museum but continued his association with it, proposing and helping to organize a show of American primitive paintings. Eddie worked with two other Newark employees—Elinor Robinson Bradshaw and Katherine Coffey—in assembling eighty-one portraits, landscapes, and decorative pictures for the show. He sourced more than half of the paintings from artists connected to the Downtown Gallery, including Alexander Brook, Elie Nadelman, William Zorach, Wood Gaylor, Stefan Hirsch, and Robert Laurent.

Edith pitched in, lending a floral watercolor, which she then donated to the museum.

"The Newark Museum is showing these paintings not because they are quaint or curious," wrote museum director Beatrice Winser in the catalog foreword. "But because they are interesting documents of the history of American folk art, and have a genuine esthetic feeling." Eddie's introduction explained: "The peculiar charm of their work results sometimes from what would be technical inadequacies from the academic point of view, distortion, curiously personal perspective, and what not. But they were not simple artists who lacked training. The work for the best of them has a directness, a unity, and a power which one does not always find [in] the works of the standard masters."

Publicity materials claimed the Newark show was the first major exhibition of American primitive painting. That claim was debatable because a month before the Newark Show, an exhibit of primitives had opened in Cambridge, Massachusetts, featuring more than 100 paintings. The exhibit was organized by the Harvard Society for Contemporary Art, run by several precocious students, including Lincoln Kirstein and Edward M. M. Warburg. The pamphlet accompanying the show stated concisely: "By folk art we mean art, which springing from the common people is in essence unacademic, unrelated to established schools, and generally speaking, anonymous."

Edith was aware of early instances of folk art collecting beyond that done by her artists, Hamilton Easter Field, and Juliana Force. She had visited a museum founded by Polish-born sculptor Elie Nadelman and his wealthy wife, Viola Speiss Flannery. During a six-year buying spree, fueled with Flannery's wealth, the couple had spent about $500,000 to acquire 15,000 examples of European and American folk art. At the time, in the early 1920s, there was hardly any competition. In 1926, the Nadelmans installed their collection at their Riverdale, New York, estate and opened a private museum, the Museum of Folk and Peasant Arts.

Edith's interest in folk art was also primed by two shows at the Whitney Studio Club, held in 1924 and 1927, which were much smaller than the Newark Museum exhibit. The 1924 show, titled "Early American Art," included folk art objects owned by artists, many of whom would join the Downtown Gallery fold just a few years later, including Dorothy Varian, Alexander Brook, Charles Sheeler, and Yasuo Kuniyoshi, who lent a carved cow—and whose paintings often featured cows. Three years later, "Early American Painting" presented works owned by a noted Boston collector, Isabel Carleton Wilde.

These were among the few early bursts of interest in eighteenth- and nineteenth-century American art and objects by unschooled artists. Edith never claimed to have discovered folk art or to have named it. That distinction reputedly goes to the Nadelmans, in naming their "Folk Art" museum. But before Edith came along this so-called folk art lay neglected, gathering dust all over the country and in barns, antique shops, and attics up and down the East Coast. If Edith didn't invent folk art, she certainly helped invent the market for it. Art historian Diane Tepfer credited Edith as the lone dealer who handled both modern art and folk art, as well as the first to promote the sale of folk art, packaged as a distinct entity, not jumbled in with other American antiques. "They didn't even show folk art in antiques shops, you know, as art," Edith later recalled. "The only difference between all these people and me was that I made a business out of it."

Along with Eddie's interest and expertise—and with his information about where to find examples of folk art—the main impetus to collect was Mrs. Rockefeller's desire to buy. In June 1931, Mrs. Rockefeller began buying folk art at a tremendous pace. The Downtown Gallery ledgers and Mrs. Rockefeller's own art-buying records reveal she purchased carved wooden figureheads from sailing ships, weathervanes shaped like animals and jockeys, dozens of still life paintings on velvet, oil painting portraits of dour early Americans captured by the fresh hand of itinerant artists, mourning pictures, and Pennsylvania Dutch *frakturs* (colorful marriage, birth, and bap-

tism certificates). In 1930, Mrs. Rockefeller's purchases from the Downtown Gallery, mostly modern art in the form of prints and works on paper, tallied $28,919 out of her overall $160,000 art budget. By 1931, her spending with Edith nearly doubled, with Rockefeller sales totaling $54,404. Folk art made the difference.

By 1931 Edith had been shaping Mrs. Rockefeller's taste for close to four years. And so when she began promoting folk art, Mrs. Rockefeller listened. She was already primed to like it. "She was a child of the Colonial Revival in New England," wrote Bernice Kert. "No Americans were more eager to collect old furniture and bric-a-brac than the educated elite of Boston and Providence at the turn of the century." Kert also believed the commonplace aspect of the folk art objects—things made for the common person—appealed to Mrs. Rockefeller's populist instincts. Around the same time Mrs. Rockefeller was buying folk art, she was giving money to such varied causes as the Young Woman's Christian Association, the Harlem Sewing Room, and even—at Edith's urging—Margaret Sanger's American Birth Control League.

Mrs. Rockefeller's interest in folk art also dovetailed with her husband's involvement with the transformation of an entire town in Virginia. In 1927, when John D. Rockefeller, Jr. set out to return Williamsburg to a simulacrum of its colonial appearance, it was the most ambitious restoration project ever to have been attempted in the country. Eight years later, sixty-six buildings were restored, and eighty-four were reconstructed on their colonial foundations. Four hundred and forty homes of later vintages were torn down. Plantings, fences, walkways, lampposts, street surfaces, and all conceivable details were returned to their former eighteenth-century glory when Williamsburg was a thriving seat of colonial power. The project cost an estimated $60 million. "As John devoted more and more of his time to the restoration, Abby began to direct his attention to this other aspect of American cultural life that was worth preserving," said Kert. "Folk art with its historical context could appeal to him in a way that modern art did not."

Gambling that folk art might subsidize her contemporary art business, Edith devoted the summer of 1931 to stocking up on inventory. Her timing was perfect. With the Depression, antiques dealers were eager to convert peeling decoys, awkward paintings by unskilled artists, and rusty weathervanes into cash. Edith decided to go on a shopping spree. Buying these old relics required driving into the rural countryside, and she needed a motorcar to transport her unearthed bounty. She chose a Hupmobile, a low-slung limousine with a thick wooden steering wheel, whitewall tires, and just a couple of metal switches on the dashboard. Although the carmaker had designed the Hupmobile for the style-conscious flapper, Edith had less leisurely pursuits in mind. She dubbed the car the Silver Bullet, in honor of its sleek metallic sheen. Since there would be no leisurely touring at the hand of a chauffeur, she ripped out the red leather back seat and laid corrugated cardboard on the floors, making a padded spot for her primitive finds.

Edith traveled along dirt roads and routes so rural that no map could be her guide. She drove up hills that no one had ever taken a car up before, places like Efrata, Pennsylvania, and Portsmouth, New Hampshire. She assumed a new identity for these trips, leaving her stylish suits and racy persona back in New York City. To chase down folk art, she transformed herself into a helpless, frumpy matron, favoring cotton dresses with long sleeves. At the sight of an old barn, she employed her "usual gambit," knocking on the door and asking politely for a glass of water, all the while hoping for an invitation inside. "I was all alone and didn't have a husband and it would just break their hearts," Edith said.

On one trip through Vermont, Edith drove past a barn crowned with a giant deer weathervane. She had scooped up cow weathervanes all day, but that was the first deer she had ever seen. She hopped out of the Hupmobile and marched over to a farmer, who was out in the field. "Do you raise deer?" she asked sweetly. The farmer looked up puzzled. "What?" he asked. He only raised cows. Edith offered to trade the farmer a cow weathervane—she happened

to have one in the backseat—for the deer. For his trouble, Edith offered to throw in an extra $25. The farmer said sure, but it was up to Edith to get the deer off the roof. She changed into pants, grabbed a ladder, and tried to climb onto the roof. The pitched slope was too steep. Edith told the farmer she'd be back. She raced down the road, back to a firehouse she had passed. The firemen were eager to help the pretty young woman in the silver car. Using their long ladders, they rescued Edith's deer, which went back to New York and ultimately found a home in Mrs. Rockefeller's folk art collection.

Edith was working hard to keep her most lucrative client loyal. During her treasure-hunting trips of 1931, she reported back frequently to Mrs. Rockefeller, who was summering at her 100–room Tudor–style oceanfront cottage in Seal Harbor. "On the Pennsylvania trip I found some very interesting things, including two weathervanes, one of an Indian with an arrow; another of an Indian hunter with a dog—both silhouette." In addition to recounting the highlights of her trip, Edith made an effort to protect her best customer from the clutches of competing sellers. She suggested Mrs. Rockefeller pass on "a wild west carving" and "painting signed 'Bronco Charlie'" which Mrs. Rockefeller was thinking about buying from a competitor. Greed wasn't Edith's only motivation. She hoped to help her client to avoid second–rate goods. "I feel it would be advisable to let that go, as the price seems entirely out of proportion." Edith wrote. "We can probably get it at a reduction of $50, or for $350. Aside from its uniqueness, it has insufficient quality to warrant such a high price. My suggestion is to turn it down. There are much finer things to be had for that sum of money and if you are not interested in having curiosities as such, the price is exorbitant." Without a doubt, Edith was especially suspect of any material Mrs. Rockefeller was offered by a dealer other than Edith. She was territorial and protective: the Rockefeller matriarch kept the gallery alive. There was nothing to be gained by sharing her best client with others.

Edith often dispatched Eddie Cahill on these early scouting trips. Much of what he found on his travels was pure junk. "There's a lot

of childish, amateurship stuff, and just things that weren't worth anything at all, from any point of view," he later recalled. "I went through hundreds of antiques shops. They were apt to be dusty places and sometimes I'd come out of them black as a fireman without buying a thing."

Finding folk art didn't always require travel. There were overlooked objects at galleries and antique shops all over New York City. Word spread that the Downtown Gallery was willing to buy good examples of primitive painting. Edith negotiated with 57th Street American antiques dealer Irving Lyon for a discount on the $580 the gallery wanted for a group of eight assorted weathervanes and watercolors. "Will you please go over these figures and give me a net price on the entire group. Please bear in mind that we have to resell these and with the market such as it is at the present, we must have a considerable reduction." When negotiating to buy folk art, Edith certainly kept quiet about the fact that her main buyer was hardly affected by the hard times. The next day, the gallery came down to $480 on the group, "and the only reason for doing this is present conditions." Edith accepted.

There was some urgency to these early sweeps. Edith feared that once word got out about Mrs. Rockefeller's collection, there would be competition from other collectors and dealers. Eddie had written an article about American folk art for *American Mercury*, an academic art magazine, that was slated to run in the fall. Edith was convinced it would be harder to find good deals once the article was published and news about the importance of folk art reached the cultured masses. When Edith learned that the article was slated to run two months earlier than planned, she warned Mrs. Rockefeller about potential implications. "It is unfortunate that this material should be made as public as early as this. On the other hand, the antique dealers do not read the high-brow *Mercury* and furthermore, we have covered so much territory and have cleaned it up so thoroughly that there is not much to worry about." At this stage, when folk art collecting was still in its infancy and Edith and Eddie were teaching

themselves as they went, the lack of expertise worked to their advantage. "It is interesting to see how confused the antiques dealers are regarding the type of material which we are acquiring. There are so many thousands of bad pictures and sculpture that it requires a definite type of discrimination to select the good things," she wrote Mrs. Rockefeller, "which only contact with fine works of art can give."

Part of the reason Mrs. Rockefeller seemed to be snapping up everything in sight was that she had decided to loan the collection to her husband's restoration project in Williamsburg. Over the summer of 1931, Edith traveled to Virginia and met with the people in charge of Williamsburg's interior design and renovations. A committee of American furniture experts had been hired to assemble furnishings appropriate to the period and architecture, but it was clear that Mrs. Rockefeller hoped to have her folk art included as well. Sourcing the period furniture didn't hold much appeal for Mrs. Rockefeller, who, like Edith, was much more interested in the visual qualities of the folk art. "But as for myself," she wrote Edith on July 18, 1931, "I am only interested in furniture that has beauty and charm. The historical side of it doesn't appeal to me much. If I have got to live with a thing, I would like to have it good looking."

By August, the folk art business was proving quite lucrative. Edith's meticulous bookkeeping revealed that by August 1931, she had sold more than $11,000 worth of primitive art to Mrs. Rockefeller. Expenses were low. Aside from the cheap goods—most things cost under $50—there were the expenses for travel, the car, and restoration of the folk art and framing. The rest of the overhead was absorbed in the expenses of the Downtown Gallery. The healthy profits from sales of folk art indicated to Edith that the business was ready to be made into a formal venture. She anticipated finding other buyers besides Mrs. Rockefeller and perhaps using folk art to lure collectors for the modern art.

On October 10, 1931, Edith and Bee met at their lawyer's office to sign papers establishing the American Folk Art Gallery. Edith was made president, treasurer, and majority shareholder with thirty-three

shares, and Bee was vice president with seventeen shares. The following year Eddie received fifty shares. The company was organized so most overhead costs would be absorbed by the Downtown Gallery (rent, utilities, advertising) and covered by a 33 percent commission on all folk art sales paid to the Downtown Gallery—something that later irked Eddie when he felt his profits were not as high as he deserved. Each of them also drew a weekly salary: Eddie took $80 a week, Edith $70, and Bee $30.

Edith mailed a detailed three-page press release to her journalist contacts announcing the new gallery, located on the second floor of 113 West 13th Street—where Bee had formerly lived—and open by appointment. Notices appeared in the *Evening Post, Art Digest,* and *Time* magazine.

Edith continued gathering inventory by cultivating another top source, Boston collector Isabel Carleton Wilde, from whom she continued to buy works. Edith knew how to turn on the charm when she wanted to, writing Mrs. Wilde, "It is such a treat to be able to find so many consistently fine examples and I must congratulate you for your remarkable discrimination."

She also tried to find new buyers for folk art, especially reaching out to those who shunned modern art and would therefore never happen on the Downtown Gallery. She tried out her sales pitch on Henry F. duPont, heir to a chemical fortune and a leading collector of all things American, writing him to introduce the gallery and to entice him with such wide-ranging offerings as a locomotive weathervane, Pennsylvania Dutch iron stove plates, and watercolors. "Knowing of your interest in the early American arts, it occurred to me to write you about our collection," she wrote, explaining that though she bought with her eye, while he preferred things of historical importance, he might find things to buy. "Although our method of selection in acquiring the works of art is based entirely on the aesthetic value of the picture or sculpture, we have a good many items which have in addition a historical interest."

Edith formally introduced her new folk art venture with "American

Ancestors: Masterpieces by Little Known and Anonymous American Painters 1790–1890," held December 14–31, 1931, one of the first shows to present folk art in the context of modern art. "American Ancestors does not refer to ancestral portraits but to ancestors of American contemporary painting," Edith wrote in her press release, a notion that was not exactly the case but was wholeheartedly adopted and reiterated in the write-ups. "Our museums realize that many of these paintings are needed to fill in the gap in the history of American art. Collectors find that their appreciation of modern American works is enhanced by a closer study of these early American painters."

Edith promoted her "American Ancestors" to journalists, artists, collectors, and museum curators. "We opened an exhibition which I believe will make history in American art," she boldly announced in sales letters. She labeled the portraits, landscapes, and still life paintings as "masterpieces." Most of the artists were unknown and anonymous and would remain so until later scholarship helped identify them. Until that time, Edith, with Eddie's help, had chosen the works based purely on their visual power and originality. Edith was especially quick to point out the rave reviews from famous artists. "José Clemente Orozco, well known Mexican artist, remarked during his visit that the exhibition room should be turned into a public museum," Edith said. "Fernand Léger was also fascinated by the collection." She was especially pleased to report that the famous French modernist had singled out a painting Peaceable Kingdom, by a nineteenth-century Quaker minister and sign painter, Edward Hicks, calling it "the most thrilling picture he has seen in American art." The painting includes a dozen wide-eyed animals grazing in a bucolic landscape—a composition Hicks reworked dozens of times. Mrs. Rockefeller bought the version in the Ancestors show, and it now belongs to the Abby Aldrich Rockefeller Folk Art Museum at Colonial Williamsburg, where it is considered one of the collection's treasures. When Edith started snapping up paintings by Hicks, she paid around $200 for each one, selling them for around $1,000. Hicks has since become the most expensive of all folk painters. (An 1837 Peace-

able Kingdom sold for $4.7 million at Christie's in New York in 1999.)

Meanwhile, Eddie mounted his folk art sculpture show at the Newark Museum. At least sixty-seven items of the 200 total came from the American Folk Art Gallery—items he and Edith had scooped up as stock—including a bootjack in the shape of the devil, Shimmel eagles, duck decoys, and weathervanes in the form of horses and roosters. The Newark show caught critics' attention as well. "America Discovers a Neglected Folk Art of Its Own" ran the headline in the *New York Times*, though the review focused on the historical, not the artistic, merits of the objects on view. A note at the front of the article set the tone: "Current exhibitions of so-called 'American primitives,' from portraits by country sign painters to ship's figureheads and cigar-store Indians, have elicited the suggestion that America has a 'folk art' which has been unduly neglected. The following article deals with items of that folk art, not as art primarily, but as contributing an added mirror of the 19th century American scene." Clearly, so-called folk art had a way to go before it was accepted as a credible art form unto itself.

Edith also brought folk art to Detroit, shipping weather vanes, velvet paintings, and cigar store Indians for a show in 1932, paid for by one of her loyal clients, Robert Tannahill. Tannahill, whose family owned the J. L. Hudson department store, was also related to the Ford motor car family. Tannahill had no need to work and instead devoted himself to art collecting. A trustee at the Detroit Society of Arts and Crafts and later the Detroit Institute of Arts, he eventually donated more than 850 artworks to the institute. He bought adventurously from Edith—O'Keeffes, Marins, and Sheelers—and also supported her by importing Downtown Gallery artists, encouraging local curators to put on museum exhibits from Edith's roster, and introducing her to other wealthy buyers.

"The exhibition is a great success, judging from the crowd and comment," Tannahill wrote Edith about the folk art show at the Society for Arts and Crafts, that was written up in all the local newspapers. "And we've made a sale, the $450 velvet, which Mrs. Ford bought." Tannahill also offered to lobby Henry Ford to consider folk

art for his historical museum. "Some day I'm going to try again to persuade Dearborn to make a really important folk art collection. There is the ideal place for it and so far they have very little." Henry Ford attended the opening with his son Edsel. Over long lunches at Romany Marie's, Edith bonded with Edsel, despite the views held by his father, who funded an anti-Semitic newspaper, the *Dearborn Independent*. "He was terribly ashamed about his [Henry Ford's] labor fights, the goons and the anti-Semitic publications," said Edith. "It just killed him, but he loved his father. We talked about it frequently, and after a while I was on the verge of becoming anti-labor and anti-Semitic to cheer him up."

That same year, Mrs. Rockefeller helped bring folk art some of the credibility she had conferred to American modern art when she agreed to lend her newly assembled folk art collection of more than 170 objects to the Museum of Modern Art. Board president Conger Goodyear urged her to attach her name to the loan, but Mrs. Rockefeller, who was generally publicity-shy, wasn't sure if that was wise. She consulted her son Nelson. "Mrs. Halpert is opposed to it because she hopes to go on selling me things," wrote Mrs. Rockefeller. "She thinks that the minute it is known I have a collection the price of Early American things will go up. I don't see how it could go up any higher than she puts them. Also I suppose she thinks everyone will offer me pictures." She lent the works anonymously, much to Edith's relief. That way Edith could control who knew the identity of the lender—promoting it quietly when it was to her advantage—but could avoid a torrent of competition if the collection and name of the donor were made public.

The folk art show landed at the Museum of Modern Art mostly because Eddie had agreed to serve as temporary museum director while Alfred H. Barr, Jr. was taking a year's sabbatical to recover from exhaustion. "American Folk Art: Art of the Common Man in America 1790–1900" was virtually ignored by the art critics (and by later MoMA historians). After ending its run at the Modern, it toured for two years to six other museums across the United States,

where it kindled an interest in and respect for vernacular art. To folk art scholars, it is one of the most important milestones in the field. Eddie's essay in the exhibition catalog helped define folk art, while the exhibition established what constituted the best examples in the field. In a discreet though powerful way, the exhibition affirmed Mrs. Rockefeller as the premier folk art collector and Edith as the premier folk art dealer. Now that folk art was no longer an insider's secret, Edith wondered how that might affect her business. Would other dealers jump in and compete? Would the cheap stellar goods scattered along the Eastern seaboard be snapped up by speculators? Edith hoped not. Without the folk art sales, there might not be any Downtown Gallery.

When Edith called folk art her "sugar daddy," it was no exaggeration. Not only did folk art help pay to keep the gallery running, it also provided Edith with funds to buy a summer home. She could see it in her mind: a salt box design with a white picket fence, shaded by trees. She shared this vision with painter Charles Sheeler and his wife, who had a house in Ridgefield, Connecticut, where Edith visited on weekends.

One day in the spring of 1932, Edith received a phone call from the Sheelers, instructing her to hop a taxi for Grand Central and take the train to Danbury, Connecticut. Edith was met at the train station by the Sheelers and a real estate agent. They drove over long rutted dirt roads, past stone walls and dense woods until they reached a small white house with a sloping roof, a white fence, and a magnificent maple by the front gate. Inside the house was painted green and black, and three giant stone hearths—taller than Edith—were hung with copper pots. The décor was atrocious, but Edith knew she could make it her perfect country dacha. She didn't even bother to bargain and made an offer on the spot.

Edith installed indoor plumbing, whitewashed the inside, and stocked the two front rooms with Shaker furniture—which Sheeler had introduced her to—and her favorite duck decoys, velvet pictures, and portraits. She planted white phlox in the garden abutting her 25

Edith's sanctuary: her Newtown, Connecticut, summer home.
View is from the side garden.

acres and pond. She dubbed another room the "Victoriana Room"
and furnished it with a curvaceous turn-of-the-century couch and,
hanging above, a large bare-breasted barroom nude Edith had
bought from Bill's Gay Nineties, a city saloon. She placed an iron
deer outside on the lawn and chose a snake weathervane for the roof,
an appropriate motif for a house on Eden Hill.

For the rest of her life, Edith would retreat to Newtown each
summer, surrounding herself by trees, her folk art collection, and
tranquility. Her dead folk artists weren't nearly so demanding as her
living ones—without all the ego-driven dramas, alcohol-fueled
breakdowns, and mental illnesses that would come to plague more

than a few. Newtown, and folk art, were Edith's security and sanctuary. Her months in the country provided recuperation that she needed to survive the hectic fall and spring. Without that annual respite, in a place where Edith somehow moderated her usual manic pace, and without the steady folk art sales, the gallery might not have survived.

8

The Palace of Virtue

"SOME HAVE VISION, some have courage, but it is rare to find someone who has both vision and courage," Edith wrote to Mrs. Rockefeller. "And you combine these qualities with an understanding and sympathy which make contact an inspiration. American art, American artists, and the American public owe and acknowledge a great debt to you for paving the way for appreciation and encouragement of native art." Edith carefully inscribed her note in the small book, on a page opposite a small Diego Rivera watercolor. The book was a gift to Mrs. Rockefeller for Christmas 1931, orchestrated by her appreciative employees. Other signers included a housekeeper at Pocantico, the seamstress at 10 West 54th Street, Alfred H. Barr, Jr., and the head of the Bayway Community Center in New Jersey, one of many organizations Mrs. Rockefeller supported.

Edith believed what she wrote. Mrs. Rockefeller's loyal and consistent buying had meant that for the first few years of the 1930s, the Downtown Gallery had been immune to the effects of the Depression. Sales had climbed steadily from approximately $43,000 in 1927 to more than double that by 1930. By 1931, Edith felt positively rich.

Sales exceeded $100,000, and her 33 percent commission rose accordingly. Folk art sales tacked on another $12,000.

Just one year later, Edith wasn't feeling nearly so flush. The Depression had finally appeared at the Downtown Gallery doorstep. Art sales plummeted more than 50 percent, and for Edith, who maintained meticulous records and tracked her sales figures regularly, that signaled troubled times ahead. Because folk art sales soared to more than $38,000—again, thanks to Mrs. Rockefeller—the gallery could afford to pay its bills. But without contemporary art sales, Edith's living artists were starting to suffer.

Over the past two years, Edith, her artists, New Yorkers, and Americans had witnessed a total collapse of faith and finance, shocking in the speed with which it quieted the roar of the 1920s. By 1932, the streets offered tableaus of helplessness: a sea of slanted hats on the breadlines and men living in slipshod shacks in Central Park. In automats, Pullman smokers, and labor locals, the talk was the same: maybe the prosperity of the previous decade would never return. In Detroit, unemployed workers marched on the Ford Motor Company's River Rouge Plant. Workers clashed with guards and the police, leaving four dead and dozens injured. In other cities, otherwise law-abiding citizens were driven to raid grocery stores and loot canned fruits, vegetables, and ham. Sixty banks a month went out of business. One of every six New Yorkers was out of work, living on $8 per month in city relief.

Maintaining faith in the face of a devastating case of national insecurity wasn't easy, but it was essential for anyone with a small business to run. Edith was no quitter. She wrangled out of a contract with painter Joseph Pollet—the only artist besides Stuart Davis given a monthly stipend—whose sales had totaled $2,000 less than his advances. Though Edith was also losing money on Davis, she was reluctant to cut him loose. He still had promise. Pollet, however, was a fading fashion and Edith didn't want to be stuck with a storeroom full of his paintings.

Edith didn't have the cash to cover all her obligations. She was

only able to send a partial payment to the Detroit Society for Arts and Crafts for the Samuel Halpert scholarship, which paid tuition for an art student. "I am sorry that I am obliged to pay only part this time," she said. "But I am among those 'financially embarrassed.'"

It was against this backdrop of poverty and desperation that John D. Rockefeller, Jr. decided to embark upon the construction of a massive, futuristic skyscraper city right in the middle of Manhattan. Rockefeller Center would turn out to be the most significant construction project of the decade, transforming five blocks of ragtag tenements into modern world-class office space, a project no less dramatic than Rockefeller's historic overhaul in Williamsburg, Virginia. Rockefeller tore down hundreds of tenements, saloons, speakeasies, and brothels to make way for the massive office and entertainment complex, including what was to be the largest theater in the world. The project provided work for 75,000 unionized construction workers but caused sleepless nights for Rockefeller as the Depression chipped away at his fortune. By 1934, his net worth had shrunk to $500 million—down from a billion in 1929.

Edith wanted in on the extravaganza. Rockefeller Center would be hiring artists to help adorn the new buildings. The center had issued statements reporting that painters from all over the world had been soliciting work and that commissions would go to "outstanding artists." Soon thereafter, an announcement from the fledgling Museum of Modern Art arrived at the Downtown Gallery, soliciting mural paintings for an upcoming exhibition. The letter came from the museum's Advisory Committee, headed by Mrs. Rockefeller's son, twenty-four-year-old Nelson Rockefeller.

The mural show wasn't explicitly linked to Rockefeller Center, but it wasn't hard to imagine the connection. "Mural painting in America has suffered from a lack of opportunity to assert itself," read the exhibition announcement. "At the present time such an exhibition would be particularly valuable for the information of many interested architects in New York who are in search of competent decorators for buildings proposed or in construction." The Museum

of Modern Art exhibit was motivated by the one building project that counted: Rockefeller Center.

Edith had known Nelson since he was a college student visiting his hometown for a little cultural infusion with his mother. Of all the Rockefeller boys, Nelson was most similar to his mother—warm, witty, friendly, and devoted to learning about art and supporting artists. Soon after Nelson became interested in art, he connected with Edith. When Nelson joined Dartmouth College's art club in 1929, Edith suggested to Mrs. Rockefeller that she advise Nelson to contact the Harvard Contemporary Art Society. Edith had loaned artworks and assistance to the young Lincoln Kirstein and his pal Edward M. M. Warburg for their avant-garde productions presented above a Cambridge student bookshop. Edith also offered to suggest speakers for Nelson's club.

Nelson continued his artistic pursuits after college. By 1932, he not only chaired the Advisory Committee at the Museum of Modern Art but was a Trustee at the Metropolitan Museum of Art. He also made regular visits to and purchases from the Downtown Gallery.

The reputations of Edith's artists along with her connections to Nelson and the rest of the Rockefeller family—meant the Downtown Gallery artists were short-listed for the invitational mural exhibition. Stuart Davis, Ben Shahn, and Charles Sheeler were among those invited to submit works. They were each given just two months to conceive and execute a three-paneled sketch of a unified mural idea, based on the theme "post-war life," as well as one large painting.

Although Edith was thrilled that her artists were invited to audition for Rockefeller Center, there was a hitch. Most of the Downtown Gallery artists, and indeed most avant-garde American artists, were unacquainted with the art of mural making as U.S. government patronage for public works was mostly restricted to classically inspired sculpture and academically approved painting. Now they had less than eight weeks to master the genre. Undaunted, Davis stretched a giant piece of canvas and created a Cubist universe,

layered with symbols of the day, including the newly constructed Empire State Building, a brown derby, and a gas pump.

The mural show was a fiasco, despite the fact that it marked the Museum of Modern Art's first exhibit in its new location. On May 3, 1932, MoMA celebrated its move from its first home in a Fifth Avenue office building to a grand limestone mansion at 11 West 53rd Street. Mr. John D. Rockefeller, Jr. was the landlord, and the new building backed onto the Rockefeller mansion on 54th Street. The new location had room for an auditorium, as well as four floors of galleries for temporary and permanent exhibitions. A critic praised the improved "elbow room."

"Murals by American Painters and Photographers," the inaugural exhibition, wasn't as politely received as the new venue. "And, alas, it must be admitted without any polite beating about the bush that much of the mural art this so promising occasion has served to bring forth," wrote the *New York Times*'s Edward Alden Jewell, "is pretty terrible." A reporter from the *Herald Tribune* was equally dismayed, noting, "In sheer, dismal ineptitude the exhibition touches bottom." Of the sixty-five artists in the show, the photo-muralists such as Berenice Abbott were singled out for praise, along with a few painters. None of the Downtown Gallery artists received any encouraging notice, nor did Georgia O'Keeffe, included courtesy of her husband and dealer, Alfred Stieglitz.

Although Edith was accustomed to venom from the conservative critics, who objected to all abstract tendencies in art, it was unusual for her artists to be universally condemned, especially by the normally sympathetic Jewell and *New York Sun*'s Henry McBride. Still, she was not deterred. There were other ways to get in the doors of Rockefeller Center. Edith assumed the architects might need sculptors as well as painters for the interiors of the fourteen new skyscrapers. She compiled a book of photographs by the "five most important sculptors of the more radical field," as she described them: William Zorach, Robert Laurent, John Storrs, Reuben Nakian, and Duncan Ferguson. She mailed the package to Harvey Corbett, one of the chief architects

on the project. Her pitch noted that her artists had done architectural commissions and understood "the time element in expensive real estate ventures." She also played up the connection between the modern sculptor and architect, noting "modern artists depend on the sympathetic understanding of the modern architects."

But all the maneuvering turned out to be unnecessary. More than anything else, Edith's role as Radio City's unofficial art adviser was sealed when the man in charge of interior design turned out to be one of her very own protégés. In June a press release from the Rockefeller Center publicity office reported that Donald Deskey had been hired to create the interiors for the International Music Hall, as Radio City Music Hall was then called. For Edith, it was the best possible news. Deskey owed much of his early success to Edith, including his introduction to the Rockefellers.

Donald Deskey had trained as a painter and architect but veered into design after a visit to the 1925 Exposition Internationale des Arts Décoratifs et Industriels Modernes, where, like Edith, he was enthralled by the new streamlined looks. He returned to New York and launched his career as a designer. His creations were as dapper as Deskey himself, who epitomized Irving Berlin's catchy tune "Puttin' on the Ritz," with his spats, clipped mustache, and hair so slick and flat it shone like patent leather. Deskey's high-profile break came when he began designing windows for Saks and Company (now Saks Fifth Avenue). His dramatic vignettes featured aluminum mannequins and quirky displays of shoes and shirts using raking light, cork, and aluminum panels, industrial materials that had never been used for window display before in America. His remarkably fresh and contemporary eye led to his first home commission, designing a futuristic apartment for Adam Gimbel, Saks's president, with stainless steel hallways, copper ceilings, and cork walls. Deskey also began designing geometric screens and formed a company, Deskey-Vollmer, to make aluminum lamps and other mass-produced furnishings, all inspired by French Art Deco designers but using newfangled materials like Bakelite, Formica, and flexwood.

By March 1929, Edith had met Deskey whose designs were a feature of the "Modern American Design in Metal," an exhibit at the Newark Museum that also included a number of sculptors from the Downtown Gallery, including Reuben Nakian, Duncan Ferguson, Robert Laurent, William Zorach, and Hunt Diederich whose nickel-plated cat, bronze fish, and fire screen were among the dozens of metal designs. Deskey-Vollmer was represented by a console table, a smoking table, metal mirrors, and lamps and chairs. Deskey's radical style appealed to Edith, leading her to hire him a few months later to furnish galleries at the 1929 Municipal Exhibition in Atlantic City.

Later that year, when Edith decided to expand her gallery, she knew she wanted Deskey to be part of her team. Duncan Candler—architect to the Rockefellers and Fords—had offered to design the expansion for free. There was a scraggly backyard behind the 13th Street building, accessible from the rear of the gallery. Soon after the stock market crash, Candler and Deskey dreamed up an addition to the Downtown Gallery: a new backyard building that would double the size of Edith's exhibition space. With a $3,500 budget, they constructed a 20 by 37–foot exhibition and storage space. A soaring ceiling with a glass roof allowed daylight to flood the space, a feature that provided the gallery's name: the Daylight Gallery.

The gallery's novelty started with its exterior. Candler and Deskey settled on an unusual design for the exterior, staggering bricks for a jagged sculptural surface. Edith's artists contributed details: Zorach designed a pair of glass doors trimmed in metal; Reuben Nakian made a stone plaque to hang over the front door; Robert Laurent carved cabinets to store pictures; and Duncan Ferguson designed a panel to frame an interior doorway, with two nude maidens shaded beneath the overhanging branches of a sinuous tree. The gallery floor was laid with pale swathes of blue, green, rust, pink, and brown concrete, designed by Marguerite Zorach.

The gallery walls were covered in a warm gray fabric that allowed the frequent hanging and moving of artworks without damaging the walls. There was a small cubicle office, glazed with one-way speak-

easy glass, so Edith could keep an eye on customers. Deskey designed brown leather swivel chairs so visitors could sit and contemplate all four walls of art. He also designed an all–metal stock room with an innovative system of storage racks that slid on metal. In a corridor just inside the front door, Edith mounted framed photographs of her artists on the magenta wall. The dramatic black-and-white portraits announced to the world that these were her boys and girls and they were stars.

"The management of the Downtown Gallery ... is felicitating itself over the fact that it has the only daylight quarters not only devoted exclusively to contemporary American art but designed and furnished by American artists and architects," wrote the *Herald–Tribune*, one of the many newspaper and magazines that heralded the gallery's arrival. "Unique Backyard Structure Like a New Shrine for Greenwich Village Pilgrims" proclaimed a headline in the *New York World*. Even the *Times*'s Edward Alden Jewell, who had objected to Deskey's furnishings at the Atlantic City Municipal Show, was won over. "Ah, but most gratifying of all are the brown leather swivel armchairs designed by Donald Deskey," wrote Jewell, "for into them you may sink with a luxurious sigh, and by a scarce perceptible effort you may swing yourself round and round, taking in an entire show without further exertion. Hitting upon this type of gallery chair was a sheer stroke of genius."

Around the same time, Mrs. Rockefeller turned to Deskey and Candler for the renovation of her own private gallery. Candler and Deskey submitted a $33,290 bid to overhaul Mrs. Rockefeller's picture gallery, print room, and ceramic room, more than ten times Edith's budget. They estimated the renovation would take three months.

A year later, in January 1931, construction neared completion. "My gallery is a great success," Mrs. Rockefeller wrote her son Nelson, "but I have not as yet seen any material or any furniture that I want to put in it." Over the next few months, Deskey installed furnishings as progressive as anything he had done in his short career.

Mrs. Rockefeller's lair inhabited an entirely different century from the traditional décor below. A room designed for the storage and display of the hundreds of prints Mrs. Rockefeller had accumulated was stark and hard-edged, lined with gray Bakelite walls and aluminum strips to allow art to be slipped behind glass and slid onto the wall with ease. Gray carpeting covered the floor, and metal strips replaced the old crown molding. A ceiling-height aluminum standing lamp, resembling a shiny castoff from the newly built Chrysler building, added strong verticality to the rectangular room. The larger gallery, for paintings and sculpture, was cozier. A sleek metal-fronted fireplace and an oversized upholstered sofa and chairs with bold geometric patterns offered comfortable seating to contemplate the blend of moderns and primitives chosen by Edith and Mrs. Rockefeller. The lighting was recessed in the ceiling, casting perfect illumination on the framed paintings and clay and metal figures on pedestals. Edith helped install the artworks, mixing the old and new—the common thread being the very American-ness of it all.

Now Deskey faced his most monumental assignment: to create a magical machine-age setting for the world's largest theater. Deskey, whom a fawning 1933 New Yorker profile described as sketching with his feet on a table and so prodigious that he never ever tired, returned to the simple conceit of the Daylight Gallery for Radio City Music Hall. Edith's gallery reflected a seamless collaboration among artists, architects, and designers—a mini-Bauhaus thousands of miles from its German inspiration. Deskey recycled this concept for Radio City, creating a total environment far glitzier than the Daylight Gallery but emerging from the same creative spark. He would use new materials, fashioning an interior to match the age, using inlaid linoleum, Bakelite, and aluminum as well as hair-hide upholstery, aluminum wallpaper from R. J. Reynolds, and pigskin wall coverings. As the aesthetic impresario, Deskey was permitted to select the artists whose works would adorn the Music Hall, and not surprisingly, his candidates were all American, and many came with Downtown Gallery pedigrees. The original list included Stuart Davis, Louis

Mrs. Rockefeller's machine-age print gallery, designed by Donald Deskey, atop her West 54th Street mansion.

Bouché, Max Weber, Maurice Sterne, Walt Kuhn, Georgia O'Keeffe, and sculptors William Zorach and Robert Laurent. Even Henry Varnum Poor, whose ceramics were sold at the Downtown Gallery, was chosen to design custom lamp bases, vases, and ash trays. The artists were charged with creating embellishments for the thirty-one powder rooms and lounges, not the most glamorous assignment perhaps, but certainly the most glamorous project of the decade.

Edith and Deskey had a history of successful collaborations, but Radio City started with all the zigs and zags of a Deskey lacquer screen. Edith was dismayed to hear that the art budgets were not nearly so generous as Mrs. Rockefeller's customary gallery patronage. Radio City would not function like any of her altruistic Depression-era projects. Although it benefited thousands of construction workers, manufacturers, and vendors, the project remained a business venture, with inflexible budgets. Edith was appalled. Even though she depended on the Rockefeller goodwill for the survival of her gallery, she wasn't about to undersell her artists' services, Depression or no Depression.

Finalizing the details of the commissions and contracts dragged on through the late spring and early summer. By July, there were still no contracts, nor was there any agreement on fees. Radio City was slated to open in December, but there were so many people involved in the project, getting approvals was painfully slow. The artists were anxious to begin, concerned about having enough time to create something important, but Radio City officials appeared to be stalling.

Worse than Deskey was the director general in charge of it all, a man anointed in the newspapers as "the Mayor of Radio City." Samuel Lionel Rothapfel, from Stillwater, Minnesota, had reinvented himself as the entertainment rainmaker of the 1920s. By the time he was in charge of Radio City, he was simply known as Roxy. Edith and Roxy might have disliked each other, but at the core, these two scrappy fighters had much in common. Both understood the value of packaging, publicity, and promotion. Roxy had made his name in vaudeville by vamping up a string of Broadway movie palaces with

garish stage shows notable for high-kicking female performers in short skirts. A short round fireball, he carried a cane and cigar, puffing and firing off orders.

"You really should invite Roxy to take a dip in the Ogunquit water to get his legs into the same condition as his so called [sic] brain," Edith wrote sculptor Robert Laurent, who was summering in Maine with his wife Mimi and their children. As she negotiated with Roxy and Deskey, her esteem for the two men shriveled. If Roxy was an unapologetic egomaniac, Deskey wasn't far behind.

Edith was particularly concerned with extracting a respectable sum for Laurent, though he happened to be one of the few artists who wasn't in dire need of funds, with income on properties inherited from his adopted father Hamilton Easter Field. But for Edith it was more a matter of principle: her artists were providing top-quality work and deserved to be paid that way. Deskey reviewed Laurent's sketches and finally commissioned *Goose Girl*, a statue of a jaunty nude girl standing, improbably, beside a goose, whose beak tilts up toward her. The subject may sound tame, but Laurent's treatment would be avant-garde. He would take liberties with the figures, streamlining the angles and transforming the prosaic duo into an appropriately Machine Age artifact. To make the art even more modern, Deskey had convinced Alcoa, an aluminum manufacturer, to donate material for casting the sculptures, rather than using more traditional bronze.

Meetings with the "honorable Deskey," as Edith took to calling her new client, finally yielded an offer of $1,300 for *Goose Girl*, along with a set of decorated cork panels, the equivalent of $19,215 in 2006. "It is needless to say that the price is ridiculous, and I shall leave it to you entirely," Edith wrote Laurent. At the time, small pieces by Laurent sold for around $100, so thirteen times that for a monumental sculpture, plus a set of panels, was not especially grand. Laurent would also be required to pay to ship the sculpture from Maine to New York, and Edith estimated it would cost him about $65, or $960 in 2006 dollars.

She reminded Laurent he wasn't being singled out for low pay. "They got Georgia O'keefe [sic] to do a mural for so silly a sum, that there is a rumor to the effect that Stieglitz and she have split up as a result of the controversy."

In spite of the poor pay, aggressive timetable, and difficulties nailing down the contract, Edith reminded Laurent that the choice whether to take the commission was his, but advised that the high-profile project was "an excellent opportunity." Laurent took the assignment and wound up with $850 (about $12,500 in 2006) for the *Goose Girl* alone, without panels. "Well old scout, please don't be angry with me about the Radio City business," Edith said. "You must believe I am doing my darndest, but am up against a brick wall with fourteen hard boiled procrastinators to contend with."

William Zorach was also selected, for a sculpture commission of a kneeling long-haired goddess, heroically titled *The Spirit of the Dance*. He conceived of his dancer as a sprightly 3-foot tall nymph, but "When Deskey showed me where it was to go, we both realized that a figure three feet high would be ridiculous in that space," Zorach noted in his autobiography. The *Spirit* was slated for a prime location in the main downstairs lounge, just outside the gentlemen's and ladies' bathrooms. Zorach enlarged his dancer to be about 9 feet tall, a rather catastrophic upsizing. The kneeling *Spirit* with the face of a Greek goddess, the perky breasts of a vaudeville vamp, and the elongated limbs of an Amazon, was about the ungainliest dancer ever conceived.

Zorach noted that unlike the dancer's proportions, his $850 fee remained fixed while the size of the sculpture grew. He was not used to such thrift. The previous year Edith had priced his monumental marble sculpture, *Mother and Child*, at $30,000, which Edith felt was deserved, both because of Zorach's importance and also because he worked so slowly. Determined to sell the work to a top museum, she held onto it until March 1952, when the Metropolitan Museum of Art paid $15,000.

William Zorach, touching up his aluminum-clad *Spirit of the Dance* at the Roman Bronze Works, 1931.

Edith also struggled to get $800 for a mural by one of her least commercially popular artists, Stuart Davis. Deskey had offered $400 for a wall-sized mural in the gentlemen's smoking lounge. Edith demanded $1,000, hoping to bring the price closer to Davis's desired figure. Of all Edith's artists, Davis needed the job the most, for mental and for monetary reasons. Although his tough guy posturing prevented him from admitting his grief, Davis's young wife, Bessie Chosak, had died in June from a botched abortion, and Davis was devastated. He had also just lost his teaching job at the Art Students League and was subsisting on his $50 weekly gallery stipend, which came less and less regularly. Though Edith had shown Davis's works in ten shows in 1931 and 1932—two solo shows and eight group shows—and critics were convinced he was a homegrown original, buyers were not interested.

Davis needed the Radio City job, but by early September, nothing had been confirmed. Davis had already mailed sketches for approval, but he had not heard back and was becoming agitated. "The fact that Deskey doesn't say anything causes me to imagine that they [the sketches] make him nervous or that he just can't believe that they are alright," Davis wrote Edith on September 9. "After all I can guarantee a picture with kick and whether people like it or not it can't hurt anyone."

Edith finally reported back to Davis that she had got him $700. Davis was pleased. "I appreciate the way you have taken the pictures as I made them without making any hollers and when people say that an association with a dealer makes a pot boiler out of an artist, I cite the case of Mrs. Halpert who buys my pictures *without* comment as to their potential salability," Davis told Edith. "I feel it was fortunate to have gotten into the clutches of a dealer like you and I hope I continue to feel that way."

Edith appreciated Davis's endorsement. "I do not believe that a dealer, a patron, or any other human being has the right to dictate the creative effort of an artist. A painter is either good or he is not good," wrote Edith. "The fact that few sales were made has not altered my

opinion or has decreased my enthusiasm in the slightest degree. My only hope is that we shall be able to continue helping you financially and that you will continue doing all the fine work you have done."

Davis got to work. "I am taking a studio in town which is just large enough to accommodate the main-sail I am painting on. It is 11 x 17 feet which doesn't sound big, but measure it off and see what it looks like," Davis told an artist friend. "I will be here all October. It has to be done by Nov. 1 or I lose $1,000 a day in publicity money. I hope everything comes out alright and that I will once again be in position to quaff the tasty and stupifying [sic] McSorley's Ale" (a reference to the beer at a popular saloon). Davis worked in black, white, green, and brown oil paint. In less than a month, he created a dramatic composition by layering objects from the idealized male

Stuart Davis at work on his Radio City Music Hall mural, 1931.

domain, including a pipe, playing card, roadster, sailboat and matches. The objects were combined without any regard for proportion, with the pipe several times larger than the sailboat and the barber shop pole dwarfing the roadster. Davis was pleased with his work. "I think it will satisfy like the Chesterfields that will be smoked in its shelter," he told Edith. The mural was indeed a masterpiece. It reflected an "outrageous defiance of scale," wrote Lowery Stokes Sims, who curated "Stuart Davis, American Painter," a 1991 retrospective at the Metropolitan Museum of Art. Sims also suggested that the mural, titled "Men without Women," drew inspiration from a 1927 collection of short stories by Ernest Hemingway that deals with male identity being challenged by women, as well as from the fact that Davis himself, a widower, was a man without a woman. "The flappers had taken over," Davis told a friend. "But they couldn't get into the Men's Room [at Radio City] . . . to see my mural."

If jazz, booze, and cash helped unleash Davis's creative powers, another artist was about to hit painter's block. Georgia O'Keeffe had made a deal with Deskey to paint the curved ceiling of an elegant powder room. For years, she had yearned to break beyond the small canvas format. In 1929, she had told a friend, "I have such a desire to paint something for a particular place—and paint it big." The Radio City commission was clearly something she wanted to do, as indicated by her participation in the mural show at the Museum of Modern Art that spring, to which she contributed a long horizontal painting of the Manhattan skyline.

Stieglitz didn't share his wife's view. He was furious that she had taken the Radio City gig without consulting him, a job he deemed underpaid and of little redeeming value. Though O'Keeffe's prices were the highest among the Rockefeller Center artists and she commanded the largest fee, receiving $1,500 for her mural, that was not nearly good enough for Stieglitz. He charged several times that price for a single of his wife's oils. The crass commercialism of a mural in a music hall—the ultimate art for the masses—also offended his sense of superiority.

Stieglitz lobbied Deskey to raise O'Keeffe's pay but got nowhere. He also clashed with O'Keeffe about the job, but his power over his wife was at a low point: O'Keeffe and Stieglitz were not battling over only the Radio City commission. O'Keeffe was angry that her sixty-eight-year old husband had started up a flagrant affair with beautiful, married socialite Dorothy Norman. As if that weren't bad enough, Stieglitz had photographed Norman in the nude and exhibited the sensual results for all the world to see. Furious and humiliated, O'Keeffe would do as she pleased—and she pleased to paint the Radio City mural.

As theater construction fell behind schedule, the amount of time O'Keeffe would have to lay her floral design on the walls and ceiling narrowed. The stress was overwhelming, and her inability to control the work conditions was unbearable. Just six weeks before the opening on November 16, the ceiling plaster of the powder room had finally dried, and O'Keeffe was ready to paint. But when Deskey escorted her and her assistant to the room, they discovered a corner of the canvas peeling off the wall. Deskey assured O'Keeffe it would be fixed, but when she returned after lunch, even more canvas had come unstuck. Angry, she walked off the job. Stieglitz later called Deskey and reported that his wife was having a nervous breakdown and was no longer going to make the mural. It was not an artistic failure but an emotional one. "It was fear," wrote O'Keeffe's biographer Roxana Robinson, "not wet plaster, that stopped her from continuing the project." O'Keeffe was undone. She had chest pains and difficulty breathing and speaking. A doctor diagnosed a case of shock and put the artist on bed rest. Soon O'Keeffe's symptoms worsened. Her days were filled with bouts of crying, and her nights were sleepless. By February she was admitted to a hospital.

When Deskey first suspected O'Keeffe might quit, he selected another Downtown Gallery artist as a backup. Yasuo Kuniyoshi, an established Japanese-born painter who had developed a dramatic folksy style all his own, was a popular artist with a consistent following. Edith sold $100–$300 paintings by "Yas" slowly but steadily that

same year. When O'Keeffe quit, Yas stepped in. He was paid $1,075 (less than O'Keeffe but more than the other Downtown Gallery artists) to whip up a surreal pink-and-green floral confection. Yas took inspiration from O'Keeffe's design but made the mural his own. White calla lilies, giant leafy plants, and desert botanicals sprang up from a dusty-rose landscape and climbed the walls.

By December, Zorach's figure, called both *Rhythm* and *Sprit of the Dance* and Laurent's *Goose Girl* were clad in aluminum and placed in their spots. Edith and Radio City launched their publicity campaigns, and soon photos of the figures appeared in rotogravure sections in newspapers across the country. The excitement was building—the city and the country listened to radio reports and newspaper stories about the imminent opening of the world's largest and most glamorous theater. The two towering silver nudes were immediately noticed, but not for their artistry. "They had interested visitors and fascinated workmen who pinned brassières on them, placed cigarettes between their aluminum fingers, and drew flashes of electricity by touching their aluminum skins," reported the *New Yorker*.

Roxy was leading a tour group through the hall, just weeks before the opening. "At the sight of William Zorach's 'Rhythm.' Roxy turned crimson," continued the *New Yorker*. "'Take that out,' he cried. 'It spoils the theatre for me.'" Though Deskey presumably offered a defense of modern sculpture, Roxy wouldn't hear it. Looking up at Zorach's dancer, he made his case. "But," said Roxy, pointing to the elongated neck, "she looks as if she's been hanged."

With just two weeks until the velvet curtains were scheduled to rise on opening night, Zorach arrived on West 50th Street to inspect his gleaming lady. He passed through the lobby, crossing the wall-to-wall carpet covered with its jumble of zigs and zags depicting musical instruments, through the soaring foyer with its gold ceiling and 2-ton glass chandeliers and down a staircase to the Grand Lounge, designed to be a prime mingling spot during intermissions. Zorach was thrilled by the prospect of seeing his sculpture, as simple of line and pose as the Art Deco curves in the country's newest and largest theater. He was proud

of his role as one of the leading modern American sculptors. Carving his sculptures was physically draining and exacted a physical toll. Working with a chisel and heavy stone had given him a bad back, and as his stoic wife Marguerite admitted, he didn't cope well with pressure. Yet he reveled in the spotlight and had willingly agreed to some glamour shots beside his Radio City muse; Zorach wearing a beret, his rhythmic beauty wearing only her mysterious grin.

When Zorach arrived that day to inspect his work, Radio City was abuzz with workmen. Downstairs in the Grand Lounge, it was hard to tell that anything was lacking. The two wide staircases led to a vast salon, a cacophany of geometric shapes and surfaces, enveloped by dramatic black walls decorated with Louis Bouché's *Phantasmagoria of the Theatre* mural. The vast floor was divided by nine diamond-shaped columns clad in gun-metal mirrors. Deskey's chairs and tables made from rosewood, red lacquer, and metal—with extra chrome accents at Roxy's request—were placed around the perimeter and columns. One could imagine Ginger Rogers and Fred Astaire sweeping across the floor in a fluid duet. But Zorach soon discovered that something was indeed missing. In the space reserved for his *Spirit of the Dance*, the floor was bare.

Within days, news of the missing sculptures (Gwen Lux's nude figure titled *Eve* had also vanished, and the future of the *Goose Girl* hung in uncertainty) landed in the papers. Pictures of the missing *Spirit* statue and a portrait of the ruggedly handsome Zorach were splashed across pages of the *New York Evening Journal*. Roxy and Edith knew that press—good or bad—was great for business. Roxy issued a statement declaring he yanked the statues "because their effect on me, as works of art, is negative." Despite his insistence that he objected simply because he thought the statues were ugly, reporters suggested that Roxy, who had made his name with lines of dancing girls kicking high in short skirts, was a prude at heart. The *Daily News* consulted with the head of the Society for Suppression of Vice, John S. Sumner, who didn't find the artwork unseemly. "I see no moral objection to them whatever," Sumner said. "There's nothing suggestive

about them, and the nudity isn't emphasized." He pointed out that they might be better suited to a museum.

Edith jumped into the fray to defend the honor and egos of her artists and also to steer the tenor of the news reports. She dictated a letter to the Rockefeller Center officials on behalf of Zorach and Laurent. The letter came as a response to an article that suggested the Rockefeller Center officials had not approved the statues. That claim was "very offensive," wrote Edith, who noted the lengthy approval process the artwork had undergone from the sketch stage. "Our understanding was that Mr. Rothafel, himself, was shown the sketches which were just as nude in the form of drawings as they are in aluminum." In spite of the fact that the ultimate sponsor of the project was the husband of Edith's best client, she didn't hold back. She accused the Radio City officials of bad manners. Removing the work "surreptitiously" from Radio City without notifying the artists was a "breach not only of courtesy but even of public decorum." She demanded the works be returned to their spots as guaranteed in the artists' contracts and she took the higher ground, framing the episode as a nasty blight on an otherwise idealistic project.

Edith magnified the episode to stand for all the indignities her artists suffered, claiming the Radio City incident reflected an attack on American art itself. The artists "were idealistically seeking to further the best interests of American art," Edith claimed. "We believe, that through such co-operation the future of American art would be bettered, that a new era would arise when the general public would not be considered as a public of morons but would be given an opportunity to see the finest developments in this field of culture." The implication was clear: leaving art in the hands of Roxy would mean art for morons.

Though her letter stated "we are not desirous of further publicity," that was patently false. Edith devised a plan for revenge. On December 27, a few hours before the curtain was set to rise at Radio City, she placed a plaster version of Zorach's *Spirit* on view at the Downtown Gallery. She sent a press release to the art critics, heralding the

arrival of the figure, which "has a spiritual harmony and poise which gives it a deeply stirring quality." Edith went so far as to include a quote by one of her heroes, Albert Einstein, a statement the scientist had made with no connection to Zorach whatsoever, but that resonated for Edith and which she appropriated with ease. "The figure has an element so aptly described in a recent statement by Albert Einstein, 'The most beautiful thing we can experience is the mysterious. It is the source of all true art and science. He to whom this emotion is a stranger, who can no longer pause to wonder and stand wrapped in awe, is as good as dead." If Edith didn't have mystical powers, what happened next to Roxy can only be attributed to bad luck.

Crowds poured into the gallery, hoping for a peek at the controversial figure. "Sober and indignant art lovers crowded the rooms," reported the *New York Sun*. "The conversation was subdued in tone but what fragments of it could be heard indicated that sympathy was entirely with the artist." Critics penned words of praise. "Mr. Zorach's figure, one-and-a half life size, representing a dancer resting on one knee, is a superb work of art," wrote the *New York Times*. "Not only is it one of the finest things this highly gifted sculptor has produced, it is, as well, one of the most significant pieces of plastic art ever produced in America."

Uptown at Radio City, opening night reviews also started out on an optimistic note. Edwin Hill, reporting for the Columbia Broadcasting System, on his radio show *The Human Side of the News*, squawked out to the country, "In all the annals of New York there has never been, so far as I know, an opening night to approach it for the brilliancy of entertainment, the surge of crowds and the thrill of a big, new thing." He reported 50,000 people "surging and swirling" in the streets outside Radio City. Edith was among the more than 6,000 swells attending opening night festivities. The crowd of luminaries included Downtown Gallery client and actor Edward G. Robinson, as well as other famous faces such as aviator Amelia Earhart, composer Irving Berlin, writer Noel Coward, and socialites Barbara Hutton and Prince Matchabelli.

The entertainment at Radio City was as extravagant as the decor—but didn't wash nearly as well. Roxy's fortune and fame were based on his elevation of the movie palace to entertainment extravaganza, bringing live music and vaudeville to the big screen. At Radio City, he had done away with the movies and made the live performances the star act. Opening night included twenty such acts, intermingling the high and low, in a show that was riddled with technical glitches and just wouldn't end. Modern dancer Martha Graham performed, as did the Flying Wallenda trapeze troupe, the Tuskegee Choir, comedian Ray Bolger, German opera star Fraulein Vera Schwarz, and forty-eight precision dancers dubbed the "Roxyettes." The curtain finally fell at 2:30 a.m.

"I was among the 6,200 present at the opening of the new Palace of Virtue," Edith wrote a friend a week later. "I listened to stirring chords of the 'Star Spangled Banner,' the dramatic broken tenor in 'Carmen,' and witnessed the eye poking tussle of Weber and Fields. I came out pure as a lily and have promised myself a life of vice for the coming new year." Edith, along with most of the critics, panned the show but raved about the theater. "The least important item in last evening's event was the show itself," said the *New York Herald Tribune*. "It was been said of the new Music Hall that it needs no performers; that its beauty and comforts alone are sufficient to gratify the greediest of playgoers." Two weeks later, the Music Hall was running a $200,000 deficit. Roxy's entertainment bonanza was a dud. In January 1933, Frank Capra's *The Bitter Tea of General Yen*, starring Barbara Stanwyck, was projected on the screen, and the theater was transformed into a movie palace with some live entertainment, ironically the format that had made Roxy's name. By March, Zorach's *Spirit* was reinstated. Roxy was not. He was carted off from opening night on a stretcher; his health precluded his return until May. Radio City's mayor drifted away, and a few years later he died of heart disease.

Even though Radio City had brought Edith's artists some measure of fame, there was no money to match the notice. With the glamour

and hoopla of that project behind her, Edith felt discouraged about prospects for the Downtown Gallery. The Depression had only deepened, and those few gallery visitors were interested only in a free show. She hid her fear from everyone except her inner circle. "This is a terrible era for us all," she wrote her French dealer friend Janina Liszkowska on December 31. "No-one will buy anything," Edith admitted. "We are struggling in the hope of pulling through, but the view looks pretty dark for all of us." Edith harbored fears not only of her own financial ruin but also the ruin of her artists. A desperate art dealer can't make sales, however, and however desperately she needed to close deals, she suppressed her fears and got on with the business of running the gallery.

Even rich clients had stopped buying. Two months earlier, Edith had attempted to entice composer George Gershwin with Max Weber's *The Cellist*, a painting he had expressed a liking for. In an "extraordinary gesture," Edith assured Gershwin, Weber had slashed the $2,500 price to $1,800; then, "so touched by your attitude towards his work," Weber had again dropped the price to $1,500. Edith reminded Gershwin that Webers typically fetched around $3,000 on the open market. Even with her artist slashing prices, Edith maintained a proud front, dispelling the inconceivable notion that for the artist—and dealer—making a sale was urgent. "In closing," Edith wrote Gershwin, as if she were an heiress with a bottomless bank account, "may I say that although we are always glad to make a sale I am urging this matter for your benefit and this is not sales hokum." If Gershwin chose not to buy—and unfortunately that's exactly what he did—as far as Edith was letting on, that was his loss.

Edith's generous installment plans were finally causing her problems, too. Buyers were extending payments for years, not months. While trying to rack up a sale with Gershwin, Edith tried to collect the $25.67 that Los Angeles theater impresario and writer Merle Armitage had owed the gallery for a year and a half. "The artists are in no condition at present time to forgo payments," she told Armitage. Armitage was understanding but unable to help "after a

very swell year of financial crashes." He promised to pay something "just as soon as I can get more money than it takes for rent and groceries," and while friendly and well-meaning, he was firm in his position that for the moment, he couldn't pay. "But just now, as you may be aware," he said, "things *are* different."

Worn down and weakened by a case of "the fashionable grippe," as she called her flu, Edith pushed to make a sale for Zorach, hopefully the high-profile *Spirit of the Dance*. The sculptor's own spirit had been on a downslide since his well-reviewed 1931 show at the Downtown Gallery, where there were compliments aplenty but few sales. Just a year earlier, Edith had unsuccessfully lobbied the Metropolitan Museum to buy Zorach's star piece, *Mother and Child*. Edith again pitched her case to museum director Herbert Winlock, dropping in the all-important Nelson Rockefeller endorsement. She followed up her initial suggestion that the museum's trustees consider the Zorach, which would be cast in bronze, with a bolder proposition: the museum should accept the *Spirit* as a gift, and then she would collect subscriptions from donors to pay for it. "I cannot give you any encouragement that it [the statue] would be accepted to represent Mr. Zorach here at the museum," replied Winlock. Regarding the subscription scheme, he was not even tempted. "It has not been customary for the Museum to encourage subscription of this sort," Winlock said, "and I foresee that as an additional argument against the statue if it were proposed."

Once it became clear the Metropolitan wasn't making room for Zorach's famous *Spirit*, the artist shipped a bronze version up to his house in Maine. "I anchored her on a natural ledge among the pines and oaks overlooking Robinhood Cove in front of our house," said Zorach. "I didn't get much money for 'The Spirit of the Dance,' but I got a tremendous amount of acclaim and notoriety." In an age when sales were few, Edith at least succeeded in making sure her artists weren't forgotten. If only that were enough.

9

A New Deal for Artists

It was a chilly afternoon in early December 1933, when Edith set out to meet one of the most important men in New York City. Dressed in a coat and hat and clutching a typed four-page proposal outlining her plan to save American art, she marched into the office of Fiorello La Guardia, the New York congressman recently elected mayor. "I'm a nobody," she announced, "with a brilliant idea." It is a testament to Edith's passion and charisma that she managed to convince the barrel-chested mayor that he needed to do something for artists, given the severity of the times. The same week, La Guardia had announced he would forgo inaugural celebrations come January. "The economic condition of the country and of the city, with its thousands and thousands of unemployed," said La Guardia, "is such that it would be inconsistent to have any celebration. I feel that this is no time for pomp and ceremony."

There was drastic change underway in the White House as well. President Franklin D. Roosevelt had launched a cavalcade of New Deal programs in 1933, soon after taking office, restoring hope to millions of Americans. By the end of 1933, nearly 400,000 unemployed

men were plucked from New York State's relief rolls and given civil works jobs. But Edith was still worried about her artists. "The small, select class of 'big buyers'—the few rich art collectors on whose support art and artists depended—no longer functions," Edith reported in her proposal. "What about the artist? Will he fit into the new philosophy, the new life pattern? We must find a place for him. We must give him the means to continue. We cannot afford to liquidate our greatest asset—culture."

The answer, Edith believed, was government support:

Heretofore, because of existing conditions, museums and galleries have prospered on snob appeal, the galleries basing their sales psychology on snobbism, high prices, rare items. The public looked at art through a glass show case, and the few art patrons bought. We must bring art to the public, the school, and the home. Artists want mass appreciation, and will price their paintings, sculpture, and prints, for the mass distribution. The artist needs a large buying public. And the state must bring the artist to the public officially.

Edith got to the point. "And it is fitting that the great city of New York lead the way," she told La Guardia, "and that the chief executive of this city set a precedent for all the other American cities, by fostering culture in a big way." Edith's plan was to mount an all-American exhibition, on the scale of the 1913 Armory Show, sponsored by the mayor and promoted to a national audience. She proposed asking the heads of all the major museums (the Metropolitan, the Whitney, the Brooklyn Museum, and the Museum of Modern Art) to select the 500 best American artists. All sale proceeds would go to the artists, with no cut for the dealers. She believed such a massive exhibit, with 200 more artists than the 1913 show, could raise money for the artists and fame for the field.

After some negotiation, La Guardia agreed to be sponsor, topping off what had already begun as a splendid week. A few days earlier,

hotels and restaurants had begun polishing highball glasses as Old Man Prohibition was buried, electrocuted and drowned in effigy. After thirteen long dry years, Prohibition was repealed. Edith returned to 13th Street after her meeting. Her hat was crooked, and she was out of breath. The guests she had invited for dinner were already seated. She had instructed the cook to start the party without her. It was time to toast and celebrate.

In early January 1934 Edith was seated in the offices of the Rockefeller Center architects, Reinhard and Hofmeister, along with Eddie Cahill and various Rockefeller officials, hashing out ideas for the exhibit. Edith had originally envisioned the exhibit back at the Sixty-Ninth Regiment Armory—site of the 1913 Armory Show—but discovered that the cost to outfit the cavernous space with walls and lighting would be prohibitive. The city didn't have a dime to spare for such things. The show needed another home.

Edith had approached Nelson Rockefeller to see if they might work together. After the opening of Radio City Music Hall, Nelson had asked Edith to work up a plan for a permanent art gallery to be located in the new Rockefeller Center complex. The idea was to create a showcase for American art from many dealers and artists, something to add a little culture and class to the office complex. Edith consulted with other dealers, museum officials and art critics before submitting a carefully crafted proposal. Although Nelson appeared to back her plan, his managing agents balked. He told her the renting committee was concerned the gallery wouldn't be able to pay the annual $25,000 rent. Also, there was resistance to permitting an art gallery to use the Rockefeller Center name, and soon the whole idea was dropped. "I am indeed sorry that our uptown gallery scheme fell through because of the difficulty over the use of the name 'Rockefeller Center,'" said Nelson in July 1933. "I still think the idea is a very excellent one and the gallery would have been a tremendous success. Perhaps we will be able to put across some such idea at a later period."

He didn't have to wait long. In December Edith met Nelson for

lunch at the Park Lane Hotel, ready to pitch him yet another uptown scheme. This time she explained that she would be putting on New York's largest juried art show since the Armory Show. Her plan resembled the American Contemporary Art Exhibition she had organized in Atlantic City at the Municipal Art Gallery five years earlier, and it soon acquired a similar name, becoming the First Municipal Art Exhibition. Edith's plan prefigured by some seventy years art dealers' dependence on mega-events to stir up publicity and sales. Edith was certainly one of the first dealers to see the potential in exhibits with great scope and scale, packaged up and presented in easily digestible, unintimidating, efficient art fairs.

Edith understood how to make news and generate sales. In addition to her Atlantic City coup, she had made a splash three years earlier. In the wake of the Museum of Modern Art's second show, the poorly conceived and received "Nineteen Americans," assembled by committee with suggestions from museum trustees, Edith set out to prove that American art wasn't as drab and dull as the Museum of Modern Art had made it appear. She whipped up "33 Moderns," nearly doubling the number of the museum's offerings, and installed her selection in the sprawling showrooms at the Grand Central Galleries, located above Grand Central Station. The space was much larger and more centrally located than Edith's gallery; she aimed to make new converts. The show marked the debut of Edith's bohemian attack on the stodgy Midtown art circuit. "U.S. modernists rejoiced and made merry last week. With the opening of a great exhibition at the Grand Central Galleries, Manhattan, they had captured one of the strongest citadels of conservatism," declared *Time* magazine. "They danced to the music of mandolins and guitars. . . . They drank tea and other liquids. They smoked cigarettes in modernist defiance of signs that read 'No Smoking.' . . . It was the biggest event in the campaign to modernize U.S. art since the Armory Show of 1913, in which several of the same artists were represented." A photo of the artists, arranged around Stuart Davis's emblem of modernism, *Egg Beater No. 5*, appeared with the story. With the Museum of

Modern Art just three months old and the Whitney Museum in the planning stages, Edith was one of the few contemporary art players having any sort of impact. In addition to reporting on all the eccentric happenings at the opening, *Time* included a fact that set Edith apart from other Depression-era dealers: "33 Moderns" had already racked up eleven sales.

Now Edith aimed to replicate her success with the First Municipal Art Exhibition. It was slated to start at the end of February, just two months away. Over lunch with Nelson Rockefeller, they discussed using the RCA building, a newly completed seventy-story skyscraper, the centerpiece of Rockefeller Center. Edith knew it quite well. Nearly a year earlier, while she was working on her plan for the Rockefeller Center Art Gallery, Nelson had given her a pass to visit Rockefeller Center while it was still under construction. The space would be perfect—a series of monumental raw spaces ready to be transformed into galleries using the ready supply of Rockefeller Center construction workers and cash. Nelson agreed to pay for all expenses—eventually totaling $45,000—needed to transform the 50,000 square feet on three floors into thirty-one galleries. (Edith believed his generosity wasn't entirely altruistic but stemmed from his desire to persuade La Guardia to approve a Rockefeller Center subway station.) Edith promised Nelson half of all proceeds from the twenty-five cent admission to help defray his costs. The other half would be set aside for a fund to buy art for the city.

The selection committee consisted of the heads of four New York museums, Juliana Force (Whitney); Alfred H. Barr, Jr. (Museum of Modern Art); William H. Fox (Brooklyn Museum); Herbert E. Winlock (Metropolitan Museum of Art); and of two artist associations, Harry Watrous, president of the conservative National Academy of Design; and Leon Kroll of the more progressive American Society of Painters, Sculptors, and Gravers. Together they chose the 500 artists for the show, each of whom was invited to contribute two or three paintings. There was also a plan for a nonjuried exhibition to follow the First Municipal Art Exhibition, under the auspices of the Salons

of America, which would give aspiring artists a chance to exhibit and help quell any potential charges of favoritism.

Edith had dreamed up the idea for the First Municipal Art Exhibition, but she needed someone else at the helm, or else other dealers would again accuse her of acting out of self-interest. Edith recommended Eddie Cahill as director for the show, despite the fact that they were no longer an item—in fact, Eddie was now romancing Dorothy Miller, the dashing brunette whom he had met at the Newark Museum in 1925 and who would later become an important curator at the Museum of Modern Art. Eddie was not the monogamous sort and was prone to wooing several women at once. Edith, who had at first fallen for him hard, would not have appreciated his dalliances, especially when she was his main sugar mama, sharing her folk art profits and supporting his efforts as a novelist. By the First Municipal Art Exhibition, they were no longer lovers, but Edith continued to help Eddie, steering opportunities his way. "I always had him in on my rackets," she said later. If she was bitter or resentful that Eddie had moved on to Dorothy Miller, she hid it for the time being. There was no reason to be jealous—Edith had her own success to be proud of and better things to do than fuss over Eddie.

For him it was a plush arrangement. He received a healthy $125 a week salary, more than ten times the $10 a week salary for the checkroom attendants. Unfortunately, it was an ill-timed posting. Within weeks, Eddie's gallstones and gall bladder colic reared up. He slipped and fell on the ice and was rushed to the hospital. He didn't get out until after the show had already begun. The work fell to his romantic companion and future wife, Dorothy Miller. And to Edith, of course.

In addition to the challenges of transforming the RCA lobby into an exhibition venue and hanging more than 1,000 artworks on three floors—without a functioning elevator—Edith took on the promotional plan. There would be live radio hookups from the exhibit; a luncheon hosted by Nelson Rockefeller for newspaper critics; invitations sent to museum mailing lists; posters distributed across the city

in libraries, museums, and galleries; and advertisements running on Fifth Avenue buses.

Edith also sent letters to clients urging them to buy before the show even opened, and she encouraged other dealers to follow her lead. She knew the promotional value of being able to announce sales on opening day and wrote to more that 100 of her clients, offering them the option of visiting the show the day before it officially opened. She also arranged for La Guardia to buy ten prints as a promotional gambit. Remarkably, it seemed Edith had pulled it off: New York's largest art show in decades would be ready for the February 27 opening night party.

Just two weeks before opening night, on a quiet Saturday night, Rockefeller Center workers entered the lobby of the RCA building and ripped down an unfinished mural that had been covered up with tar paper since May. This prompted Rockefeller Center executives to notice Vladimir Lenin's bald head and bearded face in the painting. The artist, Mexican painter Diego Rivera, had included the leader of Russia's Bolshevik party in an effort to bolster his own credibility within the Communist Party. He was on the outs following his last commission, a mural funded by Edsel Ford for the Detroit Institute of Arts. Though the mural celebrated the worker, Rivera's association with one of America's foremost capitalist families didn't win him any favor with his comrades. For the Rockefeller mural, which in addition to Lenin included all manner of overt social commentary—including a hammer and sickle, warplanes, marching troops, and vacuous socialites playing cards—Rivera was to receive $21,000, more than twenty-five times what Stuart Davis had received for his Radio City mural.

Rivera's style and subject matter were no surprise to the Rockefellers. Both Nelson and Mrs. Rockefeller had long admired the Mexican muralist's work. He had been given one of the first one-man shows at the Museum of Modern Art, had painted a portrait of Nelson's sister Babs, and was the honored guest—along with his wife, painter Frida Kahlo—at a Rockefeller dinner party. (Mrs. Rockefeller

told Edith she was worried about asking Rivera and Kahlo to wear black tie. Edith didn't see any such problem: Rivera could afford to rent a suit and Kahlo could drape a shawl over her shoulders.)

Edith blamed the whole affair on dollars and cents. She knew the Rockefellers wouldn't object to Lenin, but they would object to anything that stood in the way of finding rental tenants. Having Lenin's stern gaze peering down from the lobby wall wasn't a big selling point. Rivera initially agreed to remove the head, but as Nelson later recalled, Kahlo urged him to resist. Then Ben Shahn, who was working on the project, as well as Rivera's other assistants, threatened to go on strike if Lenin's head were removed. Rivera had no choice: he had to stay firm. He was fired and left the mural unfinished. Nelson searched for a solution, suggesting that Rockefeller Center donate the work to the Museum of Modern Art, according to Daniel Okrent, but there was either no response, or perhaps it was too much trouble to remove the mural, which was painted directly on the wall.

The timing of the mural destruction could not have been worse. Edith said Mrs. Rockefeller was appalled by the news. So were artists. A group of eleven artists, led by Ben Shahn, issued a statement that they were quitting the show. "We, the undersigned artists, indignant over the cultural vandalism of the Rockefeller Center authorities in destroying Diego Rivera's fresco, announce that we will not show our pictures at the Municipal Art Show if it is held at Rockefeller Center." They went further than that, demanding La Guardia cancel or move the show. Leon Kroll spoke on behalf of his artists' group. "Regardless of whether or not it was a great work of art, I don't feel that the Rockefeller family had a moral right to take such action. It was particularly unfortunate to do so at this time, since the purpose of the forthcoming Municipal Art Show is to get all the best artists of New York together in a 'harmony party.'" A couple of days later, Kroll and his group pulled out of the show, explaining that "this is not to be interpreted as a protest in sympathy with Rivera's work or communist propaganda, but it is a definite protest against the indignity placed upon living artists by the arbitrary action of a corporation in destroying a work of art without previously consulting with the artist."

Harry Watrous of the National Academy of Design spoke in the Rockefellers' defense. He called the protest "an almost infinitesimal tempest in a tea pot" and objected to other artists describing the destruction of the Rivera mural as "a crime against art," an accusation he termed "poppycock." "Mr. Rockefeller took offense at the political propaganda in this mural," said Watrous. "[He] felt that he had been insulted, and had the painting destroyed as he had a perfect right to do so."

The exhibition, which Nelson had hoped would advance the Rockefeller name, had so far backfired. Rockefeller Center management tried to save the show. They issued a statement Rivera had made the previous spring, when objections to his mural were first raised. "Rather than mutilate the conception," read the statement, "I should prefer the physical destruction of the conception in its entirety." With that, the firestorm quieted. Just ten days before the exhibit was to start, the artists and art groups ended their boycott and announced they would participate after all. Edith worked to smooth over bad feelings. "Rivera . . . made it impossible for the artists to continue their protest as his statement had indicated that the issue, as far as he was concerned, was purely political," Edith wrote La Guardia's secretary, Lester Stone.

Naturally, while the artists are still incensed at the destruction of a work of art, they do not feel free to support the issue further as such action will be indicative of their political affiliation or rather their support of communism as such. On the other hand, other measures will be taken to continue the protest against "vandalism" but it will in no way be related to the exhibition which is the most important event from the artists' standpoint and which they cannot afford to cancel under existing conditions—particularly in view of the fact that Mayor La Guardia has been so generous with his sponsorship.

At 10:40 p.m. on February 27, Mayor La Guardia looked out over some 5,000 people in evening dress—men in tuxedos and ladies

in coats with fur collars and dainty hats—mingling among the monumental nude statues scattered about the main lobby of the RCA building. He leaned into a microphone nearly as tall as he was and addressed millions more listening over a live radio hookup: "While American finances have hesitated, American industry was timid, and American commerce uncertain, American art has forged forward." Outside the entrance, eight artists marched up and down Sixth Avenue, hoisting picket signs in the air reading, "Hitler Burns Books; Rockefeller Destroys Art," "Join Us Against Vandalism," and "We Withdrew Our Paintings in Protest." Stuart Davis passed out leaflets on the chilly sidewalk. When he decided to go inside, someone called over a policeman and pointed him out as a troublemaker who ought to be arrested, not admitted. Davis pulled out his invitation—all participating artists were invited to the opening—and so the policeman just trailed Davis inside.

Opening night crowd at the First Municipal Art Exhibition, February 28, 1934.

During the opening week, 20,000 visitors toured the show, hailed
ıs "a mile of art" in the press. Daily radio interviews and lectures
ınderscored Edith's message: Buy art. Sam Lewisohn and Edward M.
M. Warburg, trustees of the Museum of Modern Art, spoke about
:heir reasons for collecting. Edith told reporters that $10,000 worth
ɔf art had already been sold and provided a list of early buyers,
ıncluding George Gershwin, Mr. and Mrs. John D. Rockefeller, Jr.,
Nelson Rockefeller, and Robert K. Straus—son of Edith's former

Nelson Rockefeller, Fiorello La Guardia, and Alfred H. Barr, Jr.
during opening night ceremonies.

Macy's boss Jesse Isidor Straus—who worked for a New Deal agency. Early sales reports were a strategy Edith knew would help stimulate further sales. Other buyers during the show's duration included CBS President William Paley and the Metropolitan Museum of Art, which purchased its first Georgia O'Keeffe, *Black Flower and Blue Iris*, for $1,400. The Museum of Modern Art bought one of the most puzzling pieces of the thousands on view, a motor-driven mobile with two balls shooting along wires that looked, to *New York Sun* critic Henry McBride, like "a recording instrument for Prof. Einstein," and who suspected most visitors would "pass it right by, mistaking it for a heating regulating device." The contraption, by a young artist named Alexander Calder, cost $60.

"We went to see the Municipal Show today for the first time and I must have a Stuart Davis, about the size of the small one there!!!!" poet William Carlos Williams wrote Edith. Williams was a friend of artist Charles Sheeler and had been a regular at Downtown Gallery lectures in the late 1920s. "But wait a minute, I simply can't afford it now. What I propose is to wait until I am able to sell some literachoos. . . . The whole show was of tremendous critical value to one who doesn't know much about painting."

"It was Edith Halpert who started all this and who, in its triumphant fruition, is realizing 'the dream of her life,'" wrote Edward Alden Jewell in the *New York Times*, noting Edith was "quite as good at selling ideas as she is selling pictures." Jewell, like most critics, was amazed by the scale and scope of the show. He called it "the biggest art show ever staged in New York."

Most critics focused on the event as an unusual truce between the two rival art camps that had so far defined twentieth-century American art: the realists of the academy and the avowedly moderns. The *Times* described the two groups succinctly:

On the one hand is the studied care and virtuosity of the older men filling to the utmost advantage the space allotted for a decoration or detailing the very down on a peach in a still-life;

on the other, the carefree abstractions of the youngsters who deal mercilessly with bootlegging, factories, prizefighting, and who try to visualize our confused era in seemingly mad arrangements of unrelated wheels, lamp-posts and setting suns."

Edith knew this rivalry could be played up for even more publicity. She staged an art feud with another dealer, her friend Erwin Barrie, manager of Grand Central Galleries, to debate modern art. The debate was broadcast on NBC, and transcripts were sent out to newspapers. "I do not believe that a nude figure that looks like a stuffed sausage is a work of art," said Barrie, who accused modern artists of refusing to "recognize beauty," focusing on "vulgar and revolting" subjects.

"Can Mr. Barrie be serious in his denunciation of modern art?" asked Edith. "Modern art is here, and it is here to stay. Today, practically all museums, collectors, critics, dealers, and the general public accept modern art as a characteristic manifestation of our time just as they accept all other modern forms of our daily existence, transportation, sound transmission, heating, housing, plumbing, industry and the New Deal. . . . The First Municipal Art Exhibition was planned primarily to remove all class labels, to bring all American contemporary art under one roof. There are, in my estimation, only two kinds of art, good art and bad art."

As the brains and guiding force behind the First Municipal Art Exhibition, Edith had reason to feel proud of her accomplishments in the spring of 1934. That historic show, which ran for four weeks and closed on March 31, raised an unprecedented amount of publicity for American artists. It reminded New Yorkers that hundreds of underappreciated, homegrown American artists were toiling in the shadows of the European art stars.

But once the exhibition closed, the reality of the Depression

returned. "That was a very important pick up in the economy of the time," Edith recalled. "But not enough, and it was of very short duration naturally.. . . . " Edith's relations with various artists grew strained as they accused her of cheating them. "Demuth is making my life utterly miserable and has gone throughout the town accusing us of stealing his hard earned cash," Edith wrote her lawyer.

Edith had begun to sell works by Charles Demuth, known for his crisp watercolors and oils of grain elevators, flowers, and vegetables, after the Daniel Gallery closed. Demuth, a sickly diabetic, had left the Village and returned to live with his mother in Lancaster, Pennsylvania. He was frantic for sales. Edith consigned a batch of Demuth watercolors to the Mellon Galleries in Philadelphia. Knowing that Demuth needed help, Juliana Force offered $1,000 for a yellow-and-red watercolor, *From the Garden of the Chateau*. (Demuth called his family home the "chateau.") Mellon Galleries stalled Edith, telling her Mrs. Force had not paid for the work. Finally Edith checked with Juliana and learned that she had indeed paid; the director of Mellon Galleries had embezzled the money. Demuth died the following year, leaving his oil paintings to his friend Georgia O'Keeffe. Edith continued buying and selling his paintings for the next forty years.

As the Depression deepened, financial woes led to mistrust. Edith resorted to hiring a collections agency, working on contingency, to try and force buyers to settle their accounts. If that weren't bad enough, Mrs. Rockefeller had all but stopped buying. After the Diego Rivera scandal at Rockefeller Center, which brought a storm of bad publicity, the family matriarch suddenly cut back on her art activities. Her husband had never approved of them, but now he seemed to have even more reason for his aversion. In 1933, Mrs. Rockefeller had spent nearly $25,000 at the Downtown Gallery (she also made smaller purchases from two other women dealers, dropping $200 with socialite Marie Harriman, wife of railroad scion William Averell Harriman, and $5,830 with Mary Quinn Sullivan, the collector and MoMA founder who dabbled in dealing). By the end of 1934, Mrs.

Rockefeller's spending had plummeted to $4,391, including $100 she paid Edith to hang folk art pictures at Colonial Williamsburg. (Mrs. Rockefeller also paid Eddie $200 in December to scout southern folk art for Williamsburg.)

In April 1934, after the close of the First Municipal Art Exhibition, Edith sent flowers to the Rockefellers' stateroom for their ocean liner trip to Italy. She expressed her gratitude for their contribution to the show. By donating space in Rockefeller Center, by lending their prestige, and by supporting artists with six purchases from Edith, they had made the event possible.

"I also appreciate the very kind things that you were good enough to say about me in your note but most of all I like what you say about my husband and what he has done," Mrs. Rockefeller wrote Edith, in a note thanking her for the flowers. "After all Nelson and I could do nothing without him [John D. Rockefeller, Jr.] and I feel often as if I had through my interest in art brought him so little joy and much trouble. And he has always been generous and patient through it all. I am so glad to learn you understand and appreciate this."

Though she had vowed to cut back her art spending, Mrs. Rockefeller did give Edith discretionary sums to buy art from artists who were the most desperate. Edith didn't limit the aid to her own artists. She used $50 to buy Mrs. Rockefeller an "exceptionally fine gouache" by a twenty-nine year old artist, Arshile Gorky, a sum that covered his expenses for more than a month. "The young man [Gorky] was completely destitute," Edith wrote Mrs. Rockefeller. "And while I helped him personally on previous occasions, at this moment he just about reached his limit."

Ever since the Depression had upended her artists' lives, Edith had taken on a personal oath to sustain her group. Without a husband or children, all her maternal instincts were channeled toward the artists. She coddled, praised, pushed, and supported them—always mindful of the need to make sales. Edith knew what it was like to go without—that was the circumstance of her childhood. It was no way to live, especially for the creatively blessed. She hustled all the time,

trying to pawn off Sheeler's Shaker table and his Constantin Brancusi sculpture when Sheeler's wife was dying of cancer and he urgently needed funds.

For the moment, it was only a few museums, such as the Whitney, and a few dealers and collectors who were devoted to helping artists survive with unsystematic handouts. Thankfully, the New Deal stepped into the breach. In May 1933, George Biddle, an artist on a first-name basis with the president (they had studied together at Groton and Harvard), suggested the government pay artists to make murals in government buildings. Roosevelt agreed, and by November 1933, over a million dollars was transferred to the Treasury Department for this purpose. A new agency was established with a mandate to help artists all over the country, from the most conservative academic to the most adventurous abstractionist.

Edward Bruce, head of the new agency, called the Public Works of Art Project (PWAP), had a personal preference for the more conservative strains in art and a special fondness for art that celebrated the American spirit, a school called "American Scene," which caused a stir with critics and unbridled disgust from Edith. She thought these artists stole some of the limelight from Downtown Gallery artists, and she didn't like it. (In 1935, she told Alfred H. Barr, Jr. that she refused to cooperate with magazines stressing the "'American Scene' fad," explaining, "I feel that *quality* is being entirely ignored in the accent on subject matter. Furthermore, to quote Georgia O'Keeffe, America is a country of clean white barns and churches rather than Grant [Wood] architecture and barrels.")

Bruce had promoted his agency at the opening of the First Municipal Art Exhibition, speaking during opening night ceremonies. Though Edith had begun formulating her plans for the city-wide show the same month the federal government had formally stepped in, Bruce called the exhibit "the fine response of this great city to the movement inaugurated by the Federal Government to foster art in our country through the employment of some 2,500 artists at craftsman's wages to embellish public property."

Luckily for the moderns, Bruce wasn't directly involved in choosing which artists were selected for the PWAP. Juliana Force was given the dubious honor of running the New York office. "Perhaps you do not know as well as I do the utter destitution of the artists, and how their courage is failing at the thought of facing another winter!" Mrs. Force wrote Mr. Bruce. "Over three hundred fifty painters and sculptors of first rate importance are desperately in need of jobs."

Although Mrs. Force relished her power, deciding who would receive government aid was a thankless task. There were far more needy artists than slots on the PWAP list. Mrs. Force decided who remained on the breadline and who was eligible for a $34 weekly check, along with free paints, brushes, canvases, and other art supplies. Artists were assigned to both mural projects and the easel division, where they painted on their own. All the art produced belonged to the government.

With the progressive Mrs. Force at the helm, known for her support of the overlooked Americans at the Whitney Museum, the older guard at the National Academy of Design were outraged, fearing they would be forgotten. That fear was not unfounded, as Mrs. Force first helped artists she had supported with exhibitions at the Whitney. Luckily for Edith, the Downtown Gallery artists were near the top of the list. "Suddenly they set up a project called the Public Works of Art Project," said Ben Shahn, who was thirty-five years old in 1933 and had exhibited at the Whitney Museum in 1932 and 1933. "I was on salary for two weeks before I knew why." Painter Dorothy Varian, who had exhibited in Paris in 1920 and had had a one-woman show at the Downtown Gallery in 1932, was summoned from her summer home in Woodstock, New York. She had planned to spend the winter there, an effort to economize even though her upstate cabin was not insulated against cold. "Juliana put us all on, and I was one of the first ones," she said. "I put an easel and a folding bed in my car and came to New York at once." Stuart Davis raced back to the city from Gloucester, Massachusetts, and artists Joseph Pollet and Yasuo Kuniyoshi also made the first cut.

After just one week at her posting, Juliana Force—who operated with the same alacrity as President Roosevelt in rolling out the New Deal—had signed up eighty artists. But soon the focus of the PWAP narrowed, and Mrs. Force was ordered to hire the artists who were considered the most talented—not just the most impoverished. The government didn't want to support amateurs, artistic poseurs, and hacks. Mrs. Force added more established artists such as Charles Sheeler and William Zorach to the roster, though Zorach agreed not to take any government money because he had an income from teaching art that exceeded the $60-per-month eligibility limit. The artists were overjoyed to be able to focus on art making, and close to 2,000 murals, easel paintings, and sculptures were created during the first four months of the project. The best were shipped to Washington, D.C., for an exhibit at the Corcoran Gallery of Art. At the last minute, paintings considered too controversial were excluded (including works by Ben Shahn and Stuart Davis), but the show still achieved its aim—to prove that the PWAP had been a worthwhile expense. President and Mrs. Roosevelt toured the show for over an hour and gave Mr. Bruce word that artists would figure among the beneficiaries of future New Deal programs.

Just four days later, in the basement gallery of a red brick townhouse on a narrow leafy street in Greenwich Village, Edith stood before her artists confident that though the PWAP had expired, government help would continue. She held her annual artists' meeting on October 28, 1934, at 8:15 p.m. The meetings were usually occasions for socializing and camaraderie. Kuniyoshi usually made a motion that there weren't enough parties. On this night, the mood was sober. Edith took center stage and told the roomful of artists that they were gathered together to collectively decide if there was any point in continuing to run the Downtown Gallery. From her perspective, it didn't seem possible.

By 1934, five years into the Depression, Edith finally admitted to herself that she needed to make some changes. It was no longer possible to take care of all the hungry artists prowling around Greenwich

Village. Trying to sell art by well-established artists was hard enough. Selling work by young unknowns was impossible. Museums and collectors weren't willing to help. Making matters worse, instead of uniting artist and dealer, the dire conditions were forcing the factions apart. Artists complained endlessly to Edith about the lack of sales and objected to paying the gallery's 33 percent commission. Being abandoned by the artists was even worse than being abandoned by the buyers. Edith had had enough.

"Artists are always worried about what [sic] gallery makes in sales, and ask that commissions be reduced. Since artists resent the fact that we take commission and since we are having a tough time, perhaps we are just working under the delusion that we are useful," she told the group. "Maybe we should retire from the picture." She dispelled any notion that she might be getting rich from the gallery. The gallery expenses totaled $18,000 a year, she explained, including various baseline costs such as rent, advertising, salaries, shipping costs, postage, news clippings, electricity, printing exhibition catalogs (shows were held every three weeks), and phone bills. Edith would only break even on gross sales of $54,000, "which is impossible at this time," she pointed out.

Joseph Pollet proposed turning the gallery into an artists' cooperative. "Nothing is worse than a business run by artists," Marguerite Zorach chimed in. "Have we any alternatives?" asked Niles Spencer. "Get after the museums," said Edith, repeating a plan she had already proposed to Mrs. Rockefeller and Robert Straus, head of the National Recovery Association. "Have Roosevelt send out letters suggesting that museums set aside funds of twenty percent of unrestricted purchase funds. This would take care of the established artists, with reputations. It would not take care of the younger artists but it is much more important to continue art that has already proved itself of importance."

She couldn't do it all herself, she told the artists. If she lobbied for these policies, "they would immediately think it a racket to make money for the gallery." Other dealers were suspicious that Edith

cooked up these plans out of self-interest, an allegation that had angered Edith during the First Municipal Art Exhibition earlier that year. Her efforts may well have appeared self-serving, Edith knew, but she had to do something—if it was up to the others, nothing would be done.

Ben Shahn called for a petition to be written on the spot. "How could this appeal be made effective within a reasonable amount of time?" asked Stuart Davis. Others just wanted Edith to know she was appreciated and shouldn't close up shop. Painter Dorothy Varian made her allegiance clear, stating that the "gallery is of utmost importance no matter what and should continue." But Edith hadn't called the meeting merely to vent her frustrations. She had a plan. "We are planning—because of conditions—to reduce our list of artists considerably, limiting ourselves to a small group of outstanding painters and sculptors," Edith wrote Sheldon Cheney, a drama and art critic in Berkeley, California. "With this arrangement we can do better for each artist as we feel morally responsible to keep the really important ment [sic] comfortable. Our pioneer work in establishing younger artists will have to stop for the time being." Edith, efficiency expert, had spoken.

Edith had begun to formulate a survival scheme. She realized the younger artists, whose work was unmarketable during the Depression, would be better off depending on a steady government check than irregular gallery sales. Whatever profits Edith eked out needed to be directed toward the more established artists. It was only through her own ingenuity that there were any profits at all. Edith found ways to turn nothing into something; her supreme selling skills saved the gallery. Her most recent coup was convincing a group of trustees from a new museum in Kansas City, Missouri, that they ought to collect folk art. The new William Rockhill Nelson Gallery of Art (now the Nelson-Atkins Museum of Art), founded in 1930 with money donated from a local newspaper publisher, was established without any art—just a budget to buy—and it was one of the few museums doing much collecting during the Depression. Trustees

erected an impressive Greek temple of a museum and aimed to make
it a miniature version of the Metropolitan Museum of Art, surveying
the greatest hits. Edith was furious to hear that the museum trustees
had decided to buy only European Old Masters—the sort of costly
high-brow thing the Joseph Duveen was delighted to supply. Up and
down 57th Street, Chinese urns were plucked from deep storage, and
statues of lions were dusted off at gallery doorways.

Still, Edith went out to Missouri for the museum opening and
became friendly with the trustees. She soon persuaded them to buy a
hauntingly beautiful 1820s painting that she had titled *After the
Bath*, by a long-forgotten artist, Raphaelle Peale, for $2,500. Edith
had bought the painting three years earlier from a Connecticut deal-
er who resold things to New York dealers. She had purchased primi-
tive paintings from him in the past, but on this occasion, he presented
her with a muddied canvas, obscured by varnish that had darkened
to a deep brown. Beneath the layers of grit and grime Edith saw a
large white sheet, nearly filling the canvas, and a mysterious female
nude lurking behind. She was impressed with the surrealist quality of
the painting and paid $75 for it.

She sent it off to David Rosen, her trusted restorer, who uncov-
ered Peale's signature. Edith didn't know who this Peale was, but she
recognized the painting as extraordinary. She waited for the right
buyer willing to pay what she believed the Peale was worth. When
she convinced the Kansas City museum to pay her $2,500 price, she
couldn't resist laying on the sales talk, even after the deal was done,
noting to Paul Gardner, the museum director, "frankly it just about
broke my heart to part with this picture." The painting, which is now
considered the well-known nineteenth-century artist's best known
work, is worth at least $10 million today.

Most of Edith's income came from sales of smaller works. In May
1934 Edith held her annual $100 spring cleaning exhibit, selling
twenty-two paintings and sculptures in the first week. The sales
resulted partly from Edith's aggressive letter-writing campaign, tar-
geting important clients, but a flattering article in *Time* magazine

pushed them well above average. *Time* described the exhibit as "the most spectacular '$100 show' the city had ever seen," noting that works by Bernard Karfiol, Charles Sheeler, Peggy Bacon, Yasuo Kuniyoshi, Marguerite Zorach, Niles Spencer, and others were not "studio remnants" or "unwanted leftovers." The article began with Edith's booming voice: "Why should the distribution of art differ in any way from the distribution of food or automobiles? We've been snobs and so have the artists. . . . To buy a picture you had to be a millionaire. . . . But now even the millionaires are chary," said Edith. "The artist doesn't want luxury. He can live well on $5,000. But the American artist has to rely on the American public. Foreign markets are closed to him. The answer is mass distribution."

Edith was very protective of her ideas, so she couldn't have been thrilled to see mention of three other galleries tucked at the end of the article, earning mention merely for their copycat tactics. "For the first time in its history, swank Seligmann Galleries had a contemporary U.S. show priced from $10–$250; Valentine Gallery offered Louis Eilshemius watercolors from $50–$75; Ferargil Galleries exhibited unrecognized U.S painters, selling their works for $5–$50."

Another influential Halpert show, tailor-made for the Depression era, presented cigarette holders, book jackets, wall paper, tumblers, and salt-and-pepper shakers—all designed by Downtown Gallery artists. "Practical Manifestations in American Art" featured nine gallery artists and ran the last two weeks of December 1934. "The PWAP program has been suspended. Public enthusiasm does not yet bring practical results. How is the artist to continue?" Edith asked in her exhibit program. The answer lay in "finding new channels for their talents."

The gallery was divided into cubicles for each artist, where a painting or sculpture of the fine art variety was compared with his more practical output. Stuart Davis contributed dress fabric, Robert Laurent made alabaster jewelry, and Yasuo Kuniyoshi designed wallpaper and silk fabric. Charles Sheeler was praised for his Steuben tumblers, Marshall Field drapery fabric and coffee service, ash tray,

and salt-and-pepper shakers manufactured by the Revere Copper and Brass Company. Over the next decades, Edith negotiated licensing deals for her artists—O'Keeffe and Davis designed silk scarves, for instance—and always chased down copyright fees. She was probably the first American dealer to print on every sales receipt that the copyright was held by the artist and gallery—not the purchaser.

Even more indicative of the times was Edith's willingness to compromise her principles to make a sale. Edith believed that collectors and dealers had no place telling an artist how to do his or her job. Yet when Baroness Hilla Rebay, an artist and, more importantly, the art curator for collector and mining magnate Solomon Guggenheim, made suggestions on how to improve one of Stuart Davis's paintings by making it even more abstract, the artist obliged. Rebay was buying "non-objective art," or abstract art, for the Guggenheim's forthcoming museum, which would open three years later in 1937. Davis delivered *Seine Cart Composition* to Mrs. Guggenheim, who paid $150 for the painting.

Later that week, Edith tried to expand on this goodwill. She wrote Mrs. Guggenheim, whose art collection featured European abstractionists such as Wassily Kandinsky and Edith's old friend from Paris, Robert Delaunay. "Mr. Davis was very much impressed with Baroness Rebay's ideas and is hoping to continue his experimentation during the coming summer," wrote Edith, exaggerating Davis's enthusiasm for painting to please the Baroness. "As you probably know it is very difficult for an artist to make experiments and to sell at this time. The public is far more interested in the easily recognizable more superficial type of art." After indulging in a few lines of flattery, Edith asked Mrs. Guggenheim to sponsor Davis. For $500, Mrs. Guggenheim would receive a selection of future works. With Edith unable to afford Davis's monthly $50 stipend, it was imperative she find a way to for her artist to survive. Mrs. Guggenheim declined.

Edith had more success with seventy-year-old Alfred Stieglitz, who decided to give Edith more latitude to exhibit his artists. (He had

already been consigning artworks to her since 1930.) Edith claimed she was the only dealer who got such a deal; other dealers were forced to buy the artworks outright. Perhaps Stieglitz favored Edith because she had met him as a teenager, but more likely it was because she had sway over Mrs. Rockefeller. Edith received preferential treatment, but Stieglitz limited her supply and generally refused Edith's requests to lend art for museum shows. Edith believed that was a mistake, convinced that promotion through museum exhibits was one of the best ways to build her artists' careers. Still, she was thrilled to get her hands on Stieglitz's star artists.

Edith and Stieglitz had long disagreed on pricing. Stieglitz insisted on high prices, while Edith remained true to her proletarian roots and set rates in reach of the middle-class buyer. But the Depression had forced even Stieglitz to compromise. Edith's success at selling works, most recently Marins and O'Keeffes to several wealthy Detroit clients, including Robert Tannahill, and her success with the First Municipal Art Exhibition seemed to convince Stieglitz of Edith's talents as a dealer and as an appropriate agent for his artists. They met with O'Keeffe and made a selection of works, priced from $400 to $4,000—low enough, Edith hoped, to lure the Downtown Gallery clientele. Edith agreed to take full responsibility for the paintings, not to exhibit them outside the Downtown Gallery, and to pay Stieglitz a 25 percent commission. On October 24, Edith accepted a consignment of $21,000 worth of John Marins, fifteen watercolors, and four drawings under the same terms. "Mr. Stieglitz, as a result of last season's activities, has officially appointed me his representative, and next season we shall have the precious works of Marin and O'Keeffe below the Mason Dixon line," Edith wrote Tannahill. "I feel as if I have received the American legion of honor [sic]. It is all very amusing."

With Marin and O'Keeffe assured spots on her fall roster, Edith began a campaign to weed out some of the younger artists. At the same time, she lashed out at a few of the old guard whom she felt were blaming her for the lack of business. "All the artists are becoming mean and nasty with their reduced incomes and I, myself, am pretty

impossible," Edith wrote her Ohio friend and customer Mildred Lamb. "If the boys do not behave, I think I shall take up dancing."

Another problem arose as the artists, becoming fearful about their financial futures, united in organizations that advocated policies with which Edith could not comply. One of the most important groups, the American Society of Painters, Sculptors, and Gravers, with 128 artist members—headed by Downtown Gallery artist Bernard Karfiol—passed a resolution to demand a rental fee from museums. The organization, whose aims were simply "some equitable economic returns for the individual artist," was reacting to the "large number of artists" who "have suffered to an extreme degree." They proposed a rental fee of 1 percent of the price of each artwork, per month, with a minimum of $1 and a maximum of $10 per month. Edith sympathized with the artists, but her difficulties trying to sell museums artworks—or garner support for her artists—convinced her that the plan was doomed. Indeed, museums refused to pay rent, and Edith recommended the rental policy be dropped. Doing so did not win her fans among her artists.

The tension soon emerged as Edith lashed out. "For some time I have been conscious that you have a very disgruntled feeling which seems to be concentrated on the gallery rather than on the situation in general," Edith wrote Ernest Fiene, a forty-one-year-old painter who had joined the gallery in 1932 and whose credentials included studies under Leon Kroll at the National Academy of Design. "I can well understand that you would like to have a great many sales. So would all the other artists, to say nothing of myself. We make every conceivable effort to induce collectors to buy and certainly in your case we have not let down for a moment." Edith reported his recent sales, which totaled $3,515 in 1934 and $1,279 for the first half of 1935. Edith said she hoped they could continue to work together, provided they can "clear the atmosphere." She continued: "It is very difficult for me to work in an unwholesome atmosphere and I should very much like to straighten out the matter to your satisfaction and to mine."

The same week she wrote her long-time friend, sculptor Robert Laurent, remarking on the recent chill in their relationship. "Frankly, I have been greatly puzzled by your change in attitude since last summer when both you and Mimi [Laurent's wife] not only expressed your appreciation but were exceedingly hospitable and continued the friendly feeling which I always believed existed," wrote Edith. At the time, Laurent objected to paying a gallery commission on a sculpture job, and Edith was unable or unwilling to see the situation from his perspective. "The change is very sudden, unexpected, and unexplained."

Even her patience with Stuart Davis had begun to wane. She had nurtured his talent through seven lean years with little hope of selling his paintings. By 1933, Davis was broke:

Dear Mrs. Halpert,

I am stranded in Gloucester. Can you help me to overcome this unfortunate situation. [sic] There is no baloney about the primary statement. I have every respect for the fact that your gallery is doing very little business and that it is impossible for you to make any payments. However if you can develop some dough it is a matter of the first importance to me. I have made some interesting pictures. I hope you have had a pleasant summer without too many letters like this,

Sincerely,

Stuart Davis

Edith was unable to help. "The reply was also postponed as I had hoped to include a check rather than write you a tale of woe. I find however, that it is impossible for us to send any money this week as we have just been obliged to pay a large sum of money on our mortgage which we had to scrape up by practically holding a gun to the delicate sides of several persons who still have a few dollars saved from the NRA [National Recovery Administration] program." Two years later, the levity was gone. By May 1935, Davis was furious

Edith hadn't kept up with the payments and considered leaving the gallery. He was deeply involved with several artists' rights organizations and felt he was being mistreated.

He demanded reports itemizing gallery sales, and Edith let him have it. Since 1930, in nearly five years, the gallery had sold just $2,553 of the works Davis himself owned, all prints and those paintings he kept that were not contractually bound to Edith. Of the works Edith owned, for her nearly $5,000 investment she had recouped just $1,185. "I am calling this to your attention as you seem to be harboring the idea that we have 'Done you wrong,'" wrote Edith.

> In our recent conversations you have been rather short and naturally I found that rather difficult to take. I do not know of any other gallery in this country, a gallery which is not subsidized, which knowingly would take a financial risk such as we took. We made the investment with the full realization that this was not a money making scheme. We did this only because we believed in your work and felt we were in a position to encourage American art at the time. . . . The fact that the type of painting produced by you may be first rate but is not a popular commodity is something you must take into consideration strongly. The cycle of public interest does not include abstraction and in spite of all the activities to create that interest we have not been very successful. . . . Also, will you be good enough to advise me of your decision regarding the future as I feel that we should have a very clear understanding without any resentment involved.

By this time, they were both brimming with resentment. In October, Edith received a letter from Davis's lawyer demanding $450 remaining on Davis's contract and threatening a lawsuit. Since she couldn't pay the full amount, she offered to return some of Davis's artworks instead. Davis was working on the Works Projects

Administration (WPA) mural project and receiving a government check, so his fight with Edith was not just about money. He was furious that she appeared to be plotting to change the gallery and hadn't even consulted with the artists. "I also thought it highly irregular and unbusinesslike for an organization to put into effect a change of policy effecting its constituents without having the common courtesy to inform those involved," Davis wrote Edith. "The situation even brought about bad feeling among the artists themselves, because it was said, that a small group of the regular Downtown Gallery exhibitors had formed a group with your cooperation with the objective of pushing the other exhibitors out."

The rumors Davis had heard were partly correct. Edith was planning to reduce the number of artists, but she was not ready to share her plan. Instead, she got defensive. "You have deliberately misunderstood and misinterpreted every gesture on my part," she wrote him on January 2, 1936.

> In spite of a full explanation on my part regarding the reasons governing my desire to show your work and to arrange for a subsidy you colored this in the most fanciful manner and insisted that my motives were not only dishonorable and unidealistic but also greedy and stupid. The fact that I resent all you have said and have written has been made obvious by my silence. . . . To sum this up, I can see no object in making any explanations. The only point I wish to stress is that there is no sensible reason for continuing any relation where there is wilful [sic] misunderstanding on one side.

Edith was not conciliatory. In fact, she wanted Davis to leave. She couldn't and wouldn't admit defeat. In 1936 Davis broke from the gallery and attempted to sell his own works, approaching collectors and museums directly. Davis wasn't the only artist ready to leave the Downtown Gallery. The Zorachs were agonizing over their finances. During the first nine years the Zorachs had been with the gallery, they

had felt part of something important, part of a family. During the summertime, Edith had visited them in Maine and considered them confidantes. Marguerite, a radical feminist and working mother, was a role model as a strong independent thinker who was highly capable and creative. The Zorachs were older than Edith, from Sam's generation, and famous in the small Village art scene. They shared Edith's interest in folk art, having collected it themselves, and allowed the influences of these American ancestors to permeate their own artworks. Zorach devoted a chapter in his 1967 autobiography *Art Is My Life* to Edith:

> Edith Halpert was always full of ideas and projects. She didn't have to depend on anyone. She did not follow in the footsteps of others; she did not take the easy way of promoting and selling European art where the path was clear and well trodden. She set out to promote American art because she believed in it and realized that if this country was ever to have an American art it had to come out of American artists and not out of American collections of European art. This she made her goal and she has stuck to it with a single-minded devotion. American Art owes her a great debt.

Despite their mutual admiration, by 1935 the Zorachs were worried. In September, they returned from Robinhood Cove, Maine, with little money or hope. "What are the chances at the moment of selling a Zorach masterpiece?" Marguerite kidded Edith. "Because the Zorachs are stuck. By Oct [*sic*] 1st we'll be quite broke and we've got to have 300 [*sic*] for Tessim [son] for college and a few hundred to begin life in New York. We'll have to get it somewhere. I don't know where, myself and I don't like to bother Bill if I can help it simply because it would paralyze him and he couldn't work." Edith promised to hit up one of her "pet clients," who had admired *Shells and Things*, one of Marguerite's "embroidered tapestry paintings"—as she called them—but had said he was suffering from "tax pains" and

unable to buy it. Edith said she would offer it to him for $300, instead of $350. For the Zorachs, $300 was not nearly enough.

Edith considered the Zorachs's work to be important, especially Bill's monumental sculptures, which she struggled to sell. Edith also strove to sell Marguerite's labor-intensive tapestries, but there was little demand for the work. Her embroidered compositions, created using handmade wool stitched on linen, were hailed as a new form of art. She was a self-taught sewer and invented an array of swirling, cross-hatch switches that allowed her to create shadows on blue jeans and the bulky contours of a pot-bellied stove. The embroidery suited Marguerite especially well while she had children. "You see painting is continuous, and more fluid than this sort of thing. You just sustain a mood," she said. "This [embroidery] can be picked up or put down at will. It is more precise and you must have time to think your effects out well ahead of time."

Apart from the three-year commission to make the tapestry of the Rockefeller family in Maine, Zorach sales were few. From 1929 to 1936, Edith sold $21,630 in oil paintings, watercolors, drawings, and tapestries by Marguerite, mostly in income from the tapestry commission. Bill's statues were also a hard sell. Collectors simply didn't know where or how to install the sculptures. The larger works, which took years to carve, were too monumental for private homes, yet museums weren't interested. From 1929 to 1936, Edith sold $27,265 worth of paintings and sculptures by Bill. The Zorach household earnings totaled $48,895, or about $8,150 a year. That was plenty during the Depression, but without the prospect of another goodwill Rockefeller commission, the Zorachs were worried. Bill felt he and Marguerite would be better off trying to sell their own work and keep the one-third commission due to Edith. Reluctantly he let her know.

"I cannot go on any longer on hopes or promises," he wrote her. "You will be sore at me, I know—but for years it's been schemes and hopes and promises and nothing has happened. Our savings are gone and I am not going to let anybody or anything get me down. I feel

that I have given you enough opportunity to prove that you could sell my work and you have proven to me that it is hopeless." Zorach put these words down, but waited several months before mailing the letter. He was reluctant to cut ties with Edith, but convinced it was the right thing to do. "My feelings for you will always be the same and I hope your friendship for me will always be the same," he wrote. "Its [sic] just that I have to call our present business relationship quits."

Edith was crushed. In addition to the Zorachs and Davis, Ernest Fiene and Alexander Brook had also dropped out. Although she knew she couldn't sell enough to support all the artists, she felt abandoned. During this tough period, Edith was unable to ask for help, and she didn't have anyone she could confide in or trust completely. She wasn't close with her sister Sonia—though they grew closer later on in the 1940s—and she didn't want to burden her mother, who had remarried. Nor is it likely that she confided in Sonia's daughter, Nathaly, who was just fifteen years younger than Edith and sometimes helped out in the gallery. Even her string of lovers during the 1930s never met all her needs, nor did she give the same effort to any relationship that she gave to the gallery.

It's not that she lacked for romantic attention. After Edith's relationship with Eddie Cahill ended, Edith was courted by Dr. Nathaniel Uhr. Nat, who was Edith's mother's doctor, was smitten with the passionate and vivacious art dealer who, he quickly discovered, lived for her work, not her man. He was gentle and kind and as supportive as possible, lending Edith companionship and petty cash when she needed it. He was open about his feelings and told Edith how he longed for her when they were apart. "Thursday night was heavenly. I went home with a light heart and a feeling of well being. And why—because I love you," Nat wrote Edith. "I think of you a thousand times a day and frequently at night too."

In Edith's first two major relationships, first with Sam and then Eddie, Edith had been the stronger partner; she took care of their emotional and financial well-being. Nat had more independence. He appreciated Edith's character and professional aspirations, and he

wasn't jealous of her successes. He was always trying to take care of her, reminding her to cover her car when the weather was poor, to rest, and to relax. That was not what Edith wanted, however, and a year into their relationship she abruptly told him as much. Nat was so distraught that he was unable to work or sleep. Not only had Edith rejected him, she had rejected him for another. "I must and shall accept the fact—the most important of all—that you do not love me and that you love Charles Sheeler very deeply."

Sheeler's wife Katherine had died of cancer in 1933. Edith had been friendly with both of them, spending weekends visiting the couple at their weekend home in Ridgefield, Connecticut, 20 miles from Edith's summer home in Newtown. They shared a passion for Shaker furniture, and Edith considered Sheeler, a tall, thin, fifty-year-old with gray-blue eyes and a dry wit, to be among the best of the American artists of the era. Sheeler had joined the Downtown Gallery in 1931, after exhibiting with a few galleries, including the Daniel Gallery, where he had a one-man show in 1922. He had also exhibited at the Whitney Studio Club in 1924, but none of it had added up to a living wage.

Before joining the Downtown Gallery, Sheeler had previously earned his living as a commercial photographer, shooting fashion models and celebrity portraits for Condé Nast Publications—work he wasn't especially good at and which he compared to "a daily trip to jail." By 1932, under Edith's guidance, he was able to concentrate entirely on his painting. Edith coached him to drop the photography. There was no market for art photographs, and the photographs made it harder to sell his paintings, which were considered mere copies of his photos. Sheeler had made some remarkable images. Among his most successful was a 1927 commercial assignment to photograph the foundries, cranes, and furnaces at the Ford factory at River Rouge in Michigan—a seemingly banal job Sheeler transformed into some of the most dramatic and romantic images of industrial America. "Sheeler pictured the plant as the Ford Motor Company wanted it seen—as a massive, perfectly functioning machine—while making,

seemingly effortlessly, some of the icons of modern photography," wrote art historian and curator Theodore E. Stebbins, Jr.

When Edsel Ford later wanted to commission Sheeler to make photo murals for a Ford Company pavilion at the 1934 Chicago Century of Progress World's Fair, Edith pitched the notion of painted murals instead. She was reluctant to have Sheeler showcased as a photographer after having struggled to position him as a painter. She even went so far as to tell Ford that Sheeler was no longer interested in photography. Edith knew that was not the case—Sheeler still based many of his paintings on his photos, and she was witness to his private enthusiasm for photography, evidenced by his many photos of her.

Their romantic liaison began in 1934. Sheeler had been depressed since his wife's death the year before. Falling in love with Edith was perhaps a way to pass out of his grief. He was nearly twenty years older than Edith—the same age difference she had had with Sam— but he behaved like a smitten teenager, writing her emotional love letters. "But what I really want to tell you is that nothing in this world does me so much good as a few minutes visit with you, even over the phone," he wrote Edith. "To-day was an outstanding demonstration of the fact. You are the centre [sic] of my life and I live for the primary purpose of offering as a tribute to you all that I hope to do."

His feelings deepened over the spring of 1935. "Dear Sweetie," he wrote to Edith. "It was a very special evening for me from the moment I arrived at 113. You were the dear sweet one that I have carried around in my heart these years. I have never vaulted the moon— but bread and butter are indispensable. Thank you. As ever, Charles." As cool and analytical as his canvases appeared, the inner Sheeler was heating up. "Consciousness of my identity begins to return—I am the fellow upon whom Edith has bestowed her love— that's who I am!" he wrote on July 19, 1935. He even designed a stainless steel pin for Edith with the number thirteen cut out, in honor of the gallery's address. "I am considerably unbalanced yet—

hovering somewhere between the heavens and earth but a perfect landing is assured. No one could have made a prediction, that would have given any credence by me, that I would ever dwell again in such ecstasy and be able to say with such conviction—life is good. From one who has traded in his old, badly worn, deep blues for a brand new arched spectrum. P.S. I really do mean it, don't you?"

In fact Edith didn't. According to art historian Diane Tepfer, Sheeler was so smitten he wanted to marry Edith. Now she needed to extricate herself from the relationship without damaging Sheeler's ego or his desire to produce artwork. "You have a powerful weapon to wield over me . . . on every occasion when some unknown or known reason I have offended you, you stopped working," Edith wrote him. "I had hope and still hope that we can arrive at a balance which will dismiss the thought of marriage, and will bring back the ideal friendship."

Edith didn't have time for Sheeler's infatuation. Her favorite companion was Adam, whom she adored and took wherever she went. A small brown dachshund with floppy ears, who remained defiantly un–house trained, Adam was all she could handle for the moment. She was struggling to sustain her gallery and artists and couldn't handle romantic entanglements as well. Edith arranged a commission with Mrs. Rockefeller to have Sheeler visit Williamsburg, Virginia, for a few months and paint pictures of the newly restored buildings. He would be able to live in one of the Rockefeller properties, have all his expenses covered, be paid for his paintings, and focus on his artwork. Most importantly, he would be out of her way. Edith thought the arrangement was ideal. Sheeler did not. "How about Siberia next?" he wrote Edith from Virginia. "Would you mind sounding out the Lady [Mrs. Rockefeller] for a one-way ticket?"

Edith was not amused. "If you must know, you are a very difficult gentleman to please," Edith wrote.

After being so depressed for financial reasons and being on the verge of taking any old job, this very interesting (at least I

think so) commission was offered to you by a person whom you admire and in whose collection you like to be represented. Williamsburg is a mighty charming place and the lady was very considerate in making all the arrangements so that no expense would be involved for you. While it would be ideal to have you in New York, nothing of this kind offered itself here and I personally thought this was a swell break for everybody concerned. Therefore, I was very much hurt when I received your letter.

Sheeler was disappointed that Edith didn't want him around her, but he overcame his loneliness and got to work. He took hundreds of photographs around Williamsburg and worked on paintings of several main buildings, including the Governor's Palace, Bassett Hall, and a colonial period kitchen. He continued reporting back to Edith, noting his "high class living," with finger bowls at dinner and other Rockefeller extravagances. In 1939, Sheeler remarried, and he and Edith maintained their close professional and personal bond for the rest of Sheeler's life.

After Sheeler's death in 1965—once his reputation was sealed and photography was more acceptable as an art form—Edith tried to find an appropriate home for his trove of photographs. She wound up selling to William H. Lane, her long-time client and Sheeler fan, who paid about $20,000 and understood that he was custodian, responsible for seeing "that the right thing is done with them."

"He absolutely understood that he was going to 'keep them under wraps,'" recalled dealer John Driscoll who worked for Lane from 1978 to 1982. Edith had worked long and hard to create a market for Sheeler's paintings. Photography was something he did to pay the bills—painting was his higher calling, as far as Edith was concerned. She was convinced it was important to keep his photos hidden, lest critics be disturbed by the connection between his paintings and the photographs they were based on.

Lane honored his arrangement with Edith, refusing to lend any

Sheeler photographs for a proposed show at the Museum of Modern Art in the early 1980s. Lane died in 1995 and only recently have Sheeler's photographs of smokestacks, barns, and French cathedrals been exhibited to great critical acclaim. Photography is now an undisputable art form and Sheeler is celebrated by critics and art historians as a pioneering genius of both the canvas and the darkroom.

Edith had all but given up hope on the art business. She decided to get away for the summer, head west, and wander wherever circumstances took her. She had clients in California—actor Edward G. Robinson and collectors Walter and Louise Arensberg—and putting some miles between herself and the gallery seemed like the best way to restore her spirits.

On the way Edith decided to stop in Washington, D.C., and visited her old beau and business partner Eddie Cahill, who had been appointed head of the national artist relief agency, the Federal Arts Project. This project aimed not only to help a select group of professional artists, as had been the mandate of the PWAP, but also to support anyone who considered himself or herself an artist and qualified for relief. *Time* magazine pointed out the obvious drawbacks of such a plan, reporting in an issue that featured Eddie on the cover: "One result was that many an ill-trained dauber, many a demoralized artist whose hand was out, spent the winter of 1935–1936 at a Government easel instead of shoveling snow. First WPA art exhibitions gave critics a chance to pound 'mediocrity' for all they were worth." Edith appeared at the project's headquarters just as things were starting up. Eddie's strengths had always been his charm and sponge-like intellect—not his organizational skills. The office was a mess. "I almost dropped dead! The incoming mail basket was drooling. It was overflowing to the point where the whole desk was covered. It had just slipped off, you know, it wasn't in order," recalled Edith. "Nobody knew what to do. There was no order of any kind, and so I went over the thing." Putting her travel plans aside, Edith plunged right in.

Eddie had been working sporadically for Mrs. Rockefeller when the government agency called upon him. He was not their first candidate. Edith's friend Lloyd Goodrich had been approached to run the organization, but he had declined, preferring to focus on his work at the Whitney Museum. Eddie had not found permanent work since the end of the 1934 First Municipal Art Exhibition, instead writing a play about the Depression, one that was never ultimately produced. Digestive problems had continued to plague him during the early thirties, and a series of stomach operations left his belly looking, Cahill told *Time,* "like a Paul Klee," a Swiss painter known for his wavering jagged lines. The government job offered steady pay, and encouraged by his artist friends, Eddie had accepted.

He offered Edith a job as director of exhibitions, and she began putting the place in order immediately. By 1936, there were 5,200 artists working on the project, all over the country. Some of the art was good and some not. Edith sorted through thousands of pieces, organizing traveling exhibitions that would go out to hundreds of exhibition venues in small towns, converting banks, undertakers' parlors, Elk clubs, schools, and other buildings into Community Art Centers. Exhibitions were shipped off to Columbia, South Carolina; Knoxville, Tennessee; and St. Paul, Minnesota. "These are places where they never saw an original work of art, or but rarely," said Edith. Finally Edith was getting her chance to help bring art to the average American.

Edith focused on what she did best: ferreting out talent and making new discoveries. Within weeks, she was completely immersed. She came up with systems to rival her prime years as an efficiency expert, creating charts to track traveling shows and ranking artworks (A, B, C, or D) based on technical ability. She wrote reports, documenting that 1,087 items were sent out in less than two months, with another 575 artworks ready to be shipped. Edith understood the value of these regional shows. They not only introduced art to new corners of the country, towns lacking museums or art schools, but also served as a publicity machine for the Federal Arts Project. The exhibits proved

that artists on relief weren't sitting around, cashing government checks. They were hard at work.

Edith remained in Washington during the week, flying back to New York on weekends to attend to gallery business. The Washington work made Edith feel reborn. "I am so stimulated by the events, so greatly cheered by the prospects that I am full of pep and ready to lick the world," Edith wrote Marguerite Zorach, with whom she had remained friendly. "After two or three years of being an unwanted mistress, I have found a place where I am needed, and where I feel that I am an integral—if mighty small—part of the great scheme. A new world has developed while we in New York were weeping for the old. I almost wish that I could accept the invitation to stay here indefinitely, but I still belong partly to the old order, and am coming back—but rejuvenated and clear as to my next steps. . . . And now that so many artists have deserted me in one way or another, I have recovered a sense of absolute freedom instead of the sense of failure which I harbored."

Her enthusiasm for the project soon had her working at an unhealthy rate. Edith was unable to pace herself, and again, was on a path to self-destruction. She rose by 7 a.m. and was at her desk by 8, quite a jump on her usual 10 a.m. The Washington, D.C., heat was relentless, and she watched sweat droplets roll off her body onto her paperwork. In order to get the regional shows readied, she worked fourteen hours, pushing her thirty-six-year old body to the limit.

The strain began to show. When Eddie criticized her work on a particular exhibition, she was livid and wrote him a letter saying she planned to quit as soon as she had seen out the projects she had begun. Organizing a selection of works for an exhibition at the Museum of Modern Art—called "New Horizons in American Art"—had become "a nightmare," with too little time for proper coordination and little cooperation from the regional directors, who ignored her demands. "And if I am to be used as a target for the general inefficiency and belated planning, it is ridiculous," she fumed. Eddie used his charm to try and calm Edith down. "I think we have all been over

nervous and over worked," he wrote her in a telegram. "Why not rest a few days then shake hands. . . . I believe you have always done a swell job."

Edith continued consulting until December, but her involvement tapered off toward the end of the summer as she refocused her energies on the gallery. In the fall of 1935, she had agreed to pay Bee $5,000 (to be paid in monthly installments) for her share of the gallery, making Edith the sole owner. Though Bee had been mostly a silent and felicitous partner, Edith wanted the gallery to herself. She operated best on her own, both in business and her personal life. Now she began thinking about moving the gallery uptown, both to signify the status of the gallery and to allow for a fresh start. But lacking the funds to make such a move, she decided to reconfigure it instead. She would divide her gallery—and her artists—into two distinct groups. The Daylight Gallery would be devoted to her six most established artists, all born in the nineteenth century and expected to appeal to the experienced, wealthy collector and museums. These artists, including Charles Sheeler, Bernard Karfiol, Robert Laurent, and Yasuo Kuniyoshi, were united by their "integrity, continued development and high standard of achievement," Edith wrote in a gallery brochure. Two other artists Edith was extremely proud to have on her roster, "through the courtesy of An American Place," were John Marin and Georgia O'Keeffe, whom Edith continued to sell on Stieglitz's behalf. All these artists had won prestigious awards, were included in important museum collections, and had been written on by important art historians. They were Edith's starting lineup.

The other half of the gallery was born of the WPA. Edith selected thirteen artists—twelve men and one woman—all relative unknowns and in their twenties and thirties, from the thousands of artists whose work she had reviewed on the Federal Arts Project. She created three small gallery spaces to show their work, aimed at the younger generation of collector, what Edith boldly proclaimed was "art for the people," and "at prices within the most modest budget." A brochure was printed for the occasion, celebrating this scrappy and eclectic bunch.

Headshots and brief cheerful bios described each artist's eclectic history. Stanford Fenelle "painted portraits of prize dogs, and hobby breeds and exhibits cocker spaniels. Also breeds and trains homing pigeons. Now is supervisor in the Federal Art Project, Minneapolis." Among David Frendenthal's qualifications were that he "lived [sic] entire year on [sic] average of $5.00 a week, spending $1.00 for [sic] fee in life class." His work experience included stints as a "grocery clerk, waiter, manual laborer in automobile factories, and as deck hand on [sic] freighter." Other artists included Gregory Prestopino, O. Louis Guglielmi, and Mitchell Siporin—all residing in New York— Jack Levine from Boston, Rainey Bennett from Chicago, and Edmund Lewandowski from Milwaukee. Edith assigned her youngsters bargain prices ranging from $15 to $100. At any price, these young artists were all thrilled to have been plucked from obscurity for representation at New York's prestigious Downtown Gallery. Edith again restated her original mission, to exhibit art of quality, not fad. "Since 1926—in the short period of a decade—America has seen many 'vogues.' We have passed through the French boom, the Mexican reclamé, the American Scene revival. Today, with American art interest at its height, a sense of what is 'enduring' has been reached."

She promoted the show with her usual flair, writing to her regular clients and those she wished to rope in—Edward Warburg, Marshall Field III, Paul Mellon, Edith Wetmore, and Sam Lewisohn—and also writing to Mrs. Roosevelt, urging her to visit the gallery and purchase a work by one of the young artists, "all products of the Federal Work Project," to "start the ball rolling." Edith mentioned that her motivation for taking on these younger artists was to make them self-sufficient and to help them move off the government payroll. Mrs. Roosevelt wrote back that she would visit the gallery in December and would be glad to buy a picture. Overall, forty works by the younger artists were sold, many prints priced under $10 going to old clients such as O'Donnell Iselin and Helen Resor, an advertising executive at a Madison Avenue advertising agency owned by her husband. Edith arranged to send the show to the Grand Rapids Art Gallery in Michigan.

. As 1936 ended, Edith was overjoyed to be back in business. Depression or no Depression, she was confident she would make it. Mrs. Rockefeller gave her $75 to pay for an annual Christmas party for the artists, a sum that covered fifty people at $1.50 a head. As usual, Mrs. Rockefeller wasn't invited. Edith wanted to give the artists a really good time.

Despite the flurry of end-of-year sales, the day-to-day activity was not enough to keep the gallery afloat. In the late 1930s, Edith searched for creative ways to keep profits coming. She tried scheme after scheme, hoping to hit on another winner as lucrative and consistent as the folk art sales had been during the early 1930s. One of the most potentially lucrative deals was an exclusive contract to sell Elie Nadelman's huge folk art collection. Nadelman's wife had lost her fortune in the stock market crash, and now the couple needed to liquidate the collection they had bought for hundreds of thousands of dollars, a museum-sized trove of thousands of items made by untrained artists from around the world. Edith and Nadelman agreed on a price for the entire collection in the range of $200,000 to $300,000. Edith hoped Mrs. Rockefeller might be interested, but she declined. She had already cherry-picked pieces from the collection, brokered by Edith, and had always resisted the high prices demanded by the Nadelmans. Besides, ever since the Diego Rivera incident two years earlier, Mrs. Rockefeller's enthusiasm for collecting had dimmed. "During the last year I have missed very much my visits to 113 West 13th Street," Mrs. Rockefeller wrote Edith. "They always are a great pleasure and I might say temptation to me, but I have thought it best to save my strength and restrain my inclination to buy pictures."

She didn't have the space anyway. In 1938 Mr. and Mrs. Rockefeller moved to an apartment at 740 Park Avenue. Their old home was torn down to make room for an expanded Museum of Modern Art, and the move to smaller quarters forced her to restrain her

buying. Edith spoke with her on the phone soon after the move, and Mrs. Rockefeller mentioned that her favorite quote was "Blessed is he who has nothing." "But I finally convinced her that 'it ain't so,'" Edith recounted to Anna Kelly, Mrs. Rockefeller's secretary.

Mrs. Rockefeller was in the mood to divest herself. In 1935 she donated most of her collection to the Museum of Modern Art: 181 paintings, drawings, and watercolors. Her gifts ultimately numbered more than a 1,000 works, though many were prints. She also gave Alfred H. Barr, Jr. $1,000 to spend on art during his summer sojourn in Paris—the museum's first unrestricted purchase fund. The gift of her collection was honored with an exhibition, but she modestly avoided the opening, traveling to Boston instead. According to art historian Wendy Jeffers, Barr wasn't impressed with the artworks Mrs. Rockefeller had acquired from Edith, sensing the dealer hadn't encouraged her wealthy client to buy the best wares. Perhaps Barr didn't understand that Mrs. Rockefeller bought as a patron first and collector second and that she didn't go to the Downtown Gallery in search of masterpieces; she rarely spent more than $500 on any individual artwork.

Mrs. Rockefeller, the art collector, didn't remain unnoticed for long, however. In January 1939, *Time* magazine put her on the cover, wearing a demure black dress, a simple strand of pearls, and a tilted hat. The article detailed her history as an art collector and her role as one of the founders of the museum—a fact that few people knew. "The pictures she acquires and the gifts she makes are all done with such skillful reticence that few recognize her for what she undoubtedly is: the outstanding individual patron of living artists in the U.S." The article also mentioned her "special agent," the "handsome, grey-haired Edith Halpert," a public affirmation that Edith doubtlessly enjoyed.

Edith did continue to benefit from sales to the younger generations of the Rockefeller family. Although she was unable to sell them Nadelman's collection, Edith did sell a collection of forty-two pieces of Shaker furniture to Blanchette Rockefeller, future president and chair of the Museum of Modern Art's board. The collection came

from Juliana Force. "Mrs. Force is greatly in need of money at the present time and we convinced her that it would be much more advisable to sell the Shaker collection as a group rather than break it up in single items at higher prices," Edith wrote Blanchette. "No similar collection can ever be assembled as this—with few exceptions—represents the cream of the Shaker tradition." Edith billed Blanchette $10,000 and arranged for delivery to the Rockefeller country estate in Pocantico, New York. Edith disclosed the identity of the seller to her buyer, but she did not tell Mrs. Force the name of her buyer. Edith was always tight-lipped when negotiating for her rich clients, particularly the Rockefellers. Her discretion was one of the reasons the Rockefellers did business with her for so long. However, according to Mrs. Force's biographer, after the sale, when Juliana heard the collection had been bought by Rockefellers, she decided Edith had not gotten enough money for the furniture. Juliana Force had never really liked Edith, finding her self-serving and duplicitous. Both women were iron-willed. Though she didn't say so, it must have been a disappointment not to have had Mrs. Force's approval. Edith always chalked it up to jealousy.

Edith also hit up prominent wealthy collectors she didn't know for sales—often introducing herself by letter, tossing aside any and all social conventions dictated by polite society. Edith offered philanthropist Paul Mellon folk art discounts, tried to sell Vincent Astor a ceramic penguin (she had read in the *New Yorker* of his affinity for the birds), and offered a figurehead to railroad heir Archer Huntington, who was starting a marine museum. But all these efforts didn't add up. Sales were grim, and now there was the added weight of war in Europe. Although Edith kept her politics to herself, the fact that the Nazis had stripped modern art from German museum walls—Alfred H. Barr, Jr. shared this news with Edith early on—and much worse, were launching new attacks on their Jewish population, must have upset her. In the fall of 1938, 1,000 synagogues were set on fire, 7,000 Jewish businesses and homes were looted, and 26,000 Jews were sent to concentration camps—a grim reminder of the pogroms

Edith had fled as a young girl. In September 1939 Germany invaded Poland, launching World War II. The world events only added anxiety to an already dark time.

Edith needed another windfall. And in April 1939 she got it, holding one of her most profitable shows to date. She introduced an unknown artist whose paintings quickly sold out, commanding thousands of dollars from museums and collectors. Critics raved over the discovery, and Edith dangled her inventory like jewels before collectors' glinting eyes. She had stumbled upon her ultimate sugar daddy. The only one not able to relish the instant fame and fortune was the artist himself. William Harnett, Edith's newest star, had been dead for nearly fifty years.

Edith first saw Harnett's work in 1935 when a scout or runner showed her a most unusual canvas. Edith was accustomed to visits from dealers, pickers, and other treasure hunters who scoured junk shops, church sales, and country auctions for rare treasures. The painting was astonishingly lifelike, a remarkable rendering of a rusty pistol dangling upside down on a nail. The composition was sophisticated in its simplicity but humble in its elements: just a cracked green door, a few bent nails, the inverted pistol and a peeling newspaper clipping. Edith knew immediately that it was huge find. "This is the most extraordinary canvas we have located in all these years, aside from the Peale," she said, referring to *After the Bath*. A date and signature appeared on the lower left corner. The year was 1892, about 100 years too late to qualify as folk art, by Edith's definition. Besides, this painting reflected the hand of a skilled artist who had certainly studied at the academy.

A slip of paper stuck to the back of the painting, cut from an old exhibition catalog, listed the artist's dates and academic credentials. Harnett had studied at the prestigious Pennsylvania Academy of Fine Arts and the National Academy of Design, as well as shown at the Paris Salon and the Royal Academy of London. The title of the painting, written on the reverse, was *The Faithful Colt*, a play on the artist's verisimilitude and the loyalty of a Colt gun to its owner.

Edith knew where she could sell the painting. In the middle of the Depression, it was not easy to pluck sales for unknown artists out of the air—but Edith knew this work deserved a big price and that it had a natural home. The very next day she wrote a letter to Everett Austin, director of the Wadsworth Atheneum in Hartford, Connecticut. Hartford was home to the Colt Patent Fire Arms Manufacturing Company. In 1905, the Colt family had donated a wing to the museum and thousands of artworks and historic firearms to fill it. Edith told Mr. Austin about her discovery and that she knew it was a perfect fit for his museum. Confident, she went ahead and packed up the painting and shipped it off for Austin's consideration. She asked $475. After a quick negotiation, she sold it to him for $300.

That launched a search for other Harnetts. "We are trying to locate other examples by this artist, 'the acknowledged head of still life painting,'" Edith wrote Austin. "One of our agents is on the trail of a Harnett which was originally the main decoration of a beer saloon on the lower East side." Edith spread the word among her scouts or pickers that she wanted Harnetts, and they slowly dribbled in from antique shops, dealers, and estate sales. By 1939, she had stockpiled over a dozen. Harnett appeared to have been completely forgotten—no recent books, no articles or scholars had analyzed his extraordinary talent for still life, which rivaled the great Dutch still life painters of the seventeenth century. When she was ready to present Harnett, Edith mounted a solo exhibit, "Nature-Vivre," a play on the French art history term "Nature-Morte", which translates as "still life," or literally as "dead nature." Edith playfully dubbed her show *alive* nature, which was exactly the sort of force that swept through the gallery.

A successful show at the Downtown Gallery usually began well before the art went up on the walls. Edith was a master at pre-selling. She targeted potential Harnett admirers and mailed them letters announcing her latest find. "For five years I have scoured the country for the work of an extraordinary painter who died in 1892,"

Edith wrote a trustee at the William Rockhill Nelson Gallery in Kansas City. "I am planning a one-man show in April to introduce this unknown master, and to provide myself with old-age security. Meanwhile, I am giving you an inside tip to buy early and to buy cheap. Need I say more?"

Edith also targeted a circle of high-profile art world names as possible early buyers, hoping that closing a few of those would give others confidence to buy the unknown artist. Alfred H. Barr, Jr. was immediately bowled over. Admiring a small painting, *Old Friends*, with a candlestick, books, a pipe, and a mug, he decided he wanted it for his own collection. He also wanted a dazzling larger one, *Old Scraps*, for an upcoming exhibit at the museum. A few days later, Edith pushed Barr to commit, letting him know that other clients had offered $250 for *Old Friends*. Since Barr was Barr, Edith was willing to part with it for $175, her usual inducement for museums and other important buyers. She also offered a deep discount for the museum on *Old Scraps*, chopping the $1,500 price down to $750. There was room to negotiate with the Harnetts—Edith had bought them for so little. "Please do not interpret this as sales pressure," Edith wrote. "I have an excellent reason, obviously, for wanting a Harnett in the Museum of Modern Art, and one in your private collection; therefore the great reductions in price."

A week later, by the opening of "Nature-Vivre," Edith reported to journalists, clients, and anyone who would listen that Harnetts had already found homes with Smith College, Alfred H. Barr, Jr., and Nelson Rockefeller. Before long, she could add many more names to her sales list, including wealthy collectors such as the Edsel Fords and Mrs. Gates Lloyd, surrealism dealer Julian Levy, and songwriter Jack Lawrence. Nelson Rockefeller was the most enthusiastic, snapping up three Harnetts, including *Old Scraps*, which he donated to the Museum of Modern Art. He gave another Harnett to Conger Goodyear as a retirement gift on taking over the museum presidency in 1939.

Critical reaction was equally strong. "This discovery will make Dali

die," wrote the *New York Sun*'s Henry McBride. The *New York Times* echoed Edith's own proclamations, calling Harnett "a master of the trompe l'oeil still life" and "a remarkable painter." The Harnett show was a virtual sell-out and went on tour to the Detroit Society of Arts and Crafts, the Arts Club of Chicago, the Howard de Young Museum in San Francisco, the Nelson Gallery in Kansas, and the Portland Museum of Art in Oregon.

With the Harnett profits stabilizing the gallery balance sheet, Edith decided to take advantage of her success and finally go west. A large exposition was on in San Francisco. Meanwhile, there were rich art collectors in Los Angeles who needed attention. In June she arrived in Los Angeles and visited Edward G. Robinson—to whom she delivered her Harnett sales spiel—and Louise and Walter Arensberg. Edith also visited San Francisco and the Golden Gate International Exposition. The fair, celebrating the construction of two of the world's longest suspension bridges, included dozens of exotic pavilions from countries such as Japan, China, and Brazil. Edith also visited the San Francisco Museum of Art, where she saw paintings by Yasuo Kuniyoshi and other Downtown Gallery artists.

Edith had planned several meetings with museum officials and local artists in the Bay Area and had intended to go back to Los Angeles en route back to New York. But at a bar in Carmel she made a new discovery, a muscular photographer named Raymond Davis. Raymond was thirty-eight years old, a year younger than Edith, with large blue eyes, a strong nose, and wavy blond hair. Though he was 5 inches taller than Edith, he was no match in terms of accomplishments. His schooling had been limited to elementary school in a Boston suburb. That only added to his appeal. Unpolished and unrefined, Raymond had an earthy masculinity that magnetized Edith. He had some money saved up, he said, and he had no attachments in California. He said he was ready to move to New York with her and start all over.

"Yes, I gave lots of people a shock, or should I say a surprise—including myself," Edith wrote a friend. "I am very happy that for

once I acted spontaneously. Raymond Davis is the name. He is hand-some (I think so), blond and a large guy. His profession is somewhat allied but his tastes are not. He is an industrial photographer. Modern and folk art amuse him and I am perfectly satisfied with our differences of opinion. We have great fun." Something about Raymond made him urgently desirable, and though no marriage certificate was located, her employees believed they wed soon after meeting.

Perhaps their fast union was grounded in a sexual connection. "I always had the impression that Edith was rather naïve about sex," wrote Charles Alan, who worked for Edith starting in the mid–1940s.

> That she had several affairs was common knowledge. Not as widely publicized was her second marriage. . . . One had the feeling that she was disconcerted, distrustful of the men with whom she had intercourse, was constantly seeking motives, quite as she could never comfortably receive a gift from any-one, even though she herself was generous. . . . In spite of her Bohemian exterior in her youth, and her flamboyance in later years, she was basically quite puritanical and easily shocked. I can remember an evening with several artists and their wives when Yasuo Kuniyoshi, who had just received them from a friend arriving from Tokyo, showed around a number of Japanese pornographic woodcuts. As they were passed to her, Edith glanced at them shyly and then passed them on without comment. That display of those woodcuts stimulated a lengthy and playful discussion of oral and anal coitus. Edith listened in silence, unusual for her. Then pointedly rising to mix herself another drink, stated primly: 'I think the old-fashioned way is best,' And, like a scolded schoolboy, Kuniyoshi replaced the woodcuts in their cardboard roll.

Edith and Raymond returned to New York and went to New-town, where Edith immediately resumed her work, writing curators

at museums in Boston and Wichita, searching for sales. The honey-
moon was short-lived. At first Edith didn't mind Raymond's drink-
ing. Edith was a heavy drinker herself, ending each day with the
relaxing clink of ice cubes in a glass tumbler. Alcohol made Raymond
destructive. One day he borrowed Edith's car and crashed it into a
tree. Initially Edith was blind to Raymond's rough exterior, ignoring
the scars on his cheek and forehead, his missing teeth, and the
"R.A.D.," his initials, tattooed on his right arm. Edith had finally met
a strong man, she probably thought, an adventurer who had criss-
crossed the country, making a living with his hands, working as a
garage mechanic, and later, improving himself by training in photog-
raphy. She admired that.

But soon Raymond's past caught up with him. There was a war-
rant out for his arrest for grand theft, and worse, Edith wasn't Ray-
mond's only wife—there were two others. One of them had accused
him of stealing her money and running away. Court papers revealed
that Ida Lembcke Davis, whom Raymond had married in January
1939—accused him of stealing $3,340 ($48,658 in 2006) in cash,
pretending he planned to use the money to start a photo business.
Instead, in June, he had met Edith and deserted Ida and their home
in Santa Ana, California. Raymond was married not only to Edith
and Ida. In 1931, he had married a woman in Oakland, California,
Elsie Arfsten Drake, using the alias Richard Drake. They had a
daughter. By 1938, Elsie had filed for divorce on grounds of deser-
tion, but the divorce had not been finalized, at least not by the time
he wed Ida.

On December 26, 1939, a day after Christmas, Raymond turned
himself in at the sheriff's office in Santa Ana and pled guilty to three
counts of grand theft. He was sentenced to one to ten years in San
Quentin Prison. When asked his motivation for the crimes, Raymond
answered "stupidity and plain damned foolishness." When he applied
for probation the following year, he listed Edith among his references.
The probation officer's report summed up Raymond's position. "He
states that for the past twenty years he has been leading a useless and

criminal life and it is now his desire to make retribution for his crime. [sic] He further states that during the past few months he has been using intoxicants to excess."

As for Edith, she tried to erase Raymond Davis from her life. Many of her friends said they never heard Edith mention her second husband. The marriage was annulled; the whole episode lasted less than six months. Letters arrived regularly from San Quentin Prison. Though Lawrence Allen, Edith's secretary, opened all the gallery mail, he was instructed not to open those letters.

If Edith's personal life couldn't get any worse, her professional life seemed equally low. "Needless to say, conditions in the art world have been very bad, and it is only within the past few weeks that there has been a slight pick-up," Edith told a friend. "The New York market has been blotted with works of art presumably sneaked into this country by German refugees. The prices have been horribly low and so have our spirits."

The slight pickup was the return of Mrs. Rockefeller, who spent more than $6,000 on folk art paintings in October for Colonial Williamsburg. Her purchases included *Boy with Finch* for $1,750, later dated to 1800 and attributed to John Brewster, Jr.—one of the many masterpieces Edith plucked from obscurity. Only later scholarship would identify these itinerant artists and give them their proper place in the art historical hierarchy.

In October, Edith also succeeded in selling the Museum of Fine Arts in Boston three watercolors by John Marin for $500 apiece. When Charles Cunningham, the assistant curator of painting, came to New York to see the Marins, Edith suggested the museum ought to have a Harnett as well. Within a week, Mr. Cunningham asked Edith to ship him the three Harnetts she had shown him at the gallery, including *Old Models*. It was by far the largest Harnett Edith had ever seen, measuring over 4 feet long and nearly 2.5 feet wide. The unusual scale has suggested to scholars that it was painted to exhibit at the 1893 World's Columbia Exposition. The picture depicts a Dutch jar, a bugle, a violin, and some dusty books and sheets with

musical notes against a cracked green wooden cupboard. In typical Harnett style, each object shows considerable wear, from the cracking around the base of the jar to rips in the pages of yellowing musical notes.

Old Models was not only monumental in size, it was Harnett's last effort as a painter, completed shortly before his death. In the fall of 1892, Harnett went to Arkansas to visit the hot springs, hoping for a cure for his various sicknesses. In October, he was found outside his studio at 40 West 30th Street, slumped in a coma. Two days later, he died at New York Hospital. Harnett left no will, five paintings, and $500 in cash. His art was sold at auction, including *Old Models*.

On December 9, 1939, the Museum of Fine Arts in Boston voted to buy *Old Models*. With one sale, Edith cleared $4,000. Suddenly she was in a position to do what she had been thinking about for the last few years. She would move the gallery uptown.

10

Uptown at the Downtown

DURING HER FIRST fourteen years in business, Edith had established her reputation as a trailblazer and a tastemaker. She had long ago ceased being the girl with the gallery. At forty years old, she now had the appealing earthiness and elegance of a confident, middle-aged dame. Her hair had softened to a flattering shade of gray, set off by her light blue eyes and thick dark eyebrows. The contrast between the light hair and dark brows, which had caused her so much grief as a girl, now gave her an air of originality, earned by those who have lived long and full lives. Her face was now slimmer, and two deep crevasses framed her mouth whenever she smiled or smoked, which was often.

Though youthful and still able to turn heads—with her high cheekbones, shapely legs, and the enduring sparkle in her eyes—creases had emerged on her neck, and the flesh under her eyes was weighed down with decades of hard worry and work. Edith was a woman of importance and intrigue in New York art circles. She was a force all her own, and she believed the success she and her artists had achieved deserved a grander home—a home uptown.

Edith was eager to go canvas to canvas with the other top-draw establishments, all of which were concentrated around 57th Street and up and down Madison Avenue. There were those devoted to the Europeans, such as Wildenstein, Julian Levy, and Pierre Matisse. The venerable American art galleries—Babcock, Kraushaar, Milch, Ferargil—were also clustered nearby. The gallery scene hadn't grown much during the lean 1930s, but the selling business had become firmly entrenched in midtown and on the Upper East Side. Greenwich Village remained an artists' haven, for homes and studios—not commerce. Of the 150 commercial Manhattan art galleries listed in the 1940 Manhattan phone directory, only two were situated below 14th Street: the Downtown Gallery and ACA Gallery, founded in 1932 and located across the street from the Whitney Museum on 8th Street.

Edith had begun to consider leaving the Village as early as the mid-1930s, both because she felt the best of the bohemian era was long gone and because she was filled with a desire to start anew. She wanted to leave behind fresh memories of artists breaking with the gallery. With the disastrous collapse of her second marriage in the fall of 1939, Edith more than ever yearned for change. She had all she needed in male companionship: Adam, her rambunctious yelping dachshund, who adored her for her dog biscuits and rewarded her with loyalty a man would never provide. For the moment, she was through with romance.

There was also the matter of looming debts. On January 9, 1940, Edith received a letter from the collections department at Vanderbilt University. The university held a $9,700 mortgage on her building, and the letter indicated the note had been past due since January 19, 1933. There was a second $21,000 mortgage on the property, held by the man who had sold Edith the building in 1926. By 1940, the building was worth only a fraction of what Edith had paid in 1926. Edith tried to refinance but couldn't find a bank willing to lend, and was too proud to ask her wealthy clients for help. As usual, her money woes provoked physical symptoms. At the beginning of

February, Edith's doctor ordered her to rest, and she went on a two-week cruise in an effort to regain her strength.

In early April, Edith leased the gallery space to a nonprofit artists' organization. She also found tenants for the other three apartments and hired an agent to manage the building. She began trying to unload as much as possible before the end of May, when she had promised to vacate. She donated art magazines and prints to the Clinton State Prison in Dannemora, New York. She contacted dealers who had taken works on consignment and urged them to buy at discounted prices. She met with her lawyer, who drafted documents to dissolve her partnership with Eddie in the American Folk Art Gallery. They divided the inventory, which had cost $8,594 to buy, each selecting about $3,400 in folk art objects. The remaining $1,693 would be consigned to Edith for sale in her new gallery. She rented space in a warehouse to store her portion during the move.

"Before closing, I am planning a sale to dispose of all stock owned by the gallery," Edith wrote Alfred H. Barr, Jr. on April 12. "This will be a real 'removal sale,' although banners to that effect will not cover the windows in keeping with the Broadway procedure." Edith notified her museum contacts, dealers, and private clients that art would be going cheap and for a good cause. To encourage bulk buying, she said she would establish a special artists' fund with 40 percent of the proceeds of sales. Artists would receive 50 percent, with the gallery keeping just 10 percent. She didn't say what she planned to do next or hint at the fate of the Downtown Gallery: Edith knew a mystery made good copy.

She drummed up a steady stream of smaller sales, nothing too big or important, but she did manage to clear out some inventory. Mary French Rockefeller, who was married to Laurance—Abby's middle son—selected a $400 watercolor by Charles Sheeler (*Autumn Leaves*), a $75 oil on paper by Jules Pascin, and a $25 watercolor by Preston Dickinson. Playwright and director Moss Hart bought $900 worth of folk art, and Edith threw in a Pennsylvania Dutch flower drawing as a gift. The Fogg Art Museum in Cambridge paid $60 for

a tempera by Raymond Brenin. Edith also consigned six paintings to auction at the Plaza Art Galleries on East 59th Street, scraping up a mere $28 for two minor oils by Stuart Davis.

Edith's other significant project, in addition to moving, had to do with Mrs. Rockefeller's folk art collection in Virginia. In 1935, Mrs. Rockefeller had lent her collection to Williamsburg, where it was installed in a 1755 two-story brick mansion, the Ludwell-Paradise House. Now, four years later, she was donating the collection, and Edith helped promote the news, landing an article in *Vogue* magazine, where Frank Crowninshield credited Mrs. Rockefeller as the instigator for the current "vogue of these primitive paintings," which had assumed "almost menacing proportions." On principle, Edith objected to putting folk art, the majority of which was created by untrained New England artists, in an entirely wrong historical context. "Williamsburg is phony," she later said, which could be considered a tad hypocritical, as most of the folk art she sold was cleaned, reframed, and tarted up plenty. But worse, she felt her humble friends would be out of place in the grand southern setting. "You don't send folk art to the Governor's Palace!" said Edith, referring to another building on the Williamsburg grounds.

Edith didn't have nearly as congenial a rapport with the Williamsburg officials as she had with Mrs. Rockefeller. Now that the collection belonged to this separate entity, sales would have to go through the bureaucracy of a museum. "As you know, any further purchases for the folk art collection will be made by Colonial Williamsburg and not by Mrs. Rockefeller," wrote James Cogar, a curator at Colonial Williamsburg. "We should like to know whether, in the future, we could have some agreement with you, as we have with a number of other dealers, that the purchases which we make would be sold to us at cost plus ten per cent."

It was but one of numerous occasions when Edith's commission was challenged. Mrs. Rockefeller had objected to paying commission on the Zorach tapestry commission, and later, Nelson Rockefeller would object to paying the dealer's commission when he hired

painter Rainey Bennett to travel to Venezuela and make paintings for Standard Oil. Both times Edith stood firm. Once again, she justified her fee, this time to Cogar:

> Frankly, for many obvious reasons, I have always been opposed to the cost-plus system. My reasons are based from the point of view of the seller as well as the buyer. You know how the system works, no doubt, as countless incidents have been publicly aired in the last twenty years. Even the most honest dealer is under suspicion regarding billing, and I prefer to have the purchaser make his decision on the basis of ultimate value to him, regardless of the profits or losses taken by the owner. As a definite rule, we always purchase objects we like outright, taking the entire risk financially, with the hope, of course, of making a profit ultimately. At the moment we have countless paintings and sculptures which we have been unable to place. The cream has always been offered to Mrs. Rockefeller both for personal reasons, because of her superior taste, and because of my sentiment for the collection.

When she heard about Mrs. Rockefeller's gift, she contacted B. W. Norton, head of Colonial Williamsburg, suggesting angles and contacts for publicity pitches to *Art News*, *Fortune*, and *Art Digest* magazines: "May I suggest that you play up the entire collection as the only public collection of its kind in this country (or elsewhere)."

Mrs. Rockefeller hired her to spiff up the installation, and Edith received a gracious note, along with $300, for her services. Norton asked Edith if she would contribute to a catalog on the collection. She agreed and set about writing a foreword and descriptions for the 251 limner paintings, schoolgirl velvet paintings, weathervanes, decoys, and whirligigs. Over the winter and spring she worked on the text. Norton asked her to shorten the introduction, move her name to the end of her essay, and substitute the word "colonist" for "immigrant,"

so as to "avoid any suggestion of class feeling and also the use of words that have certain unpleasant connotations."

After months of onerous back and forth, she was paid $250 for her work. She felt underpaid and underappreciated. Her introduction had been shortened, and the project had taken up valuable time. The printed catalog, a slim green volume with a color cut of *Boy Holding a Finch* floating on the cover, was ultimately a fine testament to Edith and Mrs. Rockefeller's collaboration. The aggravation became somewhat more bearable when Edith received a note from Mrs. Rockefeller. "I am perfectly delighted with catalogue and proud of what you have done, and very grateful," she wrote. "You have made a real contribution to the understanding and knowledge and appreciation of early American painting in this country—a contribution which I personally think no one else was prepared to make."

With the remaining Downtown Gallery inventory locked in storage, Edith went to Newtown—her base of operations while she embarked on the search for her new location. By August, she had found it: a six-story limestone mansion at 43 East 51st Street, near the upscale 57th Street gallery row but far enough away that she would maintain her independence. It was one of three identical buildings, with sloping steps, sturdy columns, and refined classical touches, and Edith was amazed to find that rent was just $4,000 a year. The block's grand buildings were originally built as homes for wealthy New Yorkers but had been gradually abandoned from 1910 to the 1930s, as the rich moved uptown to more fashionable areas or had just plain died off. The grand corner property, actually six linked brownstone palazzos surrounding an interior courtyard— today the Villard Houses—had once graciously sheltered railroad moguls and a woman with seventeen servants. By 1943, the building was repurposed as the Women's Military Services Club, a deluxe crash pad for ladies in the service at a cost of 50 cents a night. By the time Edith was house hunting in 1940, the block was sleepy and deserted. "This really was a ghost town," Edith later recalled. Madison Avenue was half a block away, as were the glorious spires of St.

Patrick's Cathedral, and down the block, dominating the skyline, the peaks of Rockefeller Center. Proximity to the heart of Rockefeller family operations was highly desirable. Edith was also amused at the prospect at setting up shop in the shadow of the Catholic Church headquarters. She couldn't wait to see what the priests thought of her art.

The new building had much more space than Edith needed. The first and second floors would be allocated for the gallery, and the third floor would be designated for Edith's apartment. There were two upper floors, which Edith would sublet to a bridge club for $2,400 a year, shaving off more than half of her rent. The windfall from the William Harnett sale was more than enough to cover her costs.

"At the time the Old American galleries were moving from palaces into furnished rooms," she later recalled, "but the Downtown did uptown big." Edith did not view her move uptown as a bid to join the establishment: she felt that she could be near—still a quarter-mile from 57th street—but not lose her individuality. Besides, if the facade of 43 East 51st Street reflected the staid tastes of an older generation, its interior would embody the modernity her artists stood for. Edith hired an architect and set about telling him what to do.

The ground floor would be given over to a permanent Folk Art Gallery. A wide staircase wound up to the second floor, where a large rectangular room with a fireplace and parquet floors would be reserved for the older established artists, including Charles Sheeler, Yasuo Kuniyoshi, and Julian Levi. With the moldings and other turn-of-the-century Stanford White–style decor ripped out and just a simple metal bench and a glass ashtray placed in the middle of the commodious room, Edith made the old look new. In an adjacent space painted with blue slate walls, she would hang her younger WPA discoveries, including Jack Levine, O. Louis Guglielmi, and Mitchell Siporin.

Edith found a fabric company willing to experiment and create a shiny wall covering called "Metalush," made of a metal netting that concealed nail holes and didn't sag. (Edith retained the patent.) She

installed hanging fluorescent lighting, taking advantage of a technology that had only been commercially available for two years. The *New York Times* called them "troughs of light," providing "a new color element designed to make up for the absence of ultra red," repeating Edith's pseudoscientific spiel.

Edith invited the critics for an early peek. "Edith Gregor Halpert's sure instinct for showmanship, which has been the envy of her art dealer contemporaries, reaches new heights this month as the Downtown Gallery reopens at a new address," reported *Art Digest*. "The new location for the Downtown Gallery (so called because it is still below the 57th Street meridian) is probably the most outstanding example of a modernized art dealer establishment in New York."

"But the real *clou* or apogee (it might even be called a shrine) of the new establishment is the place Mrs. Halpert has rigged up as the private showroom," wrote Edward Alden Jewell in the *New York Times*. The room, with Deskey's swivel chairs from the Daylight Gallery, had mahogany wall panels and an ornate marble fireplace. "There are several novel features, but the pièce de résistance is her [Edith's] own invention for showing pictures to clients," said *PM Weekly*. "Called Exhibidor, it looks like an ordinary door, but the central panel revolves on a pivot. While the dealer and client sit comfortably, a porter hangs a picture on the outside of a panel, turns it inside and replaces the canvas already seen with another."

Situated in her new digs, blocks from the midtown business district, Edith was ready to usher in a new era of selling—if ever the economy and international political situation should stabilize and a taste for contemporary American art would expand beyond the confines of a world small enough to fit in her new building.

In 1941 Edith continued her busy exhibition schedule with twelve shows. She openly played the provocateur with "What's Wrong with this Picture?" Comprised of seven paintings Edith considered masterpieces, all were nearly a decade old and had failed to attract

buyers. They had collectively been exhibited over 100 times, in many major museums and had been reproduced in newspapers and magazines over fifty times. "Yet these seven pictures are still available! What's wrong with these pictures?" Edith asked in her press release. "This seems to put the picture-buying public on the spot," noted the *New York Sun*. The show included Peter Blume's surrealist landscape *South of Scranton*, a perennially celebrated picture that had won a prize at the prestigious Carnegie Institute. Another mysteriously unsalable painting, Charles Sheeler's hyper-realistic 1931 interior of his Ridgefield home, *Americana*, had been exhibited twenty-five times and reproduced more than sixteen times.

To further her point, Edith handed out questionnaires to gallery visitors, soliciting their critiques and offering their responses, many of them negative, to the local art press. Comments about Blume's work included "outclassed by Dali" and "unintelligible to me," while Sheeler's painting was considered both "too abstract" and "too photographic."

Edith's exhibitions were never about pandering to public tastes. She hung what she liked and what she believed was good, regardless of the response of critics or customers. By 1941, she had plenty of artists to choose from. WPA projects were winding down as the effects of the Depression began to wear off, and America nervously tracked the war in Europe. Young painters and sculptors, realizing the weekly checks might stop at any time, began lining up outside the Downtown Gallery on Friday afternoons, the designated time when Edith would review portfolios. Though Edith had refashioned her gallery to include fewer artists, she was slowly adding to her list, always on the lookout for the next star. She didn't look for the sure thing—art that would be palatable to the conservative tastes of collectors searching for canvases to add prestige and pedigree to their Park Avenue apartments—but for originality. Edith's allegiance from the start, and as she entered her fifteenth year of business, was to find artwork so strong that it simply had to find a spot on her walls.

This ever-elusive originality arrived one day in June 1941, delivered,

along with a slew of overdue bills, courtesy of the U.S. Postal Service. In a thick book bound in hunter-green cloth, Edith found an entire show ready to be plucked from the pages and hung on her gallery walls. The book, entitled *The Negro in Art*, was the latest volume written by Edith's friend Dr. Alain Locke, a fifty-five-year-old Howard University professor. Locke had belonged to the first wave of radical thinkers in Harlem during the 1920s and 1930s, who advocated black pride among artists and writers and spurred the budding artistic renaissance there. (Locke's impeccable credentials included a Harvard degree and the first Rhodes scholarship awarded to a black person.) He was one of the few blacks straddling the segregated art world. Black artists stayed in Harlem, while the area south of 125th Street was for the most part uniformly white. Locke ventured south and started visiting Edith's Greenwich Village gallery at the end of the 1920s. Art was among his passions. While studying at Oxford, he had explored the great European museums and discovered African art was a significant influence for many important contemporary artists. Locke, like Edith, believed art had the power to uplift and felt sure that black art could strengthen the black community in Harlem. Edith welcomed Locke's visits, and her reception was much more open than what he would have found at most of the midtown art emporiums.

Edith did not hide her notions about racial equality from anyone visiting the Downtown Gallery. Lawrence Allen, the black man she had hired through the National Association for the Advancement of Colored People, remained an employee for forty years. Allen was consummately capable, able to handle Edith's emotional ups and downs as well as her torrent of demands, professional and otherwise. He was much more than her secretary, doing whatever needed to get done. He allowed her to dominate him and, for the most part, did not try to assert himself too boldly—Edith's all-controlling nature meant she needed to be unequivocally in charge. She was very strict and unforgiving. In the early 1930s, Edith and Allen had a falling out: Edith accused him of lying and fired him. He later returned to the gallery and asked for his job back. She acquiesced.

During the brief period when Allen was not working for the gallery, he wrote Mrs. Rockefeller, asking her to sponsor a gallery of Negro art in Harlem. Mrs. Rockefeller forwarded the letter to Edith, noting that she had declined the offer. Edith wrote back, condescendingly calling Allen's letter "a masterpiece" and joking, "I feel rather slighted that I was not scheduled to be one of the performers." She did admit that his idea had merit. "On the other hand, I do think it is a good idea to have a gallery of negro art in Harlem. Harlem going art conscious would be a rather interesting event."

Harlem had changed considerably since Edith had lived there. Blacks now outnumbered whites, and by the mid-1930s, Harlem was hard on its heels. Following a riot in 1935 where thousands looted, broke windows, and generally vented pent-up anger, Mayor La Guardia commissioned a report on the area, which described it as dilapidated, with crumbling tenements, broken-down schools, and a rubbish and roach-ridden Harlem Hospital. The "record of discrimination against the Harlem Negro in the matter of employment" was blamed for the "continuous impoverishment of the more than 200,000 citizens of this area." Blacks were restricted from most jobs with the public utilities. The Fifth Avenue Coach Company had a no-Negro policy, while Consolidated Gas, New York Edison, and New York Telephone hired just a few blacks for menial jobs. The common refrain in the report was that black workers were "less efficient than white workers" and that "Whites and Negroes could not work in harmony." There were no blacks in unions like the Commercial Telegraphers Union, the International Brotherhood of Teamsters and Chauffeurs, and the New York Newspaper Printing Pressmen's Union. Even at Wadleigh, Edith's old high school, now serving 30 percent black girl students, "Southern white teachers in the school object to the mingling of white and Negro children in purely social affairs," found the report.

In this milieu of discrimination and misunderstanding, Locke came to Edith, knowing she would help. He was well aware of Edith's influence with collectors, and he occasionally brought her art by

black artists, hoping that she might find something to sell. In 1929, she had picked out some watercolors by Hale Woodruff, who was known for his murals of black life and images of southern poverty, which came to be called the Outhouse School because of the hilly landscapes dotted with outdoor latrines. Edith sold Woodruff's watercolors to Mrs. Rockefeller and corresponded with the artist, who had moved to Paris in an effort to escape the prejudice and racism he encountered in America. She was able to raise nearly $700 from Mrs. Rockefeller to help fund Woodruff's European travels. "These things are much appreciated by those of us who love art but who have little money to promote it," Locke wrote Edith, thanking her for helping Woodruff.

Although Edith had some familiarity with black artists, both from Locke and from her experience working on the WPA projects, she was bowled over by the depth and range of talent that she saw in *The Negro in Art*. Most of the artists dealt with the social strife of the day—blacks suffered enormously during the Depression—but each artist did so with a fresh and unique style. Edith was also astonished to learn about nineteenth-century black artists like Henry O. Tanner and E. M. Bannister, who seemed to have attained a remarkable level of artistry and some recognition, despite the odds. But the current opportunities for black artists were few. There had been just two solo shows by black artists in recent memory. In 1928, the Madison Avenue New Gallery displayed the accomplished portraits of Archibald J. Motley, Jr., a thirty-six-year-old Chicago artist. In October 1940, Bignou Gallery on 57th Street mounted a show of paintings by Horace Pippin, a brilliant self-taught artist.

Inspired by Locke's book, Edith decided to correct this omission, aiming to integrate the art world with an exhibit that would prove how deserving and important the work of black artists really was. Politically charged art was a hallmark of Edith's gallery already; she showed the radical social realists Ben Shahn and Jack Levine, both of whom used their paintings to attack the capitalist establishment. Indeed, Edith had always presented artists operating outside the

white male mainstream. She certainly never promoted European artists and searched for talent outside the Anglo-Saxons, the group that had historically dominated New York's art academies. She represented women artists and Jewish artists right from the start. And now she had discovered another neglected population. The black artists whom she proposed exhibiting took up issues of racial injustice and articulated them indelibly on canvas.

Since Locke had singled out for his book the artists he felt best represented black talent, Edith decided to ask for his endorsement of—and, she hoped, his assistance with—the show. She wrote him a letter explaining how much she had enjoyed his book and admitting to being "woefully ignorant of the background material." She suggested an exhibit that would open in December of that year, one that would bring Locke's artists closer to Madison Avenue and to the art establishment than had ever been attempted before. The fact that Edith's scholarship in the area was weak was not a factor; Locke's credentials were enough to cover them both. Without a college degree or any formal art-history training, Edith was accustomed to learning as she went. She was a reluctant intellectual and shied away from libraries—the quiet halls of book repositories were no place for her, not to mention the fact that smoking was forbidden there.

Locke responded immediately. His enthusiasm was palpable—it was just the thing he'd been waiting for. "I do hope you can arrange the exhibit, and will gladly help to the best of my resources," he wrote. He also singled out a couple of artists he thought Edith might especially like and directed her to a young man he had included in his book, Jacob Lawrence. Two weeks later, Locke came to New York from Washington, D.C., to show Edith photographs of artworks and to take her to the Harlem Community Art Center to see Lawrence's work in the flesh.

Lawrence, a soft-spoken, twenty-three-year-old painter with a wisp of a mustache, worked in a studio building at 33 East 125th Street, which was home to many of Harlem's best artists and writers.

His $8-a-month studio door was held shut by a scraggly piece of string, an illustration of the hard financial times faced by the artist, who had never sold any of his paintings but had survived on piece-meal grants and loans from the Julius Rosenwald Fund and Harmon Foundation. He had spread sixty small panels across his studio floor, each one bursting with primary colors and cumulatively telling a tale of the epic trek that had come to define black experience in the twentieth century, what Lawrence called "The Migration of the Negro." Between the world wars, a million blacks had moved North to escape disease, poverty, unemployment, racism, and the near-certainty of a hopeless future in the South, as industry and jobs continued to move away. It was a story that Lawrence felt compelled to tell. It defined his people and the very circumstances of his life.

Lawrence's parents had migrated north before their three children were born. His father abandoned his mother, Rosa Lee, in

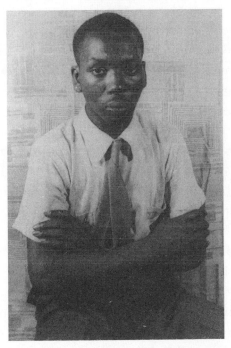

Jacob Lawrence, July 1941.

Philadelphia, and hoping for opportunity, she left her three babies in foster homes while she struck out for New York City. In time, she sent for her children, and they survived in Depression-era Harlem aided by relief programs. Lawrence learned to paint at a series of settlement houses, where he went after school until his mother finished her workday as a housekeeper. (He later dropped out of high school.) The free art classes provided Lawrence with brown kraft paper and poster paints, materials similar to the water-based paints and cheap board he would continue to use throughout his life. The bustling streets, the packed churches, the bars, and the brothels of Harlem would later give Lawrence inspiration for his powerful and poetic images of the neighborhood.

As tough as his images were, his personality was softer and gracious. "His personality is ingratiating," wrote Selden Rodman in a profile of Lawrence. "He is small, solidly built, with an egg-shaped head, the hair close cropped, almost shaven, with a very black and very clear skin. He speaks in a drawl, almost pedantically, as though he were constantly searching for the exact phrase or meaning. He is a little repressed. But when something strikes him as funny, his whole face lights up and the really handsome qualities of his eyes and other features are projected beyond the reticent mask."

By the time of Edith's visit with Locke, Lawrence had already achieved a degree of success. He had found his signature series format, something he applied in an unprecedented scale and size. Other artists, such as Monet with his famous water lilies, had worked in a series format, but Lawrence used the device in a novel way, as a means to narrate his story, like the illustrations in a book. His series of paintings of Haitian leader Toussaint-L'ouverture had been included in an exhibit of contemporary Negro artists at the Baltimore Museum of Art in 1939—sponsored by the Harmon Foundation, whose mission was to support black achievement—where he was deemed a painting prodigy. From the very start, Lawrence used his art to express himself. "A great purpose of art is to communicate ideas. Color and design are only means to this end," he said in a later

interview. "These 'series' suit me best because their subject matter is what I believe in and do best."

Despite these early successes, Lawrence's exhibitions had been restricted to a few left-wing organizations and regional shows of black artists. That did not discourage Edith from thinking that he deserved to be seen by the entire country. From the moment she saw his work, she knew she had discovered a magnificent talent. The next step was for Edith to show Deborah Caulkins, an art director at *Fortune* magazine, photographs of Lawrence's work. On the basis of Edith's enthusiasm, Caulkins made an appointment for Lawrence to come to her office to talk to her about a possible spread in the magazine. When Lawrence showed up at the Time-Life Building in midtown Manhattan with a selection of panels from the "Migration" series, Caulkins, who had commissioned works from several Downtown Gallery artists already knew it was the work she had been waiting for. The plight of blacks relocating from the South was a major story, and all that had been missing was the right storyteller. Lawrence's wrenching images of Harlem tenements, child laborers, and starvation encapsulated the experience in a forceful manner that avoided melodrama. Caulkins chose twenty-six panels for *Fortune* to reproduce in the forthcoming November issue. Edith, who always maximized an opportunity, suggested to Caulkins that the series be exhibited for one week at the Downtown Gallery in November—in advance of the larger group show of black artists—to coincide with the publication, and offered to host a reception for Time-Life executives.

Edith wrote Lawrence the good news, telling him she planned to give him a solo show as a tie-in to the *Fortune* article. Lawrence, who had never heard of the Downtown Gallery and didn't know any of the artists who regularly exhibited in such an illustrious venue, wrote back that he would be happy to accept the offer.

Having made progress in the organization of the December show and having signed up several other black artists to exhibit, Edith closed the gallery for the rest of the summer and escaped to her house in Newtown, bringing her maid and a gallery porter so she might

devote herself to quiet rest. The summer hadn't come a moment too soon, for Edith's energy had been waning for months. Soon after trading her custom-made suits for simple cotton dresses and getting back to her gardening, Edith's forty-one-year-old body gave out. It was as if all the fatigue and strain she had ignored during months of intense financial pressure finally burst, just as she relaxed her defenses. A series of fainting spells and heart palpitations prompted Edith to go to the hospital, and Nat Uhr ordered her to rest there for a while.

Edith was good at plenty of things, but resting was not one of them. She summoned Lawrence Allen to the hospital and gave dictation from bed. In letters to friends, she made light of her condition. She wrote Dorothy Miller:

> In two more weeks, according to these experts, I shall be able to get about a bit. Meanwhile I sit and worry about neglected work. The old mare ain't what she used to be and can't adjust herself to facts. . . . I don't promise to pop off, but one never can tell with my particular swooning spells. The folk art has evidently conditioned me à la 19th century.

While Edith convalesced, plans for the black exhibition took a strange turn. Deborah Caulkins alerted Edith to the fact that someone else was scouting material for a black show, evidently to be held in New York in October, two months ahead of the Downtown Gallery's show. Edith was furious that her idea seemed to have been copied. She dashed off a letter to Alain Locke, asking him to investigate, and Locke wrote back, saying that he had found the culprit. Among the artists whom Edith had contacted regarding the show, there was one from Chicago, Charles Sebree, who, Locke wrote, "I warned you was psychotic." When Sebree heard about the plans for the Downtown show, he suggested an exhibit of black art to Eleanor McMillen Brown, a society decorator whose firm, McMillen Inc., planned to sell an African art collection belonging to Frank Crowninshield, the editor of *Vanity Fair*, and offered to help Brown round

up artists for the show. "So far as I can learn, the project is to put Crowninshield's African Art collection on the market and use the contemporary Negro material for 'local' color," Locke wrote.

Locke knew that Edith might be discouraged from having her show if there were a competing exhibit with many of the same artists. And so he set about convincing the artists that Edith's gallery was the better venue in terms of prestige and exposure. He phoned Peter Pollack, who ran Chicago's WPA-founded South Side Community Art Center, where many of the best Chicago artists, including Sebree, worked, and pleaded for help. Pollack called a meeting with the Chicago artists for the following morning, just hours before a representative from Brown's decorating firm was scheduled to arrive and select works for the other show. At the meeting, Pollack argued that the Downtown Gallery was the more important gallery, that Edith's show would be more serious and scholarly, and that it had the backing of Dr. Locke. There was strong resistance. Some artists had already committed to the McMillen show after hearing about the decorator's contacts with wealthy collectors like the cosmetics tycoon Helena Rubinstein and the assurance that prices would be "marked up fancy." The artists, beleaguered by the Depression, were desperate for sales.

The meeting worked in Edith's favor, though, as Locke reported back to the bedridden dealer in a letter dated August 5: "It is much to the credit of the best of these young artists, many of them half hungry, that in spite of such allurements and Sebree's special pleading, Carter, Charles White and Charles Davis declined to send work" to Brown.

A similar battle took place in New York over the artists who worked in Lawrence's building on 125th Street. In that instance, Locke was there to lobby for the Downtown Gallery show in person, and while some artists, such as Lawrence and Charles Alston, agreed not to participate in the McMillen show, others, such as Romare Bearden, felt obligated to honor the earlier commitment. Locke wrote Edith that Bearden "did not send his new or important stuff; a derivative watercolor or two." Locke also underlined his commitment to the show:

You know my interest in your proposition; and you can count on my cooperation to the utmost. . . . I suppose you have had time to think the whole plan through by now. As I see it, a comprehensive select show will override all possible rivalry the McMillen proposition can offer. Now that you know you have a nucleus of the best painters loyally with you, I hope nothing will dissuade you from going through with your original plans.

Edith, who was possessive of her artists and her ideas, was angry but not dissuaded. She knew that Locke had helped secure the best artists for her show, leaving McMillen with the second tier. Part of Edith's goal for the show, however, was that these artists, whom she believed deserved to be known, would be signed up by other galleries once she offered them exposure. She was still taking a big risk, however: there was little evidence that she would sell any of this "Negro" art, and although plenty of unsold canvases had languished on the walls at the original Downtown Gallery, the stakes were raised at the 51st Street location. Edith needed to do even more than she had in the past to insure sales.

Edith sensed that she could make the art more palatable to her white buyers if she avoided the frequently cited connection to African art, a tactic that ran counter to Locke's theories about the "New Negro" celebrating his or her African heritage (and counter to the spirit of the Harlem Renaissance in general). Edith had no objections to African art and occasionally bought African sculpture for her own collection, starting while she was married to Sam, as was common practice among modern artists fascinated with what seemed primitive and utterly original. She simply preferred to emphasize the connection to American folk art. Edith didn't discuss her marketing strategies with Locke, who had written dozens of essays on the relationship between African art and modernist art, but she did vent her frustration about the McMillen show to Deborah Caulkins in a letter dated August 12th:

Aside from a personal rancor that this group is stealing my particular idea, I also resent the fact that the African sculpture background is brought in as one of my objections was to kill this savage relation with contemporary art among the Negroes. The Early American or Folk art background seemed so much more logical and so much more dignified and so much better for the cause, that I was glad to have your approval and that of the others with whom I had discussed the matter.

With a month remaining in her summer holiday, Edith left the hospital and returned to Newtown to devote herself to reading, gardening, and making plans for the fall season. She wrote to Lawrence, telling him that *Fortune* had confirmed its intention to run his series in November and offering him a spot on the Downtown Gallery's permanent roster. The letter reached Lawrence at a New Orleans rooming house where he had moved with his new bride, the painter Gwendolyn Knight, intending to paint a series on the abolitionist John Brown, supported by a $1,200 grant from the Rosenwald Fund. "I appreciate your offer very much," he wrote back.

Edith continued making inquiries about which other artists should be included in the show; she wanted representation from across the country and needed experts to help her select works that would hold up under scrutiny from Manhattan's seen-it-all art critics. She assembled an informal committee of advisers, including the directors of the Dallas Museum of Art and the Art Institute of Chicago, reviewed photographs, and contacted artists. She knew that she would need to borrow from private collectors as well as from university and museum collections. Robert Carlen, a dealer in Philadelphia who had been a great source for folk art paintings, especially versions of the *Peaceable Kingdom* by Edward Hicks, provided paintings by Horace Pippin.

There was also other gallery business to conduct: she contacted Mayor La Guardia's office, asking him to make an appearance at the "Dealer's Show of American Art," an exhibit on 57th Street targeting

the summer tourist trade, organized by Edith and ten other galleries. Alluding to concerns about America's inevitable declaration of war and with her customary dose of flattery, she wrote that "During this time of chaos, it is most gratifying to find that our most important public officials include in their defense program the consideration of art in all its phases." Edith, in her eagerness to promote New York as the new capital of the art world, wrote to a member of La Guardia's administration, saying that the "Dealer's Show" represented "the first concrete step toward establishing the fact that New York is the ART CENTER of the WORLD today." She continued, "Not only has American art progressed to new heights in recent years but it has also became a vital factor in our living—affecting architecture, American dress design, furniture, gadgets, etc. Many of the famous European artists have made New York their home during the past year." The show attracted some 4,000 visitors during its month-long run in the summer of 1941, but La Guardia was not among them—he was too busy meeting with President Roosevelt on matters of national security. As if the mayor's absence were not bad enough, sales at the show were dismal. With the city's intolerable heat and little attention paid to art buying, Edith hoped things would improve in the fall— with her health, with gallery sales, and with the mood of the nation.

At the beginning of September, Edith returned to the city to prepare for a full fall schedule of six shows, culminating in December with "American Negro Art: 19th and 20th Centuries." After a summer in Connecticut, in spite of her hospitalization, she felt refreshed. She was sleeping better and felt prepared to handle the onslaught of work that would be necessary to make it through the season. Though news of the devastation caused by Adolf Hitler during the fall of 1941 dominated the newspapers and radio, with the Nazis' seizing Odessa in October and ordering Jews to wear yellow stars, Edith remained strangely silent on any personal political views. When it came to art, she was brimming with opinions and never afraid to share them. Outside this confined universe of colors and shapes, she kept her beliefs to herself.

If world events clouded her mood, she didn't mention it to anyone. There were plenty of concrete concerns right there in the gallery. The financial strain that Edith had endured during most of the 1930s continued, especially with the new costs associated with her uptown space. While she sublet the top floors, she still faced considerable expenses. New York Steam threatened to turn off the heat if the bill from the previous year was not paid, and Edith wrote to Consolidated Edison to complain about "the extraordinarily high bills for our water heating." Another major strain was the 13th Street building, which she didn't want to sell. Its value was much lower than the price she had paid in 1935, when she bought out her partner's interest, but now she was struggling to keep up with mortgage payments, since not all the apartments had been rented. The top-floor tenant had stopped paying rent, protesting that the building had fallen into disrepair and that a tramp had taken to sleeping in the vestibule.

But Edith's commitment to the Negro artists' show—in spite of the financial burden it caused—never wavered. She decided to forgo the usual 33 percent gallery commission and create a fund for Locke to use in acquiring works by black artists, which could then be donated to public institutions. She also agreed to cover all the costs of promoting the show and of shipping and insuring the artwork.

With one eye focused on the group show, Edith made some preparations for the "Migration" series preview, Lawrence's one-man show, which would take place in November. At the end of October, she sent out a press release. As one of the first mainstream New York galleries to exhibit a one-man show by a black artist, Edith carefully crafted her announcement—Henry McBride, the esteemed *New York Sun* art critic, always hailed Edith's releases as the best around—to avoid words like "primitive" or "naive," terms that critics used in the rare instances when black artists were reviewed.

The pictures on view may be called an unbiased, factual report portraying the struggles of the negro people. Yet they can by no means be classified as merely sociological documents. They

244 : THE GIRL WITH THE GALLERY

have the dignified beauty and depth of emotion which one
sometimes finds in the traditionally rhythmic work songs of
the negro. The emotional impact is translated into brilliant
color harmonies, set down in broad abstract patterns with
realistic content. Simply, directly, but with dynamic force,
Lawrence achieves a true symbolism, and a [sic] individually
powerful method of making his message known through aes-
thetic means. This young artist brings an original expression to
the school of social content in America.

Deborah Caulkins supplied Edith with a list of thirty Time-Life
executives to invite to the opening, including Henry Luce, the editor
in chief of Time Publications, and his wife, the journalist and play-
wright Clare Boothe Luce, who lived just a few blocks from the
gallery, at the Waldorf-Astoria. But, as the opening drew near, Edith's
fatigue returned, followed by the fainting spells. She went to the hos-
pital for more testing, and Nathaniel Uhr came to the gallery in per-
son to give her the results. He could find no physical explanation for
her symptoms. Over the summer, doctors had assured Edith that her
symptoms were not a product of stress alone and that there was truly
something wrong with her, and she had gone along with their diag-
nosis, even though she thought the fainting and sleeping problems
were probably just a result of too much work. Now she was beside
herself that she had been misled. She wrote Nat:

I feel much better knowing that I can look a soda in the eye
without blanching. What I regret, however, is that five months
of what should have been a creative period (in a minor sense,
of course) just disappeared from my life; that I got into the hair
of my best friends; and that I haven't done right by my artists
and American art. The loss of earning power during the period
is of less importance. Today, I must confess that I am very sorry
that I did not follow your advice to have the hospital check up
months ago. But like many other regrets in my life, these will

Sam Halpert often used Edith as a model for his paintings, as he did here for *Interior (the Dressmaker)*, 1921.

Portrait of Edith by Sam Halpert, mid-1920s.

Marguerite Zorach's risqué *The Picnic*, set in Maine, circa 1928. Edith is depicted in a blue dress, sitting between her lover, Eddie Cahill, the rakish figure with the mustache, and Marguerite, in red.

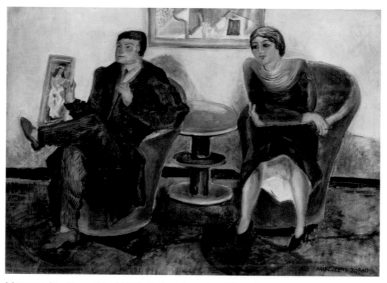

Marguerite Zorach's *Edith Halpert and a Client* features Edith in her Deskey swivel chair in the new Daylight Gallery, circa 1930.

Egg Beater No. 4 by Stuart Davis, 1928.

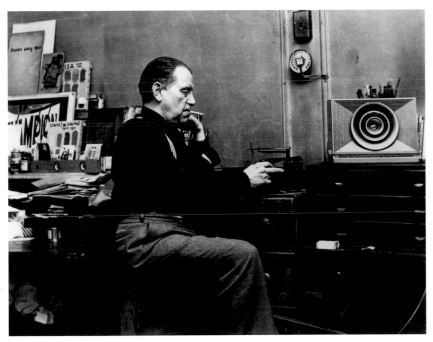

Stuart Davis's art was inspired by his passion for jazz. Davis in his studio, circa 1951.

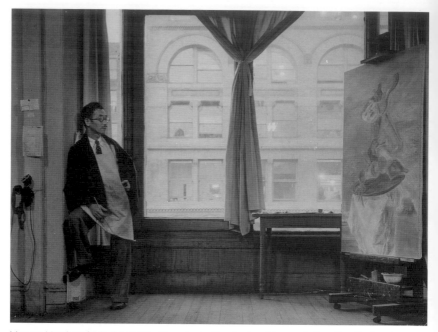

Yasuo Kuniyoshi in his 14th Street studio during his work for the Federal Works Project, circa 1940.

Yasuo Kuniyoshi's 1927 *Self-portrait as a Golfer.*

LEFT Edith sold Abby Rockefeller *Boy with a Finch* in 1939 for $1,750. The painting was later attributed to deaf itinerant artist John Brewster, Jr. and is now part of the Abby Aldrich Rockefeller Folk Art collection at Colonial Williamsburg in Virginia. RIGHT Profits from the sale of William Harnett's 1892 *Old Models* gave Edith the funds necessary to finally move the gallery uptown.

Electra Webb bought the TOTE weathervane from Edith in 1941. It is now considered a masterpiece of Webb's Shelburne Museum in Vermont.

Portrait of Charles Sheeler by Edward Steichen, circa 1932.

River Rouge Plant by Charles Sheeler, 1932.

Installation shot from the American Negro Art exhibit of 1941. Panels from Jacob Lawrence's "Migration" series hang above Edith's desk.

Jacob Lawrence's *The Migration of the Negro, No. 57: The female worker was also one of the last groups to leave the South*, 1941.

Ben Shahn's wartime *Italian Landscape*, 1943–1944.

Georgia O'Keeffe, circa 1960.

be removed from my consciousness soon, and will merely add another small dent to my corrugated subconscious.

On the night of November 3, with Lawrence's sixty panels filling the main gallery, a steady stream of Edith's clients and the Time publishing crowd filtered into the gallery. A short review in the November 15th issue of *Art News* reported:

The Downtown Gallery has launched the work of a talented young Negro artist, Jacob Lawrence, who in sixty panels tells us the story of his race's struggle with present day conditions. . . . It is a story of disappointments and race antagonism, of problems and eventual rewards, and Lawrence tells it so dispassionately that it carries conviction. This young artist . . . has an exceptional flair both for the most direct means of expression and for fine vigorous color pattern.

Lawrence remained in New Orleans during the show, but Edith wrote to him, telling him that the pictures looked "remarkably well," and that "there is a great deal of enthusiasm, but we have not made too great an issue of these as we want to save excitement for the large show of Negro art . . . we decided to hold off on the real fire works until December." The artist was pleased to hear about the review and the *Fortune* article—something he later recalled as the most exposure he had ever received—which began by describing the painter as "a young negro whose work promises to earn for him the same recognition accorded to Paul Robeson, Marian Anderson, W. C. Handy and other talented members of his race."

Edith rehung the "Migration" series in her office after the week-long show, making room in the main gallery for another exhibit. Several clients had expressed interest in buying individual panels, but Edith and Lawrence had agreed to try to keep the series together. She hoped that the appropriate buyer might emerge during the group show in December. Her next task was lining up a committee

of influential people for the December exhibit, especially names she could include on the invitation to the opening-night party, which would serve as a benefit for the art fund (tickets were $5). Letters trickled in from people whom Edith had invited as honorary sponsors. Mayor La Guardia and Eleanor Roosevelt accepted, as did the collectors Mrs. Rockefeller, Edsel Ford, Mrs. Henry Morgenthau, Jr (the wife of Roosevelt's secretary of the treasury), and Adele Levy, the daughter of Julius Rosenwald (who had made a fortune with Sears, Roebuck, and whose foundation supported black artists, including Lawrence). Locke assembled cultural luminaries, among them dancer Katherine Dunham, singer Ethel Waters, actor Paul Robeson, poet Countee Cullen, writer Richard Wright, writer Carl Van Vechten, and writer/poet Archibald MacLeish. It was a star-studded crowd.

While crates of artwork—containing seventy-five paintings, prints, and sculptures from fifteen states—began arriving at the gallery, Edith continued to fill out the roster of artists. She traipsed around the city, climbing up Harlem tenement stairways and making studio visits. She was determined to keep the show's quality high. It is likely that Edith gave the artists her sales pitch, promising that she would make the show different and special. There was a sense among black artists that the few other black shows held at noncommercial venues had not been taken seriously by critics, who generally applied lower standards than those used to judge exhibitions by white artists. Mounting the first commercial black show was a major responsibility, and Edith hoped for a critical and commercial success. The artists in the show had a variety of backgrounds—some had studied at well-known art schools, one was a janitor at Louisiana State University, and another had worked as a porter for the Pennsylvania Railroad for thirty years—but, in her press release, Edith stressed the level of achievement that all of them shared:

> In making the final selection, Mrs. Halpert, the gallery director, was guided entirely by quality rather than sentiment or patronage. There is an extraordinary degree of accomplish-

ment in the work of these artists, a high professional standard which reflects little of the adverse conditions under which the work was created.

She felt so strongly about the show and its mission that on the program, the invitation, and the press materials she printed the objectives of her gallery: "To continue its educational program in demonstrating to the public the valuable contribution made by American negro artists" and "to provide opportunities for further development of negro art by inaugurating a special Negro Art Fund for the purchase of paintings, sculpture and graphics by living negro artists, such works to be presented to museums and other public institutions."

Before leaving Washington and heading to New York for the opening, Locke wrote Edith a final word of thanks: "This is a good place while you are still in the throes of this labor of love, to tell you how deeply I appreciate your work and interest and sacrifice through it all." On December 6, Locke checked into the Hotel Theresa, on 125th Street, a grand building known as the "Waldorf of Harlem," which had been desegregated a year earlier. He planned to meet Edith at the gallery on Sunday to help with any final details before the opening the next day.

The day before a show opened was usually a final quiet interlude devoted to hanging canvases and arranging sculpture. Not this time. At just before 8 a.m., a fleet of dive-bombers attacked the U.S. naval base at Pearl Harbor, and by late afternoon Japan had declared war on the United States and Britain. Art was not on anyone's mind. The next day, December 8, was the opening; not surprisingly, Mayor La Guardia and most of the other invited dignitaries didn't show up, though Edsel Ford made it. The mood was somber, and the few who did make their way to the Downtown Gallery for the benefit party were distracted, devastated, or both.

At 5 p.m., Edith's first guests arrived. President Roosevelt's favorite blues musician, Joshua White, played, along with the Harlem Highlanders jazz band. Guests drank cocktails and wandered around

the first floor, where Edith had placed the nineteenth-century works, surrounding bucolic landscapes with weather vanes and duck decoys placed on black stands. The earliest work was an 1851 landscape by the Ohio artist Robert Duncanson called *Blue Hole, Little Miami River*, lent by the Cincinnati Art Museum. In the painting, three tiny figures fish on a swampy shore ringed by leafy green trees and brown boulders. The world on the canvas looked far more idyllic than the world outside.

Upstairs, in the spacious second-floor galleries, Edith displayed the art made since 1900—art that addressed the harsh conditions of a modern, racist society. *Lovers*, by the Brooklyn artist Ernest Crichlow, showed a hooded Klansman groping a black woman. As Crichlow looked at his painting, he felt the tug of two opposing emotions. He was thrilled to have his artwork finally shown in a fancy midtown gallery, but his joy was tempered: Crichlow suspected that the exhibit would receive far less attention because of the war.

Yet in spite of the breaking national news, the city's leading art critics made their way to the show, and within weeks a flurry of favorable reviews appeared in the major newspapers and art magazines. Critics latched onto the bold colors used by many of the artists and decided that the coloration had a racial foundation. "A Negro uses color with more resonance than the white man," the *Art News* critic wrote. "It is apt to be wilder, more exotic color, but it is also purer, deeper, more unconventional." Critics lacked the context and sensitivity to resist characterizing the black art as "exotic" or "wild." This theme continued in the *New Yorker's* review: "There must be more truth than I'd realized in that ancient gag about Negroes loving bright colors, for the most striking single thing about the exhibition of American Negro art at the Downtown Gallery is the almost barbaric profusion of bright reds, rich blues, and resounding purples the pieces contain."

Opening-night sales were unusually slow. Edsel Ford picked out two paintings by Charles Alston, spending $350 for both. Charles Sheeler bought one of Lawrence's New Orleans paintings for $35,

and Alain Locke chose a $60 painting by Malvin Gray Johnson, a North Carolina artist, for Howard University's art collection. For the remaining three weeks of the show, Edith wrote her clients and aggressively sought sales, but it was not easy. She found some success with several of the curators who usually bought, including the Albright Art Gallery in Buffalo, and the Carnegie Institute in Pittsburgh. Private collectors who stepped up included a faithful customer from the Social Register set, O'Donnell Iselin, whose family's banking and mining fortune allowed him to buy art. Like Sheeler, Iselin bought one of Lawrence's New Orleans paintings, *Bar & Grill*, but he paid the full price, $50. Edith's sister Sonia, now Mrs. Michael Watter of Rittenhouse Square, Philadelphia, bought Horace Pippin's *Lillies* for $250. The Reverend Shelton Hale Bishop, the rector of St. Philip's Church on 133rd Street in Harlem, bought a portrait by Charles Alston for $100 on the installment plan.

Edith sent copies of Locke's book to her friend Lloyd Goodrich, future director of the Whitney Museum, and to Mrs. Rockefeller as a Christmas gift. Mrs. Rockefeller thanked the dealer, saying, "I know that I am going to enjoy 'The Negro in Art.' It's very encouraging that this book should have been [sic] gotten out." Edith sent the exhibition catalog to the assistant chief of the fine arts section of the Public Building Administration's newly formed Federal Works Agency, who said he was considering a national mural competition open to blacks and requested the addresses of the artists included in the show. Edith did generate an unprecedented amount of attention for the artists, but her hopes of interesting other dealers in representing them were dashed. With the onset of war, dealers were skittish about signing on new and untested artists, and no other dealers approached any of the black artists about representation; Edith and Lawrence remained the lone pairing.

Although Edith had managed to sell several of Lawrence's individual pieces, the "Migration" series remained hanging in her office once the show came down. Still, Edith was determined to find an appropriate buyer for the series, which she considered the most

important representation of black life by the most talented black contemporary artist. For a work of this significance, that meant a museum. She had received numerous inquiries about individual panels, but no one was interested in buying all sixty. So, with the panels still languishing on her walls in January 1942, Edith hatched a plan. She decided, in spite of Lawrence's request that the sixty panels stay together, to offer the series in two groups of thirty, making it more attractive to potential buyers. Edith thought that the Museum of Modern Art might want one set, but doubted that they'd buy both. The fact is, the museum had yet to buy much at all from Edith; Alfred H. Barr, Jr., the director, was no big fan of Edith Halpert and was far more interested in spending his meager acquisition dollars on European art. Barr considered most American art second-rate, and Edith's artists mainly entered the museum's collection through gifts from her clients, mostly Mrs. Rockefeller. During the 1930s, the museum bought fewer than ten paintings from Edith—and over the years Edith periodically challenged Barr about his lack of support for her local talent, the Americans she had handpicked whose works hung just a few blocks away from the museum. Barr usually became defensive, but although her tactic might not have worked, she at least made her views known. In this case, Edith thought that Barr could not refuse the "Migration" series if she could only find a way to have it donated.

In mid-January, with the city convulsed by air-raid warnings, Edith stayed focused and made her pitch. She wrote to Adele Levy, who had not yet seen the series despite agreeing to have her name included as a sponsor for the Negro artists' show. Edith had never met Levy in person, but that didn't stop her from writing a bold letter, making vague claims about the historic importance of the series, alongside other embroidered claims about the museum's desire to own the work:

Various visitors and members of the Museum of Modern Art agree with me that at least thirty of these panels should be in

the collection of the Museum of Modern Art. Mr. Barr has expressed his enthusiasm for these panels and I have reasons to believe that they will be accepted with great appreciation. Both the artist and I would be very glad to cooperate in making the price so reasonable that the purchase of thirty panels would represent a ridiculously low price. We feel that the Museum of Modern Art is the logical institution for this collection and that it would benefit not only the Museum and its public, but the artist and his race. For this reason we are quoting the price of one thousand dollars, or at an average of $33 per panel.

Edith thought that a second potential buyer might be Duncan and Marjorie Phillips, whose Phillips Memorial Gallery (now the Phillips Collection), in Washington, D.C., was devoted to modern art. Phillips sent a Western Union telegram to Edith in advance of his visit to New York in January 1942, asking her to set aside art for his consideration. During this visit, she suggested loaning the "Migration" series for an exhibit at Phillips's museum—hoping that he would decide to make a purchase—and soon they agreed to a show, to take place from February 14 to March 9.

Edith had agreed to ship the series to Washington on February 2, but three days later the panels were still in New York. Edith wrote to Marjorie Phillips, who helped with the administration of the museum, apologizing for the delay. She explained that the Museum of Modern Art had requested the panels on approval and would not permit them to be shipped during negotiation. Again, she exaggerated Barr's desire for the works: "Yesterday Mrs. David Levy purchased thirty of the panels to present to the Museum of Modern Art at the urgent request of Mr. Barr," Edith wrote. It was true that Barr had agreed to accept the gift—the urgent part was Edith's own invention.

Edith told Mrs. Phillips that Barr would take either Nos. 31 to 60, the North pictures, or alternate numbers from 1 to 60. She noted that she hoped the Phillipses would consider buying the thirty that the

Museum of Modern Art did not select. Once Barr agreed to accept Levy's donation, Edith would be free to ship the entire series off to Washington, she explained. Several weeks later, Edith still had no word from Phillips about his interest in buying the series. She phoned him and told him that she needed an answer, putting on the squeeze; Barr, she said, was eager to announce the purchase of his thirty panels and wanted to know if he was getting the second thirty or the alternates. Phillips agreed to pay $1,000 for the alternates, and Edith sent out a bill that very afternoon.

Both museums embraced their new acquisition and agreed to cooperate and make the entire series available for viewing. The panels were exhibited first at the Phillips Collection in March 1942 and then sent on a two-year tour to fourteen regional museums, returning to the Museum of Modern Art in October 1944. Lawrence's series was later described by *Time* magazine critic Robert Hughes as "the first, and arguably still the best treatment of black-American historical experience by a black artist." It is work that critics and art historians consider the pinnacle of Lawrence's achievement, a priceless testament to human experience. Lawrence came to be ranked as the greatest black American artist, and with the utmost grace and humility he was one of the few Downtown Gallery artists who always gave Edith credit for his success: "So I always owe Edith Halpert," he recalled in an interview. "I think she is one of the great American dealers."

Edith's Victory Garden

"OUR COUNTRY is facing the most serious crisis we have ever had in our history," intoned Mayor La Guardia on December 15, 1941. His radio chats were aimed to reassure the people of New York that they would be safe and also to explain the implications of war with Japan, Germany, and Italy. "It means that our country is now under attack from both sides." New Yorkers would have to take new wartime precautions, leaving their windows open during air raids to lessen the chance of panes breaking during a bomb blast. La Guardia reported that the city had already recruited 112,000 air raid wardens and needed more. Over the next few months, New York would need to prepare itself against potential air raids and land attacks from German U-boats patrolling the East Coast. Parts of the city would be pitched into darkness, staged blackouts aimed to thwart airborne attacks. American Legionnaires would be posted atop the Empire State Building on spotter duty.

Edith reacted to the daily news of potential danger by filling both floors of her gallery with as many totems of American patriotism and military prowess as she could find. "Battles and Symbols of the

U.S.A." went up in March 1942, with 15 percent of the purchase price pledged to a war charity of the buyer's choice. She combined objects from her own enormous folk art stockpile with works she had sold and borrowed back from important clients. Her meticulous files, including photos and descriptions of everything she had bought and sold, written in her own secret code, made it easy for her to cull material from her seventeen years in business. The show not only put Edith in touch with former clients, it added a new luster to the same old folk art. She displayed more than a dozen eagles—copper weathervanes and wood carvings—as well as watercolors of revolutionary soldiers and an 1863 painting of the Battle of Gettysburg, courtesy of Nelson Rockefeller. Even Colonial Williamsburg agreed to lend Edith a couple of pieces she had sold Mrs. Rockefeller in the early 1930s: a delicate watercolor of a sylph-like lady, *Miss Liberty*, and a painting of George Washington riding a white steed into battle.

Edith was shameless in turning the war into a sales angle, plucking her sale theme from the headlines. Her fluid approach to exhibitions meant that she was able to make her shows timely and newsworthy—a most modern tactic. She even used her exhibition to promote the role of the artist in battle, noting in her press release the "importance of artists as reporters" and "their unique contribution in creating a factual record and in reflecting the spirit of the time." With America's sudden entry into the war, Edith once again tried to assert a place for artists at a time when art seemed inconsequential compared to the day's life-or-death events. Museum directors were focused on protecting their collections, not expanding them. The Metropolitan Museum announced that it planned to evacuate its "most irreplaceable objects." In Washington, D.C., Duncan Phillips shipped his most precious artworks to Midwestern museums for safekeeping. Edith took no such precautions, but she did suggest to her artists that they might want to spend $20 for extra insurance against fire, theft, and damage for artworks left in the gallery over the summer. Edith's weekly drives from Newtown would be impossible with the gas rationing. The art would be left to fend for itself, against the elements and the fascists.

The war made it nearly impossible for artists to focus on making their art. At least half a dozen Downtown Gallery artists, as well as Edith's secretary, Lawrence Allen, were eligible for the draft, and waiting to be called up meant each day was clouded by the threat of a life-altering, and potentially life-threatening, letter. The Depression had taught Edith how to run a gallery during a national crisis, and now she faced an international emergency. Still, she was convinced the gallery must go on. At the age of forty-two, she had nothing else to live for. Edith had poured every shred of her energy and creativity into the gallery. There was no life for her outside the art world. If there was no Downtown Gallery, there might as well be no Edith Halpert.

Edith continued the war angle in her gallery program, underscoring the relevance of art at a moment when it seemed irrelevant. Later that spring, she joined with twelve other American painting dealers in mounting a show with proceeds pledged to benefit the war bond campaign. It was unusual for American dealers to work together, and Edith, always a fan of collaboration, was a strong advocate of the plan. She took the strategy even a step farther and wrote her best customers, offering them special reduced prices. "You buy art. We buy bonds," was the tagline. This appeal to patriotism and the pocketbook failed to stimulate sales, however, and only three paintings were sold. Edith realized she needed to appeal directly to her longtime supporters. "Needless to say, the war has hit the art world square on the chin," she wrote Nelson Rockefeller, who was working for the government in Washington. "In order to exist we have to have the help of all our friends." Throughout the war, Nelson made a few modest purchases that provided a psychological boost to the dealer and artists, but not significant sums for the gallery coffers.

Edith also turned to Nelson's mother, who was following the war attentively, with four of her sons in the service. "It has been a very long time since I have had the pleasure of seeing you," she wrote Mrs. Rockefeller. "The war has affected us most adversely, needless to say. Art is not on the priority list naturally, and we hold frequent meetings of the artists both to ascertain what we can do to contribute to the defense program materially, and what we can do to maintain buy-

ing interest among the museums and collectors." Unlike her patronage a decade earlier, Mrs. Rockefeller did not come to Edith's rescue. She was struggling with hypertension, had recently been hospitalized, and was required by doctors to remain indoors. Mrs. Rockefeller was preoccupied with her sons and the shadow of her own mortality hovering close by.

After the Battles exhibit, in April 1942, Edith organized a retrospective of paintings by fifty-two-year-old Yasuo Kuniyoshi, an artist she had shown since the Downtown Gallery opened. The exhibit was motivated not by commerce but was an act of moral support. Since the United States had gone to war with Japan, it had became commonplace to curse the "Japs." Kuniyoshi received suspicious glances on the street and was treated like a criminal by the government. Edith was outraged.

She brought together twenty-one of Kuniyoshi's strongest paintings dating from 1921 through 1941, one from each year. It was strictly a loan show, with works borrowed from important collectors, including Sam A. Lewisohn, Edward G. Robinson, and Mrs. Rockefeller, as well as major museums such as the Detroit Institute of Arts, the Newark Museum, and the Phillips Collection. Though the artist had exhibited at the gallery the year before, and most solo shows came about once every three years, this was Edith's effort to help "Yas," one of the most popular, jovial, and talented artists on the Downtown Gallery roster.

"From the beginning his work revealed the born artist, instinctive and natural, but with the refinement of a race with a long tradition," wrote art historian Lloyd Goodrich about Kuniyoshi, who was one of the first Japanese modernist artists who came to prominence in New York before World War II. "At the root of all Kuniyoshi's work was an intense physical pleasure in painting itself," the "product of a deep sensuous vitality."

Kuniyoshi was born in Okayama, Japan, and had moved to the United States in 1906, a sixteen-year-old immigrant hoping for a better future. He studied nights at the Los Angeles School of Art, work-

ing days to support himself in whatever sort of menial job he could find. He moved to New York in 1910 and studied at the National Academy of Design, the Henri School, the Independent School, and the Art Students League, where he would later work as a teacher for twenty years. He met Hamilton Easter Field, who invited him to Ogunquit, where he met and married his first wife, painter Katherine Schmidt. Kuniyoshi had one-man shows at the Daniel Gallery in 1922 and 1928, but his career really took off in the 1930s, once he joined Edith and became involved with many artists' organizations, including Salons of America, the Hamilton Easter Field Foundation, and American Artists' Congress and Artists Equity, where he served as president for four years. His critical reviews improved with time. Following a 1933 show at the Downtown Gallery, Edward Alden Jewell of the *New York Times* observed, "Queer mannerisms were always getting in the way," of Kuniyoshi's paintings but felt he had since improved. "Drawing defines forms that are more convincingly substantial and color exhibits an organic eloquence that before was sometimes minimized by superficial brush pyrotechnics."

Kuniyoshi was later also a fixture of the Woodstock summer art colony. "He had become so Americanized he became more American than some Americans, you know slang and dirty stories," Schmidt later recalled, "and he always got dirty stories a little wrong; it didn't seem to make any difference to him."

In 1941, Edith—sensing trouble ahead for foreigners in the United States—asked Alfred H. Barr, Jr. if he might use his political influence to help Kuniyoshi become an American citizen. Barr contacted Washington friends, but immigration laws forbade anyone born in Japan from gaining citizenship. With war looming, Kuniyoshi fell into a profound depression. He felt unwelcome in his homeland. In March 1941, Edith hung thirteen new Kuniyoshi gouache paintings in the gallery, and their bleak depictions were noted by critics. The *Art Digest* described Kuniyoshi's images of New England, where he had traveled, as depicting "a rather forlorn world," with a "slightly morbid interpretation."

Kuniyoshi traveled to the Fine Art Center in Colorado Springs, an old mining town, where he was finally able to relax. "As the international situation grows worse," he wrote Edith, "This is really the place for me, as I haven't heard a remark or a concern about my being here." Conditions were worse in New York and escalated after the United States declared war on Japan. Kuniyoshi was classified as an enemy alien and placed under house arrest, and his bank account was impounded. Though he had long campaigned against Japanese aggression in China and was a leading member of New York's art establishment, he suffered the same indignities as other Japanese living in the country, though those on the West Coast had it worse and were forced to live in internment camps.

The April 1942 loan exhibition presented Kuniyoshi as a model American, even if the government wouldn't permit him to be classified that way. "It is a characteristic American story of opportunity and success," Edith wrote in her two-page press release, twice as long as usual. "It is a story of a boy from a foreign land exposed to a new environment, to a new way of life. It is the story of his assimilation and emergence in the American pattern. It is the story of the development of a great talent enriched by the opportunities in American life and in turn enriching that life. It is the story of art and life in a democracy."

Following the loan show, dozens of newspapers and magazines printed articles praising Kuniyoshi for his aggressive anti-Axis, anti-Japanese stance. Articles lauded his commitment to the cause, describing his work writing short-wave radio scripts for a U.S. propaganda agency and his talents as an artist. The *New Yorker* described him as "the foremost living Japanese painter in the world" and "one of the most active opponents of Japanese militarism." The show raised over $500 for United China Relief, through admission charges and a raffle. *Art News* called it the "best 'American' show we have seen all year," and critics singled out paintings of cows, crows, and a self-portrait as a golfer as among the best—works that combined the artist's passion for American and Japanese folklore and blended

Western and Eastern painting techniques. Although Edith strived to bolster her artist's spirits, she could only do so much. She recalled that the police had cased Kuniyoshi's show, looking for any evidence of trouble. In April 1942, just weeks before the loan exhibit opened, Kuniyoshi attended Gertrude Vanderbilt Whitney's funeral on Park Avenue, along with sculptor and friend Robert Laurent. "As Yas and I walked down the Avenue together," said Laurent, "it seemed to me that the crowds on the sidewalks were all staring at Yas, as if an enemy were in their midst."

By the fall of 1942, gallery business had not picked up: robust growth was evident only in the 4-foot tomato plants Edith grew in her Connecticut victory garden. Edith made use of her bounty, canning vegetables and making jam preserves from berries. This was usually the extent of Edith's culinary efforts, but over the summer she was forced to expand her cooking repertoire. She usually brought her maid to the country, but this year, with business so poor, she had let the maid go.

In her letters to friends, Edith described her most strenuous activity as plucking weeds, though in reality she never stopped working. Edith asked Lawrence Allen to come to Newtown to take dictation and to keep her company. When he failed to appear at the station, she received a wire from the telegraph office that he would come the following day. When he didn't arrive for a second time, Edith unleashed her fury in a letter, a reaction that appears rather exaggerated, given the offense. "Unless some major tragedy occurred, your conduct is absolutely unpardonable," she wrote Allen. "After a month's vacation with full pay, the least I expected was prompt cooperation, and some sign of gratitude. . . . Not even my most intimate friend, nor the most thoughtless client would cause me such inconvenience. Moreover, I wasted two gallons of gas, at a time when we are all trying to conserve every bit for the war effort." Her letter is indicative of her temper and hints at why those who knew her later described her as a woman who could be quite difficult.

As in the past, Edith looked to her folk art trove to keep the gallery running. She wrote another letter to Mrs. Rockefeller, stating candidly that she urgently needed to raise $5,000. "It is most embarrassing for me to send you this pleading letter," Edith wrote. "But I know how strongly you feel about American art and artists, and what you have done towards their success." But Mrs. Rockefeller's folk art collecting days were long over. Edith wasn't able to interest the director of Colonial Williamsburg either. The collection was closed.

But then just months later, Edith nabbed Electra Havemeyer Webb, a plucky down-to-earth heiress in pearls and soft white curls, who began buying from the Downtown Gallery in 1941. The daughter of a sugar magnate—and wife of a Vanderbilt—Webb grew up surrounded by Degas and Cézannes courtesy of her mother's passion for collecting. One day in 1941 she strode by the Downtown Gallery window and spotted a wooden Indian bust in the window. She went inside, and Edith proceeded to sell her the $100 bust, along with six other items. In 1952, Webb opened a sprawling museum in Shelburne, Vermont—ultimately including thirty historic buildings and even a steamship—devoted to Americana. The folk art collection—like Mrs. Rockefeller's at Colonial Williamsburg—is acknowledged as one of the finest in the world. Electra solicited Edith's assistance, and as she had done with Mrs. Rockefeller's collection at Williamsburg, Edith helped install the weathervanes, tavern signs, cigar store Indians, ship figureheads, and a smattering of folk art paintings.

Edith's dealings with Electra, as she called Mrs. Webb, were more satisfying in a way than her more formal relationship with Mrs. Rockefeller. First, Edith didn't have to penetrate the layers of museum bureaucracy at Colonial Williamsburg. Next, she had a willing customer for her still vast stockpile of folk art. She made the same deal with Electra she had had with Mrs. Rockefeller, offering her "the entire cream of my collection" and "first choice on any new acquisitions."

Also Electra trusted and depended on Edith, signing her warm letters "devotedly, Electra." Edith was the teacher and Electra the will-

ing and wealthy student—the power dynamics were clear-cut, just as Edith liked them. Once the museum opened, following hundreds of purchases from Edith, Electra wrote Edith thanking her for "working so hard over our (yours and mine) collection." Edith always felt she didn't get the credit she deserved in assembling Mrs. Rockefeller's collection—especially in the 1950s, when she felt Eddie Cahill was claiming more credit than he deserved. Electra gratefully accepted all of Edith's suggestions, from getting the collection written up in Vogue magazine to making wall labels. She even invited Edith to be on the museum's board—one of many instances where she made sure the dealer felt important and included. As a measure of their friendliness, Electra admitted that her son, Watson, Jr., had dubbed his own cigar store Indian figure "Mrs. Halpert." Edith was so comfortable with Electra she lent her a copy of the racy book Lady Chatterley's Lover, about a titled Englishwoman's dalliances with the gamekeeper. She also didn't hesitate to let Electra know that she didn't much like the dowdy hand-knitted jacket she had received for Christmas one year, joking she was more of a mink coat gal. "Do you visualize me as someone who would stay in bed wearing one of those goddamned things," she recalled telling Electra, "or stay in bed period?" Edith suggested a more appropriate gift: a case of liquor.

But Electra didn't ramp up her buying until the early 1950s. In the early 1940s Edith was still striving to eke out sales. After getting turned down by Mrs. Rockefeller, Edith turned next to Edsel Ford. She suggested he make a bulk purchase of folk art or something from the contemporary group. "Won't you please consider a purchase at this time, either for your own collection or for your offices, dining rooms and public rooms in the factory?" she wrote. "The latter will set a precedent for industrial organizations which can list such works of art as decorations and morale builders for their workers." Edith had seen exhibitions of artworks owned by the International Business Machine Corporation at the 1939 World's Fair in New York and the Golden Gate Exposition in San Francisco. She believed corporate art buying had potential to help the American art market and had asked

a tax lawyer to examine the implications of a 1942 tax law that appeared to make art buying a deductible corporate expense—yet another instance of Edith acting ahead of her time.

The war also forced Edith to tackle jobs she had formerly left to her porter, Ernest DeSharp, who had been drafted. Edith didn't mind tending to the steam and other odd jobs required to maintain the building. Women's roles were changing, and Edith, a worker since the age of fifteen, was amused that the rest of her gender was catching up. "With women in factories, welding, riveting, and what-not, I guess we shall have to shift for ourselves after the war," Edith wrote Nathaniel Uhr, who was posted as an army doctor at various bases around the country and had come back into her life as a pen pal and sometime dinner companion.

The gallery was so quiet, Edith was able to cook a stew on Saturday afternoons without interruption. She continued to entertain, with regular dinner parties for artists, critics, collectors, curators, and other members of the extended gallery family. Penny poker and Edith's storytelling were the main entertainment. Adam would curl up on Edith's lap and watch his mistress hold court. Edith did continue to worry—about paying her bills, about her artists, about the status of American art, about the war, and about her health. She had trouble sleeping, and Nat mailed her sleeping pills to help her make it through the long dark nights. Her mother, Frances, was now in a nursing home—one less thing to fret about, but the gallery remained a constant concern. "Do I indulge myself these days," Edith wondered, "arranging wonderful one man shows for my sole benefit?"

In 1942, the first of the Downtown Gallery artists were drafted into service, mostly those younger artists whom Edith had discovered during her work with the WPA. By the end of 1943, that number tallied seven, and Edith took to calling herself "a seven star mother." She added a few artists to the roster in the early 1940s, with so many unable to keep producing. Stuart Davis recommended a thirty-seven-

year-old devout abstractionist, Ralston Crawford, who was serving in the Air Force and whose "very American style and subject-matter" Davis deemed a good fit for Edith's troop. Edith also added surrealist Peter Blume and George L. K. Morris, scion of a wealthy New York family, who lived at One Sutton Place and whose social credentials were at least as impressive as his abilities with the paintbrush.

Edith also began selling works by Horace Pippin, a black painter from Philadelphia who had been included in the Negro art show in 1941. Pippin had never studied art formally and was classified as a primitive artist, making wondrous scenes of black life and history. He worked slowly, churning out one canvas every few months, which Edith immediately sold to collectors. She got his work through Robert Carlen, a dealer in Philadelphia, and she coached Carlen on how to create a market for Pippin, applying her usual practice of keeping prices low. "It is more important to place him [Pippin] in collections at this time," said Edith, "than to try to extract the highest possible prices over a much longer period." By the time Edith and Carlen took their cut of Pippin's paintings, which sold for between $300 and $800, it wasn't enough to make a substantial contribution to the bottom line. Decades later, Pippin is still revered as a genius.

With her adopted sons off in various branches of the Army, Air Force and Navy, Edith kept busy maintaining a lively correspondence, encouraging those who needed it, and always pushing for sales and exhibitions on the home front. She mailed issues of *Art Digest* to Sergeant Mitchell Siporin and chocolates to Private Jack Levine, and wrote entertaining letters to many of her artists, now scattered in Georgia, Africa, and beyond. Twenty-nine-year old Levine, one of the gallery's fastest-rising stars—both the Metropolitan and the Museum of Modern Art bought large canvases during the early 1940s—signed his letters back to her "love, Jack." "I had a crush on her," he later admitted, attracted to her panache and her high cheekbones. "She had her own kind of dash."

Over the summer of 1943, Edith hosted guest after guest in Newtown. Artists on furlough, collectors, museum folk, and even her

accountant were invited for visits. Edith also paid special attention to the wives of her artists. She made sure their bills got paid, advanced them money when needed, and invited lonely war widows for weekends in the fresh air and rural charm of her pre-Revolutionary saltbox.

Just as soon as her boys started shipping off to training stations, Edith began working her contacts. Edith understood that military assignments, like selling art, were driven by who one knew. When she heard that there was to be a special category of artist-soldier, around 100 men chosen to visually record the war, she asked George Biddle, chairman of the War Department Art Advisory Committee, about getting gallery artists Mitchell Siporin and Edward Lewandowski into this program. She also pushed Biddle to include a black artist among the group, recommending an artist she had exhibited in 1941, Romare Bearden, who was already in the service, along with Jacob Lawrence and Charles Alston. Unfortunately, the war correspondent program was never approved by Congress.

Edith found her next opportunity to mingle with military officials at the opening of a camouflage exhibition at Macy's department store on February 5, 1943. Though she was hardly the ingénue art dealer of her younger years, Edith still knew how to hold the center of attention at a party and could turn heads for her wit as well as her dress with a revealing low-cut back. She made a point of meeting the highest-ranking official present: Colonel Fisher, who headed the Air Force base at Mitchel Field in Long Island. Colonel Fisher found Edith engaging, friendly, and approachable. He thought artists could be of use in his camouflage studio, where military uniforms and equipment were designed and camouflage skills honed. After the party, Edith asked the colonel if she and a group from the Museum of Modern Art—where there had been a camouflage exhibit in 1942—including Alfred H. Barr, Jr. and curator James Thall Soby, could come out to the base and tour the camouflage studio. He agreed and soon Edith, Barr, and others were careening around the base in jeeps with no tops—at least as thrilling as seeing the camouflage designs. Over the

next few years, Fisher's influence did help several Downtown Gallery artists get transferred to Mitchel Field. Edith nurtured this friendship, inviting Colonel and Mrs. Fisher to a gallery opening, where she promised to introduce the colonel to one of his favorite artists, Charles Sheeler, with the added inducement that Duke Ellington and the boogie-woogie piano beats of Pete Johnson would be providing the all-American musical accompaniment.

Louis Guglielmi was one of those who received a transfer to the engineer corps at Mitchel Field, where he could be near his dealer and his wife. His duties included making posters alongside other artists who were mostly drawn from the ranks of civilian commercial illustrators. Gu, as he was called by Edith and friends, described Colonel Fisher as "my patron saint." In spite of his seemingly plum posting, out of harm's way and serving time with a paintbrush in his hand, Gu felt isolated. "The drill sergeants are very patient fellows," he told Edith. "Most of the time I do not know what they are talking about what with the military language and their Texan drawls. I am the lousiest and dumbest soldier that ever tried to do a right flank." He had made his reputation on his surrealistic paintings, the fantasies of a creative and eccentric mind that could hardly relate to the Midwestern types populating the barracks at the Air Force base. He later compared his war years to being in jail. He didn't even look like himself, his hair shorn short in the regulation GI haircut. He felt his identity was fading. "I have almost forgotten I am a painter," he told Edith. "Sometime I find myself painting with my eyes. It must be either pure escapism on my part or the natural way for me to be happy."

Several of the other artists fared better. Jacob Lawrence was drafted by the Coast Guard in October 1943 and was sent to join a black troop at a training center in St. Augustine, Florida. Edith urged Lawrence to tell his captain about his painting, with a view toward getting some special treatment. The captain responded with enthusiasm, offering Lawrence a large sunny room over his garage as a studio. "This station is considered a choice spot for men in the Coast

Guard," Lawrence wrote Edith. "I think that your contact had a lot to do with them placing me here. . . . So I wish to thank you for what you have done."

Edith was hopeful that Lawrence would continue to make art. Most of the others found no time, materials, or inspiration. "If you are permitted to paint where you are it is a very fortunate situation," she said. "So many of the boys are completely divorced from their art now, but as they say, 'This is war.'" Although many of the men in service left few artworks behind, making it hard for Edith to continue to exhibit and sell, Lawrence was prolific. His chosen medium, the small format gouache paintings, allowed him to make dozens of panels a year. In 1943 Edith exhibited Lawrence's "Harlem" series, thirty paintings of pool halls, peddlers, smoky bars, and peeling tenement apartments. Edith again rounded up a group of respected and influential sponsors for her opening, including Justine Wise Polier—the first female justice in New York—and Reverend Clayton Powell, Jr. Buyers included Harlem poet Countee Cullen and the Whitney Museum, paying $60 to $125 per panel.

Edith also had Lawrence's series on the life of abolitionist John Brown at the gallery, twenty-two panels the artist had completed in 1941. Edith knew the series was as significant and masterful as the "Migration" series, and gave Alfred H. Barr, Jr. the first option to buy. "The series is certainly fine," said Barr. "I wish we could get it for the museum, but I don't know how so soon after we have acquired half of the 'Migration of the Negro.'" Adele Levy, who had donated half the "Migration" series to the museum, also declined.

Lawrence had ample time, space, and material to paint, but one all-important element was lacking: he felt uncomfortable in his surroundings, lodging in a hotel with the other black soldiers, suffocated by the glares in a white Southern town. Lawrence, a child of Harlem, had grown up in a black world. He struggled to find a way to translate his feelings into paint. "St. Augustine is a very dead city and really southern when it comes to Negroes," he told Edith.

There is nothing beautiful here [*sic*] every thing is ugly and the people are without feeling. As a Negro I feel a tenseness on the streets and in the Hotel where I am working—in fact: every where. . . . Negroes need not be told what Facism [*sic*] is like, because in the south they know nothing else. All of this I am trying to get into my work. It is quite a job, as it cannot be done in a realistic manner. I have to use symbols and symbols are very difficult to create, that is good strong ones.

Edith knew how it felt to be an outsider and reminded Lawrence of his power as an artist. "Your previous letter distressed me for various reasons," she wrote. "While we read about the situation it never strike [*sic*] us closely as when we get it directly from some one who has had the actual experience. Naturally I am eager to see the drawings that you made down there. They may be very useful not only as works of art but as valuable propaganda in the future."

Jacob Lawrence beside a panel from the "Migration" series, on view at a 1945 group show at the Institute of Modern Art in Boston.

By the following year, Lawrence was transferred to serve on the USS *Sea Cloud*, the Navy's first integrated ship, a weather patrol boat, where again he found himself in fortunate circumstances. He was given another choice assignment, with a public relations status that allowed him to paint full-time. His new captain was impressed by Lawrence's talent and renown and shared art magazines with him. As Lawrence crossed oceans, Edith navigated his career with a steady hand. In October 1944, the Museum of Modern Art mounted a solo show of Lawrence's work, combining the entire "Migration" series with pictures recently made in the Coast Guard. Lawrence, dressed in his crisp sailor's uniform and shiny black shoes, attended the show and posed for publicity photos. When he was finally discharged in 1945, he won a Guggenheim fellowship, which helped his transition back to civilian life. Lawrence moved to Brooklyn with his wife Gwendolyn and began working on a series based on his experiences at war. The final image in the fourteen-part series portrayed an exhausted soldier, hunched on a stump, his face obscured by a broad metal helmet. Lawrence had found his symbols. He called the piece *Victory*.

If wartime sales were slow, there were signs that better times lay ahead. Galleries in France and Germany were shuttered, forcing European buyers and dealers to travel to New York to acquire art. *Time* magazine reported a "Boom in Old Masters," describing the frothy spending by European refugees in art galleries and auction galleries. "At Parke-Bernet Galleries, fabulously wealthy Belgian Baron Cassel van Doom stumped pompously to every important sale, solemnly focused a pair of high-powered binoculars on everything that reached the auction block," wrote *Time*. For Edith, even more vexing than the nobles roving the auction houses, dropping fortunes for predictable names, were the reports of the astonishing sums being paid—especially when Edith rarely cracked the four-figure mark. Dr. Albert Barnes paid $175,000 for a saccharine Renoir of children by the French seashore, while a Spanish millionaire in a "loud necktie half hidden by his grey spade beard," paid $26,742 for a Francois Boucher painting titled *L'Amour*.

Edith was also well aware of the wave of famous European artists who had recently decamped to New York. The group included the surrealist majordomo, André Breton, as well as other famous radical moderns, such as Piet Mondrian and Marcel Duchamp, who were part of an expatriate enclave in the East 50s. Mining heiress Peggy Guggenheim rented a triplex apartment on 51st Street and the East River, which served as an unofficial clubhouse for the group. Guggenheim's pad wasn't far from the Downtown Gallery, but there isn't evidence of much mingling between Edith's Americans and the European émigrés, though Mondrian became a Stuart Davis fan. However, there is little chance Edith missed their splashy entrée on the scene, a benefit exhibition organized by Duchamp in the fall of 1942 just up the block from the gallery. In a vacant mansion on the corner of Madison Avenue, Duchamp wove a dense web of several miles of string around the rooms, looped around columns and obscuring paintings hanging on walls. Edith was likely impressed by the Europeans' ability to garner attention and cause a stir. She was probably less amused by the fact that they were vying for the spotlight she wanted for her own boys and using an outlandish stunt to do so. A week later, Peggy Guggenheim opened an astonishing gallery, Art of This Century, on 57th Street, which she devoted to her circle of artist friends. Edith wasn't threatened, however. She knew art dealing was a tough business, not a hobby for an heiress.

Wartime prosperity was bound to strike the contemporary American art market, eventually, and Edith was determined to be ready for it. In the meantime, the most expensive items moving off the gallery walls were folk art, not Zorachs or Sheelers or Jack Levines. Once again the contemporary artists needed a push. To remind curators and collectors about the talent on 51st Street, Edith decided it was time to produce another one of her comprehensive gallery catalogs, packaging her artists as a stable of stars. The catalog featured flattering black-and-white portraits of each artist, several done for barter with photographer Arnold Newman. Each artist's biography was included, with lists of awards and prestigious museum and private

collections where their work could be found. Edith mailed copies to important collectors, museum curators, and art critics. "Thanks so much for sending me a copy of the Gallery catalogue," wrote Alain Locke. "It is quite the meatiest compilation of its kind I have ever seen, and summarizes so graphically what you and the Gallery have contributed to the development of American art." The chairwoman of the Art Department at Wheaton College wrote, "I hope that this will become a model that one or two other galleries will see fit to copy," and the curator of paintings at the Philadelphia Museum called it "a model of its kind" and "definitely a library item."

The economic surge, and a new enthusiasm for American art, finally materialized in the Downtown Gallery ledger in 1944. New buyers appeared on 51st street, many wealthy and others comfortably middle-class. There were doctors and lawyers among their ranks, as well as owners of businesses who had benefited from wartime production, ranging from the grain business to tool and hardware manufacturers. Some came because of an article or photo clipped from a newspaper or magazine, and others came upon the recommendation of a friend or museum curator.

Milton and Edith Lowenthal, a young Park Avenue couple, were first stirred to collect following their visits to a giant juried show of American Art that ran at the Metropolitan Museum of Art during the winter of 1942–1943. They couldn't get enough, visiting the show some twenty-six times and purchasing four pieces from the exhibit. "In one tremendously thrilling moment there fell from our shoulders the weight of an apologetic attitude the American people have too long felt towards the art of their country," said Milton, a lawyer, in 1952. "No longer were we a nation of ingenious machines but also a nation possessed of a soul and a spirit urgently and magnificently expressing itself in canvas and stone."

The Lowenthals began buying from Edith in 1943, ultimately acquiring forty-six paintings from the Downtown Gallery over the

next fifteen years. Edith believed in their seriousness of purpose and knew they intended to give their collection to a museum, as they ultimately did, dividing it between the Brooklyn Museum of Art and the Metropolitan. Edith sold them examples she had categorized as museum pieces, including Sheeler's magnificent *Americana* for $1,800 and Stuart Davis's *Report from Rockport* for $700.

Roy Neuberger, a young financier who had founded his firm, Neuberger Berman, in 1939, made regular visits to the gallery in the afternoon after the markets closed. He would stroll over from his Rockefeller Center office and query Edith about her opinions on various artists and art world gossip. "She was ahead of most people most of the time," he wrote in *The Passionate Collector*, a memoir of his eighty years of collecting. Most of Neuberger's purchases were well under $1,000 during the 1940s, including paintings by Horace Pippin, Ben Shahn, Jack Levine, and Jacob Lawrence. He continued buying from the Downtown Gallery during the 1950s and 1960s, ultimately accumulating more than forty pieces. In 2003, some sixty years later, reflecting back as a 100-year-old man, his memory of Edith was crisp. Seated in his sprawling apartment in the Pierre Hotel, a respected collector and founder of the Neuberger Museum at State University of New York (SUNY) Purchase, New York, he reminisced, "She was a good business person, a whipper snapper, bright and ambitious in every way. But she was not an easy person."

Burton and Emily Tremaine, a couple from Connecticut, also began making regular purchases, using their wartime profits from Tremaine's lighting company, the Miller Company. In the late 1940s, Edith sold the Tremaines paintings by O'Keeffe, Marin, Sheeler, Demuth, and Lawrence. She even concocted a plan to assemble the "Miller Company Collection," proposing the company spend $50,000 over the course of five years to collect the most progressive art, a natural fit, went Edith's pitch, for a company that made the most progressive lighting. Her commission worked out to a dazzling $11,000—but the plan was never consummated.

Some of Edith's earliest buyers also returned. A major Santa

Barbara collector, Wright Ludington, a Mayflower descendant and trust-fund beneficiary who was serving as a lieutenant stationed in Virginia, eagerly bought whatever important works Edith suggested, including a $7,500 Zorach sculpture, a $750 Sheeler painting, and a $4,000 barn by O'Keeffe. He was a loyal and consistent buyer and one of the founding forces behind the Santa Barbara Museum of Art, which ultimately received the bulk of his collection.

Another new gold mine was institutional buying—a sector Edith had lobbied for decades. During the lean years, Edith had continuously courted museum curators and directors by lending art to exhibitions and by offering invitations to dinner parties and art openings. These relationships finally started to pay off as museums across the country suddenly had funds to assemble American art collections. "At the present rate the mid-western museums will put the eastern institutions to shame with their courage and their more progressive outlook," Edith wrote the head of the art department at the State University of Iowa, offering her standard 10 percent museum discount and information on Stuart Davis the museum had requested. Edith also continued to organize loan exhibitions—though more frequently prints and watercolors due to limited inventory—for smaller museums. In exchange, Edith asked for a token $100 purchase guarantee or a $50 rental fee. From the mid-1940s, Edith regularly hopped on airplanes and criss-crossed the country, visiting museums in Kansas, Nebraska, and Houston. Her constituencies and her buyers were spread across the country, and she didn't hesitate to pay a visit and usually give a lecture on the merits of contemporary American art.

Edith relished the new energy in the market. She attended an auction at Parke-Bernet—one of the major New York auction houses, later acquired by Sotheby, a London firm—and was amazed at the prices. The seller, Maurice Speiser, was Ernest Hemingway's lawyer, who had acquired avant-garde art early and cheap. Edith attended the sale to bid on some paintings, including John Marin watercolors, for a client. "In keeping with the times, the publick [sic] went com-

pletely berserk paying prices way beyond the value of the objects," she told the client for whom she attended the sale. "Much of the over priced purchases were made by total new comers. . . . The art busi- ness is becoming more entertaining than the night clubs, and every- one is happy."

Newspapers and magazines tracked the return to prosperity. In an article heralding the arrival of the "Fabulous New Collector," Emily Genauer of the *New York World–Telegram* described New York City galleries as plastered with red star stickers, the standard not-so-sub- tle way to indicate sold merchandise. The article described the art explosion as a natural outcome of the wartime economy, which had created both new wealth and fewer luxuries and consumer goods to spend it on. *Newsweek* magazine proclaimed an art "bull market," with reports from Parke-Bernet of a 20 to 40 percent price increase and the biggest auction totals in over a decade. Old Master dealer Knoedler said his business had doubled in one year. Edith got the last word in the article, crediting the WPA with igniting the widespread interest in American art. "This is going to be the cultural center of the world," said Edith. "No doubt about it."

The era brought more than a dramatic lift in sales. With the influx of European émigré artists and increased exposure to abstraction, tastes began to change. Until this time, abstract art was generally unac- ceptable to the public. Not only was it visually baffling, but also it was criticized for ignoring the Depression-era human suffering, a time that lent itself more readily to the figurative.

Abstract art's commercial failure had helped push Edith and one of her most seminal artists, Stuart Davis, apart. Their messy profes- sional divorce climaxed in 1936, when they officially parted ways. Stuart was beaten down by the relentless fight to have his work accepted, and he finally blamed his dealer for his poor sales.

Davis was able to make do without Edith until his WPA benefits ran out in 1939, but by then he was desperate. He had married

Roselle Springer in 1938 and couldn't support his wife on his teaching income from the New School. He tried to act as his own agent, but he made painfully few sales. In March 25, 1940, he sold his 1928 *Egg Beater No. 4* from his seminal series to Duncan Phillips. Though he was happy to have placed his painting in such a good collection, he got just $375 for it. (Nearly ten years earlier, Edith had several unsold "Egg Beater" pictures listed in her stock records for $800 each.)

Finding a dealer had become urgent, and the forty-seven-year old artist began looking in earnest. But after a nearly three-decade-long art career, no dealer of any stature was willing to take Davis on. His friends, who had remained with Edith, including Niles Spencer and Julian Levi, told him the best solution was to return to the Downtown Gallery. Pride and resentment stood in the way. Davis was still furious that Edith owned a vast stockpile of his paintings, some fifty-five oils, watercolors, and gouaches as part of their four-year contract. Edith had been entitled to most of his output in exchange for cash advances. Finally he asked her if he might try and sell some of those works. In 1940 Edith agreed to consign nineteen oils and one watercolor to him for a year. She provided him with a list of wholesale prices, ranging from $25 to $200 and told him to keep whatever he made above those figures.

Just before the year expired, Stuart mailed Edith a check for $100. He had managed to sell just one painting and had evidently learned a valuable lesson in the process: he couldn't function as his own dealer. "Painting pictures and selling pictures are two different branches of activity within the field of art," he told Edith. "Having suspected this I now know it to be a fact on the basis of objective experiment. Thus, in the last few months I have thought that it was necessary for me to have a dealer, a representative, who would believe in the value of my work." Finally, he admitted he had been wrong. "In brief, I have come to realize that it is hard to sell pictures and that the dealers [sic] failure to do so is not necessarily an indication of conspiracy."

Edith decided enough time had passed. She welcomed Davis home.

In February 1943, she mounted his first solo show in nine years, including twenty paintings all made since 1938. Davis was one of the artists best able to articulate his own work, and he wrote an article for *Art News* magazine in honor of the show, listing his inspirations, including trains, kitchen utensils, electric signs, skyscrapers, gasoline stations, and jazz. The list baffled readers and gallery-goers, who were puzzled that Davis alluded to real influences but painted in unrecognizable shapes and colors. Edith supported her artist's abstract idiom, excerpting the heart of Davis's *Art News* article on the cover of the exhibition program: "To many people a picture is a replica of a thing, or a story about some kind of situation. To an artist on the other hand it is an object which has been formed by an individual in response to emotional and intellectual needs. His purpose is never to counterfeit a subject, but to develop a new subject."

Edith avoided the whole abstract or realist argument, focusing instead on the artist as an individualist. "Classifying the art of Stuart Davis has been a trying task for all concerned, and given labels have elicited much controversial comment. Actually, whether they are considered abstractions or realism is of no consequence," she wrote in the show's press release. "Whatever the current fashion, Davis courageously refused to be assimilated." In fact, avoiding the abstraction label was a deliberate sales strategy, as the controversial word had doomed Davis in recent years. "I think there is no likelihood of our acquiring a Davis here or of selling one to a collector," Clyde Burroughs, curator of American Art of the Detroit Institute of Arts, wrote Edith. "Only a small minority of our people like his pictures and I think it would be wasted effort to try and persuade our board to consider one." The director of the Portland Museum of Art in Oregon, who had been a good gallery client and was open to Edith's suggestions, was even more reluctant. "I am somewhat doubtful about the Stuart Davis," said Robert Tyler Davis, the museum director, "as almost no abstract or semi-abstract paintings have been shown here."

There were six sales from the 1943 show, with prices ranging

from $150 to $900, and sales continued to trickle in. By the next year, Davises were in short supply. One of the biggest paintings and stars of the show, the electrifying 1940 *Hot Still-Scape for Six Colors—7th Avenue Style*, a bold abstraction in reds, blues, and blacks, vibrates with the intensity of Davis's interlocking shapes. Edith fell in love with the painting but knew she had to get Davis's work out in the world. She sold it to a Portland, Oregon, collector for $1,200—a record for the artist. Even Portland was developing a taste for abstraction.

Indeed, the youngest artists on the scene—Mark Rothko, Adolph Gottlieb, Barnett Newman, and others—were now delving into abstraction, filtered through a fascination with Greek mythology and the American Indian. While Davis and other Downtown Gallery artists took their cues from the future and the postindustrial world,

Stuart Davis and Duke Ellington in front of *Hot Still-Scape in Six Colors— 7th Avenue Style* at Davis's solo show at the Downtown Gallery, 1943.

the younger set turned their focus back toward antiquity. Jackson Pollock, a thirty-one-year-old painter from Wyoming who had worked for the WPA, had his first show at Peggy Guggenheim's new 57th street gallery in 1943, the same year Davis started selling at the Downtown Gallery again. The Museum of Modern Art bought Pollock's *The She-Wolf* from the show, rumored to have paid $600. Edith sensed the man had no future, however, and when Peggy Guggenheim approached Edith about representing the pre-drip Pollock, she refused to take him on.

Guggenheim was searching for a new home for Pollock, following her own decision to shutter her gallery and return to Europe. Her venture had been a financial debacle. "Sales were low," writes Anton Gill, Guggenheim's biographer, "and the losses she was sustaining confirmed her resolve to shut up shop." Guggenheim had flair and her family's millions, but she lacked Edith's business savvy. Art of This Century set Guggenheim back more than $92,921, with sales tallying just $17,835. Meanwhile, sales at the Downtown Gallery soared all through the 1940s, rising from $67,784 in 1944 to $189,094 by 1947. So when Peggy Guggenheim asked Edith about representing Pollock—on contract, she hoped—Edith had plenty of money to do so if she wished. But the art didn't speak to her. Even though she turned Pollock down, she expressed admiration for his talents. "I enjoyed seeing the newer pictures," Edith wrote Guggenheim, "which change my attitude towards Pollacks [*sic*] progress."

Response to Davis's work finally picked up in 1944. A 1937 painting won a prize in a show sponsored by Pepsi-Cola and was reproduced in 600,000 calendars. Another painting won honorable mention at the Carnegie International exhibition at the Carnegie Institute in Pittsburgh, an important annual show. Edith also succeeded in interesting Milton and Edith Lowenthal in Davis's work, a relationship that would last for decades. In exchange for their loyal patronage, the Lowenthals were permitted to visit Davis in his studio and to have the first pick of his works fresh from the easel. Milton Lowenthal later became Davis's lawyer. They also grew to be close

friends. When Stuart and Roselle became parents in 1952, the Lowenthals picked them up at the hospital and paid for a new pram. Stuart Davis's stature was confirmed in 1945 when the Museum of Modern Art gave the fifty-three-year old artist a one-man show. Edith and Davis discussed the exhibit in advance and the pitfalls of retrospectives, which sometimes hurt—rather than helped—artists' careers. "It always scares me a bit to see a retrospective at the museum," Edith wrote her museum pal Donald Baer, who ran the Santa Barbara Museum of Art. "So many of them sounded the death knell for the artist, but Stuart and I decided that he could survive. His career has been so consistent yet there has been considerable variety in his work making for a stimulating show." Edith made sure Davis was accorded the same treatment given to European artists, insisting that the curator, James Johnson Sweeney, use color plates in the catalog to effectively convey the power of the artist's work. Edith offered to contribute $100, if it would help. She also suggested selling Davis prints at the show to help defray expenses. (The museum also used the occasion to purchase its first important Davis, though not through Edith. Dorothy Miller bought *Egg Beater No. 5*—a figurative picture different from the rest of the series—from Samuel Kootz, who had paid Davis $200 for it in 1937. Kootz flipped it to Miller for $600). The *Times* reviewer described the show as "charmingly decorative." Edith spoke of the show only in glowing terms, noting to a journalist friend that the usually grumpy artist had actually cheered up. "The Davis show is a howling success," said Edith, "and Stuart has been seen smiling on numerous occasions."

Conditions in the art world were finally improving, but Edith was suddenly faced with a classic New York conundrum: her landlord wanted her out. With her lease set to expire in 1945 and the landlord tired of building violations brought on by the gallery and Edith's houseful of tenants, Edith decided it was time to buy. She offered $60,000 for the building—an offer she made with little cash and with

the hope she might find a bank to lend her the money. Her offer was turned down flat. A broker alerted Edith that the building directly across the street, at 32 East 51st Street, might be for sale. A bank had recently foreclosed on the property, and the asking price was just $35,000. For a five-story mansion, the price seemed cheap, but the building would need a total renovation to accommodate the gallery and apartments above.

Edith planned to replicate much of what she had done across the street, using the same blue-and-gray wall coverings and designing her own apartment, just above the gallery, as a showroom where art

The Downtown Gallery's new home at
32 East 51st Street

would be displayed with understated modern furniture, carefully cho-
sen so as not to compete with the art. She also planned to replicate the
way she had run the gallery on 13th Street, using rental apartments to
subsidize gallery rent. There was space for five apartments on the
fourth and fifth floors, with a three-room apartment, the largest, on
the third floor reserved for Edith. The ground and second floors
would be saved for the gallery, as well as a basement for storage. Edith
set up a separate corporation for the building and signed a lease for
the gallery, with rent set at $500 a month. As she had throughout her
life—first during the childhood in Harlem and then in the first gallery
on 51st Street—she would be living over the shop. With her work and
life so intimately intertwined, it was the obvious thing to do.

With most of the details settled, the only remaining obstacle
between Edith and her new home was the matter of approval from
another powerful landlord in the area: the Catholic Church. When St.
Patrick's Cathedral was under construction in the mid-nineteenth
century, the church had snapped up buildings along 51st Street as
homes for clergy. It used its political power to ensure that only pri-
vate residences and desirable neighbors were permitted on the block.
An 1888 edict outlawed breweries, distilleries, slaughterhouses, sta-
bles, and carpenters. The rules were altered in 1941 to permit certain
business, but not nightclubs or businesses that might call for dancing
or the playing of dance music. The gallery wasn't a nightclub, but it
sometimes looked and sounded mightily like one, especially during
opening parties with Duke Ellington and a bar stocked with every
conceivable cocktail mixer. At 43 East 51st, Edith hadn't had trouble
from the church, except for the occasional glare from a priest whisk-
ing by the bizarre creations hanging in her windows. Edith didn't
mind being outnumbered by men of the cloth. It was an impressive
address in a good neighborhood, around the corner from Stieglitz's
gallery on 53rd and Madison and accessible to businessmen heading
home after work. She wanted to stay.

The renovations began in April 1945. As she had done in the past,
Edith wanted the most advanced technological developments of the

day. Her contractor built exhibition galleries on the first and second floors and a storeroom in the basement and outfitted six apartments with bathrooms and kitchenettes. Edith chose oak flooring and tiles for the hallways. She had telephones installed and even a new concrete sidewalk. But soon she discovered that tackling a construction project during wartime was not ideal. "You know that I am struggling with a nasty rebuilding job now with no materials and no workmen," Edith wrote her art restorer, David Rosen. "What a time to pick. I'll be in hock for the rest of my life."

The initial renovation budget was set at $10,000, but costs soon escalated to $40,000, more than the cost of the building. The original schedule called for three months, which dragged on for six months. By summer, Edith was in a state of panic. With spiraling costs and only a few months to secure a mortgage, Edith wondered if she might lose the gallery altogether. She confided in a few of her artists, including Niles Spencer, who had been with the gallery since 1932. Niles decided it was time for the artists to come to Edith's rescue, just as she had helped so many of them through difficult times. He contacted many of the artists and suggested they loan Edith the money to complete construction, eventually raising $11,250, with fifteen artists mailing checks for $500 to $1,000. As the checks arrived, Edith was both relieved to have the cash as well as overwhelmed by the sentiment behind the loans. It was a concrete gesture of support, and it came from artists who didn't have much money to spare. In November, Edith was approved for a $40,000 bank loan, but she decided to keep it a secret from her artists and repay their loans as originally planned, paying off the notes with interest the following year.

While the construction workers installed medicine cabinets and sprinkler systems, Edith prepared her inaugural show. She'd decided on an exhibit of the best works the gallery had handled, a veritable greatest hits of the Downtown Gallery, borrowed from museums and collectors. Nothing would be for sale. Doing a museum-quality loan show was a chance to reflect on the accomplishments of the artists and the dealer, but it was also practical, given the recent supply

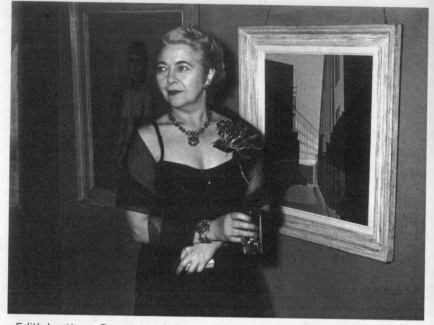

Edith hosting a Downtown Gallery opening in the late 1940s or early 1950s.

problem. Edith's artists worked slowly, especially some of the older guard like Davis, Sheeler, and Zorach. For the first time, there were more buyers than artworks available for sale. Edith was forced to refuse requests for loan exhibitions, which ran counter to her belief in circulating artworks. "This is a very difficult period for us," she wrote the director of the American Federation of Arts, who had asked to borrow some paintings. "Pictures are actually selling and artists are producing so little." With so little supply, Edith was finally able to raise prices instead of lowering them. "In recent months we have been obliged to make increases in several artists based on legitimate reasons of supply and demand," Edith wrote a banker client from Lincoln, Nebraska. "The former being practically reduced to nothing and the latter increasing by leaps and bounds."

In October 1945, the workmen stopped hammering just hours before the start of the opening party. Edith had borrowed works

from collectors and institutions around the country, refused by no one except Colonial Williamsburg. On the first floor she had hung two of her proudest and most profitable finds, which spanned nineteenth-century realism: Raphaelle Peale's 1823 *After the Bath*, on loan from the William Rockhill Nelson Gallery of Art, and William Harnett's 1892 *The Old Cupboard Door*, lent by the Museum of Fine Arts in Boston.

Upstairs, Edith highlighted her contemporary artists. The Worcester Art Museum had lent a Sheeler, a Lawrence had come from the Metropolitan Museum of Art, and a Kuniyoshi had arrived from the Carnegie Institute in Pittsburgh. Participating private collectors included many of Edith's best buyers: Nelson Rockefeller; Robert Tannahill; Wright Ludington; Edward Root; and folk art aficionados Richard Loeb, Mrs. Rockefeller, and Mrs. Electra Webb. As Edith's program made clear, the artworks weren't sold to just any old place— they were "placed by the gallery," consistent with Edith's credo that if the art had to leave 51st Street, it had better land in a good home. "And the housewarming brings into play a bang-up group of work by Downtown 'regulars,'" wrote the *New York Times*. "All of it lent from museums and private collections. Make this one of the musts." *Art Digest* focused on the dealer. "A visit to the exhibition will bear convincing testimony to the good taste, artistic sensitivity and executive skill of Edith Halpert. She can well be proud of her twenty-year labor in the vineyards of our native art expression. Few have equaled her success along the pioneering paths."

12

Inheriting Stieglitz, Courting O'Keeffe

EDITH WHIRLED around the gallery, searching for her eyeglasses. Adam scuttled behind at her heels. She was going to be late for an opening at the Whitney Museum of American Art. She wore an emerald green wool dress for the occasion and a matching hat topped by a pheasant feather that quivered as she walked. In addition to finishing up the day's business—and searching for her glasses—she awaited the arrival of Charles Alan. Charles's younger sister, Aline Louchheim (neé Bernstein), an associate editor at *Art News*, had phoned Edith to schedule the meeting. Since the move uptown, Edith had been in dire need of an assistant, someone who might eventually be able to take charge of running the gallery. She needed to be as productive as possible for the next few years. She was already forty-five years old, and thought she might be ready to retire in about five years' time.

"I can't get anyone to do anything," Edith announced to Charles, moments after he arrived. He had a narrow boyish face, with a broad forehead and close-set eyes. "I can't get anyone to help me. See those books?" Edith pointed to a shelf in her second-floor office, lined with black loose-leaf notebooks. She explained the books contained

photographs of all her artists' work, lists of their exhibitions, the whereabouts of sold artworks, and all press clippings. "I can't find anyone to keep them up. Do you think you can do it?"

Charles was still marveling over Edith's hat topped with the longest feather he had ever seen, except for a headdress costume at the Chinese Theatre in Hollywood. Edith sat on the edge of a chair behind her desk, buried beneath piles of letters, unsigned checks, art magazines, photos, and newspaper clippings. As if on cue, Adam let out a staccato series of wheezing yelps. "Oh Adam, be quiet!" Edith ordered. She opened a desk drawer and tossed a dog biscuit to the floor. "Adam is unhappy because he knows I am going out without him," she told Charles as she pressed a button on the side of her desk, eliciting a buzzing sound on the first floor. Lawrence bounded up the winding staircase and stood in the doorway. Charles studied Edith's secretary, a small, light-colored black man with graying hair, who was, Charles noticed, slightly effeminate. Edith asked Lawrence to take Adam for a walk. She turned to Charles. "So when can you start?"

Charles Alan, who had dropped the Jewish-sounding Bernstein when he worked in theater design, was thirty-seven years old, fresh out of the Army, and looking for a new career. He had grown up in a brownstone on West 75th street, in a house primped by servants and paid for by a successful businessman father who traveled frequently and was prone to headaches. Charles's mother was "a somewhat remote and glamorous creature who lived in a room with heavy gold-colored satin draperies," Aline Bernstein recalled years later. Charles first became interested in stage design at the Horace Mann School for Boys, an elite private elementary and high school, and then continued his studies at the Yale School of Drama. After college he moved to California, where he designed for Metro-Goldwyn-Meyer, Norman Bel Geddes, and others.

But after three years in the Army, he decided he didn't care to return to the theater business. He heard from a man he had had a brief affair with that there was an opening at the Downtown Gallery and enlisted his sister's help in landing the interview. After just a few

minutes in the gallery, impressed with both the grandeur of the building and Edith's even grander manner, Charles had made up his mind: he would take the job. Edith had not asked about his background qualifications or given him a rundown of what his responsibilities might be. Charles had not even asked about salary. He trusted her immediately and felt they were somehow fated to be together. "Tomorrow," he answered.

"Then you'll be here at nine-thirty," Edith instructed. "That's when the telephone starts ringing. People are always calling to ask my advice. I'm going to charge a consultant's fee, like a doctor. I must get to the Whitney. Don't disappoint me."

Two blocks north of the Downtown Gallery, in a large corner room on the seventeenth floor of an office building, eighty-two-year-old Alfred Stieglitz faced the fact that his days as a messiah for American artists were long over. At a time when life expectancy for men was sixty, Stieglitz had already lived a long life. He had been a central figure during the teens and prosperous 1920s, but now, with mid-century approaching, he was a relic of earlier times. His mustache had turned white, as had the mangy hair poking from his ears. The famed Stieglitz eyes no longer served him as well as they had forty years earlier when he issued strident dictums on who wielded the paintbrush with originality and who was strictly a follower.

Stieglitz had championed his handful of artists, treating them as rare and exotic birds, coddled and isolated from the rest of the species. From 1929 to 1946 he operated the third incarnation of his gallery, once again christened with a new name: An American Place. The gallery was highly regarded by critics, the cognoscenti, and a small group of collectors, but it did not have nearly the influence of "291." Aging and illness had slowed Stieglitz down, even if the company of a much younger woman—Dorothy Norman, his long-time mistress—had helped him retain his virility. Now plagued by heart irregularities and angina attacks, he depended on nurses to care for

Portrait of Alfred Stieglitz at An American Place by Ansel Adams, circa 1938. The paintings are by Arthur Dove and John Marin.

his health, and assistants to manage the nominal gallery activities. Stieglitz still ran the gallery, but by afternoon he was stretched out on a cot, resting.

As the spring drifted into summer in 1946, Stieglitz fretted about his artists. As usual, Arthur Dove's finances were precarious. Dove had one patron—Duncan Phillips—on whom he depended to fund his meager life, living as he did with his wife in a cottage in Centerport, New York. Otherwise, not another soul was interested in Dove's strange landscapes. Stieglitz was also anxious about John Marin's health. The seventy-five-year-old Marin had recently fallen while painting his house. "I am about at my wits end," Stieglitz wrote Duncan Phillips on July 3. "The demands made upon me increase hourly, and I have not got the heart to say no when I know that I should do so in order to protect myself." Seven days later, Stieglitz suffered a major stroke and slipped into a coma. He died three days later.

Stieglitz had figured in Edith's life for over thirty years, dating back to her schoolgirl visits as an aspiring teenage painter. Years later she remembered his "hypnotic monologues," Stieglitz's legendary diatribes defending modern art. She had always shared his taste and a fondness for the bravura and bravery of the small circle of artists he had championed.

Though Edith and Stieglitz had a long professional relationship, it was never especially close or warm. Doris Bry, Georgia O'Keeffe's assistant, suggested that their relations were inspired by commerce. "He didn't do it out of any affection," said Bry. "He was practical." Edith knew their relationship was not based on mutual admiration. It was mutually convenient. "I was useful to him [Stieglitz] because I did sell an awful lot of pictures during a long period of time," she later recalled. Though Edith was always careful to acknowledge Stieglitz's greatness ("I've told everybody publicly that Stieglitz was the most important thing that ever happened to American art,") she always resented Stieglitz's insistence that art and money shouldn't mix, as if there were something unsavory about the whole art-dealing realm. As Stieglitz's fame grew, so did Edith's resentment. She decided, in her

bitter later days, that Stieglitz's reputation had taken on mythic pro-
portions.

Edith's biggest objection was Stieglitz's reliance on donations
from wealthy patrons to pay his rent. Edith, who came from nothing,
was far too proud to ask for handouts. Even when times were dire
and she risked losing her gallery, she refused to ask Mrs. Rockefeller
for a loan or anything but a legitimate sale. Stieglitz was born to
wealth and privilege, and that gave him the confidence to ask for
money from others. He didn't have as much to prove as Edith did,
nor did he have her resistance to accepting help from others.

"Let's get it straight. He charged a much higher commission that
I do, than any dealer does, because he had people to pay his rent,"
said Edith, listing Philip Goodwin, Richard D. Brixey, and others as
examples of Stieglitz's generous patrons. Edith said that when she
made a sale for Stieglitz, she took her 25 percent commission (rather
than her usual 33 percent), and then divided the proceeds between 75
percent for the artist and another 25 percent for Stieglitz's "rent
fund." "He had all these rich people contributing to the rent fund,
and the rent there at American Place was very little." Compared to
the costs of running an operation like the Downtown Gallery, Edith
figured Stieglitz's overhead—with no employees, no advertising, and
a band of rich people willing to support his cause with checks—was
nominal.

Despite his anticommercial stance, Stieglitz controlled some of the
best-known American artists. When Edith became a dealer, she aimed
to prove herself to Stieglitz and to do what no other dealer had suc-
cessfully done: convince him to consign artworks from his small
coterie of artists, making them available to Edith's larger circle of buy-
ers and museum directors and curators. Her persistence, charm, and
access to rich clients persuaded Stieglitz it was the right thing to do.

Edith's primary appeal was that she was a conduit to some of
America's wealthiest art collectors during the Depression. During the
1930s there was no demand for Doves, Marins, O'Keeffes, and Hart-
leys. Yet Edith persisted, shepherding moneyed collectors to Stieglitz's

gallery. When she arrived with Mrs. Rockefeller, Edith's status shot up like the newly built Empire State building. "I liked Mrs. R—and I hoped she liked the Place," Stieglitz told Edith after the visit.

According to Stieglitz's grandniece, Sue Davison Lowe, Stieglitz was opposed to Mrs. Rockefeller's Museum of Modern Art and repulsed by the "millionaire cronies on the Modern board," who were "parading their munificence on behalf of culture." If that were true and Stieglitz was predisposed to dislike Mrs. Rockefeller, he swallowed his principles several times, asking Edith to bring Mrs. Rockefeller to an O'Keeffe show. "I think you ought to accompany her," said Stieglitz, "as she is your friend and you her advisor on art matters." In turn, Edith was uncharacteristically obsequious. After spending $4,500 for Mrs. Rockefeller on four Marin and Demuth watercolors in 1931—about a quarter the price of a Rolls Royce— Edith still felt obliged to stroke the mighty ego. "I want to thank you again for your courtesy," Edith wrote Stieglitz. "And for the beautiful spirit you are inspiring."

Her words rang hollow. Edith disagreed with the way Stieglitz ran his gallery. She thought his artists' reputations suffered from lack of promotion. Stieglitz limited distribution and access to the artworks, refusing to lend or to lower his aggressive pricing. Edith recalled watching a museum curator visit the gallery and beg to borrow a group of Arthur Dove paintings, one of her favorite Stieglitz stories. "Young man," Edith said, quoting Stieglitz. "If anyone wants to see Notre Dame, he goes to Paris. If anyone wants to see Dove, he comes here."

To Edith this exclusive club model had gone the way of academic art. The art market was a professional forum, not a place for the whims and experiments of eccentrics. She advocated lower prices and placing works in collections that counted, collections ultimately headed for museums and not resale on the auction market. Stieglitz was known for his mercurial and—for many—infuriating pricing, with a habit of asking a potential buyer how much he or she could

afford. "Halpert took the business of being an art dealer more seriously," said Sarah Greenough, the curator and head of photographs at the National Gallery of Art in Washington, D.C.

Edith knew she could do better. Her first test came in 1932 when Edith assumed charge of one of Stieglitz's most talented—and obscure—artists. Marsden Hartley had shown with Stieglitz since 1909 but was frustrated by the lack of sales. In 1921, Hartley appealed to Stieglitz for funds to travel to Europe. The dealer resorted to drastic measures, consigning 117 paintings to auction at Anderson Galleries, a sale that netted the artist $5,000, enough to send him off to Italy in style. Edith would have been outraged by this strategy. She believed auctions were high risk; artworks might fall well below retail prices, damaging public perception about the delicate balance of supply and demand. She preferred selling to clients who understood that they were not to offload the artworks at auction; and to collectors who would offer to sell the works back to the gallery first or, better yet, donate them to a museum for a tax deduction. Controlling supply was a basic business principle. Flooding the market with more than 100 paintings at one time was unthinkable.

Edith had tried to help Stieglitz with Marsden Hartley, a tall, dour artist from Maine who became known posthumously for his remarkable symbolic portraits of his lover, a German soldier, but who was totally overlooked while he was alive. Edith had sold a few of his paintings to her loyal collectors and had encouraged Juliana Force at the Whitney Museum to consider giving Hartley a show. For her efforts, Stieglitz transferred Hartley to Edith in 1932. "For 22 years I paid for storage for Hartley!! I can't do it anymore," he told Edith. "The first money you get for Hartley you will have to use to settle these accounts, otherwise he is apt to lose his pictures." Unlike Stieglitz, Edith was not about to pay Hartley's storage bills. Instead she forwarded Stieglitz's letter to Hartley, suggesting he pay the bills himself. Mrs. Rockefeller provided temporary respite in 1934, buying four paintings for $1,150 from a one-man Hartley show in the

Daylight Gallery. Outside of Mrs. Rockefeller, there was little hope for sales. At the time, Edith was thinking about reducing the size of her artists' roster and gently nudged Hartley to the posh, well-financed 57th Street Marie Harriman Gallery, owned by the wife of railroad tycoon William Averell Harriman. The gallery, which operated from 1930 to 1942, could afford to represent artists regardless of sales.

Two other Stieglitz painters, John Marin and Georgia O'Keeffe, were better known by the early 1930s, and Edith found their works easier to sell. Edith knew that she could make even more sales if she could convince Stieglitz to let her send the works to a museum show in Detroit. Amazingly, she did. In 1934, soon after Robert Tannahill bought an important Marin painting, Stieglitz agreed to send a group of Marins and O'Keeffes to the Detroit Society for Arts and Crafts. Edith wrote Tannahill that the show "will encourage him [Stieglitz] to be more democratic about works of art instead of reserving them for the few snobs who pay high prices to get into the newspapers." As if to help bolster Edith's point, Tannahill bought an O'Keeffe.

At the time, Stieglitz had larger concerns than selling his wife's dramatic flower paintings. Following her Radio City Music Hall nervous breakdown two years earlier, O'Keeffe had stopped painting. "My chief hope is that she may regain a bit of self-confidence," Stieglitz wrote to Edith. "The rest will come in time if it is to come." Preoccupied with O'Keeffe's health and hospitalizations, Stieglitz agreed to permit Edith to keep a stock of paintings at the Downtown Gallery. "Of course I think it can be arranged for you to have a few O'Keeffes and Marins for a while at your place," he said, "if you think you might do something with them." They agreed that Edith would keep a 25 percent commission on sales, but would not lend any artworks to other galleries or send paintings traveling, where they might be susceptible to damage.

Stieglitz also objected to lending artwork because of the sheer amount of work involved. When Alfred H. Barr, Jr. approached Stieglitz in 1936 about mounting a John Marin retrospective, Stieglitz

confided in Edith. "My impulse was to refuse. . . . It means a heap of work for me and I don't enjoy that extra amount one tiny bit." Edith's help made certain museum exhibitions possible. She worked with Stieglitz to arrange Marin retrospectives in Boston and Detroit. She also used her publicity contacts to get articles written in the better magazines, such as a Marin profile the literary men's magazine *Esquire*.

The arrangement worked, though the two dealers had drastically different philosophies. Stieglitz favored higher prices and fewer sales. Edith preferred lower prices and higher distribution. Having Marin and O'Keeffe on the gallery roster added prestige, but Edith wanted sales. She promoted O'Keeffe and Marin as aggressively as her own artists. She convinced Stieglitz that a Marin show of watercolors, all priced at $500, would excite buyers. That wasn't cheap—about the cost of college tuition—but it was far less than the thousands Stieglitz normally demanded. Edith played up the price, printing on the announcement: "For obvious reasons, an early visit is recommended."

In another brazen sales gambit, she concocted a plan to sell in bulk to museums, telling Stieglitz of her scheme to offer the Metropolitan Museum of Art a large group of American pictures with the proviso they might exchange the paintings at any time, if another work by the same artist appealed more. She adopted this selling scheme from Joseph Duveen, whom she had met through Mrs. Rockefeller. Duveen offered his millionaire customers the option to sell back their purchases. This plan didn't take off, despite Edith's optimism that museums would save the Depression-era American art market. At the time, museums were still lavishing money on European art. They weren't interested in American moderns.

Edith's persistence generated some results, though. She reported to Stieglitz in 1935 that she had sold $7,100 in Marins and $2,500 in O'Keeffes in the first half of the year alone. "Many thanks to you for Marin and O'Keeffe," Stieglitz said. "You have done wonderfully well. And I hope you are as satisfied as I am with the results.

. . . Running the Place as I do single handed with such ridiculous intensity is a bit much for a seventy-two-year-old."

Her collaborations with Stieglitz did not ensure Edith inheritance of his artists. Now that Stieglitz was dead, Edith didn't waste time being sentimental. She wanted his artists. She needed the inventory to meet the demands of the booming postwar art market. It was no time to launch unknowns. Marin and O'Keeffe were among the biggest names of the day, and although Arthur Dove had remained entirely obscure, Edith was confident she could get him the attention his remarkable talent deserved. She was next in line to inherit these artists and later said it was as simple as that. "He [Stieglitz] willed the artists to me," she later explained. In fact, that wasn't true at all. When Stieglitz died, his affairs were a complete shambles. Even if the Downtown Gallery was the logical extension for the American Place, Stieglitz hadn't taken steps to formalize this arrangement. It was up to Edith to fight for it, as she had been forced to fight for everything.

She would have to take on a formidable opponent—Stieglitz's semi-estranged wife, painter Georgia O'Keeffe. Stieglitz had never kept orderly records, leaving O'Keeffe—who detested paperwork and administrative tasks—to sort through what she politely called "Stieglitz's affairs," a project that would consume more than three years of her life. Stieglitz's will had left O'Keeffe in charge. Dorothy Norman, who had helped with the gallery since 1927, insinuating herself into Stieglitz's life first as his lover and later as a gallery assistant and aspiring photography protégé, stopped coming around the gallery, though she remained in charge of the rent fund and her name was on the lease.

After Stieglitz's death, O'Keeffe continued to pay rent on An American Place. O'Keeffe figured she and Marin would continue to use the Place for storage and exhibits. Those were the practical justifications. On an emotional level, O'Keeffe was not ready to move on.

Also, she needed to sort through the thousands of artworks stored there. She needed someone to appraise Stieglitz's collection, including the 850 modern European and American artworks Stieglitz had bought or received as gifts from artists. Edith was the obvious choice for this task because she knew how much the various artworks were worth. O'Keeffe also knew that Edith wanted to solidify her connection to the estate and would be willing to help out cheap.

Edith's appraisal listed works by six primary artists (Demuth, Dove, Hartley, Marin, Edward Steichen, and Walkowitz) and assorted miscellaneous paintings and sculptures by others, totaling $64,425. The most valuable body of work was by John Marin, the commercial star of the Stieglitz clan, with $28,840 worth of paintings and watercolors—a much lower total than the retail prices Stieglitz had been quoting for years.

Plowing through Stieglitz's collection in the searing heat shoulder to shoulder with the irascible O'Keeffe was not how Edith had envisioned spending her summer. They made quite a study in contrast: garrulous Edith with her fondness for tailored Hattie Carnegie suits and red nail polish and stately O'Keeffe with her pared down uniform of black clothes, not a trace of makeup, and her long hair knotted at the nape of her neck.

It was the first time Edith had worked directly with the fifty-nine-year-old artist. Though she had sold O'Keeffes for two decades, Stieglitz had always acted as intermediary. "I worked with O'Keeffe and developed a tremendous admiration and affection for her towards the end," Edith wrote a friend. "She is quite an extraordinary gal and is actually broken up about the loss of Stieglitz."

After Stieglitz's death, it was up to his three artists to decide whether they wanted to join the Downtown Gallery. His most obscure and underappreciated artist was the first to defect. Arthur Dove's paintings, like Marin's and O'Keeffe's, started out examining nature and departed from there. "I should like to take wind and water and sand as a motif and work with them," Dove wrote in the introduction to a 1927 show. "But it has to be simplified in most

cases to color and force lines and substances, just as music has done with sound." His radical paintings dated back to 1910, when he began abstracting and simplifying.

"America had never seen an artist like him," writes Elizabeth Hutton Turner, a curator at the Phillips Collection. Indeed, contemporary critics praised Dove's originality, though they seemed unsure what to make of his works. "Dove to us is the one outstanding native painter who has gone his own road and on his own feet," wrote Murdock Pemberton, the *New Yorker*'s art critic in 1927. "Now don't jump down our throat before we finish. His road, of course, is a special path and almost wholly untrodden by the boys and girls who paint pears or trees or such-like accepted symbols." Several years later Pemberton admitted that Dove, in all his abstract glory, was an acquired taste. "We doubt if Dove will ever be as much appreciated by the layman as he is by the painter. Of late, however, he has been turning out an occasional canvas so representative that even the casual visitor can admire it."

During the 1920s and 1930s, Dove depended on Duncan Phillips's patronage to survive, an arrangement he resented. In exchange for a $200 monthly stipend, Phillips was permitted to choose from Dove's best work. The stipend permitted Dove to live but not live well. Ultimately Stieglitz's failure to attract other buyers angered Dove, but perhaps that was a calculated failure. It has been suggested that Stieglitz realized that Dove's work might compete with O'Keeffe's—that their artwork was too similar—and that it helped O'Keeffe to keep Dove out of the limelight.

Soon after Stieglitz's burial, Edith pursued Arthur Dove. She entertained the artist and Helen Torr, his painter-wife, with art world stories, impressing them with her vigorous personality and also her business savvy. "I wish you could know how happy you made me feel that you are in charge of all the work," Dove wrote after agreeing to join the Downtown Gallery. He was elated to hear Edith's plans to promote him with traveling exhibitions—lending to museums and other galleries—and was impressed with her network of collectors

around the country. "And I feel that we shall not have to be quite so dependant upon Mr. Phillips keeping his feet against the door that keeps starvation out," said Dove, "marvelous as he has been to us."

Dove didn't live long enough to see Edith fulfill her promises. In November, just four months after Stieglitz died, Dove's heart gave out. He died at the age of sixty-six. The following year, Edith held a posthumous retrospective of fifty Dove works dating from 1906 to 1946. She underlined Dove's status as a "pioneer abstractionist" and early innovator. "Today, many younger contemporaries employing Dove's idiom are being hailed as highly original and imaginative," Edith wrote in her press release, alluding to the recent wave of abstract artists she admired, such as Mark Tobey and Arshile Gorky. "But Dove invented his own language of abstract art almost forty years ago." Edith didn't hesitate to blame Stieglitz and Phillips for the artist's obscurity. She said that though Dove was little known by the public, it had nothing to do with a shortage of talent. The fact that his work had been available for viewing only in two venues—at the Stieglitz Gallery and the Phillips Collection—had prevented him from attaining the amount of fame and acclaim he deserved. It wasn't Dove's fault for making difficult art. It was just too difficult to see this art.

Four years later, the Museum of Modern Art gave Dove a retrospective. Alfred H. Barr, Jr., echoed Edith's sentiments in his introduction. "Arthur Dove, especially, anticipates by 35 years the current interest in a kind of abstraction." wrote Barr, who said Dove deserved honor because of his allegiance to his "lonely art" and his "importance as a precursor of the strongest current in mid-century American painting."

Edith would continue to represent the Dove estate for more than twenty years. She managed to find fresh, newsworthy ways to keep his work in front of critics and helped his artworks filter into appropriate museums, some sixty-two by 1967. Edith was convinced Dove was the first artist to make a pure abstraction—way back in 1910—and spread the word. In 1958 he was honored with a five-venue trav-

eling retrospective. "Among those between-the-wars pioneers Arthur Dove had a leading role which is at last being adequately assayed," wrote *New York Times* critic Howard Devree, who felt the show "should go far toward belatedly establishing him among this country's outstanding original artists." Nearly forty years later, top Doves are rarely on the market, but when they appear at auction, they can sell for over a million dollars.

With Dove's estate under her control Edith's turned her attention to Stieglitz's moneymakers, John Marin and Georgia O'Keeffe. Other dealers began circling, eager to add the famous Stieglitz artists to their own rosters. Old guard American galleries, such as Knoedler, courted O'Keeffe and Marin, as did a slew of the most prestigious European dealers with New York galleries, including Wildenstein and Company and Paul Rosenberg. The notion that any European dealer might poach either of the great American artists offended Edith. As the only dealer hand-selected by Stieglitz to sell their artworks while he was alive, she believed she was his rightful successor.

John Marin's reputation as a radical American artist dated to 1910, the year of his first solo show at "291," Stieglitz's first gallery. He churned out so many watercolors, he had an exhibition with Stieglitz nearly every year until 1946. Marin didn't start painting until he was twenty-eight. By the time his Cubist-inspired watercolors of the Woolworth Building were celebrated at the 1913 Armory Show, he was already forty-three-years old and had absorbed the lessons of the Parisian avant-garde during the five years he spent in Europe. Marin was aloof and disinterested in everything but his painting. He had weather-wizened skin, a conical nose, and a firm jaw. He depended on his wives—three total—to hack his unruly hair into what looked like a jagged upside-down bowl. Like O'Keeffe, Marin preferred staying away from the crowds and rush of New York. He lived in a modest middle-class neighborhood in Cliff-side Park, New Jersey, and retreated in the summer to an ocean–front

cottage on the rocky Maine sea coast of Cape Split. The consummate outdoorsman, he was an experienced sailor and fisherman, as facile with with a fly rod as with a paintbrush.

Marin's spontaneous watercolors transformed both the Maine coastline and Manhattan skyscrapers into lively modern compositions. Taking advantage of the 1920s vogue for watercolor—historically a medium less respected than oil painting—Stieglitz promoted Marin's watercolors exclusively. In conjunction with Marin's exhibits, Steiglitz published Marin's stream-of-consciousness writings and letters, filled with poetic ramblings, strange spacing, and idiomatic grammar:

> I didn't want to start this letter but I knew that when the letter to you was written—well—I'd be glad it was written
> interruption—had to help clean a Chicken—
> had to shell out some peas—another interruption later on
> —have to paint a picture—
> Why does one paint a picture?

Edith was determined to add the famous and prolific Marin to her roster. After Stieglitz's death, she began writing Marin about her sales activities on his behalf, emphasizing the prestige of the buyers: of the five works she had sold, two had gone to museums and one had been acquired by the International Business Machine Corporation for their corporate collection. But selling a few Marins didn't mean much. Edith wanted a Marin show.

Wary of seeming overly aggressive, she came up with a hook: 1948 was New York's golden jubilee, the fiftieth anniversary of the incorporation of the city. There were a number of city-wide events planned to celebrate the anniversary. Edith figured she could ride this publicity with a retrospective show of Marin's depictions of New York. She was able to convince the artist, who was barely making any sales, of the logic of her proposal, and she set about selecting a group of watercolors, drawings, and oil paintings dating from 1910 to 1944

for "Marin—New York." She described the show to critics as "an event of greatest importance" for an artist "generally considered America's first living artist." Edith sold eight pieces, with watercolors going for between $500 and $900.

Despite this success, Marin appeared in no hurry to anoint Edith as his new dealer. Marin was not a salesman. He had turned the dealing over to his son, thirty-four-year old John Marin, Jr., who was looking for something to do since his release from the Army. The son, who had demonstrated little interest in art—preferring sports—had few professional prospects. Latching onto his famous father was the natural path, and he ultimately served as one of his father's caretakers, despite the fact that Marin had neglected his role as a father, focusing his energies on his art making.

When Edith heard rumors from a dealer friend in Boston that a traveling Marin show had been offered to his gallery, Edith got nervous. She had been patient, not wanting to appear pushy when dealing with the reticent Yankee. Now it was time to force a decision. "As you know," Edith wrote Marin, "I have always been hesitant, because of my admiration and awe of you, and my deep regard for Stieglitz, in pushing myself forward into your plans." With an edge of desperation she added, "you are my favorite artist, American or otherwise, possibly more so because not otherwise. . . . I can also say, with all due modesty, that I—or The Downtown Gallery—is the logical and only place for Marin. Stieglitz said so to me, many times, and demonstrated his attitude by entrusting Marin paintings throughout my entire career."

She received a letter back from John Jr., in a bizarre imitation of his father's famous voice, which probably irked Edith more than amused her: "Too much times runs along—but do I write a letter—no I say there is always tomorrow—now I have turned tomorrow into today."

Another year passed before Edith could announce Marin had joined her gallery. Later in life, Edith said Marin had required minimal prodding to join the Downtown Gallery, picking her as the one

logical successor to Stieglitz and rejecting a $20,000 annual stipend offered by dealer Paul Rosenberg. In truth, Edith was forced to offer Marin more than her reputation. She agreed to hire John Jr. to work at the gallery, and more than that, she agreed to construct a new room for the permanent display of Marin's works.

John's wife, Norma Marin, said the hiring upset Charles Alan, who viewed John Jr. as a threat to his own plan to take over the Downtown Gallery once Edith retired. Charles "pushed around" John, who was submissive and did not fight back. In fact, John was no threat to Charles's status. Edith knew John was kind and friendly—and bore that magic last name—but that he was a man of limited intellect.

"Edith has always been obsessed with records," Charles later recalled. "So John just sat making all those entries in all those photograph books and all those record books and pasting in all those clippings. . . . And he was not unfriendly with the clients. The fact that he was the son of John Marin, Sr. meant a great deal to them."

The second part of Edith's bargain with Marin required her to create a Marin room. She hired a young architect, Edward Larabee Barnes, to design a narrow, 7-foot room in the backyard, where a selection of Marins would remain on permanent display, separate from the other gallery artists. Though the room was modest in scale, Edith hired a professional lighting company to design fixtures to blend natural and artificial light. Marin mixed the crisp white wall color himself. The Marin room also included a selection of books and catalogs on the artist, as well as an alcove with etchings. Edith later said that she only offered to build the Marin room after the artist decided to join the gallery, which sounded impressive but wasn't true.

Marin was over eighty years old but continued to churn out paintings and watercolors. For three consecutive seasons, 1950 to 1952, Edith presented his newest works. She also defied Stieglitz by promoting Marin's later oils, challenging the art historical premise that Marin's greatness emanated from his watercolors. She fended off overtures from European dealers, who vied for the Marin estate once

John Marin, touching up a painting in the Marin room, December, 1950.

the artist died in 1953, and she continued to promote Marin, even as his work fell out of fashion in the 1950s, supporting dozens of retrospectives, one-man shows, and group exhibitions, and placing his works in important museum and private collections. In 1953 Edith and Duncan Phillips lobbied the Metropolitan Museum of Art to organize a memorial show. Edith believed the museum owed it both to Marin and to Stieglitz, from whom the museum had received several gifts of hundreds of artworks. The museum declined, explaining

that it lacked the space and funds for such an exhibit. Phillips was accepting, but Edith didn't believe the museum's explanations and was furious. She refused to stop fighting on Marin's behalf, and his memorial show ultimately stopped in ten venues, including the Museum of Fine Arts, Boston, Whitney Museum of American Art, The Phillips Collection, and the Art Council Gallery in London. Edith continued representing the Marin estate until 1964.

That left O'Keeffe.

After Stieglitz's death, O'Keeffe focused on settling her husband's estate in preparation for a permanent move to New Mexico. She had discovered the region in the 1930s and took to visiting regularly in the winter months, finding a landscape of pink cliffs and hills she considered her own. Early on she rented a cottage at Ghost Ranch, a remote dude ranch 35 miles from the nearest telegram office or telephone. The accommodations were spartan, which appealed to O'Keeffe's minimalist sensibility, but the challenge of obtaining vegetables and other necessities distracted her from her painting.

O'Keeffe bought a small house at Ghost Ranch, and later, in 1945, she bought a second property, a dilapidated adobe house used for pigs and cattle in Abiquiu, a little village at the base of the Chamas Mountains. It was here that she created her ideal life, complete with an organic vegetable garden with beans, chilies, and corn; electricity from a generator; and mail delivery from a postal box on the highway. Her life was given over to painting and rambling around the desert in her Ford Roadster. O'Keeffe was as isolated as she needed and wanted to be: the only other Anglo in the village was the man who ran the general store. Her life could not have been more different from Edith's in New York, filled as it was with days in the gallery and evenings at art openings fueled by her favorite stimulants—scotch and cigarettes. They were similar on deeper levels, though, both proud and independent women who wished to control their environments and minimize distractions from their primary focus: for

Edith, the gallery, for O'Keeffe, her painted world. "It is hard to think of your city world," O'Keeffe wrote Edith. "Here my life is my own and I find it very pleasant."

They did share a number of other characteristics. Both were obsessively controlling and demanding. Compromise came rarely and with great reluctance. As younger women, their beauty and charisma had helped them gain notice in an art world dominated by male curators, collectors, and critics. Edith's had a racier, earthier appeal, whereas O'Keeffe's cool Garbo-like allure carried her to cult status. Both appeared financially and emotionally independent, without the need for a man to provide money or prestige. In fact, O'Keeffe was much more emotionally dependent on Stieglitz, and in her later years she relied on a handsome, much younger sculptor, Juan Hamilton, to provide her with emotional security and caretaking. But in their youth, both women were the providers for their much older husbands: Edith supported Sam, and O'Keeffe did the same for Stieglitz. Though their husbands provided an entreé into the art world, their marriages ended in disappointment. We know Edith's story. In the case of O'Keeffe, Stieglitz was unfaithful in a series of affairs, and according to one biographer, predisposed to unseemly infatuations with adolescent girls. His romance with Dorothy Norman lasted many years and was humiliatingly conducted in public. Though some say the marriage between O'Keeffe and Stieglitz somehow worked: "They were passionately in love, but they faced the difficulties of any marriage that stands over such a long time," said the curator and head of photographs at the National Gallery of Art, Sarah Greenough. "They went through a very bad period, but they stayed together and worked through it. How profoundly gratifying it is for someone to have total faith in one's worth. He was always her champion, even when they were going through the worst of times." O'Keeffe's biographers have linked Stieglitz's infidelities with her nervous breakdowns, which required hospitalizations and long periods away from her husband. New Mexico was not only a place to paint: it was freedom from an unfaithful man.

Edith and O'Keeffe both discarded societal expectations, each finding her own highly unusual way to live. Edith rejected the conventional gallery tactics, inventing a new way to promote and sell art, work for which there was barely an audience. When prospects were slim, she relied on sales of cigar store Indians, needlepoint samplers, and duck decoys, having invented value where there was none. O'Keeffe also rejected what she was taught, including lessons on how to paint. At the age of twenty, as a student at the Art Students League in New York, O'Keeffe realized she had mastered the technical skills but now needed to find her own vision. "I began to realize that a lot of people had done this same kind of painting before I came along. It had been done and I didn't think I could do it any better." She left New York, found a teaching job in a remote town in Texas, and invented her own private way to paint, starting with the simplicity of a line.

Despite all their similarities—or maybe because of them—of all the hundreds of relationships Edith nurtured during her four decades of dealing, none was more fraught with tension than hers with O'Keeffe. They fought terribly.

It mostly had to do with power struggles. After Stieglitz died, Edith sold paintings sporadically for O'Keeffe, who kept much of her unsold inventory out of Edith's grasp, stored at An American Place. To access paintings, Edith was required to ask O'Keeffe's permission and then meet Doris Bry, O'Keeffe's New York assistant, to go into the vault and select works. At first, Edith accommodated O'Keeffe, allowing the artist to dictate the terms of their arrangement. O'Keeffe insisted on narrow metal frames, either silver or painted white, made by one particular New York City frame maker and, on at least one occasion, even suggested to the new owners of one of her paintings that they paint their walls white. Her smoothly painted canvases were regularly sent to Mrs. Caroline Keck, a restorer at the Brooklyn Museum of Art, for spraying with a protective varnish. When buyers complained to Edith that their O'Keeffes lacked the artist's signature, Edith figured out a way to appease her customers, without upsetting the artist: she had the paintings photographed and mailed the photos

to O'Keeffe, who would then sign the photographs. Edith also emphasized to O'Keeffe that she was carefully vetting all prospective buyers, as Stieglitz used to do, noting when a buyer had an important collection or had especially good taste.

One consistently contentious subject was traveling exhibitions. O'Keeffe, like Stieglitz, loathed lending her artworks. She had a pathological fear her fragile paintings would be damaged. The fear was not without merit: art shipping was unsophisticated, and sometimes artworks arrived at their destinations with broken glass, scratches, and flaking paint. Edith felt strongly that the virtues of exhibiting outweighed the potential pitfalls. She always encouraged her artists to participate in traveling exhibitions, seeing the value in free publicity. When Edith recommended lending an O'Keeffe painting for a prestigious show in Argentina, organized by artist Marcel Duchamp, O'Keeffe said she would rather not, dismissing the famous artist as "a very casual young man." Sometimes Edith prevailed. O'Keeffe reluctantly gave permission for a painting to be included in the Carnegie International high-profile annual art exhibit held at the Carnegie Institute in Pittsburgh. O'Keeffe generally kept her eye focused on the short term, judging the merits of a show on the immediate sales and disruption to her own peace and quiet. Edith, in her quest to build careers and dynasties, had a far longer view.

O'Keeffe also differed from most of Edith's artists because she didn't need sales to survive. "By 1929 O'Keeffe was self-sufficient and financially independent because of Stieglitz's efforts," says Barbara Buhler Lynes, curator of the Georgia O'Keeffe Museum and director of the O'Keeffe Museum Research Center. "She had stock market investments and other things that generated income." Like Edith, O'Keeffe was shrewd with her money. (Edith always advised her artists to invest their profits in stocks and bonds and began investing in annuities in the 1930s.) On top of O'Keeffe's accumulated wealth, according to one of her biographers, she had inherited $148,000 in cash and stocks from Stieglitz. Regardless of the source, if O'Keeffe never sold another painting in her life, all her needs would

be provided for. This made it all the more aggravating that O'Keeffe insisted on the 25 percent commission that Edith had negotiated with Stieglitz, less than the 33 percent commission paid by every other artist.

The two women also clashed over Stieglitz's philosophy of keeping prices high. "O'Keeffe was shaped by Stieglitz on marketing," recalled Doris Bry. "For a top thing, you get a top price." Edith couldn't disagree more. She wanted to get the art out into the world and didn't espouse the view that it should be restricted to the rich and mighty.

For several years Edith patiently sold the occasional O'Keeffe. But by 1949, as O'Keeffe finalized museum bequests for the Stieglitz collections, Edith began asking about the possibility of a one-person show and suggested they formalize their relationship as dealer and artist. "You speak again of a show," said O'Keeffe. "I can't say yet."

O'Keeffe was reluctant. It was impossible to replace Stieglitz, and although there weren't many options, O'Keeffe wasn't especially fond of the pushy dealer. But Edith did know her O'Keeffes and knew how to sell them. O'Keeffe was also pleased that Edith had made arrangements to work with Marin and to hire "young John," as she called Marin's son. O'Keeffe also appreciated Edith's strength and business savvy, once asking for her "hard headed woman opinion."

She also knew she had to bring order to her own affairs. After witnessing the disarray of the Stieglitz's estate—which required a full-time assistant to organize—O'Keeffe wanted to get her own inventory under control. Stieglitz had an enormous stockpile of her work. Worse, he did not have any discernable method to his record keeping: jots on scraps of paper and exhibition checklists served as the primary clues. "It was just a mess of unorganized stuff," recalled Bry. O'Keeffe tried to keep track of things herself but felt overwhelmed. "I don't want to leave anything like Stieglitz left for someone else to clean up," she said to Edith. "I am inclined to think that I should destroy the lesser things. . . . Now it doesn't matter if I sell

or not. . . . I sometimes think I'll just stop making any attempt to sell paintings, just stay in the country and get queer I suppose."

O'Keeffe's threats to destroy her artworks and quit selling did not dissuade Edith. She assured O'Keeffe of the care she took as a dealer to find appropriate homes for the paintings. "As you know, we are very careful about placing pictures and are very proud of the fact that only five or six have ever appeared at auction. We prefer to turn down a sale to a questionable person or frequently decide to take a slightly lower price when we know the painting will be 'put.'" Edith also outlined a sales strategy: "Sell your minor pictures for low prices to young collectors who have not very much money and hold out your 'A' pictures for high prices, at the same time removing from the market your 'A-plus' pictures for placing [in] institutions you yourself select."

Just when Edith thought O'Keeffe was ready to close up An American Place and move on, she wasn't. Instead of showing her new paintings at the Downtown Gallery, O'Keeffe decided to exhibit at the Place. "You may be very annoyed with me but I am sure I am right and I hope you will be with me on it," she explained to Edith. "I can visualize my show as looking much better there than any other place. . . . It is a high price in dollars I pay but that is alright. . . . for me the idea is better than the money."

Edith was furious, despite O'Keeffe's promise that after the show, Edith could finally announce O'Keeffe as the newest member of the Downtown Gallery, as Marin had recently decided to do. "Your letter shot all my plans to bits. . . . You and Marin have vacillated so much." She warned that Stieglitz's control over Marin and his wife persisted, even from the grave. "As I mentioned on previous occasions, without Stieglitz, it is merely a room on the seventeenth floor of an office building, where great pictures had hung in the past. The place is not the PLACE without Stieglitz."

O'Keeffe was as stubborn as Edith. "I know that if I can do it this year it will be the last time I can do it that way, and I would like to. It may be foolish, I'll admit, but then I'll just say I'm foolish. . . . I

know the place isn't the Place without Stieglitz. No one knows that better than I do."

The show, "Georgia O'Keeffe: Paintings 1946–1950," went up at 509 Madison Avenue on October 16, 1950, the first and last exhibit in the four years since Stieglitz's death. It was organized by O'Keeffe's assistant, Doris Bry. Among the thirty-one paintings were landscapes inspired by New Mexico. "I want you to be sure in your mind that I think of doing it because I wish to," O'Keeffe explained to Edith. "Because to me it feels like a better way of finishing a certain part of my life." Critics weren't so sentimental. The show gained just a handful of reviews. For the art establishment, An American Place had already ceased to exist.

After the show O'Keeffe terminated her lease. Edith couldn't conceal her resentment, blaming O'Keeffe for the fact that sales were way down. She argued that whether or not O'Keeffe was concerned about earning money from her artworks, it was important to present her work regularly and in the proper context. "A great deal of confusion was engendered in the public mind," Edith wrote to O'Keeffe in 1951, arguing that buyers had begun to associate O'Keeffe with the Downtown Gallery. "The American Place exhibition, naturally, threw them off the track and we have had practically no one in to inquire for your work since then. Thus I feel that we have to do *something* to re-stimulate the interest."

Finally, in 1952 O'Keeffe was willing to compromise. "What would you think of a pastel show," wrote O'Keeffe. "Could be very handsome, or even pretty. . . . I do not mind the word as most artists do." And with that, O'Keeffe agreed to her first solo show at the Downtown Gallery. Though she was just displaying pastels, not the flower paintings and desert landscapes that had made O'Keeffe famous, Edith took the show seriously, describing the artworks as "paintings in pastel" and billing it as a miniature "survey of her development." She described a 1914 abstraction as "of great significance," establishing O'Keeffe as "one of the forerunners of the present abstract school."

O'Keeffe said she didn't mind if Edith mentioned her affiliation with the gallery, suggesting something along the lines of, "Other work by Georgia O'Keeffe can be seen at the Downtown Gallery." Edith retooled the language so there was no ambiguity. A crisp line of black text on the back of the program stated "The Downtown Gallery is the only representative for the work of Georgia O'Keeffe."

Officially on board, O'Keeffe only halfheartedly abided by her responsibilities as a member of the gallery. Each spring and fall, Edith was required to write O'Keeffe multiple letters begging for new paintings for the twice-a-year group shows that highlighted new works by all the gallery artists, shows Edith used to generate publicity for the gallery and residual sales all season long. With O'Keeffe so far away, Edith had difficulty conveying the seriousness of her requests. O'Keeffe was aloof and had no desire to become friendly with her dealer. For nearly two decades, she headed her letters "Dear Edith Halpert." Edith played along, addressing the artist in neatly typed letters: "Dear Georgia O'Keeffe." Edith wasn't going to make much of an effort to befriend O'Keeffe, either. Theirs was a relationship of letters. Though Edith crisscrossed the country regularly for art openings and to visit collectors, and often said she considered traveling to New Mexico—encouraged by O'Keeffe to see the artist's world—she never made it. She sent Charles Alan to Abiquiu instead.

Though they tolerated each other, there was no trust. O'Keeffe accused Edith of lowering prices on her artworks without asking. She was also convinced the gallery damaged her paintings, accusing Edith of "careless handling" and repeatedly insisting "will you please *not have anything* of mine without either glass or plexiglass covering." Edith did ignore O'Keeffe's demands on a number of occasions, lending artworks to museums surreptitiously—permitting the museums to hang the paintings but not include them in the exhibition catalog. O'Keeffe also fought with Edith over museum guarantees, demanding that museums spend $4,000 on her paintings in exchange for an exhibition. Edith thought this was too aggressive and impossible to ask of smaller institutions. She suggested O'Keeffe accept $2,500 instead.

Edith constantly struggled to find ways to motivate O'Keeffe to give her work to sell. She knew O'Keeffe didn't need the money—something that usually motivated her other artists—so Edith appealed to her ego instead. "Whether or not sales are important to you, I am sure that the response of an understanding public must be. Perhaps, I am barking up the wrong tree. Evidently, the only female artist in the gallery is harder for a female dealer to understand than the boys." This approach failed. "And don't for a minute get it into your head that I do not wish to sell," said O'Keeffe. "I have never made any such statement. . . . To make my living every year is my idea of the only way to have any feeling of stability in my life."

Three years had passed since the pastel show, and Edith launched another campaign to encourage O'Keeffe to consider a new exhibit. With the art world's attention focused on the wall-sized abstractions churned out by the young hotshots—Pollock, Franz Kline, Rothko—making O'Keeffe seem fashionable required focusing on her more abstract tendencies, playing her up as a precursor to the rage for abstraction. Edith advised O'Keeffe to select works reflecting "the so-called abstract direction." There were a few roadblocks to selling O'Keeffe in the 1950s: First, her work was overshadowed by the new output of younger artists. And second, Edith had the problem of countering critics' insistence that O'Keeffe's flower paintings were about sex, an interpretation the artist refuted. "I will make even busy New Yorkers take time to see what I see of flowers," O'Keeffe wrote in her autobiography. "Well—I made you take time to look at what I saw and when you took time to really notice my flower you hung all your own associations with flowers on my flower and you write about my flower as if I think and see what you think and see of the flower—and I don't."

Edith instead emphasized the formal beauty of O'Keeffe's images. She knew having O'Keeffe identified as a female painter or specifically a painter of female genital organs limited her commercial and critical appeal. And she blamed Stieglitz for having fostered this sexual interpretation. "All that sex business that was built up about her

pictures," Edith later recalled. "Well, it was an old, old man with a young bride . . . all the sex that was brought in to O'Keeffe's pictures by everybody—he started it. This was an old man boasting of his prowess indirectly. All the photographs he made of her were always of very female parts."

O'Keeffe finally agreed to send Edith a group of new paintings, but couched her cooperation with a long list of requirements, including that she hang the show herself, that the gallery be painted white (at Edith's expense), and that the announcement be, in O'Keeffe's preferred aesthetic, "as plain as possible please." She shipped the paintings in a padlocked box to prevent any theft.

O'Keeffe made it quite clear to Edith that she didn't appreciate the dealer's efforts to sell her work. "I hope it will be my last show," she told Edith. "My first one at "291" was 40 years ago. . . . I hope to work the next 40 years and have no show. When I think of it I not only had the headache of my own shows with Stieglitz, I had the bother of all the men's shows too. It was as if I was having a show all the time." She wanted to focus on her painting, not her career. "And if you don't like the paintings," she told Edith, "just box them up and return them. It will not hurt my feelings. I'm in no humor to care."

When Edith opened the padlocked box, she discovered O'Keeffe had not heeded her advice. Most of the paintings O'Keeffe had sent to New York had obvious subjects: trees, lakes, animal bones, and doorways. Only three were in the "abstract mood" Edith had requested. "More of the less literal paintings are expected of you," Edith told O'Keeffe. "We girls must show the boys which is the superior sex."

Despite this note of humor, Edith's patience was exhausted. Even if others tolerated O'Keeffe's diva behavior, Edith would not. Edith's esteem came from her expertise as a dealer. She didn't claim she could do anything else as well: art dealing was her life. That O'Keeffe continually questioned Edith's advice and spoke to her without respect was unforgivable. "Something must be done to change the attitude and the unnecessarily crotchety correspondence that passes between

us," Edith wrote. "I have been extremely patient under your rather imperious treatment. I appreciate your importance as an artist and have always tried to be courteous as I am with every individual with whom I have contact. I am not accustomed, however, to being treated as an underling, being scolded and railed at. Frankly, I do not like it. . . . Also, I resent very much this attitude of dangling the one man show before me."

O'Keeffe's intense focus on her painting meant she didn't pay much attention to Edith's complaints. "I hope you recovered from your grouch," she wrote back. "Now that I get to work I don't really care about other things." Besides, O'Keeffe didn't care for Edith any more than she liked the whole business of selling. Assembling an exhibition pulled her away from the easel. In addition to the hassle of making crates, she needed to worry about frames meeting her exacting requirements and about the damage that might be inflicted upon her art.

Given all of her worries, she continued to sell, if only to help clear out her studio, creating the psychic space she required to produce more art. "I was absurdly pleased to find my big rooms empty except for my tools . . . got to work and have three new paintings," she told Edith after shipping off several crates of artwork. "I want to sell because baring [sic] accident I expect to work for a long time yet," she told Edith. "There is no use in keeping what I do with no one to inherit it and no one to do anything with it if I die."

O'Keeffe's desire to control her legacy and the works by which she was remembered compelled her to destroy forty paintings she considered inferior pieces. She then suggested to Edith that her other paintings stored in New York be sent to her in New Mexico. Edith deflected this request. "Don't you think it is a mistake to have many of the pictures sent to you?" asked Edith. "You seem to be in a very destructive mood from the number of pictures you have done away with as stated in your letter."

Finally Edith was satisfied with the mix of paintings for O'Keeffe's show, having concocted a blend of abstract and figurative works at

different price levels. She was determined to expose O'Keeffe to a new generation of collectors, the young wealthy buyers who had emerged since World War II and who had been infants during Stieglitz's heyday in the 1920s. She reported to O'Keeffe that all the private collectors, except for one, were under the age of forty. O'Keeffe admitted she was satisfied. "I am glad that you seem to be pleased," she wrote. "It would have been difficult if I had felt you were not. For me it clears the air and I am ready for a new start. A show for me has never been a pleasure as it seems to be for many— it has always been like a necessary evil that I get through in one way or another."

As Edith worked to keep O'Keeffe's prices high, there was the ongoing challenge of what to do when an O'Keeffe came up for sale at auction. The risk was that a painting might sell for very little, setting a dangerous precedent. Usually Edith and O'Keeffe schemed to avoid this scenario, with either dealer or artist agreeing to buy the work at auction or at least bid up prices to a respectable level. The only problem was that O'Keeffe was required to spend nearly as much money protecting her paintings on the auction block as she did selling. In 1955, she earned just $1,500 more than she spent at auctions. The following year, she sold $11,500, but racked up a $5,150 auction tab. Whatever annual earnings O'Keeffe made, she shrewdly made enough museum donations from her own art collection that her tax deductions offset any taxes she might have otherwise owed.

During the early to mid-1950s, O'Keeffe fell out of fashion. Her decline in sales affected her self-esteem. "I wish I knew why my work goes so badly but I don't," she wrote to Edith. "Maybe I am just slipping. I have been this way before but never quite so good for nothing." Edith tried to offer support from afar. "I am distressed that you are unhappy with your work," she replied. "Under no circumstances, will I accept this notion of yours that you might be slipping. This is absurd, and I am sure that some extraordinary pictures will result any minute."

Dissatisfied with her current work, O'Keeffe agreed to allow Edith

to exhibit a cache of fifty watercolors, many dating back to 1916 and 1917, the artist's formative years in Texas and Virginia. Edith eloquently wrote about the watercolors in her press release: "She simply responded to the true forces of nature and to a world rich with evocative, inner meanings, finding her answer in bold forms and emotive masses of color."

Toward the end of the 1950s, O'Keeffe's spirit and confidence lifted. Her letters to Edith described jonquil leaves sprouting and her 3-mile walks at sunrise and sunset with her two chow dogs. But just as the tension between them had begun to dissipate, Edith felt O'Keeffe had again overstepped her bounds. Without consulting with her, O'Keeffe had agreed to a retrospective at the Worcester Art Museum, in Worcester, Massachusetts—hardly the museum Edith might have chosen had she known O'Keeffe was amenable to doing such a show. The Worcester Museum was a fine institution, but Edith would have lobbied for a high-profile place, accessible to more viewers. Edith considered her role as a dealer as the artist's strategic partner, but O'Keeffe continued to treat her as hired help. O'Keeffe had signed on for Worcester because of her friendship with Daniel Catton Rich, director of the museum. As she had done with her final show at An American Place in 1949, O'Keeffe—often a shrewd business person but not always—operated from her heart, not her head.

O'Keeffe did, however, agree to a Downtown Gallery show just after the Worcester show, shipping off two boxes of paintings and a list of invitees for the opening party, including writer James Baldwin and sculptor Alexander Calder. "I hope you will not ask me for another painting for a long time," she wrote. "Please." The 1961 show was a success. Edith reported to O'Keeffe record attendance and record sales of $49,837 for the year. ($311,000 in today's dollars). O'Keeffe mustered a rare compliment: "I have heard it remarked that you are the best salesperson in the N.Y. art world at the moment, which may or may not interest you."

Their truce was short-lived. Regular visits by Doris Bry, to check up on O'Keeffe's paintings, angered Edith. She told O'Keeffe that Bry

316 : THE GIRL WITH THE GALLERY

acted like "a one-man police force." She again let O'Keeffe know that as a sixty-year-old woman and forty-year veteran of the art business, she didn't appreciate being treated as "a mental deficient" or "ignorant teenager." At times O'Keeffe threatened to break away from Edith, declaring, "If I am too impossible for you it is probably best that you give me up" and blaming her for damaging paintings much more during their decade-long association than in her thirty years with An American Place—an unfair accusation given Stieglitz's refusal to send any of O'Keeffe's inventory on the road.

Even though her earnings continued to climb—with sales of $55,932 in 1963—in 1964, O'Keeffe knew what she had to do: "I must leave you," she wrote. "I believe that I appreciate you though I cannot always agree with you." Bry had urged O'Keeffe to leave the gallery, sensing that Edith's failing health and mental instability compromised her ability to do her job. Within weeks, O'Keeffe's 100 oils and watercolors were picked up from the gallery and placed in storage. O'Keeffe tried to lessen the blow, telling Edith she didn't plan to sign up with another dealer. (Two years later, she would appoint Bry as her agent.)

Though O'Keeffe had quit and collected her paintings, after a seventeen-year association Edith couldn't quite believe she had truly gone. She reminded O'Keeffe that together they had generated sales in excess of $500,000 and had added O'Keeffes to forty museum collections. Edith couldn't accept that O'Keeffe's break was final, and thought perhaps it was just "temporary punishment," as she told O'Keeffe. She continued writing O'Keeffe, asking to sell first on consignment and then offering to buy paintings outright for resale. Her letters became filled with rants against the contemporary art of the day, art as insubstantial as the miniskirts worn by young women.

In the years after the war, Edith was able to capitalize on all her investments of the 1920s and 1930s—the artists she nurtured, the collectors and curators she developed, and the expertise she accrued day by day running the Downtown Gallery. She controlled the most important group of American painters in the country, and although

she considered her work to be in service of a larger cause, she also knew her own fortune and power were intimately linked to the names beneath her own: the list of artists printed simply and casually across a sheet of gallery stationary. As the most brilliant art marketer of her era, Edith was at the peak of her world. But just as the conditions in the art market became receptive to American art—and Edith and her artists were able to cash in on all the dark decades behind them—Edith's own faculties started to slip. She handled it the way she handled most of the challenges that had appeared before: she buckled down to hard work and forged ahead.

13

Art for Mr. and Mrs. America

IN THE MIDDLE of a winter memorable for heating fuel shortages and the biggest snowfall in New York's recorded history, Edith gathered her artists for their annual meeting. In addition to the usual concerns about increasing sales—and the necessity of teaching jobs, commercial illustration jobs, and advertising commissions—there was a new problem. An American art collection, including seventy-nine oil paintings and thirty-eight watercolors, assembled two years earlier by the U.S. government, was about to be dumped back on the art market.

The collection included most of the established Downtown Gallery artists. Assembled as examples of work by the finest practitioners of the American avant-garde, these same paintings were now classified as surplus war assets, slated to be auctioned according to a Byzantine sealed bidding process. Edith told the group it was a risky situation. She predicted artworks by the more famous artists would command strong prices, whereas those by the lesser known artists might sell for very little, damaging their reputations.

Though the meeting centered on the economic implications of the

sale, the collection's political significance loomed much larger. Assembled just two years earlier, the artworks had become a lightning rod for hostility against modern American art and artists. Both were attacked as un-American, sympathetic to communism, and downright dangerous. *New York Times* critic Edward Alden Jewell called the attacks on modern art and artists "one of the most provocative and shocking developments since America became a cultural force in the world."

It all seemed innocent enough when J. LeRoy Davidson, a former curator at the Walker Art Center in Minneapolis, appeared at the Downtown Gallery in March 1946. Davidson had been hired by the State Department to help organize traveling art exhibitions to promote America's virtue through the visual arts. By exhibiting examples of modern American art, the government hoped to counter the Soviet Union's propaganda portraying the United States as a land of crass materialism, obsessed with washing machines and shiny Buicks.

Armed with a $49,000 budget courtesy of the U.S. government, Davidson was charged with assembling a contemporary art collection for the State Department. These works would be exhibited at the Metropolitan Museum of Art in the fall and then split into two groups for a five-year tour, with one bound for Europe and the other for Latin America. The tide had finally turned: the rest of the world was eager to see American art. It was no longer considered Paris's poor stepchild.

Davidson focused on the most modern American artists, avoiding the academic, the American scene, and anything hinting of the conservative. He visited a handful of 57th Street dealers, scooping up colorful figurative canvases by Robert Gwathmey and Philip Guston, as well as abstractions by Robert Motherwell and Adolph Gottlieb.

Davidson made a third of his purchases at the Downtown Gallery, providing a welcome boost in sales. He bought during several visits, constrained by his budget and the available inventory. With the gallery doing so much business, there wasn't much to choose from. Some of the best examples resonated with the effects of the recently

ended war, and all were priced under $1,000 apiece. *Subway Exit* by Louis Guglielmi portrayed a dazed mother whisking her son up a subway staircase; Ralston Crawford's *Plane Production* was a crisp composition with flat interlocking grey and blue shapes; and Ben Shahn's *Hunger* featured a gaunt boy, blank eyes rimmed in darkness, stretching out one empty hand.

Inventory was scarce for some of the older artists, and high prices obliged Davidson to choose second-tier examples. Unable to afford one of O'Keeffe's monumental flower paintings, Davidson selected a small hilly landscape and a surreal still life of a green skunk cabbage. With no new Stuart Davises in stock, Edith plucked a 1930 canvas from her stockpile, charging Davidson $1,000 for *Still Life with Flowers*, a colorful mélange of fantastical and recognizable imagery, including a café, musical note, and a Harvard pennant.

"Some people are probably making cracks about what would happen were the Department of State to be as 'radical' in the handling of world affairs as it appears to be in its choice of art," wrote the *Times* critic, reviewing "Advancing American Art" during its three-week run at the Metropolitan Museum of Art. New York critics praised the show's adventurous taste and the State Department's bold foray into art collecting. *Art News* magazine named the show the most significant modern art exhibition of 1946. The art was shipped to Paris, where works by Jacob Lawrence, William Zorach, and Charles Sheeler were included in an international festival celebrating the first conference of the United Nations Educational, Scientific, and Cultural Organization.

"Advancing American Art" vindicated Edith's efforts to encourage government sponsorship of American art. Edith had credited the Depression-era WPA art programs with keeping American art alive during the 1930s. She now applauded the government's efforts to once again support American art.

After its exhibit in Paris, the collection was divided in two: half was shipped to Port au Prince, Haiti, and the other half to Prague. Although the exhibition was praised by art critics abroad, as well as

by the New York art establishment, rumblings came from other quarters. "Red Art Show," warned the *New York Journal American*, describing the artists as "left-wing painters" and members of communist-front organizations and the un-American fringe. This same story ran in other papers owned by the conservative Hearst Corporation, which devoted much space to warning America about the growing Communist threat. Certain paintings were singled out for derision. "If you contemplate adding to the suicide rate," said the *Journal American* of Louis Guglielmi's *Tenements*, "We recommend this picture for the guest room." Ben Shahn's *Renascence*, which included imagery from Hiroshima, was compared with "a picture a somewhat backward four year-old might turn out to illustrate a nightmare."

Suddenly the divide between the insular and urbane New York art world and the conservative tastes and right-wing politics of the rest of the country came into sharp relief. For decades Edith's artists had toiled in quiet anonymity, known only to a small clutch of adventurous collectors and curators. Now that this work had come to the attention of the rest of the country, Edith and her group soon learned that their progressive style was not appreciated. It was feared.

When the popular *Look* magazine reproduced images from "Advancing American Art" with the headline, "Your Money Bought these Pictures," politicians were inundated with complaints from their constituents. Congressman John Taber, chairman of the House of Representatives Committee on Appropriations, wrote Secretary of State George Marshall, calling the paintings "a travesty upon art," aimed to "make the United States appear ridiculous in the eyes of foreign countries" and "establish ill-will towards the United States." Other politicians wrote Marshall complaining that having the government spend money on this art was both demoralizing and a waste of taxpayer money.

Criticism came straight from the top. President Harry Truman dismissed "Advancing American Art" as "so-called modern art" and "merely the vaporings of half-baked lazy people." To the unschooled

eye, modern art was an easy target. Even paintings as seemingly tame as Kuniyoshi's *Circus Girl Resting*, of a cross-legged lady sitting beside a bowl of fruit, drew the president's ire. "If that's art," Truman declared, "then I'm a Hottentot." Modern art offended because it didn't appear to take any skill. It was too easy and therefore worthless.

Attacks came from within as well. Certain artists were infuriated by their contemporaries' contributions. Academic and conservative artists were accustomed to being snubbed by the avant-garde Whitney and the Museum of Modern Art, which were, after all, privately funded institutions guided by their own aesthetic missions. To be rejected by the U.S. government, in a show funded by taxpayer dollars, was something else. Albert T. Reid, head of the Allied Artists Professional League, wrote Secretary of State James Francis Byrnes a letter with unmistakably xenophobic and anti-Semitic overtones, stating that the artworks were not "indigenous to our soil" and were marred by unwholesome European influences. By ignoring traditional art, Reid charged, the collection didn't represent America, wasted taxpayer money, and promoted communist ideals.

The wave of criticism had its effect. Davidson lost his job, and the government halted the exhibitions. The art was returned to New York warehouses, and the *Journal American* reported that George Marshall, who succeeded Byrnes, had shut down the exhibition of "Communist Propaganda." The *Journal* asked what had happened to real American artists, Midwestern boys like Grant Wood and Thomas Hart Benton who presented a positive view of America, pure-blooded artists who came from the heartland and appealed to those tastes. For Edith, this sort of veiled anti-Semitism, racism, and homophobia aimed at modern artists was unacceptable.

The only thing left to do was protest. On May 5, 1947, Edith, along with hundreds of artists, dealers, and museum officials calling themselves the Progressive Citizens of America, held a protest meeting at the Hotel Capital. Diverse groups, including the New York Society of Women Painters and the Sculptors Guild, vocalized their

outrage. Speakers included James Johnson Sweeney, former curator of painting and sculpture at the Museum of Modern Art, and Juliana Force, director of the Whitney Museum of American Art. Speeches defended modern art, which had been repeatedly equated with communism, America's number one enemy. "We are really protesting a wave of reaction," said John D. Morse, editor of the *Magazine of Art*. "Somebody doesn't like modern art. It is a symptom, an emblem of change, and will always be resisted." Edith was among the distinguished list of speakers. She read from a prepared four-page speech, comparing Mr. Hearst's complaints that the show's paintings come from an "alien culture" rooted in a "European sickness" with Adolf Hitler's 1933 proclamations against art from the "godless, wholly materialistic . . . enemies of civilization and culture." Edith spoke on behalf of all the outsiders whose work she championed—whether Japanese, Jewish, female, black, or even abstractionist.

"Works of art are not a dispensable luxury for any nation," she said. "We will have communism in art if Congress can control what we paint, and free and individual expression is stifled." The government was not persuaded. The next day, Secretary of State Marshall declared that taxpayer money would not be wasted on modern art. Henceforth, exhibitions designed to promote America would be stocked with portraits of George Washington.

Ironically, two years after *Look* magazine ridiculed "Advancing American Art," it published a list of the top ten artists in the United States, a list that included five Downtown Gallery artists—all of whom were included in the State Department collection. Edith made copies of the article and mailed it proudly to clients, vindicating her taste and eye for talent. The article came a bit late for the collection. It ran in January 1948, the same month the State Department announced the collection would be auctioned off. The decision to sell came directly from Secretary of State Marshall, who hoped the government might recoup its expenses and be done with this embarrassing episode.

Government regulations, however, made profits impossible.

Laws stipulated that state-funded institutions and war veterans receive preferential treatment and that institutions were entitled to a 95 percent discount on the amount of each successful bid. Despite these terms and the publicity surrounding the collection, there weren't many bidders. Ultimately, three veterans and eight of the public institutions who seized the opportunity won unprecedented art bargains. Auburn University in Alabama bought thirty-six works with a bid of $21,453, which worked out to $1,072 after the discount. The University of Oklahoma also wound up with thirty-six works, paying $13.93 for *Harlem* by Jacob Lawrence, $60 for Ben Shahn's *Hunger*, $100 for a Marin, $50 for an O'Keeffe, and $30 for an Arthur Dove.

The auction had made it possible for two southern universities to acquire instant art collections. The problem was that the prices printed in newspapers—that the $49,000 collection was liquidated for just $5,544—served neither the government nor the American art market. The exhibition and its sale also presaged a spike in attacks against modern American artists that would plague several of the Downtown Gallery artists for years to come. The oppressive climate moved three major contemporary art museums—the Boston Institute for Contemporary Art and New York's Museum of Modern Art and the Whitney Museum of American Art—to issue a statement defending modern art:

> We deplore the reckless and ignorant use of political or moral terms in attacking modern art. We recall that the Nazis suppressed modern art, branding it "degenerate," "bolshevistic," "international," and "un-German"; and that the Soviets suppressed modern art as "formalistic," "bourgeois," "subjective," "nihilistic," and "un-Russian." . . . We believe that there is urgent need for an objective and open-minded attitude toward the art of our time, and for an affirmative faith to match the creative energy and integrity of the living artist.

America was now the world's richest country, the leading exporter of oil and cars, a land of sweater sets, Revlon hairspray, and pedal pushers. From Elvis Presley to Marilyn Monroe, America had usurped Europe's position as the dominant force and prime cultural influencer. American museums finally began appreciating native talent.

While the new generation of critics and collectors doted on the newer, younger galleries, run by dealers who had started out decades after Edith had begun, including Martha Jackson, Betty Parsons, Sidney Janis, and Samuel Kootz, Edith still maintained her power and influence. The gallery was flooded with requests to lend artworks to museums around the country. In 1947 Edith and ten other American art dealers formed the Association of Dealers in American Art to help promote American art. Edith was named acting chair.

Meanwhile Edith tracked the emerging middle class and organized exhibitions to draw attention to the fact that more people could and should buy art. She mounted some of her most ingenious theme exhibitions, including "Art for 13,000,000," based on her discovery of a statistic that 13 million Americans were buying cars, fur coats, and televisions on the installment plan. Edith included twenty-six artworks, all priced at $600, or $50 monthly payments for a year. She said the show was designed to "give fledgling collectors the chance to try their wings without hardship." She included works by her old and new guard. An oil by Georgia O'Keeffe, *Red Amaryllis*, hung alongside paintings by Kuniyoshi, Charles Sheeler and Stuart Davis's gouache *Egg Beater Number 3*.

Edith aimed to emphasize another aspect of art collecting with "Art for the 67%," featuring two paintings by each artist—each one designated for the "Missus" or the "Mister." Edith stated that 67 percent of the U.S. adult population was married, and her show was aimed at couples who often had trouble agreeing on the selection of an artwork. To make it easier, Edith noted her gallery policy that any painting could be taken home for approval, allowing time for couples to come to a joint decision. There had been a shift in art collecting, Edith explained. In the "good old Duveen days," art was

"purchased for many reasons other than simple enjoyment. There were questions of prestige, of snob-appeal, of social and cultural 'background,' and one eye was often cocked at the museum in which the works of art would eventually land." Edith claimed those days were over. "Paintings and sculptures are purchased to be lived with. Their place in the home is primary, other considerations follow in their proper order."

The gallery also did an enormous amount of selling to business-men (Joseph Hirshhorn, Earl Ludgin, Otto Spaeth, and Robert David Straus, among many others), who hung art in their offices as well as their homes. Company collections—spurred by the whim of an art-obsessed boss—were established at the Northern Trust Company, the Miller Company, and the Meta-Mold Aluminum Company, among others. In 1953, Edith asked her friend and client Dunbar furniture designer Edward J. Wormley to transform a gallery room into an office suitable for a high-powered executive. Wormley installed a 12-foot gray-and-brown tweed sofa called "the Texan," along with chairs, a bar, and a roomy desk. Edith selected stereotypically "male" art for her "Art for the Office" show, including an O'Keeffe painting of a fishing hook and a Davis oil with a cigar and copy of a detective story.

Edith searched for other ways to capitalize on the expanding mar-ketplace. The ever-efficient businesswoman, she knew she needed to hire more employees at the gallery, continue to broaden the network of buyers—and most difficult of all, get more art to sell. To find new buyers, Edith developed a relationship with West Coast decorators, setting up a satellite Downtown Gallery in the heart of Hollywood. She shipped them artworks, press releases, names of California col-lectors, and detailed directives on every aspect of the business. Though given the inside track to replicate Edith's success—she even loaned out one of her salespeople—the venture stumbled along before folding. Without Edith's dynamic selling and constantly inno-vative mind, it was impossible to franchise the Downtown Gallery concept. Edith did eventually find other West Coast dealers to whom

she consigned work, in addition to galleries in the Midwest, Florida, Massachusetts, and other places.

By the 1950s, the Downtown Gallery was unquestionably the premier destination for the best modern American artists, and many collectors came and bought. Even though Edith always aimed to attract as many buyers as possible, she cultivated a select few who bought in great depth. Barbara and Lawrence Fleischman, a young, newly married Detroit couple who were eager to learn about art, visited the gallery at the suggestion of the director of the Detroit Institute of Arts. Lawrence was ambitious to make a name for himself in the insular Detroit cultural scene. On their first visit, Edith bowled them over with her charisma and salesmanship. They bought four paintings. "We got out on the street and looked at each other," recalled Barbara, "and wondered what we had done." Soon the Fleischmans were given all the perks of Edith's favored treatment, including invitations for dinners with artists and other collectors. They were well aware of her sales gambits, where she would bring them to the back of the gallery and have paintings brought out for display on velvet stands. "She'd say 'Ah, bring out that Sheeler,'" recalled Barbara. "'I'll show you something, but I don't think you can have it,' or 'I've got somebody else who wants this.'"

By 1953, the Fleischmans owed $18,467 on their account and were buying at a rate that even Edith considered dangerous. Larry worked for the family carpet business, and though they had an arrangement in which he paid in installments, to Edith it appeared he was out of his depth. "It would be a mistake to overindulge beyond your immediate limits," she told him. "You will realize the importance of creating a personal pattern of collecting." She urged him to find a personal taste instead of buying a cross-section of everything for sale. The Fleischmans continued their collecting, eventually buying examples by nearly all the Downtown Gallery artists. Marin—the most famous of all Edith's artists—was their favorite. They bought twenty-one of his paintings.

Though Edith gave the Fleischmans access to many choice

artworks and they treated her warmly, Lawrence later admitted he hadn't especially liked her but had merely tolerated her because of her artists and what he might learn. "Edith had her own sales technique," Lawrence later said. "She was quite a good saleswoman. However, her particular sales approach irritated me. If she hadn't represented the artists that she did I would never have gone back. We used to see each other frequently because I wanted to learn from her." He also admired her devotion to her artists, a passion he felt was motivated not by dollars but by her own belief in the importance of her artists. Edith's relationship with the Fleischmans was reflective of many of her professional dealings with collectors whose passion for artwork was equaled by their own search for personal glory. Just as Edith cultivated these relationships—which ultimately proved hollow substitutions for true friendships—to grow her business, certain collectors used her right back.

As the gallery became more successful, Edith became more reclusive. She rarely went out in the evening, though she regularly entertained in her one-bedroom apartment, shuffling her upholstered Dunbar furniture around the living room to accommodate a dining table and chairs. Edith's furniture was comfortable, simple, and modern, an unobtrusive backdrop designed to set off the artworks. The living room was hung with works by O'Keeffe, William Harnett, and even De Kooning—an artist she didn't represent but admired just the same. Before dinner, Edith's cook Albert would pass nuts, smoked salmon, and cocktails. Edith sat at the head of the table, a pack of cigarettes clutched between her bright red fingernails.

One evening O'Keeffe, Stuart Davis, and a young collector couple, Drs. Melvin and Helen Boigon, both psychiatrists, were among the dinner guests. The Boigons had recently purchased O'Keeffe's *Jack-in-the Pulpit No. IV* for $5,000—a radiant black flower edging toward abstraction. Melvin sat on the couch and leaned toward O'Keeffe, who wore a black suit. (Edith peeked at the jacket label and whispered to Helen, "Balenciaga.") Melvin was ecstatic about owning the O'Keeffe and launched into a monologue about the

meaning of the painting. O'Keeffe sat quietly. When Melvin finished, O'Keeffe looked over at Davis. "My goodness, Stuart," she said. "We don't know what we say when we say it."

This evening was typical of Edith's social life. "She had no friends except those who were somehow connected with her business, the artists, and personalities of others in the same milieu. Those formed the narrow border of her life," said Charles. "She would have six or eight dinner guests, purchase a large turkey or prime rib of beef, depending on the season, charge it to the gallery, and then dine alone, or with me, on the remains for nights after. She spent evenings when she was left completely alone obsessively arranging and re-arranging her bureau drawers, rolling her many pairs of stockings perfectly and re-folding exactly her underwear and nightgowns."

That was the paradox of Edith Halpert's life: she was surrounded by people, yet she was always alone. By the 1950s, she was much closer to her sister Sonia, who would visit Edith in Newtown, as would her mother Frances, Sonia's daughter Nathaly, and Nathaly's husband Harry Baum and their daughter Patricia. Edith kept a small red album in her office where she collected autographs and sketches from artists and other notables who filtered through her doors—a charming and thoughtful gift she would eventually present to Patricia. But aside from these obligatory family connections, Edith had always avoided forming close personal attachments. Decades earlier, she had been unable to accept the romantic love offered by Nathaniel Uhr, one of her few relationships born outside the art world. When Adam died, she was so traumatized she never owned another dog, unwilling to go through the excruciating pain of loss again. She did eventually get a cat, but she never found a lover, companion, or friend in whom she could confide completely.

In the late 1950s and 1960s, Edith grew suspicious that clients were friendly to her in order to get access to her inventory. She had always told her staff to sell from the bottom up, meaning sell the worst examples first and save the best for last—a way to maximize profits as values increased over the years. Similarly, she began to have

bouts of paranoia and suffered rifts with Lawrence and Charles. After decades of dedicated service, Lawrence turned to Edith for help buying a house in New Rochelle, where he planned to live with his brother and sister-in-law. When he asked Edith for a loan, she replied with an officious letter in which she described her own finances as precarious—something that was not true but not exactly a lie. "I shall not dilly dally with explanations nor with moralizing about assuming responsibilities beyond one's depth," she wrote. Though she finally offered to loan him $2,000, Lawrence was offended. "However, as for 'assuming responsibilities beyond one's depth,' seems to me to be an attitude you take whenever others want to better their condition," Lawrence told Edith, whom he addressed as Mrs. Halpert. "And despite my limited income, I have a great desire to *own* good things. At the moment, it happens to be a house I want." Lawrence was well aware of Edith's prosperity. During the 1950s the gallery churned out the sales. It must have been frustrating for him to be a salaried employee, forced to watch Edith count her pennies. The lessons of the Depression meant that Edith was tight-fisted in the extreme, forever turning off lights and demanding her employees reuse picture wire on the back of paintings, an onerous task that was both bothersome and occasionally painful if the wire was frayed.

There was also growing tension between Edith and Charles. When an apartment on the top floor at 32 East 51st Street became vacant, Edith offered Charles a low rent, living just two floors above Edith's own one-bedroom apartment and three floors above the gallery. He accepted. Although the proximity could at times be suffocating, Charles recalled a lively scene in the building:

> In the apartment on the floor between us lived two homosexuals, one of whom had a predilection for the Navy, and the lover of the other, who was generally alone on weekends, had a preference for the Army. On Saturday nights there was a continual coming and going, the sounds of doors opening and closing, the blast of jazz, the clamor of obscenities shouted

through the hallways. Edith professed to be ignorant of these occurrences and, at a party one evening, when she heard a group of men gossiping and snickering about the goings-on at a house, "No. 32," she believed they meant "32 rue Blondelle," a Parisian brothel frequented years before by Pascin, Kuniyoshi and other artists, and she was dumbfounded to realize that they were actually discussing her home, 32 East Fifty-First Street.

Since he was usually just a couple of floors away, Edith expected Charles to be available to help with building maintenance. Charles resented her demands that he run from his fifth-floor apartment to the basement to repair the oil burner or replace a tenant's electrical fuse or that he wake up early on Sunday morning to add water to the boiler. Even worse than building maintenance, Edith depended on Charles as a convenient escort for dinners and openings. Charles became increasingly annoyed that Edith did nothing to correct rumors that they were having an affair. Most nights, Charles would excuse himself around 11 p.m., feigning fatigue, only to sneak off to the jazz clubs. When Edith found out he was homosexual, her main concern was the gallery. "She hesitantly but frankly admonished me, saying that my private life was of no interest to her as long as it was not detrimental to the gallery." For Charles, that was yet another indication that for Edith, the gallery was all that mattered.

Then there was the complex matter of Edith's dependence on Charles during her fainting spells. When Edith swooned, Charles shoved aromatic spirits up her nose, an undignified act for everyone involved. After comparing symptoms with a client, Edith grew convinced her fainting spells were a result of hypoglycemia, or low blood sugar. When she became overwrought she burned up the sugar in her body too quickly and went into a state of insulin shock. Once unconscious, a spoonful of orange juice or whiskey ladled between her teeth brought her back. Edith hated being unable to control her own body, dependent on Charles when she slid off her chair, limp on the floor in

an unconscious heap. Unable to admit her own frailty, she blamed others for bringing on the spells.

Charles also refused to make the gallery his world in the same way Edith did. She resented that, considering it evidence of a lack of loyalty and dedication. For Charles, it was a way to avoid Edith's fate. "I think it was Edith's very close involvement with the artists that put me off a little bit and the example of her life which frightened me. I think what I felt about it has not been borne out in that she really had no life outside the gallery. . . . It was always to do with business. Her whole life was somehow tax deductible."

For a while Charles indulged Edith's demands, hoping to take over the gallery. But he was unhappy working for a paycheck and wanted an ownership stake. He was strung along by Edith's casual proclamations that she intended to retire in 1950. They were hollow promises. Edith would never admit it, not even to herself, but there was no one she trusted enough to run the gallery besides herself. At first she wanted to believe that Charles might be a potential successor. "You have the taste, the appearance, the background," she told him. "You talk and write exceedingly well. You have extraordinary ability."

But there were problems. "But you work like Jackson Pollock. You are impatient and want quick results, without considering an all-over pattern, a long-range purpose. Moreover, you take much too personal an attitude, and indulge in resentments which color whatever you do." There was another problem with Charles. "At times I have felt that you disliked the work of so many artists, that your interest in them fluctuates constantly, that you were not in agreement with my loyalty to them and belief that they will come through with their experiments." She could never turn over the galley to anyone who cared less than she did, setting the bar impossibly high.

Once Charles realized Edith had no intention of retiring, his devotion faltered. "After I had been there for about five years and realized that she was not going to retire as she had said she was, I began to

spend fewer evenings with her and with artists and collectors and became less and less her escort, which I had always been, to museum openings and things like that. I again began going to the theatre and to the opera and to the things that really had interested me all the early part of my life and which I had given up when I worked with Edith." He even quit on at least one occasion after a fight but did not leave.

Charles also began squiring Jean Arthur, an actress he had known from his early days in the theatre, around town. Edith had lost her dependable escort and Charles's undivided attention. She liked people to think she and Charles were romantically involved—it gave her a thrill, a sense of power and sex appeal she felt she had lost. Now that he had replaced her with Arthur, forcing some space between them, Edith was unhappy. Even though Charles's interest in women was never romantic or sexual, Edith still felt jilted.

Her feelings were all tangled up at the gallery, where there was no divide between the personal and the professional. Edith felt she was never able to just relax and be whomever she really was. She admitted as much to Charles. "I am alone. . . . Most of all I am terribly, terribly tired. I am tired physically. I am tired of family responsibility, tired of feeling guilty about everyone—mother, you, the artists, Lawrence, oh everyone," she wrote. "Mostly I am tired of the plastic shell I have sprayed over my innermost feelings . . . and particularly tired of pep talks to myself." The lesson Edith had learned as a girl— that she could depend on no one but herself—now left her a successful, dynamic, independent, fifty-year-old woman, who was, at heart, quite alone.

As the 1950s wore on and inquiries from would-be buyers soared, Edith was no longer concerned about competition from European artists. The threat was now from younger artists, especially those loyal to abstraction. Edith's artists, some of whom had exhibited in the 1913 Armory show, were no longer the avant-garde. In 1949,

Life magazine published drip paintings by thirty-seven-year-old Jackson Pollock, with the headline "Is He the Greatest Living Painter in the U.S.?"

Critics seemed hell-bent on discrediting the earlier generation in an effort to prop up the new. Critic Harold Rosenberg praised the abstract expressionists for "extinguishing the object." He slammed Downtown Gallery artist Jack Levine's *Gangster Funeral* as mere decoration. Influential critic Clement Greenberg branded Ben Shahn—one of the most famous of the Downtown Gallery artists—passé. Greenberg rose to rapid fame on the strength of the abstract expressionist artists he championed. To promote his group, he condemned figurative artists like Shahn as old hat. "This art is not important, is essentially beside the point as far as ambitious present day painting is concerned," he wrote in response to Shahn's 1947 Museum of Modern Art retrospective. "There is a poverty of culture and resources, a pinchedness, a resignation to the minor, a certain desire for 'quick' acceptance—all of which the scale and cumulative evidence of the present show make more obvious."

The Downtown Gallery generation was criticized for being too figurative, too content-driven, and even too European in their influences. The irony, not lost on Edith or the rest, was not just that many Downtown Gallery artists had been slammed for their abstractionist tendencies for decades, but also that though many had acknowledged the influences of Paris and European painting, they had melded these influences with their own multicultural American tendencies. Now the younger artists were being hailed as the authentic American voice and aesthetic—despite the fact that they too had immigrant roots and that they too were influenced by both European and American forces.

Not only were Edith's artists in danger of being brushed off the artistic landscape, the new younger artists churned out canvas after canvas. Most of Edith's artists, except for the prolific Georgia O'Keeffe, produced slowly. She needed inventory. And she needed to inject energy into her roster. In 1952, Edith traveled across the country, stopping in Texas, Kansas, and California. During her travels she

elected a dozen young artists, mostly abstractionists, and decided to launch their careers. She turned the first-floor gallery, formerly used for folk art, into the "Ground-Floor Gallery" for the youngsters. In a complete change of her earlier policy of acting as an agent, she bought $1,000 worth of paintings from each of the newcomers so that she would have a reliable and consistent inventory. Prices ranged from $25 to $300.

At first her plan worked. Many of Edith's faithful collectors dutifully bought paintings by her rising young talents. *Life* magazine ran a story about Edith and her "New Crop of Painting Protégés." The photo captured Edith, the white-haired doyenne, seated in front of six of her young hopefuls. At fifty-two years old, Edith was a generation older than any of her boys, each posed beside their abstract canvases, wearing thin ties and serious expressions. Edith, a stylish matron in a tailored black pants suit and her trademark "13" pin, looked confident and at ease. Only the lines below her eyes betrayed her worry and fatigue.

Below the new artists, another photo showed the "old timers," artists who had been with the gallery for years and ranged in age from thirty-five to sixty-eight. Jacob Lawrence, Stuart Davis, Jack Levine, Charles Sheeler, and Ben Shahn were among the nine who appeared in the photo, all of whom would occupy prominent spots in American art history. None of Edith's newcomers (Robert Preusser, Charles Oscar, Robert Knipschild, Johah Kinigstein, Wallace Reiss, Carroll Cloar, Herbert Katzman) would achieve the same level of fame. Though she never would have admitted it, Edith's eyes and heart were lodged in the 1930s.

She didn't nurture these younger artists for long. Edith had been unrealistic about her ability to take on new protégés. In fact, she was ready to reduce the size of the gallery. The volume of correspondence and daily business had increased exponentially. The Downtown Gallery had become a destination for anyone researching American modern art. Edith's detailed records were invaluable. She ran a virtual clearinghouse for American art, and the administrative burden was

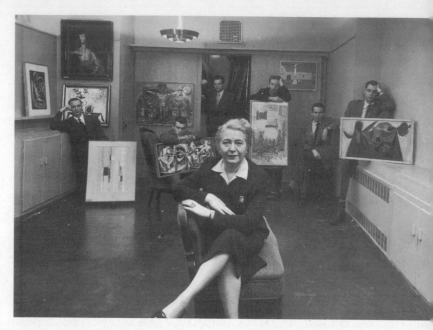

Edith, wearing her lucky "13" brooch, with her "newcomers,"
featured in *Life* magazine, March 17, 1952.

Edith's "old timers" in *Life*. Seated, from left: Jack Levine (on floor), Stuart
Davis, William Zorach, Bernard Karfiol. Back row, from left: Jacob Lawrence,
David Fredenthal, Yasuo Kuniyoshi, Charles Sheeler, Ben Shahn.

overwhelming. As she had done in the 1930s and then again in the 1940s, she needed to reduce her numbers. The fact that she realized that so soon after taking on a new batch of artists underscores her ambivalence to scale back her business.

In 1953, Edith worked out a deal with Charles that he could take all the younger artists and open his own gallery. Charles agreed to pay Edith $5,000, as well as $1,000 annually as a consulting fee, in exchange for representation of seventeen artists, including Jacob Lawrence, George L. K. Morris, and Jack Levine. He also received an option on all oral and written contracts Edith retained, including those with Stuart Davis and Arthur Dove.

Charles opened the Alan Gallery in 1952 in a small, second-floor space on Madison Avenue. The venture tottered along for fourteen years before closing. Charles lacked Edith's business savvy and was never able to match her profitability. "Selling was sort of beneath him," recalled Chris Wohler, who worked with Alan in the early 1970s at the Terry Dintenfass Gallery. "He was really poor at business." For his first one-man show, he selected Jack Levine, who was well known and whose *Gangster Funeral* had just sold to the Whitney. Charles and Levine agreed not to invite Edith to the opening. Levine was upset with Edith, feeling as if he had been sold off to Charles—whom he thought was "stuck-up"—and Charles thought it was the best way to signal the independence of his new venture. Edith saw things differently. She never forgave them.

Alan ran his gallery until 1966, when he sold it to California dealer Felix Landau and continued working there for three more years. In the early 1970s, he was hired by dealer Terry Dintenfass, contingent on his bringing the Dove estate to her. Alan was very friendly with Arthur Dove's son Bill and was able to steer the estate over, but it was an unhappy arrangement. Charles was depressed and showed up for work moody and unmotivated. Terry fired him the day his contract ran out. Beleaguered by money problems and overcome with malaise, just two weeks into 1975, sixty-six-year-old Charles Alan climbed into bed and swallowed pill after pill. His death, "apparently of a heart

attack," was reported in an obituary the following week in the *New York Times.*

Though the 1950s were successful for the Downtown Gallery in terms of profits, Edith's artists came under siege. Outside of the rarified New York scene, the most popular American artists were Norman Rockwell and Andrew Wyeth, whose cloying canvases of middle America were easily accessible and likable. The Downtown Gallery artists—gray-haired, bespectacled, and some ailing and close to death—were deemed un-American and unpatriotic in their art, which questioned and challenged the sanctity of the postwar world. The lessons of "Advancing American Art," which had taken American contemporary art back a few paces, festered during the 1950s. Indeed, attacks against modern art and artists only gained momentum.

Many artists were persecuted during the late 1940s and 1950s—both by government agencies and private watchdog groups. In 1948, the attorney general classified the Photo League, a photography group whose 103 members included Ansel Adams and Paul Strand, as subversive. Ten Hollywood writers and directors were brought before Congress and accused of communism. When the Museum of Modern Art organized an exhibition for patients at a New York naval hospital, a Michigan congressman, George Dondero, warned that its communist imagery might infect recuperating sailors.

Ben Shahn was one of the artists Dondero singled out for attack. Shahn was a major art world figure who had made his name standing for the very sort of leftist radical politics that were vilified during the 1950s. He was also famous. When Edith discovered him in 1929, he was an unemployed thirty-one-year-old lithographer, supported by his wife Tillie, who worked as a bookkeeper. A Lithuanian immigrant, he had come to New York as a boy and struggled to make it as a painter. Like Edith, he never forgot his humble roots, growing up in an apartment that shook from the subway and working days and

attending art school at night. His early poverty etched in him a deep empathy for the working man.

He was Dondero's perfect target. Shahn was vocal about his political leanings. He was active in many of the left-wing artist organizations—sympathetic to socialist and labor organizations—as were many artists, including Stuart Davis and Yasuo Kuniyoshi. These groups had formed during the Depression as artists realized they needed to protect their interests and negotiate with the government for benefits. Shahn was a natural leader and vocal force among the artists. He got involved with the Artists' Union, the American Artists' Congress, and the John Reed Club, named for the founder of the American Communist Party and dedicated to organizing art shows and art schools.

One of Shahn's early mentors was Mexican muralist Diego Rivera, an avowed communist whom Shahn had assisted at Radio City. Rivera's flat perspective and storytelling style inspired Shahn's series of paintings on the trial of anarchists Nicola Sacco and Bartolomeo Vanzetti, which ended with the two Massachusetts Italian Americans being executed in 1927. The execution traumatized Shahn. "I hate injustice," he said. "I guess that's about the only thing I really do hate." Shahn's twenty-three paintings on the subject were exhibited at the Downtown Gallery in 1932. Even though the Depression had hurt gallery business, the show was a huge hit, both with critics and collectors.

Shahn used his paintings, prints, and posters to fight injustice and to tell stories: the anti-Semitism of the Dreyfus Affair, the trial of socialist leader Tom Mooney, and the devastation of war. His style later came to be known as 1930s Social Realism. From the very start his imagery was grounded in protest.

Although her artists were activists for the poor, siding with labor and the common man and woman, Edith kept her distance. She didn't join any of the leftist artist organizations herself and maintained discretion on her political views, never mentioning them in letters to clients, and only rarely to artists. "When political talk would begin," recalled Shahn's second wife, Bernarda Bryson-Shahn, "Edith had a

tight smile. She was a business woman and all her customers were wealthy people."

The 1930s activism came back to haunt artists in the 1940s and 1950s. Shahn was targeted by anticommunist watch groups, and his artwork was scrutinized even by longtime supporters. Art critic Henry McBride found distressing political overtones in Shahn's 1948 painting *Allegory*, of a red chimera against a mottled blue-and-purple background, standing over four lifeless children lying on the ground. McBride read some meaning into the chimera's color, suggesting the use of red was no accident but a tribute to the "present enemy, the Soviet Republic." McBride joked he hoped Shahn would not be "boxed up" and "sent away to wherever it is that they send disturbers of the peace."

Shahn was furious. He claimed the painting was inspired by a newspaper article he saw about a fire in Chicago that killed four children. The government sided with McBride, and the Federal Bureau of Investigation classified him as a suspected communist. In 1953, special agents visited Bernarda and Ben at their New Jersey home. The Shahns offered the agents lunch, which was refused. Ben told them he had never been a member of the Communist Party and refused to name anyone he thought might be a communist. He admitted having belonged to up to eight groups that the attorney general had labeled subversive. The FBI continued to watch Shahn for the next ten years.

Shahn's branding as a suspected communist didn't interfere with Edith's efforts to sell his artworks. In the late 1940s and 1950s, buyers lined up for new Shahn canvases. Ben Shahn was a celebrity, and his collectors came from those ranks, including film director Billy Wilder, television producer Fred Friendly, poet Marianne Moore, financier Roy Neuberger, Nelson Rockefeller, Wright Ludington, and Duncan Phillips. Edith could handle Shahn's radical politics. What she could not handle was his insistence on running a side business for commercial commissions. Shahn's fame and charisma made him a darling of art directors and magazine editors, who gave him a steady

stream of assignments, including covers for *Time* magazine. Shahn refused to follow gallery policy and didn't tell Edith about many of his gigs. He also refused to give Edith her cut on commercial work. This behavior clashed with the most fundamental principle of the gallery, and Edith felt Shahn owed her—they had weathered the lean years together and now that business was good, she intended to share in the bounty.

"I feel strongly that the arbitrary arrangement you have established is no longer tenable . . ." Edith told Shahn. "There is no reason why Stuart Davis, Sheeler, O'Keeffe, and others should pay commissions while you do not." Shahn disagreed completely. "I have to look upon myself as a free agent," he told Edith. "It would be neither dignified nor civilized to do otherwise, and anyway I couldn't." Despite efforts to compromise, neither Edith nor Shahn was ever satisfied, and their relations grew prickly.

Edith was also protective of Shahn's image as an artist. She knew collectors and curators were not impressed to find the signature Shahn squiggles decorating a box of chocolates. "You dissipate your energies as an artist on most of the commercial jobs as illustrations for young women's magazines, book jackets, industrial pamphlets, and talks. Your reply is that it stimulates you. Surely, with your imagination and creativity, it is hard to believe that you need superimposed ideas."

Even though Edith couldn't convince Shahn to slow the pace of his commercial work, his reputation as a political radical and possible communist cost him jobs. After a privately funded watchdog newsletter, *Counterattack*, complained to CBS about using Shahn for illustrations, CBS issued a public statement defending the artist. Shahn didn't receive another assignment from CBS for two years.

A decade after the "Advancing American Art" collection was liquidated, another art crisis erupted where no one expected it. *Sports*

Illustrated magazine and a nonprofit arts organization, the American Federation of Arts (AFA), organized a traveling art show called "Sport in Art." The show was arranged under the auspices of the newly formed United States Information Agency (USIA), founded by President Dwight D. Eisenhower in 1953 to promote American values and culture abroad. The exhibition circulated to the prestigious Museum of Fine Arts in Boston and the Corcoran Gallery in Washington, D.C., with a heroic last leg scheduled for the 1956 Olympics in Australia.

Stanley Marcus, a Dallas businessman who owned the Neiman Marcus department store, offered to sponsor a stop at the Dallas Museum of Fine Art. Marcus was a regular client at the Downtown Gallery and a booster of efforts to bring culture to Dallas. Soon after Marcus announced that "Sport in Art" was en route to Texas, a group calling themselves the Dallas County Patriotic Council demanded that four "unpatriotic" paintings be removed from the show. The offending works included a painting of a skater by Yasuo Kuniyoshi—who continued to be attacked even though he had died in 1953—as well as a painting by Ben Shahn and a sculpture by William Zorach. The group said the artists were communists, or close enough.

Edith hired a lawyer in Texas, but there was little she could do. The Dallas Museum trustees contacted Time Inc., which owned *Sports Illustrated*, and asked for confirmation that the artists were not, in fact, communists. The publisher of the magazine said that none of the artists appeared in files of the Subversive Activities Control Board, which had held fifteen months of testimony, and that none of the artists had been named a communist by the House Un-American Activities Committee. Nevertheless, the show never made it to the Olympics.

That same year a major exhibition of American art, slated for tour in Europe, was killed over accusations of subversive art. The show was again sponsored by the USIA and assembled by the American Federation of Arts. When the USIA complained that ten of the 100 artists had pro-communist tendencies and were "unacceptable" and

"social hazards," the AFA refused to be pressured. It stated that it would not participate in the show if any artists were barred and that it did not want to know the names of the ten artists in question. It cited a 1954 policy that art be judged on its merits, not on the political or social views of its maker. The show, which was to have included Ben Shahn, Yasuo Kuniyoshi, and John Marin, was cancelled.

Despite the constant attacks on "undemocratic" and "unpatriotic" modern art throughout the 1950s, the U.S. government decided yet again to use art as an ambassador, sending artworks to the Soviet Union as part of an official cultural exchange between the two countries. In the summer of 1959, the rival governments organized national exhibitions: The soviets erected a mini-Moscow at the Coliseum exhibit hall in New York City, and the American government created a simulated Main Street USA just minutes from the Kremlin. The USIA aimed to show life for the average American. Research suggested that the average Russian was not interested in America's most advanced technologies, but in seeing what life was like for his or her American counterparts. And given the American postwar standard of living, the assumption was the United States would come out looking grand.

George Nelson, a designer famous for his marshmallow sofas and ball clocks, was hired to create the overall exhibition design. Architect Buckminster Fuller was chosen to erect one of his famous geodesic domes to house several of the exhibitions. Edward Steichen's "Family of Man" photography exhibit, which was originally organized for the Museum of Modern Art, formed the cornerstone of the exhibit. California furniture designers Charles and Ray Eames put together a slide presentation of quintessentially American images, projected on seven giant 30-by-20-foot screens. A blast of 2,200 images every twelve minutes bombarded Russians with the mosaic of everyday American life.

In addition to fashion shows and shiny tailfin cars, a display of America's prowess also required representation from the arts. After all the controversies ignited over government-sponsored art

exhibitions since the late 1940s, however, it was something of a surprise that the government decided to dabble in art exporting again.

The USIA chose the selection committee carefully. A four-man team, approved by President Eisenhower, was headed by Franklin C. Watkins, a painter and instructor at the staunchly academic Pennsylvania Academy of Fine Arts. Henry R. Hope, head of fine art at the University of Indiana, was another conservative choice. They balanced two others known for their more progressive leanings: abstract sculptor Theodore Roszak, who taught at Sarah Lawrence College in Bronxville, New York, and allowed his fascination with science fiction and Buck Rogers to filter into his art; and Lloyd Goodrich, director of the Whitney Museum. Goodrich was one of Edith's close friends and a strong supporter of the gallery. His spot on the team guaranteed Edith's artists would be among those chosen for the show.

The committee's mandate was to select fifty paintings and thirty sculptures. It was an impossible chore. "Critical New Yorkers will find the selections outdated," predicted Watkins. "Philadelphia and, perhaps, Detroit may consider them intolerably radical and non-typical." The USIA promised not to interfere. By the spring of 1959, the committee members had finalized their selections. They wished to present a cross-section of the best American art from the past thirty years, the period that could be considered modern—and, coincidentally, roughly equal to the lifespan of the Downtown Gallery. Works dated to the 1920s and progressed to Stuart Davis's 1958 *Combination Concrete*, a cacophony of phrases and jumble of letters (prominently "Drawing," "New," and "Go Slow") framed by a deep red border.

On Saturday, May 30, articles appeared in newspapers listing the artworks that had been selected. The timing of the announcement was by no means accidental. On Monday, just two days later, the crated cargo was tucked into the bowels of the S.S. *Finnsailor*. Before any objections could be raised, the art was at sea.

The selections were a vindication for the Downtown Gallery. Of

the forty-eight painters, twenty-one had shown with Edith at some point. The list also included a few of Edith's pet abominations, such as American scene painters Thomas Hart Benton and Grant Wood. At the other end of the spectrum, the show included the younger set, artists who were usurping the limelight from Edith's generation with their giant abstractions. They included Willem de Kooning, Jackson Pollock, Mark Rothko, and Robert Motherwell.

Once the delicate selection task was complete, the committee still needed to find someone capable of transforming art-stacked wooden crates into an exhibit worthy of representing America to its prime rival. Edith was the obvious candidate. Not only was she a supreme saleswoman and booster for American art, but she was also known as a gifted organizer who would be able to navigate whatever primitive conditions existed at the exhibition site. Also, she had visited Russia just a year earlier, part of the first wave of Western tourists to venture behind the Iron Curtain.

Edith had hoped to visit Russia since the 1930s. She made two failed attempts in 1930 and 1934. She said she lacked the proper paperwork and was also dissuaded by her mother, Frances, who thought going back was a truly bad idea. Finally, in 1958 she carefully planned her first trip. Russia was only just emerging as a travel destination for adventurous Americans. The Soviet Union encouraged visitors, hoping to convince Americans that the country, with its worker-friendly communist regime, had plenty to offer. In the months leading up to her trip, Edith clipped dozens of travel articles. She wrote the cultural attaché, requesting special behind-the-scenes access to the Pushkin and Hermitage Museums. In her final preparations for the three-week trip, she left Lawrence in charge of the gallery, asked friends to keep an eye on her Newtown house, and visited the dentist to have white porcelain caps placed over her nicotine-stained teeth. Prideful of her appearance, she packed custom-made suits and dresses, satin shoes for evening wear, and her favorite hats. She had no taste for vodka and siphoned scotch into empty milk bottles.

She traveled in her usual first-class style, staying at Leningrad's Astoria Hotel in a room filled with gilt French furniture, crystal chandeliers, Oriental carpets, and bronze sculpture. "There is hot water *and* toilet paper," she wrote a friend. Though Russia was an exotic destination at the time, Edith was surrounded by Americans. "I remember well meeting hordes of Americans, each armed with a paper-wrapped copy of John Gunther's *Inside Russia Today*, accompanied by a guide-interpreter who escorted these groups to the officially-assigned tourist sites. Naturally, everything they saw was most impressive, well-documented with statistics and slogans."

Edith was impressed by Leningrad's beauty, especially the cathedral's domes, the Neva River, and Henri Matisse's famous mural, *Dancers*, at the Hermitage. ("What a wallop," she recorded in her notes.) At the vast museum, she was the only visitor roaming around galleries filled with Picassos, Cézannes, and Monets. "Many of the rooms were dark, but the female (always) attendant turned on the lights at my request, and flicked them off the moment I left for [the] other room."

One evening she hired a limousine to attend the opera and was embarrassed by being overdressed in her red gown, fur stole, and satin shoes. Despite all the appearances of a civilized society, Edith was convinced the whole thing was a setup. "The czaristic props are utilized in various aspects to impress the many visitors of all nationalities avid to see for themselves the miracles performed by the Soviet regime. They are well rewarded, and one hears the ohs and ahs on all sides." Edith considered herself too savvy to be fooled. On a visit to an Agricultural Exposition set in a stately government building, she saw exhibits on Soviet grain, housing developments, and hydraulic stations. In an area devoted to fruit production, she spied a barrel filled with oranges and when no one was looking, she reached for a fruit. The barrel concealed a trick: the fruit was just two rows deep. Edith wasn't fooled: Russia was no land of plenty.

After four days in Leningrad, some rudimentary Russian came back to Edith, long suppressed in the fifty-two years since she had left

as a young girl. Her trip included three days on the southern coast in Odessa, her birthplace. "When I landed in Odessa in 1958, I dropped my bag at the hotel, said that I would be right back. . . . The Hotel Odessa was right on the waterfront, and I ran like hell. I didn't even wait for my car, or anything, but I ran like hell to the steps, and there was 'Duke' Duc de Richelieu." The statue of the Duke was no longer so terrifying as Edith had remembered from her girlhood. Much else had diminished in Odessa as well. The city had lost its former splendor. It seemed run-down and dingy. Edith roamed the wide cobblestone streets and finally spotted the building with balconies and iron grills she remembered from fifty years earlier: her apartment building. Her reaction was not what she expected. "The thing that hurt was that as I stood there, I waited for something to happen—you know, there was no nostalgia, no tugging—just rubble. . . . the city is just rubble."

One year later, Edith was summoned to return to Russia, this time as an official ambassador for the artistic creations of her adopted country. Though she was exhausted after a hectic spring and reluctant to miss a summer in Newtown, Edith knew it was the mission of a lifetime.

The enterprise got off to a rocky start. Four days after announcement of the names of the artists selected for the show, the House Un-American Activities Committee declared the show un-American. Francis E. Walter, a Pennsylvania Democrat and chairman of the House committee, announced that of the sixty-nine artists, thirty-four had records of communist affiliation. He accused twenty-two of being hard-core communists, and he had documented "a minimum of a total of 465 connections with Communist fronts and causes" to prove it. He said "Mr. and Mrs. America" had flooded him with letters, outraged over the choices. Walters demanded these artists be yanked from the show.

Conservative artists joined the attacks. Wheeler Williams, president of the American Artists Professional League, and whose professional accomplishments included a memorial statue of Senator Robert

Taft in Washington, D.C., testified the selections were "childish doodles," "scribbles," "crudely drawn," and a "discredit" to the United States. Williams explained the communist motivation for infiltrating the ranks of American artists: "They want to destroy all phases of our culture; and if they can destroy our faith in God and our faith in the beauty and wonders of our cultural heritage, including the arts and literature and music and so forth, they can take us over without a hydrogen bomb." After attacking the jury and virtually every artwork in the show, Williams demanded the entire exhibit be recalled.

President Eisenhower admitted he didn't like the selections either but said he wasn't going to meddle. "I am not going to be the censor myself for art that has already gone there," he said. He admitted that the committee lacked an understanding of the taste of the average American. "Possibly there ought to be one or two people that, like most of us here, we are not too certain exactly what art is but we know what we like, and what America likes—whatever America likes is after all some of the things that ought to be shown." He singled out one painting for criticism: Jack Levine's 1946 *Welcome Home*, an unflattering depiction of a gluttonous general gorging himself at a lavish dinner. Eisenhower declared the painting more "lampoon" than art.

Edith leaped to Levine's defense, and newspapers ran with her rebuttal. "Some people think the President's paintings aren't so good either," said Edith, a line that made front page news in the *New York Herald Tribune,* the *Milwaukee Journal,* and other papers. A photograph of Edith, looking stately and standing beside a folk art painting, ran alongside the stories. "The Levine painting is not anti-American," Edith said. "It's just anti-pompous-general, the way kids felt in the army."

Ultimately, there was a sort of compromise. The Moscow selections were permitted to remain, but in an attempt to neutralize them, President Eisenhower added some new artworks. Three days before opening day, twenty-six additional paintings were loaded onto a plane bound for Moscow. They were eighteenth- and nineteenth-century paintings chosen to appeal to "Mr. and Mrs. America," including

Gilbert Stuart's celebrated portrait of George Washington and a bronze bust of Abraham Lincoln. President Eisenhower lent a painting of a dead duck from his own collection.

The publicity storm made trouble for Edith. She received threatening phone calls at her Newtown house and grew worried that vandals might attack while she was in Russia. She asked the local police to patrol Eden Hill Road in her absence.

Edith arrived in Moscow five days before the VIP opening of the fair. After depositing her luggage at her hotel, she went straight to the fairgrounds in Sokolniki Park. At the administrative offices on the park's outskirts, she discovered her fight with President Eisenhower had made the Russian papers. The American officials were not amused. "They all looked at me as if they hoped I would drop dead," Edith said. The fair's press officer was especially indignant, she recalled, "accusing me of everything but being a paid spy of the Soviet Union." To Edith, the whole controversy was absurd. She was pleased to see an article in a Russian newspaper which asked, "Are they afraid that by sending us their abstractions, their modern art, they would convert us to Communism?"

Bigger problems loomed. Crates containing the artworks were being held at the Pushkin Museum, scheduled to be released only one day before the opening. Edith demanded the art be delivered to the fair the very next day. Wearing heels and dripping with sweat, she then set off to find the exhibit space. She conjured up her rudimentary Russian, marching though the park asking candy and ice cream vendors: where is the dome? "The noise of hammering, carting, hauling, calling, screaming was incredible," she recalled. "There was bedlam everywhere." In the center of it all was a 200-foot geodesic aluminum dome, designed by architect Buckminster Fuller, who had given a couple of lectures at the Downtown Gallery nearly thirty years earlier. The dome housed eight exhibitions, including ones on space exploration and nuclear research. At the center, IBM had set up a fact storage device called RAMAX. The machine, a repository for millions of pieces of information, awaited queries from Russians curious about life in

America. RAMAX knew, for instance, the number of babies born each minute and the number of university students studying Russian.

The fine art exhibit and consumer goods exhibit were located in a 4,000-foot-long glass pavilion behind the dome. Edith climbed the stairs to the second floor. "My dress was dripping wet, my feet ached, so that I just sat on the floor and surveyed the four cubicles we were to have for the Art Exhibition," said Edith. "The space seemed so inadequate that I was on the verge of tears." There was no lighting, and sun came pouring in through the windows, casting irregular patches of sunlight across the walls. Overhead, the metal ceiling was hung with colored panels that threatened to cast an unseemly glow on the artworks.

The next day, the crates arrived. With help from six men from the Pushkin Museum, Edith unpacked the art and moved it into place. A 980-pound sculpture of a monumental woman by the French-born artist Gaston Lachaise raised eyebrows, not for its weight but for the unflattering girth of the subject. By Friday morning, four days later, the artworks were all in place, each with a typed label provided by Edith. Some 400,000 catalogs in Russian had been produced with Edith's help and were ready to be handed out. A plush carpet covered the floor, donated by Lawrence Fleischman's father. A thick foam pad under the carpet attracted much envy. Chunks from the corner were sliced out by enterprising Russians eager to learn about American innovation.

"I felt very proud and patriotic," said Edith. "The total juxtaposition [of the artworks] emphasized the great variety of expression and in my mind seemed the most effective evidence of the freedom of expression in a democracy." At first the art exhibition appeared more controversial than anything else. But when U.S. Vice President Richard Nixon toured the glass pavilion with Soviet Prime Minister Nikita Khrushchev, they sipped Pepsi-Cola and studied a replica of a model ranch house, furnished by Macy's, stopping for heated debate near a washing machine. Nixon claimed that the $14,000 house was well within reach of an average working-class family. "You Americans think that the Russian people will be astonished to see these things,"

said Khrushchev, his words translated into English and broadcast to the United States on three television networks. "The fact is that all our new houses have this kind of equipment." The discussion soon escalated, as Nixon asked, "Is it not far better to be talking about washing machines than machines of war, like rockets? Isn't this the kind of competition you want?"

Edith watched the sparring from above, cheering Nixon on in the historic exchange later dubbed the "kitchen debate." As the vice president toured the glass pavilion with the prime minister, she waited, heart thumping and face flushed, for their arrival. She watched as the scrum of suits, reporters and photographers' flash bulbs swerved away from the art exhibition. Edith was shocked: Nixon had steered Khrushchev right by. Apparently washing machines trumped oil paintings.

Edith was disappointed to miss out on her moment in the spotlight, but by the next day, all was forgotten. "The next day the show was open to the public and in they came in an avalanche, not only those who intended to visit the art exhibition but others who were pushed in forcibly by the crowds. We had the largest captive audience. They couldn't move in or out." Edith estimated a throng

Crowds at the American National Exhibition in Moscow in front of Jackson Pollock's *Cathedral*, 1959.

20,000 visitors strong each day. Fearing for the safety of the art-works, she slipped a list of urgent demands under the hotel room door of the fair's main organizer, requesting guardrails in front of the paintings, three security guards, the installation of fans, and the bolt-ing of a pedestal holding Einstein's bust. "The works of art must be guarded and unless the following precautions are completed at once—and certainly before the weekend crowd, the gallery must be closed—and I will be obliged to request that I be relieved of this truly inhuman responsibility. By at once, I mean today."

Once precautions were made to ensure the art's safety, Edith fell into a daily routine. Each day between 1 p.m. and 3 p.m., she trans-formed the exhibition into her own art debate, limiting admission to artists, academics, architects, and others in related fields. "You in the Soviet Union claim that your art is an art for the people. Nonsense! What people, may I ask?" she said in her gallery talks.

Yours is art officially dictated for propaganda. Ours—yes, art in the USA is art for the people. Contemporary American art is purchased by banks, shopping centers, industrialists, churches, temples. It is used in advertising, in commercial brochures, TV pamphlets, medical journals, business offices etc. But what is even more important, it is bought by people in every economic category for the home—from the local fireman to the million-aire. It is part of everyday living, and the choice is of a range so wide that every personal taste can be satisfied.

After hours, Edith continued her discussions. Artists smuggled their "black-jack," or illicit, unsanctioned artworks for her evalua-tion. Edith was impressed to find that so many young artists were painting experimentally, and though she described what she saw as "not remarkable," she applauded the fact that it was "abstract" and felt the show would surely be "a vital impetus for continuity."

Reactions to the exhibit were not especially different from those back home. Among the favorite works was Andrew Wyeth's

Children's Doctor, a portrait of a famous female pediatrician. Jackson Pollock's drip painting, *Cathedral*, caused puzzlement both for its name and technique. Abstract metal sculptures were also a source of consternation. The Russian art critics—who championed their own socialist realism—saw little of merit.

To visitors, however, the most powerful example of American democracy was the fact that Jack Levine's painting, criticized by none other than President Eisenhower, hung in the show. The director of the United State Information Agency said the Levine served as a symbol of freedom. "Whether one admires or rejects 'Welcome Home' as art and whether the artist is politically naïve or worse, his painting has become, by a strange turn of fate, a symbol of freedom in contrast to a closed society."

Edith, too, stood for freedom. When she escorted a group of Russian newspaper men, they asked her what had happened to the woman who had fought with President Eisenhower. "I am that woman," Edith said. She showed them her passport to prove it.

The 1959 show capped off a monumentally successful and complex decade. Edith's artists were ranked the best by their peers and by the established critics and museum curators. They were attacked by forces outside the art world for their seemingly subversive content and were simultaneously dismissed by newer art critics for having any narrative content at all. To navigate this complex set of forces required superhuman strength and stamina. At fifty-nine, Edith's reserves of both had begun to wane. At least after Russia, she had a whole new reserve of material for one of her favorite pastimes: storytelling. During the 1960s she would spin her Moscow tales in dozens of directions. By the time she returned to New York, she insisted the KGB had rifled through her bags and that she had been planted with secret spy material. Reality was never enough for Edith. She always hungered for more. As she entered her last decade, the divide between reality and fantasy began to blend more and more. Before long, she couldn't tell the difference.

14

Dealer Descending

AT A QUARTER TO 10 P.M., Edith strode through the doors of Washington's Corcoran Gallery of Art for the opening of "The Edith Gregor Halpert Collection." She came from a dinner party thrown in her honor by a Washington society matron at her Georgetown townhouse. Dressed in a flattering knee-length sleeveless shift and with her hair coiffed in handsome silver waves, Edith mingled with hundreds of museum patrons who turned out for a first peek at one of the most impressive and avant-garde art troves ever bestowed on the old dowager of a museum. Following a long courtship, Edith had just about decided that the Corcoran was to be the future and final home for her collection. On the walls and podiums lining a series of second floor galleries were 166 of Edith's most important artworks, gathered up from her apartment walls, dusty closets, and gallery storeroom. "She was showered by the 'thank you's,' of more than 550 Washington art lovers," wrote the *Washington Post*.

Escorted by Hermann Warner Williams, Jr., the gallant museum director outfitted in a tuxedo and a smile for having landed such a plum prize, Edith grinned graciously and toured the show. The artworks constituted a survey of twentieth-century American art, a trove that could instantly transform the Corcoran's modern Ameri-

Edith, far right, at the opening of her 1962 Corcoran Gallery exhibit, with Hermann Warner Williams, left. Stuart Davis's *Pochade* and a John Marin hang on·the walls.

can holdings from paltry to plentiful. There were mini-retrospectives of the Downtown Gallery artists, including Sheeler, Davis, Shahn, O'Keeffe, Weber, and Marin. There were also totems of Edith's importance as a muse and model, including a 1925 Sam Halpert painting of his bare-breasted wife languishing on a bed, and William Zorach's 1930 elegant marble bust of Edith's head, gazing out boldly for all eternity. The Edith Gregor Halpert Collection had found a home, and Edith had found a way to help ensure a legacy for her artists and herself.

"I want foreigners who visit the U.S. to enter that room and be able to see before them the whole current of what American artists have been creating during the last 60 years," Edith proudly told a reporter on opening night. Critics agreed the gift was a major boon for the Corcoran. "The collection will be an invaluable addition to the Corcoran's present collection in rounding out and enriching its

20th century collections and certainly the Corcoran is the ideal home for this important segment of American art history," the *Washington Post* reported. The paper's editorial page described the collection as "one of the most impressive in private hands." Articles also noted that just a couple of small details stood in the way of the gift becoming finalized. The Internal Revenue Service was studying the tax implications of the potentially $2 million gift—a hurdle that Williams dismissed as a "technicality." Also, renovations were imminent. "We hope to begin renovating in several weeks at best," the museum's assistant director, Gudmund Vigtel, told the *Washington Post*, "at worst by the end of the year."

Securing a home for her art was just one of Edith's priorities as she entered her fourth decade of art dealing. Edith wanted to get her own story out. In the fall of 1960, she began the first of several attempts to write her memoir, in collaboration with a writing partner. The first effort, with Washington-based journalist Frank Getlein, resulted in some lengthy interviews and outlines and interest from Harold Strauss, editor in chief of publishing house Alfred A. Knopf—but ultimately nothing came of it. She also attempted to write a book on folk art—frustrated that others had laid claim to the field, though they had come along later and used Edith's own archive. That book also never materialized. Edith couldn't plunge deeply into one project: her mind was too restless, her attention span too limited.

Her efforts to document the history of the gallery—and her own personal contributions—found a natural outlet in her interviews with the Archives of American Art. To prepare for the lengthy in-depth chats, Edith pored over her gallery records and reflected on her early days. This process led her to realize her best years had passed. "It's time for me to retire," she declared during one interview.

> I've felt that for several years, because I just don't get any ideas. When I look back, and it's because of you that I look back at some of this stuff, or I talk about it, I was popping with ideas when I was young. And here I am, absolutely sterile. . . . This summer I thought about it, and I decided that I was finished.

That's all right. Thirty-six years is long enough. I have nothing to complain about. I've been treated very well, and I've been patted on the back. I even got an award from *Art in America*, the only dealer who ever got it. I have no complaints, so I thought, "why don't I retire gracefully while I'm still sitting on top."

She had certainly achieved a place of status and wealth—indeed, her gallery had earned her the means to establish the Edith Gregor Halpert Foundation, which gave her tax–free dollars to fund whatever projects she pleased. She provided financial support to worthy American art projects such as museum catalogs and studies organized by the American Federation of Arts. Many of the projects she supported anonymously. Edith didn't especially want glory from her donations; she just wanted recognition for her artists.

She had reason to worry. As time wore on, the Downtown Gallery artists were shoved aside as old-fashioned. Newer stars burned brighter. As the 1960s hurtled ahead, the New York art market expanded rapidly, and the Manhattan gallery corridor exploded along 57th Street and Madison Avenue. Edith was far from the lone female in the pack. A number of savvy and ambitious women had opened galleries and were taking advantage of the expanding web of buyers. Among the top dealers in this new wave were Martha Jackson, Betty Parsons, Terry Dintenfass, Virginia Zabriskie, and Grace Borgenicht.

But for Edith, the art world had become an inhospitable land. She was disgusted by the new art spectacles and accused museums of running discotheques bent on hype rather than focusing on what she considered their rightful job of carefully filtering out the good from the bad. The Museum of Modern Art in particular seemed to proselytize indiscriminately. She didn't hesitate to confront Alfred H. Barr, Jr. and board president Blanchette Rockefeller and share her frank frustration on behalf of her artists, whom she felt were unjustly neglected. When museum officials permitted Swiss sculptor Jean Tinguely to set up his *Homage to New York* contraption, an assemblage made from bicycle wheels, dishpans, and a piano fit for the junkyard, Edith was aghast

to find it in the museum's courtyard, the Abby Aldrich Rockefeller Sculpture Garden, no less. Tinguely then ignited his creation and it shook, fell apart, and imploded. For Edith, who had no trouble understanding the importance of Stuart Davis's "Egg Beater" series, the Tinguely was so far out, she hesitated to consider it art.

"If you follow the activities in Museums throughout the country you will find that such activities are not unique; that they are encouraged extensively, and the works are exhibited in the context of some great examples," Edith lamented during one of the dozens of lectures she delivered to museum audiences during the 1960s. She claimed a Larry Rivers painting hanging at The Four Seasons restaurant, just a couple of blocks away from the gallery, took away her appetite. Pop artists like Andy Warhol also drew her fire. "These were all commercial artists and doing the most vulgarized version of commercial art as Pop Art," she said. Edith was a self-proclaimed "square in a pop hole." Bottom line—these young kids had it too easy:

> These guys in the early days didn't have a damn thing. There was nothing. They didn't have the press. They didn't have the museums. They didn't have the collectors . . . and these guys today, these youngsters, get up in the morning, they paint a picture, they hang it up in an exhibition, and the Ford Foundation gives them a prize. . . . They have their Ben Heller [major contemporary art collector], the B. H. Friedmans who stand there and catch the next picture that comes off the easel. They have Jim Sweeney who gives a lecture at the Albright Gallery and says "No work of art is contemporary unless it's on the easel and you still smell the breath of the artist on it." [sculptor Isamu] Noguchi was sitting next to me and I said "indeed!"

With the drastic changes in American art after 1950, Edith's gallery roster had become the establishment. The younger artists she brought on during the 1950s never achieved the same level of fame

as her first group. "She had nothing to do with Pop artists," said Gudmund Vigtel, assistant director at the Corcoran Gallery of Art in the early 1960s. "She went with ones who reminded her of the older ones. As sharp as she was picking right artists, she did not recognize the talents that came. They certainly didn't make it on the national scene."

Though the gallery's critical reputation might have dimmed—Edith cursed *New York Times* critic John Canaday, who rarely came to her shows—she benefited in one very tangible way. "The gallery's bank-balance was swelled by the acquisitions of the newly-wealthy middle-class purchasers," Charles Alan wrote, "(not rich enough to buy post-impressionists and not daring enough for the new avant-garde), who felt dully safe with the styles and reputations of Edith's artists."

But Edith had grown offended by the emphasis on money and profits in the art world and the new breed of art buyer, whom she suspected was motivated by speculation and status and not an interest in and appreciation for the arts. "A great change has taken place in the art world with two new classifications among collectors—THE INVESTOR and THE RICH MAN WHO IS BORED," Edith wrote a client. "The first buys names and the second buys erotica, happenings etc., concentrating on sensationalism exclusively." She waged a "one-man battle against the new 'investment' buyers. We have been turning them down wholesale and are getting a bad reputation but I am really adamant on the subject, as you know," Edith wrote James Schramm, an important Ohio customer. "I like the sweet words we get from so many of our clients who express their pleasure in living with pictures, rather than in the turn-over valuations."

Edith was shocked by the madness of the art market, filled with numbers and attitudes she couldn't begin to fathom. "When the crash comes and it's in the making right now and has been for some time, it will drive out, I hope, all the investors—you know that hundred thousand dollar deal that Time reported about me—now they come in and say 'Is it a good investment?'" Edith had her answer ready for

these new buyers. "I'm sorry," went her line. "I can't sell anything to you. I don't have a brokerage license and I may not sell securities."

Edith's sense of dislocation—exacerbated by the bizarre 1960s fixations on such unappealing icons such as the boyish, rail-thin Twiggy and the shaggy Beatles—was made worse by her own mental and physical state. Wounds inflicted years earlier began to fester. One of the most damning instances was an episode over William Harnett. In the 1940s, Alfred Frankenstein, the music and art critic for the *San Francisco Chronicle*, received a Guggenheim Fellowship to write a book on Harnett. Edith liked Frankenstein and was delighted about the book. She gave him full access to her records. His research soon turned up the unexpected: he determined that many of the paintings Edith had sold as Harnetts were actually painted by another talented artist, John Frederick Peto. Edith felt her integrity and her eye were being challenged and was furious with Frankenstein's allegations that she had sold works by an unknown follower bearing fake Harnett signatures. She fought back, trying to have Frankenstein's Guggenheim fellowship pulled and to have him discredited. She wrote letters to her customers offering to buy back their Harnetts—none accepted. Though Frankenstein did not directly accuse Edith of chicanery, the question remained: who had forged Harnett's signatures? Though her clients didn't blame her for selling forged Harnetts—and, indeed, time has borne out that Peto was an exceptionally fine painter—the events did hurt her. Nearly half the paintings in her "Nature-Vivre" show were determined to be Petos. "I think what distressed Edith more than the disputed validity of the Harnetts was her hurt at having been betrayed by that man, by Frankenstein, whom she had trusted, to whom she had proffered her friendship and her affection. The result was that she, who had always been almost neurotically wary, became increasingly paranoid," Charles Alan wrote. Frankenstein disclosed his findings in a lengthy book, *After the Hunt*. Edith was left without recourse. She often referred to the Harnett book she herself intended to write, one of the many books she planned that never materialized.

Then, in the mid-1950s, she suffered two very personal losses. In 1956, her mother, Frances, died. Just two years later, Sonia died of cancer. Sonia's death in particular devastated Edith, coming so suddenly and taking away her closest living relative. Her loss was magnified when Sonia's widower, Dr. Michael Watter, decided to auction the art collection Edith had sold the couple over the years. Edith had given Sonia and Michael preferential access to top pieces—with a view that one day they could donate the collection to a Philadelphia museum. When she discovered Michael had consigned the collection to Sotheby Parke Bernet, she was outraged. The auction catalog for the October 19, 1967, sale read like the Downtown Gallery roster with works by O'Keeffe, Pippin, Lawrence, Levine, and Kuniyoshi. When Edith saw it, she tried to block the sale. She contacted the Philadelphia Museum of Art and suggested that the artworks she had sold and given to Sonia were really intended for the museum. A museum lawyer wrote Edith, saying they had only been promised five paintings, not the whole group. He also noted that if there had been some sort of an understanding between Sonia and Edith to donate the paintings, "the Museum's position might be," wrote the lawyer, "to stand by the terms of that gift, even if it means pressing the matter to litigation." The sale went ahead, fetching hundreds of thousands of dollars and leaving Edith bitter at what she considered a wasted opportunity to memorialize her sister.

Now that Frances and Sonia were gone, all that remained of Edith's family were her niece Nathaly Baum and nephew Howard Chase, who each had one child; Nathaly's daughter Patricia Baum and Howard's son Ronald. Nathaly continued working in the gallery a couple of times a week, commuting from her home in Washington, D.C., and Edith continued mailing monthly checks to Howard's wife Sally. Howard was sporadically employed and intermittently at home. Edith had convinced Maurice Chase, Sonia's first husband and a successful Cincinnati businessman, to help support Sally and Ronald, with Edith agreeing to match whatever Maurice was willing

to pay. Edith had no contact with or regard for her nephew. "Frankly I think we have little to expect from Howard," she wrote Maurice, "whose sense of responsibility is practically nil and I doubt can ever be developed."

With her sister gone, Edith's predisposition to paranoia grew. She felt there was no one she could ever really trust. An episode in 1960 proved that her suspicion was not altogether unfounded. That spring, she hired a new accountant to help overhaul her records. Instead, he found evidence of ongoing theft. The accountant alleged that Edith's longest-standing employee, Lawrence Allen, had been stealing thousands of dollars from her coffers. Apparently, Lawrence had embezzled gallery payments and doctored the records to cover up any trace of his acts. Edith was in shock. She had been in the hospital having a cyst removed from her breast, and news of Lawrence's betrayal was far more painful than the aftereffects of surgery.

Edith wasn't willing to listen to explanations or excuses. She fired Lawrence, changed the locks, and wrote him out of her will. She also froze the pension account she had set up for him, which had some $13,615.36 in savings, realizing that she could use this money to recover some of her losses. Edith also threatened to have Lawrence arrested unless he agreed to sign a confession in front of the police. A letter signed and dated August 23, 1960, from Lawrence appears in the gallery files, stating that Edith had permission to use the savings account funds to "pay The Downtown Gallery the total of the amounts which I have heretofore improperly taken from The Downtown Gallery together with the value of any other properties belonging to The Downtown Gallery which I have improperly appropriated, and also together with the expenses which you incurred in connection with these matters." At the bottom of the statement, a note from Lawrence stated that he had not taken any paintings or property belonging to the gallery. Edith's accountant mailed letters to all clients with outstanding balances and asked them to confirm payments. It took several years to sort out the damage, and during that time Lawrence sent Edith several garbled Western Union telegrams:

"NOW THAT TWO MONTHS HAS PASSED IS IT POSSIBLE TO SETTLE THE ACCOUNT. EAGER TO LEAVE TOWN TO AVOID CONTINUOUS INQUIRIES FOR INFORMATION INCLUDING CODE HYPOCRISY IS FRIGHTENING LAWRENCE ALLEN." The telegrams suggested he was at least as damaged by the events as Edith had been.

When Edith told her artists and clients about Lawrence, most found it hard to believe that the charming, polite, and seemingly devoted man could have possibly stolen from Edith. Some even began to suspect Edith was not herself. "I always thought him faithful to you," O'Keeffe wrote Edith. O'Keeffe's assistant in New York, Doris Bry, was concerned about Edith's behavior. She suspected Edith's accusations were indicative of Edith's own mental instability. Bry told O'Keeffe it was time to get out. "She forced him into it," said Downtown Gallery client Bernard (Jack) Heineman, Jr. of the confession letter. "We all did think he was innocent." Others believed Edith's accusations, saying Lawrence had run up debts supporting boyfriends and might have had a drug problem.

Even without the upheaval surrounding Lawrence's departure, the day to day running of the gallery caused Edith increasing angst. Although the Downtown Gallery artists were passé to some critics, they were suddenly interesting to students of art history. Students, scholars, writers, and curators inundated the gallery with requests for information. Edith's lifelong obsession with meticulous files made the Downtown Gallery archive a treasure trove for research. But the gallery was not able to accommodate the flood of requests. During the early 1960s the gallery staff included Edith, John Marin, Jr., and an ever-changing array of bookkeepers, porters, and eager young men auditioning for the associate director slot—never satisfactorily filled since Charles Alan's departure years earlier. And as Edith never let anyone forget, the gallery was there to sell; it was not a clearinghouse for the curious. "I kept a record for two weeks and found that 85% of my time daily is given over to my duties as an information center with museum personnel, writers, members of the press, artists,

young collectors, and some odds and ends among psychotic visitors," Edith told Frederick Wight, director of the art gallery at the University of California at Los Angeles. "This gallery has turned into a complete madhouse now that museums all over the country have discovered the 'pioneers' of modern art in America."

Edith's efficiency systems had historically allowed her to run her business. But now the art world had grown exponentially, just as Edith's own productivity was on the decline. Stacks of unanswered correspondence piled up in folders on Edith's desk. Even the folder marked "Urgent" was sometimes allowed to linger for weeks. The phone rang continuously. And Edith still wanted to attend to all the important matters herself. She was unable to delegate, and each day left more and more loose ends.

Edith used evenings and weekends to try to catch up. Armed with the folders of unanswered letters, she would spread out on her couch, a pack of cigarettes and a glass of scotch nearby, and enunciate into her Ediphone. She'd remain propped up in her living room—surrounded by her paintings and the shadows—as the clock ticked well past midnight. Edith had a history of working herself to exhaustion, ignoring signs to slow down. Now that she was into her sixties, her body couldn't withstand the abuse. She admitted it only to a few trusted friends and even then couched her complaints in the usual Halpert humor: "Between the fabulously increased attendance in the gallery and the telephone calls plus veritable avalanche of new collections who want to know all about art in one easy lesson," Edith confided in Wight, "I function like an early American whirly gig."

But unlike the charm of folk art whirligigs, wooden toy figures with arms all a-sputter, Edith's flailing scared her. Her memory was not what it had been, and she made mistakes at the gallery. She was so verbal and appeared so lucid, her decline was subtle at first. But over time it became more obvious. During a speech at the Des Moines Art Center in 1961, she slurred her words and was visibly confused. Someone who had attended the lecture wrote Edith a letter accusing her of intoxication. Edith had another explanation, a story she used

on several occasions to explain her bizarre behavior. "Icebergs came shooting down from the eaves," Edith told her longtime friend, writer Edwin Gilbert. "I can tell you a funny incident I had with one of these little numbers coming through our roof, crashing down on my office air conditioner, ricocheting and shattering the large plate glass window behind me, konking me on the head and resulting in a concussion." Edith continued to blame her memory losses on the icicle concussion, and her friends were divided as to whether they believed that an icicle, or illness, was to blame.

With Lawrence gone and Edith's energy waning, Nathaly Baum worked in the gallery a couple of days a week on alternating weeks. Nathaly was just fifteen years younger than her aunt and had worked in the gallery off and on since the 1930s. She lived in Washington, D.C., with her husband, Harry Baum, a tax lawyer for the Justice Department. When she came to New York, Nathaly stayed in one of the vacant upstairs apartments. Edith had begun trying to vacate her rent-control tenants, planning for a day when she might wish to sell the building. Nathaly assisted Edith pleasantly and perfunctorily, though she lacked Edith's flair for selling and was not interested in taking over the gallery once Edith decided to retire. For a brief interlude, Edith hoped Nathaly might want that role. After collector Bernard Heineman, Jr. complimented Nathaly to Edith, she wrote him back: "I am so pleased that you said what you did about Nathaly as it gives me an added sense of security about the future in the knowledge that our clients are so pleased with my 'heir.'"

This was Edith's own short-lived fantasy. Nathaly's priorities were her roles as mother and housewife, especially as her husband was having his own medical problems. Before long, Edith went back to calling Nathaly the gallery archivist and continued to search for another suitable successor, or at least someone to call associate director who would free her up for speaking engagements and the role she enjoyed most: ambassador for American art. "I still feel it is more advantageous to American art and artists for me to *schlepp* around the country," she wrote her friend, Boston dealer Boris Mirski, "than

to *pachke* with catalogues, dictation, and all other details, which I find utterly dull."

The auditions lasted for years. She tested out a respected Boston dealer, Hyman Swetzoff, but they parted ways when it became clear they had different notions on how to run a gallery. She negotiated to hire the director of the Mint Museum in Charlotte, North Carolina, but the deal broke down when he insisted on a $17,000 annual salary. Edith was only willing to pay $14,000. She rejected the director of the Long Beach Museum of Art, sensing he didn't have enough passion for the gallery's artists. "At this point I have just about given up the hope of getting someone as an aide and successor," Edith told Frederick Baum, her lawyer and Nathaly's brother-in-law. "Everyone likes the idea of the gallery basically for the social activities which are part of the setup, but are utterly bored with the practical work involved in the supervision of the enormous number of details." In reality, Edith knew there was no one good enough to replace her, no one who could love the gallery and the artists as deeply and devotedly as she.

The matter of succession also affected Edith's choices regarding her own considerable art holdings. She hadn't set out to become a collector. "I don't think it's honorable for a dealer to skim off the cream," she said. "Even if I want a painting I put it up for sale, hoping, of course, that no one will buy it. Some get snapped up. Then I have to wait around until they come back on the market again." Indeed, one of her favorite paintings, Stuart Davis's magnificent 1940 *Hot Still-Scape for Six Colors—7th Avenue Style"* only landed in her apartment after the original buyer had decided he wished to sell. By the 1960s, after thirty-five years in business, Edith had amassed a major collection—a combination of her personal trove along with the gallery inventory. She had bought works over the years to encourage her artists when sales were slim and she had bought at auction, both to prop up prices and also for long-term investment. Her collection numbered around 300 artworks by forty artists. Her inventory included at least fourteen Stuart Davises, eleven Charles Demuths, sixteen Doves, more than twenty Marins, fourteen Shahns, and ten

O'Keeffes. That didn't even count her folk art holdings, which were stockpiled in a warehouse and in Newtown.

As with most things, Edith was orderly and controlling. She wanted to nail down a plan for her artwork after she was gone. The collection, which formed a veritable time capsule of the first half of the twentieth century in American art, belonged, Edith knew, in a museum. For decades she had urged her collectors to donate works to museums, usually reserving the prime examples for buyers who were museum-minded. One such client was William H. Lane, a stocky, plain-spoken man from Lunenburg, Massachusetts, who started appearing at the Downtown Gallery in the early 1950s. A man who played hard at whatever he did—whether flying his plane, studying opera, or running his family's plastics company—once Lane fell under the spell of Edith and her artists, he set about assembling a world-class collection.

Lane made his purchases either through his company, Standard Pyroxoloid Corporation, or through the William H. Lane Foundation, which gave him certain tax advantages. He would drive his old station wagon to New York and return home with a trunk-load of Doves, Sheelers, and O'Keeffes. Lane's marriage to his first wife, Jean, was unhappy, and he escaped to New York, to Edith, and to art. Edith introduced him to the artists and encouraged him to sit and study paintings. He did so for hours on end. "He comes in and sits with pictures for days," Edith said of Lane. Edith also sold him on the notion of buying what she called "evolutions" of artists' work— meaning examples spanning the beginning, middle, and end of an artist's creative output. She also worked out bulk discounts for Lane, asking artists to take a reduction in consideration of Lane's level of buying and willingness to lend artworks to museums. He bought more than fifteen Stuart Davises, dozens of Doves, and more than twenty Sheelers—among his dozens of other purchases—usually paying well under $2,000 apiece. Lane honored his preferential treatment, staying true to Edith's edict that museum exposure was the ultimate goal. By the 1980s, parts of the Lane Foundation collection

had toured 360 museums and galleries and in 1990 Lane donated ninety paintings and works on paper to the Museum of Fine Arts in Boston, where the works rotate on view in the Lane Gallery, a permanent testament to Lane's collecting prowess and the achievements of the Downtown Gallery group.

Edith would have approved. That is what she wanted for her own collection: a permanent home. In the fall of 1960, Hermann Warner Williams, Jr., director of the Corcoran Gallery, met with Edith to discuss his goals for improving the museum. Williams shared a confidential report with Edith that expressed the museum's desire to build an encyclopedic survey of American art. The report bluntly assessed the urgent need for twentieth-century American artworks, coupled with the problem of no purchase funds. Williams, called Bill, knew Edith's collection would be a major coup for the Corcoran. He was familiar with the gallery and the dealer from his regular New York visits, scouting artworks for the Corcoran Biennial, the museum's one foray into contemporary art. The Downtown Gallery was home to many of the major figures of the contemporary art world and was a required stop. The Corcoran usually borrowed a handful of canvases from the gallery. Edith and Bill would descend into the basement storeroom and pluck paintings from racks. Bill knew what was sitting in that storeroom and what hung upstairs in Edith's private quarters—and he wanted it.

The Corcoran had appeal for Edith as well. It was large enough to be a prestigious and impressive presence in the nation's capital, advantageously located half a block from the White House. After her Moscow adventure, Edith was more adamant than ever about the need for a museum devoted to the history of American art in the capital. The Corcoran could be the place. It already had an impressive nineteenth-century collection and a good start on the eighteenth century. But the collection was small enough that Edith's artworks would be a transformative addition. She needed a place where she could be in charge.

On January 16, 1960, "The Edith Gregor Halpert Collection" headlined at the Corcoran. It was the first of two major shows—the

second would be in 1962. The smorgasbord of 125 artworks was displayed chronologically, starting with weathervanes, dark exacting Harnetts, and a proud cigar store Indian. The chronicle of American art marched onward into the twentieth century, with swirling mysterious Arthur Doves, high-key abstractions by Stuart Davis, and even a small canvas by Dutch emigré painter Willem de Kooning. The *Washington Post* hailed Halpert as "an art dealer who has not only kept her finger on the pulse of American art, but has helped develop that art by her discerning and eclectic patronage." Washington's society matrons on the Corcoran Gallery Ladies Committee threw a tea in Edith's honor. For the occasion, Edith donned a cloche of white feathers that matched her own snowy coiffure and emphasized her bronzed skin, the lingering effects of her Hawaiian winter holiday. She knew she was being wooed and didn't mind at all.

The following year Edith returned to the museum to speak. "I have offered my modest collection of American art to the Corcoran Gallery, supplemented by several other collections which dovetail ideally," Edith told a crowd of museum patrons. "Being a tough realist, I demanded a separate building to be devoted entirely to the art of the 20th century. None of the donors involved wish to be commemorated with plaques. No one asks to be made a trustee or president. It is the artists and the art that will be commemorated."

The Corcoran trustees were keen to acquire the Halpert collection; they weren't, however, prepared to build a wing. Money was part of the problem. Edith estimated the wing would cost $250,000. The board pegged the number at $500,000, without taking into consideration annual upkeep. All funds needed to be raised from private donors, something the museum wasn't all that successful at. Solicitations to foundations yielded nothing. The museum was already short of funds to operate the existing galleries. An annual $129,000 income from the endowment did not allow adequate funding to pay for upkeep, polishing, and cleaning the museum's preexisting 800,000 square feet. An additional $500,000 was urgently needed to install air conditioning in the forty galleries, each with 20-foot ceilings. Dur-

ing the summertime, sunlight pierced the second floor glass roof, requiring employees to bring out an embarrassing sign announcing that the second floor galleries were closed due to temperatures above 95 degrees. Then there was the matter of Edith's strange art. "I'm sure that the art had no appeal to them [the trustees]," recalled Gudmund Vigtel. His boss, Bill Williams, understood the importance of the collection, but the members of the Board of Trustees were skeptical. "I guess they thought it was important because Bill told them so. I don't know that any of them were collectors." The elderly board was more appreciative of the holdings the Corcoran already possessed, the eighteenth- and nineteenth-century portraits and landscapes emanating from a more genteel world. William Wilson Corcoran had founded the Corcoran in 1869, deeding his $100,000 collection of works by his artist friends and painters of the majestic American landscape: Albert Bierstadt, George Inness, and Frederic Edwin Church.

Edith's artists looked nothing like the splendid nineteenth-century emanations of the Corcoran's rugged adventurer artists. Even though the Halpert collection neglected the most radical art movements of the day, including Color Field, Pop Art, and the earlier works of the Abstract Expressionists—it was radical for Washington. Besides, Edith in her feather hat and brassy tones looked and sounded like nothing the Corcoran trustees were used to dealing with. "She was a brash New Yorker," explained Vigtel. "She wasn't scared of anybody and had a strong harsh voice. She was not what they were looking for in the drawing rooms of Washington."

If they hoped Edith and her paintings would go away, the trustees were wrong.

Articles about the gift and the museum's foolish refusal to meet Edith's demands ran in all the newspapers. Edith was winning the publicity war. She publicly shamed the board for failing to appreciate her offer and build her a wing. As a compromise, museum officials offered to renovate and air-condition ten galleries, formerly used as below-ground storerooms. There would be a separate entrance with

a sign reading "Twentieth-Century Gallery of American Art," conforming to Edith's wishes. This arrangement was offered up as a temporary solution until funds could be raised to construct the proposed wing. Edith was not impressed, but for the moment it would have to do. In 1962, the Halpert Collection—a selection culled by curators and considered to be selections to constitute the gift—was once again exhibited, and Edith was once again feted.

Edith's lawyer Frederick Baum executed a draft of the gift agreement, which provided the museum with a 10 percent interest in the collection, with Edith retaining 90 percent during her lifetime, turning over 10 percent increments annually. Meanwhile, Edith continued soliciting donations for the Corcoran from her clients and artists. The gift agreement remained unsigned.

Edith didn't seem to be in any hurry to finalize her plans, even as her own artists died or abandoned the gallery. O'Keeffe was the first to pull out, in 1963. In 1964, John Marin, Jr. left and took his father's estate with him. The same year, Stuart Davis died and Edith began bickering with his widow, Roselle. Edith had adversarial dealings with many widows, which usually resulted in the artist, or the artist's estate, leaving the gallery. It was a matter of control, and Edith wasn't willing to share.

Sheeler had stopped producing. After a 1959 stroke, his right hand was paralyzed, and he was unable to make art. Edith helped arrange for rehabilitation, and although Sheeler regained his speech, his hand was finished. "Seeing the disintegration of a human being, seeing this perfect specimen become an imperfect specimen was terribly painful," said Edith. "Seeing that wonderful hand . . . lying in his lap useless. . . ." Sheeler and Davis were her two favorite artists. "Why," she asked, "do people disintegrate?"

Edith's own health was certainly dragging her down. She continued to have stretches of amnesia. She might or might not recognize a client at a party, and her forgetfulness caused problems with sales, billing, and all the details of the day-to-day running of the gallery. She developed tremors in her arm, sending her to a doctor. When the

Catholic archdiocese offered her $300,000 for her building in 1963, she decided to accept the offer. The church permitted Edith as much time as she needed to find another location. She decided it was time to move to a quieter spot: a location where she would operate by appointment only. Also, climbing the stairs at 32 East 51st Street had become onerous. Edith wanted a one-floor operation.

"People would drift in off the street 20 times a day to ask for art appraisals—I saw more fakes than I could count," Edith told the *New York Times*' Grace Glueck in June 1965. "They want to use the facilities, eat their lunch, make telephone calls. We had to be constantly on the watch for theft. I got tired of it." The article announced Edith's upcoming move, after twenty-five years on 51st Street, a move she described as nothing but positive—not once acknowledging that she needed to slow down.

Three months later, the Downtown Gallery reopened on the corner of Park Avenue and 57th Street, a crossroads marked by hotels, apartments, and offices. The space was a subterranean basement, formerly occupied by the Cavendish Club, a bridge club, located in the Ritz Tower. Though the address was smart and the space commodious—outfitted to Edith's specifications and paid for by the landlord—there was no mistaking: it was underground. There was no natural light. Compared to her first gallery, with the sunny daylight gallery showcasing her artists' canvases and carvings, the final incarnation of the Downtown Gallery was a literal and figurative step down.

Edith had planned to live above the gallery, in an apartment she bought at the Ritz Tower. She thought that living above the shop, but considerably higher up, would help create some distance and privacy for her personal life, but she never felt at home in the place. It was too small for all her artworks and too expensive for her tastes. She remained for just a couple of years, never really unpacking or hanging her art. Soon she moved to a larger two-bedroom apartment in a newer building at 136 East 56th Street.

Meanwhile, the Corcoran Gallery tried to shore up the legal agreement. A new curator was hired, who promptly wrote Edith that

the only reason he had taken the job was to work with her collection. In October 1965, she told Bill Williams that she intended to sign the agreement in November. Her health problems—pain, headaches, amnesia—were such a worry that she had finally decided to have an operation meant to relieve some of her symptoms. She had a benign tumor growing behind one of her ears according to Bella Linden, another of Edith's lawyers. Edith's behavior was still erratic—sometimes perfectly lucid and at other times confused. Again, she apologized to clients and employees, claiming a ladder had fallen on her head during the gallery renovations. She said a winter vacation was all she really needed, though she didn't admit the vacation was taking place in a hospital.

The operation forced her to make some important decisions. "I have finally decided to make the gift to the Corcoran Gallery," Edith wrote Frederick Baum, "now that they have assigned an ideal space in the museum." She asked that the agreement be simplified to just three pages, and admitted, "I just don't seem to function anymore." Edith forged ahead, exchanging drafts of contracts with her lawyer.

She also set about updating her will. She met with Bella Linden, who had urged her to review her will before the operation. They met to discuss her wishes, and Linden drew up the document. "She didn't think her family liked art very much," recalled Linden. "It was the money they cared about." On December 13—just two days before she was scheduled to be admitted to the hospital—Edith signed off on her final wishes. She donated her eyes to science and asked that her ashes be strewn to the wind. She gave her art collection to the Corcoran and promised her folk art to the Smithsonian. Other art gifts were allocated for special friends. She left a Sheeler drawing, *Central Park*, to the William H. Lane Foundation and a bronze by Reuben Nakian to her friends Melvin and Helen Boigon.

Her family was given artworks of sentimental value and a piece of her considerable fortune, tucked away in investments following a lifetime of relative frugality. Nathaly received the Newtown home (excluding all artworks and furniture), Edith's jewelry, and artworks

with a personal connection, including the portrait of Edith by Sam Halpert. Her grandniece Patricia was given all her government bonds. Albert Pyle, her longtime cook, received $1,000, and the Friends Hospital of Philadelphia received $10,000, as did her nephew Ronald Chase and the Archives of American Art. Howard Chase was given linens and other household items. The residual property was to be split between Nathaly and the Edith Gregor Halpert Foundation.

With the will complete and the Corcoran agreement underway, Edith went for her operation secure in the knowledge that her wishes had been laid out. "Dr. Moore is certain he found the leak," wrote Nathaly, after the operation. "Your 'faucet' is all plugged up now." Edith left the hospital almost two weeks later. She had received strict orders to rest. As she had done in the past, she went right back to work, unable to resist the tall stacks of letters piling up in the gallery. Her secretary—Richard P. Miller, who went by the name of Tracy—encouraged her to rest. She refused. Her patience with the Corcoran was nearly gone. The museum had continued to court Edith, but she continuously made new demands. Following a dinner with Bill Williams at the Harvard Club, Edith wrote him:

> As I pointed out, what disturbed me most was the unexpected inclusion of your earlier possessions in the area presumably devoted to my collection, to say nothing of the large number of recent acquisitions, of which you had no photographs on your recent visit. The other, possibly even more serious problem was the addition of your permanent committee to the original acquisition committee of five on which we had agreed. In any event, this will be my last try. As you no doubt noticed I become terribly disturbed each time some new gimmick is slipped in to the new version.

Edith seemed driven by whim and not reason. "We couldn't anticipate what she was going to complain about next," recalled Donelson

Hoopes, who worked at the Corcoran during this time and later worked briefly for Edith at the Downtown Gallery. "Nothing pleased her. We couldn't pry the collection loose." Bill Williams did not give up hope. A survey of American painting "Past and Present" had been on the exhibition schedule for over a year, planned with the assumption the Halpert gift would already be hanging on the walls. Bill had mentioned the upcoming show to Edith and his hope that her collection—as the property of the Corcoran Gallery—would anchor the twentieth-century portion of the show. The Corcoran mailed Edith a letter listing all the artworks they hoped to borrow. She responded that she knew nothing of the show and refused, claiming it was "impossible under any circumstances to send all of these loans for a period of five months." She continued: "Furthermore, I have always made it a practice to lend paintings owned by the artists or estates as long as these are available; since I consider showing my or the gallery's collection competitive. I am sure you will understand."

When Francis Biddle, a Corcoran benefactor and famous judge who had presided over the Nuremberg trials, asked Edith about rumors her collection was going to the Smithsonian, she replied, "In my present state, it is very difficult for me to absorb the contents of any legal document."

When Bill Williams decided not to attend Edith's annual fall show in 1966, Edith lashed out. She reported to Bill that she had studied the catalog for the current show at the Corcoran, "The Contemporary Sprit":

Of the 85 works listed, I note the name of only one artist associated with this Gallery and realize that the Friends of the Corcoran show very little interest in this Gallery's roster. Also, checking further—out of sheer curiosity—I note that purchases made by the Corcoran Gallery—barring the early era—are as follows: Dove—1961-$250., Shahn—1963-$405., Marin—1963-$475., Osborn—1964-$315., Sheeler—1965-$2,700., Morris—1965-$1080. This amused me very much as it breaks

all records of museum sales we have made (in reverse) in-
cluding small beginners. I thought you might be interested
accordingly.

Edith's enthusiasm for the Corcoran had faded. She was much less
interested in Washington, D.C., after plans were announced for a fed-
erally funded Washington museum for the thousands of artworks
owned by collector Joseph Hirshhorn. She told a friend, "It seemed
unnecessary for me to make the contribution there." She later con-
sidered donating her collection to the Israel Museum and made her
intentions know to Elaine Weitzen, director of the American Friends
of the Israel Museum. "I know that Edith wasn't too happy with her
family," recalled Elaine Weitzen. "That was one reason Edith want-
ed to leave everything to the Corcoran or the Israel Museum. I think
the Corcoran was number one, and then the Israel Museum. She said
we'll be really happy."

After her move to the Ritz, most of Edith's artists realized she was
no longer fit to run her the gallery and tried to leave. It usually got
ugly fast. Ben Shahn wanted out in 1965 and asked his lawyer, Mar-
tin Bressler, to handle the breakup and get back his art. Bressler
recalled Edith was furious and refused to return the art. "We had lit-
igation with Edith," recalled Bressler. When he met with her "she
smoked terribly, she coughed terribly, she was breathing funny and
wheezing. She was upset at Ben and I was scared," Bressler said. "I
asked for a doctor to be there." Bressler left the meeting suspicious of
Edith's accounting. He compared the purchase orders she had sent to
Shahn with her own records—obtained with a court order. "She kept
two sets of books," Bressler said. "She doctored copies she gave to
Ben." Bressler said Edith did this because she and Shahn had dis-
agreed on the amount of commission he paid her on certain jobs.
Rather than fight, according to Bressler, Edith just kept two sets of
accounting books. Bressler said Shahn won the lawsuit and eventual-
ly got back around 100 artworks. William Zorach's lawyer, Barry
Berkman, recalls a similar tale with a lawsuit to retrieve artworks.

According to family and friends, Edith still struggled with the question of what to do with her collections. She was unable to commit to an institution—unable to face the fact that one day she would no longer be able to watch over the artworks. One young, plucky museum director, Marvin Sadik, approached Edith about organizing an exhibit in her honor for the University of Connecticut. Sadik, who had run the National Portrait Gallery in Washington, D.C., knew Edith's reputation and those of her artists. "I felt that in a sense she had not been sufficiently memorialized," said Sadik. "And after I met her I understood why." After she agreed to the show, he began going to the gallery frequently. "I used to leave her gallery as if I had been paroled from Alcatraz," said Sadik. "It was a nightmare. She wasn't capable of rational behavior." Sadik chalked Edith's behavior up to two factors: first, that she had been eclipsed by dealers of the day like Leo Castelli. Second, he suspected she had serious medical problems. "When I got to know her she was heavily dependent on booze. She ultimately had a brain tumor that killed her and I suspect the tumor affected her personality." Sadik found the whole thing depressing. "When I knew her she should have been retired and not still plugging along."

The same month Sadik's exhibit honored Edith at the University of Connecticut, Edith visited the Madison Avenue law office of Rosenman, Colin, Kaye, Petschek, Freund, and Emil. On November 1, 1968, she signed a short document, just two paragraphs long, revoking her 1965 will. The revocation was signed by Ralph Colin, who was the attorney for the Museum of Modern Art as well as the Art Dealer's Association but had never been one of Edith's confidants or especially close. They had had prickly dealings. Colin's colleague, Gilbert Edelson, also signed and dated the document as a witness. Edelson said in an interview he does not recall why Edith revoked her will and acknowledged it was not uncommon for people to revoke wills without having another in place. Bella Linden, who had written the 1965 will, disagrees. "Most lawyers would revoke an existing will in a new will," said Linden. "What happened is not what she wanted

at all and I doubt if it was ever explained to her the ramifications of the revocation of the will." Linden said that after Edith went to Colin, she stopped discussing her will. Linden had been one of three trustees of the 1965 will, along with Edith's niece Nathaly. Whatever the circumstances, the fact remained: Edith Halpert, the former efficiency expert and supreme organizer, a wildly successful and progressive woman who had amassed a fortune in artworks and investments, was left without any say in the disposition of everything she had stood for and worked for.

It is hard to know if Edith had the mental capacity to even notice or care. One of her longtime clients, songwriter Jack Lawrence, recorded his memories of this period in his memoir, *They All Sang My Songs*:

> In the late 60s Edith developed a brain tumor and deteriorated rapidly. We took her to New York Hospital a few times for examinations by specialists who recommended surgery, but she would have none of it. She was far too gone to recognize her true condition. We watched this woman, who had always been so chic and smartly turned out, virtually become a bag lady with mismatched torn stockings and stained dresses. She would phone to invite us out to dinner but, to avoid having people see her in public, we always insisted on eating at home. She would appear carrying her belongings in a Bloomingdale's shopping bag. Her speech was incoherent and her talk was nonsense. For those friends who had known her over the years this was heartbreaking, but there was little we could do. We were shocked to learn that some "friends" had actually taken advantage of her incompetence and bought important art works at ridiculous low prices which she quoted in error.

In her confusion, Edith hired dealer Bernard Danenberg, who convinced her to sign a contract selling him the gallery. Edith later

threw Danenberg out of her office, according to her lawyer David Ellenhorn, who represented Edith when Dannenberg sued to enforce the contract. Ellenhorn defended the lawsuit, claiming Danneberg had taken advantage of Edith. "She didn't know what she was doing," recalled Ellenhorn. "I only met her a few times but I found her to be difficult. She was old, semi-senile and erratic. In the court papers we portrayed her as out of it." Ellenhorn said he scared Dannenberg off by finding a woman who had worked with him at another gallery and saw him forging a signature on a painting. "We dug up a lot of dirt on him and he folded quickly and we got a very good settlement [and] he dropped the case."

Still Edith wouldn't consider closing the gallery. She kept a bottle of scotch stashed in the storeroom, along with the coffeemaker. She sat all day in her office, a dark room with a maroon carpet, filled with files and ashtrays. Her drinking, according to employees and clients, advanced to the point where she was sometimes drunk by late afternoon. She railed at employees who went out for lunch, offering to pay for a sandwich from Le Pavillion, the expensive French restaurant in the Ritz Tower if they would remain with her. She was unable to maintain her appearance. She wore dresses that zipped up the back and would walk to the gallery in the morning with the zipper undone, needing the help of Murray Wax—her secretary in 1968 and 1969— to finish dressing. Her old protégé Charles Alan described her appearance at an opening: "Her once shimmering white hair . . . always so carefully dressed, is now shockingly thinned and dulled and matted. Her shining blue eyes are frosted and below them the furrowed flesh sags to her mouth on which the bright lip-rouge has not been applied quite evenly. There is a rustiness about the black of the velvet of her dress that no longer fits her wasted body; it seems either too long or too short now, and the hem-line is not quite straight."

In November, Edith was admitted to New York Hospital-Cornell Medical Center. Adele Rosenstein, her trusted friend and sometimes bookkeeper, visited Edith during her months in the hospital and reported back to Jack Lawrence that Edith hadn't recognized her.

Adele told Jack Edith clutched a notebook, as she had once clutched her cigarettes, and explained she was busy writing down her story. When Adele looked at the pages, there were nothing but scribbles.

On October 7, 1970, a grainy black-and-white photo of Edith appeared in the *New York Times*, along with a notice that "a moving force in the world of art, its production, its display and its marketing," had finally come to rest. Edith was seventy years old and had died at New York Hospital, the cause reported as "after a long illness." Two days later, at 10:30 a.m., a small group gathered at the Riverside Memorial Chapel on Amsterdam Avenue and 76th Street. Relatives made up more than half of the attendees: Howard Chase, Nathaly Baum, her daughter Patricia, Patricia's husband Romano Vanderbes, and Dr. Michael Watter, Sonia's second husband. Ruben Tam, one of Edith's Hawaiian artists who had moved to New York, was the only artist who bothered to come. Bernard Heineman, Jr. was one of the only clients. The group assembled in a small upstairs room. Afterward, a reception was held in a room next door.

Only death could remove Edith from the Downtown Gallery. Nathaly wound up the business and closed the doors more than forty-five years after Edith first dusted off her 13th Street doorstep. Even though Edith was gone, her words and deeds lived on, stored in boxes at the Archives of American Art, ready for the day when someone might stumble across the funny, earthy, and brilliant prose of Edith's letters. And be amazed by all she had done.

Epilogue

THE VERY CRÈME of American art aficionados—several hundred dealers, collectors, and curators—filed into Sotheby Parke Bernet's hulking limestone-clad office building on upper Madison Avenue. It was just before 8 p.m. on an otherwise sleepy Wednesday night. Most of Madison Avenue was quiet as a tomb. Street-front shops had closed for the night. Across the way, a doorman in a cap and bow tie stood watch under the gold-and-white Carlyle Hotel awning. It was one of the toniest blocks on Manhattan's Upper East Side, a setting that might have amused Edith Halpert, the late dealer whose specter hovered ever so faintly over the proceedings.

In her 1965 will—a will she revoked just three years later—Edith Halpert had asked that her ashes be strewn to the winds. Instead, her remains had been interred at the National Memorial Park in Falls Church, Virginia, not far from her niece, Nathaly Baum's home, and where her niece too would be buried in 1986. Eight years later, on March 14, 1973, the Madison Avenue gathering was far from a funeral, but it included many art disciples who had come to pay their respects indirectly and to observe as Edith's art collection was cast to the winds, a dispersal to the highest bidder.

Rows of seats filled up with men and women in feathered haircuts and fashionable flared trousers. Thick white auction catalogs lay splayed across their laps, filled with color photographs of hundreds of Edith's artworks: her magnificent, mysterious Doves; her jazzy, electrifying Stuart Davises; and her silent, shifting Sheelers. There were also more personal items, brimming with sentimental value: a delicate 1929 pencil drawing by Jules Pascin of Edith Halpert and Pop Hart in a sensuous embrace; a Ben Shahn drawing signed to Edith; and a 1960 New Years Card from Charles Sheeler inscribed to Edith, "who has been so good to me."

Upstairs in the balcony, dealer Lawrence Fleischman of the Kennedy Galleries sat in his usual seat. Down below, a St. Louis businessman named Barney Ebsworth readied himself to snatch up Edith's O'Keeffes. A handful of Japanese art dealers had also arrived. James Maroney, Sotheby's thirty-year-old American painting expert, carefully surveyed the crowd and prayed for fierce bidding.

Sotheby's had a lot riding on the sale's outcome. Maroney and his auction house colleagues had studied Edith's collection, poring over plywood storage bins jammed with paintings at the Downtown Gallery, artwork scattered around her rental apartment, and even the contents of her Newtown home. When they tallied their figures, they realized they were looking at a $2 to $3 million collection—the single biggest trove of American modern artwork to ever hit the auction block. For Maroney, an ambitious Sotheby's employee at the helm of the newly founded American painting department, the Halpert Collection had the potential to be a career-making sale.

But first he had had to convince the sellers that an auction at Sotheby Parke Bernet was the way to go. Frederick Baum, Edith's old lawyer—now acting on behalf of her estate—had driven a hard bargain. There were several other groups who had offered to buy the estate outright. Downtown Gallery client and real estate developer Charles Benenson organized one such consortium and offered $2 million. Maroney had lobbied Sotheby's management, and they offered a $3 million guarantee—a promise that regardless of the

sale's outcome, the estate would garner at least $3 million, more than $14 million in today's dollars. It was the first time an American painting collection was offered a guarantee, and it was a mighty big gamble.

While Sotheby's wondered if the auction would turn out in the red or the black, some of Edith's friends fretted over the proceedings. "We were shocked," said Elaine Weitzen, who had believed Edith would bequeath some of her art to the Israel Museum. "When she died there was nothing." Other friends were less surprised to discover Edith had died without a will. "She died intestate because of her illness," said longtime friend Helen Boigon. "She couldn't get it together after whatever made her cancel that will." Others sensed Edith's ambivalence was driven by other forces. "Edith was going to give her material to the Corcoran, the Smithsonian and the Israel Museum but she cancelled her will because she got angry at everyone," explained Bernard Heineman, Jr. Other friends blamed Edith's family. "On many occasions, and in front of her niece, she [Edith] told us that certain works were destined for certain museums and that her niece was to get money but no art," recalled Jack Lawrence. "Once the estate was settled her niece put all the art up for auction and took the proceeds."

In fact, there were two heirs to Edith's estate, her niece Nathaly Baum and her nephew Howard Chase. Chase, who was living in Los Angeles, had divorced Sally and remarried. His son, Ronald Chase, had died in a car accident. Frederick Baum, Nathaly's brother-in-law who had advised Edith on legal matters, was now acting on behalf of both Nathaly and Howard.

As it turned out, the auction paid off for everyone. The cream of Edith's collection raked in $3.6 million, "a total that has left art dealers and collectors agog over the prospect of a significant new market," reported the New York Times, which described prices as "spectacular" and results as "prophetic."

"It was a sale like none other we'd ever seen," recalled Maroney, who said he got a raise and promotion as a result of the Halpert auction. "American painting auctions didn't really exist before 1970.

The Halpert sale put modernism on the map." Prices leaped to a new level. "We were accustomed to selling artworks for $8,000 to $30,000. A hundred thousand was the big time. We'd only sold a couple pictures for $200,000, the same today as $20 to $30 million. It just didn't happen." If the Halpert sale took place today, it could easily top $100 million, says Peter Rathbone, the current head of Sotheby's American painting department.

There were records galore. Georgia O'Keeffe's dazzling peach and white *Poppies* blasted by a $50,000 estimate, selling for $120,000 and instantly becoming the most expensive artwork by a living American artist ever sold at auction. Edith's other prize possessions hit record heights: Stuart Davis's *Hot Still-Scape for Six Colors—7th Avenue Style* sold for $175,000, also more than double presale expectations. Elie Nadelman's *Tango*, of a graceful dancing couple carved in wood, sold for $130,000, the highest price ever paid for an American sculpture. Among the biggest surprises were the astounding prices paid for Kuniyoshis. *Little Joe with Cow*, estimated to sell for around $35,000, brought $220,000 from a Tokyo dealer. Kuniyoshis had sold at auction for $3,500 just a few years earlier.

The *Washington Post* reported the bittersweet aspects of the sale, noting that Edith had "jiggled her $2 million prize like a puppet on a string before the lustful eyes of gallery [museum] officials" and that she had "continued to dicker almost until her death." Those museums that she had flirted with as potential repositories for her collection—the Corcoran, the Smithsonian, and the Israel Museum—were the biggest losers. They received nothing.

After years of fussing over high utility bills and fuming over frivolous spending by her employees, Edith died a wealthy woman. Her final estate accounting reveals she was worth in excess of $5 million, around $22 million in today's dollars, including auction proceeds and more than a half million invested in stocks and bonds. A year after she died, robbers broke into the Newtown house and stole everything. Pieces of Edith's precious folk art collection turned up for sale with various local antique dealers. Despite investigations by the FBI

and local police, the thieves were never caught. The estate unloaded the rest of her folk art remains for $428,000 to dealer Terry Dintenfass—who later consigned most of it to Sotheby's.

Edith would have been pleased to learn that Abby Rockefeller's youngest son, David Rockefeller, bought Sheeler's magnificent *White Sentinels*, a tempera of a barn in cool whites and blues. She would have been furious that Bernard Danenberg bid for a group of Japanese backers, buying Nadelman's *Tango* and then making limited edition bronze casts for resale. Her passion for art and artists, which consumed her during her life and defined her in death, helped make New York the art capital of the world and American art count, a vision she saw clearly, decades before almost anyone else. As Edith would say with a shimmy of the hips, not bad for a little girl from Odessa, trained on penny candy.

Notes

This book depends heavily on the Downtown Gallery Records, which have been preserved at the Archives of American Art at the Smithsonian Institution in Washington, D.C. In the interest of documentation and future scholarship, I have included endnotes for many of the most consequential facts and quotes plucked from Edith Halpert's voluminous archive, recording both the frame and reel, so that others may continue to follow Halpert's remarkable trail. Many of these records can be viewed on the Archives of American Art's website: www.aaa.si.edu.

To share Halpert's inimitable voice, I have quoted extensively from the transcript of her 813-page oral history interview, conducted by Harlan Phillips of the Archives of American Art from 1962 to 1965, and those quotes, stories, and facts are cited as such. I also relied heavily on notes from Edith's unpublished autobiography, *Art Dealer in America*. Diane Tepfer's dissertation on the Downtown Gallery and book on Sam Halpert must also be singled out for their importance. I have footnoted from those sources when material was quoted directly or when I relied on Tepfer for information I did not discover or conclude during my own reporting.

Because the book attempts to tackle nearly forty years of art history and mentions dozens of Downtown Gallery artists, I have relied on the research of many art historians who have considered these subjects in depth. I have cited this material when quoted or applied directly. Books providing general background information are listed in the documentation section.

In addition, all other quotes are cited in the endnotes, as is any material deemed important, controversial, or specific enough to warrant a reader's curiosity.

Abbreviations used in notes:

AAA/DTG Downtown Gallery Records, 1874–1974, Archives of American Art, Smithsonian Institution.

AAA/HCP Holger Cahill Papers, 1910–1993, Archives of American Art, Smithsonian Institution.

AAA Archives of American Art, Washington, D.C.

AAA OH EGH Archives of American Art commissioned oral history interview, Edith Gregor Halpert and Harlan Phillips, 1962–1965.

AAA OH Archives of American Art commissioned oral history interview

AAR Abby Aldrich Rockefeller

EGH Edith Gregor Halpert

EGHFG *Art Dealer in America,* notes for Edith's unfinished, unpublished autobiography, written by Edith Halpert in collaboration with Frank Getlein, circa 1960–1961.

EGHUK Drafts for biography, circa 1960s, written by unknown ghost writer, probably Frederick Wight.

NYT *New York Times.*

RAC Rockefeller Foundation Archives, Rockefeller Archive Center.

SD Stuart Davis.

SDCR Information courtesy of working files, Stuart Davis Catalogue Raisonné, to be published by Yale University Press in 2007. Editors: Ani Boyajian and Mark Rutkoski.

SH Sam Halpert

TEPHAL Tepfer, Diane. *Samuel Halpert: Art and Life, 1884–1930.* New York: Millenium Partners, 2001.

TEPDIS Tepfer, Diane. "Edith Gregor Halpert and the Downtown Gallery Downtown, 1926–1940: A Study in American Art Patronage." Ph.D. diss., University of Michigan, 1989.

Chapter 1: A Samovar in Harlem

p. 1 "Odessa business": AAA OH EGH, p. 1.

p. 1 "The first six years of her life": This information is based on Edith's unverifiable claim that her family came to the United States in 1906. According to a birth certificate obtained from the Odessa Municipal Archives, Edith might have been born in 1899 and not 1900, as she always claimed. If that was the case, she would be a year older than the ages given throughout this biography.

p. 1 The Archives of American Art joined with the Smithsonian Institution in 1970.

p. 2 "Prologue": AAA OH EGH, p. 1.

p. 2 "Hard knocks": AAA OH EGH, p. 2.

p. 2 "Pop Art . . . commercial art": AAA OH EGH, p. 638.

p. 3 "We weren't driven out": AAA OH EGH, p. 1.

p. 5 "Born on April 25": Abel Polese, a graduate student and researcher in Odessa, searched the Odessa Municipal Archive for birth records for Jewish girls with the family name Fivoosiovitch born 1897–1902. He located one with a similar surname: Ginda Faivusiovich, born January 7, 1899. The father's and mother's names are close Russian Jewish approximations of Gregor and Frances, Edith's parents' names. Ginda could be Edith. Edith always gave her birth date as April 25, 1900.

p. 5 "Very good style": AAA OH EGH, p. 2.

p. 5 "Middlemen": Herlihy, p. 212.

p. 5 "The store": TEPDIS, p. 14. Tepfer interviewed Halpert's niece Nathaly Baum (d. 1986) and Halpert's cousin David Lucom, providing first-hand reports of family history.

p. 5 "Duma": Author's phone interview with Stephen Zipperstein.

p. 5 "Jews constituted": Herlihy, p. 252.

p. 6 "No Jews or dogs": Herlihy, p. 254.

p. 6 "Trading gateway": Herlihy was my main source for information on turn-of-the-century Odessa (landscape, politics, demographics, economy, architecture etc).

p. 6 "Grid system": Herlihy, p. 12.

p. 6 "Running water": Ibid., p. 237.

p. 6 Ibid., p. 266.

p. 7 "Exotic strangers": Kaufman, p. xlix.

p. 7 "Twenty languages": Herlihy, "Odessa Memories," p. 4.

p. 7 "48 Rishelyevskaya": Edith mentions this address in notes from her 1958 trip to Russia (reel 5637, frames 239–240).

p. 7 "Odessa equivalent": AAA/DTG, EGHFG (reel 5637, frame 442).

p. 7 "Courtyard": Photos of 48 Rishelyevskaya in 2006 provided by research assistant Abel Polese.

p. 7 "Acacia trees": TEPDIS, p. 14 and Kaufman, p. l. Bel Kaufman lived at 57 Rishelyevskaya Street, near Edith's building, and recalled the scent of acacia trees. Edith said acacia trees were still there in 1958 (reel 5637, frame 242).

p. 7 "Nasty little kid": AAA OH EGH, p. 2.

p. 7 "He'd scared me": AAA OH EGH, p. 2.

p. 7 "Roasted sunflower seeds": Kaufman, p. 1.

p. 8 "Half a ruble": 1 Herlihy, p. 270.

p. 8 "*konka* transported Odessans": Iljine, p. 96. Postcard shows *konka* at intersection of Rishelyevskaya and Zhukovskogo.

p. 8 "Blond hair and dark eyebrows": AAA OH EGH, p. 4.

p. 8 "They lied to you.": AAA OH EGH, p. 4.

p. 8 "Maybe I did": Ibid., p. 4.

p. 9 "10 percent of all deaths": Herlihy, p. 235.

p. 9 "Could not succeed.": AAA DTG, EGH's notes during 1958 visit to Moscow (reel 5637, frame 240).

p. 9 "The trade had slowed": See Herlihy for information on the rise and decline of the grain trade in Odessa.

p. 9 "American agricultural expert": Herlihy, p. 212.

p. 9 "Grain often was soaked": Ibid., p. 208.

p. 10 "Not worth even exporting": Ibid., p. 210.

p. 10 "Theft and burglaries": Ibid., p. 296.

p. 10 Information on pogrom from Herlihy and Weinberg.

p. 10 "Violence escalated": Ibid., p. 166–167.

p. 11 "No protection": Herlihy, p. 304–308; Weinberg p. 172–173.

p. 11 "Reported dead": Reports vary as to the number of dead and wounded. Herlihy, *Odessa,* says on p. 307, "Jewish casualties included 302 known dead" and "some reports claim death toll at 1,000." Reports of wounded range from a few thousand to five thousand. Herlihy cites 1,400 ruined businesses and 3,000 families reduced to begging.

p. 11 "Fifty thousand fled": Ibid., p. 307.

p. 11 "Least expensive ticket": Howe, p. 39.

p. 11 "A small fortune": Ibid., p. 39.

p. 12 "I was a pet": AAA OH EGH, p. 5.

p. 12 "She arrived May 6, 1906": TEPDIS, p. 15. Tepfer notes that Edith reported the arrival date. She could find no record of the Fivoosiovitch family listed on NYC Ship Manifest Records for May 1906, nor could the author using any variation on the family name, searching the passenger arrival records available online at www.ellisis-land.org.

p. 12 "More than 150,000": Gurock, p. 43.

p. 12 "A housing boom": Ibid., p. 28.

p. 12 "Jews became the dominant group": Ibid., p. 40.

p. 12 "100,000 Jews": Ibid., p. 28.

p. 13 "Women discovered": Joselit, p. 39.

p. 14 "The wealth of America": AAA OH EGH, p. 5.

p. 14 P.S. 159. Information on school address provided by NYC Planning Board. The school was demolished in the 1960s, according to the board.

p. 15 "That was injustice": AAA OH EGH, p. 13.

p. 16 "Very good time": Ibid., p. 14–15.

p. 16 "I was the business woman.": Ibid., p. 23.

p. 16 Profile on Maurice Chase, "Busy Man Is Booster, Has Eventful
 Career," *Kentucky Post*, January 25, 1915.

p. 17 "Work full-time": Howe, p. 173.

p. 17 "Dry goods store": TEPDIS, p. 15.

p. 18 "Peanuts": AAA/DTG, EGHFG (reel 5637, frame 437).

p. 18 "November 29, 1912": State of New York, Certificate and Record of
 Marriage, certificate number 28985: Sonia is married using the name
 Sophie Fine, spelled different from Edith's last name Fein. Edith start-
 ed using Fein by 1914. Sonia/Sophie lists her age as nineteen, suggest-
 ing she was born in 1893. Edith claimed to be five years younger than
 Sonia, making her birth date 1899, not 1900 as Edith claimed.

p. 18 "She was helpless": AAA OH EGH, p. 18.

p. 18 "Compensate for the hurt": Ibid., p. 60.

p. 19 "The new school": Clark, p. 151.

p. 19 "Eight instructors": Ibid., p. 157.

p. 19 "Americanized name": Details about Halpert's student records pro-
 vided by Peter Hastings Falk in an e-mail dated December 28, 2004.
 Falk is cataloging student registration cards for The National
 Academy of Design.

p. 19 "foreign-born": Clark, p. 158.

p. 20 "110 East 5th Street": Address listed in 1916–1917 Covington Direc-
 tory.

p. 20 "Covington, Kentucky": Dave Schroeder. Author phone interviews
 and e-mails.

p. 20 "60,000 citizens": Schroeder, author phone interview.

p. 20 "Thirty-five Jewish families": Lassetter, p. 6.

p. 20 "Borrowing a rabbi": Ibid., p. 7.

p. 21 "Chase is held in high regard": "Busy Man Is Booster, Has Eventful
 Career," *Kentucky Post*, January 25, 1915, p. 1.

Chapter 2: What Shall I Choose?

p. 22 "Left home at 15": AAA/DTG, EGHFG (reel 5637, frame 415).

p. 24 "201 East 58th Street": Halpert's addresses, at 201 East 58th Street
 and 1566 Madison Avenue in 1914, were provided by Peter Hastings
 Falk. In 1915 she registered with an address at 1575 Madison
 Avenue.

p. 24 "Allcars transfer": Bloomingdale's store advertisement, NYT, March
 12, 1915.

p. 24 "No two floors": Traub, p. 44.

p. 24 "Less desirable jobs in the garment trade": Howe, p. 266.

p. 25 "I was hired": AAA/DTG, EGHFG (reel 5637, frame 424).

p. 25 "To hell with the comptometer": Ibid. (reel 5637, frame 425).

p. 25 "I bent over my machine": Ibid.

p. 26 "Bad for morale": Ibid. (reel 5637, frame 426).

p. 26 "Opportunities for women": Hower, p. 375.

p. 27 "She was out-earning": AAA/DTG, EGHFG (reel 5637, frame 427).

p. 27 "Undersell the competition": Hower, p. 349.

p. 27 "Model of modernity": Ibid., p. 325.

p. 27 "Store policy was enforced": Ibid., pp. 382, 383.

p. 27 "The store sold everything": Ibid., p. 330.

p. 28 "Wanted to be a buyer": Hendrickson, p. 50.

p. 28 "She won the monthly prize": AAA/DTG, EGHFG (reel 5637, frame 626).

p. 28 "Jesse Isidor Strauss": Ferry, p. 62. Straus and his two brothers were partners from 1912 to 1919, when Jesse Isidor was named president.

p. 28 "Formidable presence": Despite his status within the Jewish community, Straus built luxury apartment buildings at 720 and 730 Park Avenue in 1927 because Jews were barred from other prestigious addresses on Park and Fifth Avenues. President Franklin D. Roosevelt appointed him ambassador to France in 1933.

p. 29 "Speaking her mind": AAA OH EGH, p. 34.

p. 29 "She paid": A copy of Edith G. Fein's student record for 1915–1916 was provided by Stephanie Cassidy, the archivist at the Art Students League.

p. 29 "Radical school": Landgren, p. 23.

p. 30 "In separate classes": Ibid., p. 63.

p. 30 "Social function": Many artists later associated with the Downtown Gallery studied or taught at the league, including painters Yasuo Kuniyoshi, Max Weber, Georgia O'Keeffe, and Stuart Davis and sculptors William Zorach and Robert Laurent.

p. 30 "Out I went": AAA/DTG; EGFG (reel 5637, frame 448).

p. 30 "For the first time": Ibid.

p. 31 "First learn to sell": AAA/DTG, Secretary for Jesse Isidor Straus to EGH, April 26, 1917 Quoted in TEPHAL p. 28.

p. 31 "Coats and Persian rugs": Stern Brothers advertisement, NYT, January 17, 1917.

p. 32 "Miracles to be cherished": Milton W. Brown. *American Painting, from the Amory show to the Depression*. Princeton, NJ: Princeton University Press, 1955, p. 39–40.

p. 32 "Brigman visited": Quoted from Purdue University Women in Photography Archive online at www.cla.purdue.edu/waaw/Palmquick/Photographers/BrigmanEssay.htm

p. 32 Re: Matisse: J. Edgar Chamberlin, *New York Evening Mail*; Whelan, p. 241.

p. 33 "Navaho rug": Watson, p. 168.

p. 33 "$44,148 in sales": Ibid.

p. 34 Re: Guy Pène du Bois: "Juliana Force and American Art: Memorial Exhibition September 24–October 30, 1949," Whitney Museum of American Art, New York, p. 43.

p. 34 "For Stieglitz": Author phone interview with Greenough, February 23, 2006.

p. 35 "In fact": Norman, p. 138.

p. 36 "Ferdinand Howald purchases": Richardson, p. 3.

p. 36 "Howald disliked": Ibid.

p. 36 Phillips Memorial Gallery: Renamed the Phillips Collection in 1961.

p. 36 "unlooked-for achievement": Turner, pp. 18–22 on $6,000 Marin episode.

p. 37 "Soft and suave": Newman E. Montross: Goldstein, p. 120.

p. 37 "Only visited once": AAA OH EGH, p. 93.

p. 38 "Many artists": Berman, p. 159.

p. 38 Whitney Studio tales: AAA/DTG, EGHUK (reel 5637, frame 645).

p. 38 "Every meeting that was free": AAA/DTG, EGHUK (reel 5637, frame 642).

p. 38 "Prevailing art condition": AAA, John Weichsel papers invitation for gathering, January 9, 1915 at home of John Weichel.

p. 39 "Guild's mission: Howe, p. 581.

p. 39 "Joined the Guild": AAA OH EGH, p. 98.

p. 39 "He sponsored lectures": AAA/DTG, EGHUK (reel 5637, frame 443).

p. 39 "At seventeen": TEPDIS, p. 38. Cited in AAA, John Weichsel papers, records list E. Fein as treasurer or accountant as early as January 1917.

p. 40 Guild exhibition in 1917: Howe, p. 581.

p. 40 "Weichsel plucked Edith": AAA/DTG, TEPDIS, p. 23.

p. 40 "sitting at the feel": AAA/DTG, EGHUK (reel 5637, frame 627).

p. 40 "One evening": TEPHAL, preface, p. xii. Tepfer quotes Edith Halpert describing Sam's "massive shoulders and powerful head-too huge for his limbs."

p. 40 "No ordinary girl": Assumptions about EGH and Sam's early relationship are drawn from "True Love," a short story written by EGH in 1919 while taking writing classes at Columbia University. The fictionalized story, about a married couple, seems autobiographical. AAA/DTG (reel 5636, frame 495).

p. 41 "It hurt": AAA OH EGH, p. 101. Edith claimed Kroll told her that not because she lacked talent, but because she was with Sam and he needed a working wife to support him. There is probably some truth

in the matter, but it also provided her with a dramatic finale to her artistic aspirations.

p. 41 "I Am Afraid I'm In Love": AAA/DTG (reel 5636, frame 459). This undated poem appears with several others dated October 1917 and appears to be from the same period.

p. 42 "Rescued him from the ghetto": Interview with Wesley and Carolyn Halpert, the artist's nephew and wife, on August 20, 2004.

p. 42 "We lived from hand to mouth": TEPHAL, p. 99. Letter from SH to John Weichsel, archives Jewish Museum, New York. I relied on Tepfer's book for many of the biographical facts about Sam Halpert.

p. 42 Elias Halpert: Myrna Davis, Sam Halpert's niece, phone interview with author, April 1, 2005.

p. 42 "Criminals in the Jewish Mafia": Information about Benjamin and Irving Halpert's associations with mobster Dutch Goldberg comes from interviews with Wesley and Myrna Halpert.

p. 42 "He stole to pay": Myrna Davis interview.

p. 42 Halpert studied at the National Academy of Design, according to Diane Tepfer, and his letters seem to corroborate this. However, no student registration card for him was located in academy records, according to Peter Hastings Falk.

p. 42 "It wasn't long": SH to John Weischel, November 14, 1915. Jewish Museum Archive. TEPHAL, p. 99.

p. 43 "With a $200 donation": Sam likely received other financial support during this stay.

p. 43 "Fad of the day": SH to John Weischel, November 14, 1915. Jewish Museum Archive. TEPHAL, p. 100.

p. 43 Warshawsky's reminiscence: AAA, Abel Warshawsky papers (reel 3893, frame 231).

p. 44 "The prospects looked hopeless": Letter from Sam Halpert to Alfred Stieglitz, November 13, 1914, TEPHAL, p. 97.

p. 44 "Since I last wrote you": AAA, John Weichsel Papers, SH to John Weichsel, March 29, 1915.

p. 45 "They wed": NYC Municipal Archives, Certificate and Record of Marriage: Samuel Halpert and Edith G. Fein, May 25, 1918. Edith lists her age as 20 on the marriage certificate, putting her birth date at 1898, not 1900 as she later claimed. Edith's address is listed as 660 Dawson Street and Sam's is 209 West 119th Street.

p. 45 "I had married American art": AAA/DTG EGHFG (reel 5637, frame 416).

p. 45 106th Street: TEPHAL, p. 87. Tepfer's chronology indicates they moved to 209 West 118th Street in 1920.

p. 45 "Worthwhile": Cary, NYT, February 2, 1919, AAA/DTG (reel 5572, frame 814).

p. 46 "Feel!": AAA OH EGH, p. 42.

p. 46 "She threw away": AAA/DTG, EGHFG (reel 5637, frame 440).

p. 46 "Thirty-nine years": S. W. Straus & Co. advertisement, NYT, January
 3, 1919.

p. 46 "Straus agreed": AAA/DTG, EGHFG (reel 5637, frame 440).

p. 47 "By 1925": AAA OH EGH, p. 47.

p. 47 148 West 57th Street: AAA, Leon Kroll Papers, letter from SH to Leon
 Kroll, April 13, 1925, which lists address as 148 West 57th Street
 (reel D326, frame 1171).

p. 47 "Very unhappy": AAA OH EGH, p. 50.

p. 48 "Save the marriage": TEPHAL, p. 13.

p. 48 "My only possession": AAA, Leon Kroll Papers, SH to Leon Kroll,
 April 23, 1925 (reel 2075, frames 1174–1175).

p. 48 "Two months later": Ibid.

p. 49 "When they arrived": TEPHAL, p. 1.

p. 49 "Modernist sensibilities": Ibid., p. 68.

p. 50 "Little difficulties": AAA OH EGH, p. 49.

p. 50 "Weeklong job": A copy of Edith's eleven-page "Reorganization Plan
 for Galerie Lilloises," subtitled "Practical and Inexpensive Changes,"
 is chock full of suggestions ranging from special placement for gloves
 and hosiery, the use of sample vaporizers to sell perfume, and the
 importance of comfortable seating for female shoppers. A copy of the
 plan was found in Edith's Personal Notebook, 1915–1925, which is
 not found in the Downtown Gallery records but was made available
 to the author courtesy of Halpert's family.

p. 50 "Patent leather hair": AAA OH EGH, pp. 397–399.

p. 50 "Finis.": AAA OH EGH, p. 106.

Chapter 3: The Girl with the Gallery

p. 52 "Draw what it does": Tragard et al., p. 13. I relied heavily on Tragard
 for facts, context, and period photos about Ogunquit artists' colonies.

p. 52 "Virginal Wayfarers": Ibid., p. 17.

p. 52 Information on Field from Tragard and Bolger.

p. 52 "They found a kinship": TEPDIS, p. 168.

p. 52 Lloyd Goodrich recollection: Tragard, p. 30.

p. 53 "Went their separate ways": Ibid., p. 37.

p. 53 "Flung herself nude": Ibid.

p. 53 Robert Laurent: Ibid., p. 47.

p. 55 "Let's be gay": AAA OH EGH, p. 122.

p. 55 "Turned into tears": Ibid., p. 123.

p. 56 "Like most years since Dickens": AAA/DTG, EGHFG (reel 5637, frame
 436).

p. 57 Facts about Berthe (Bee) Kroll Goldsmith were provided to author during phone interview with her niece, Marie Rose, December 19, 2005 and June 12, 2006.

p. 57 "An intimate thing": AAA OH EGH, p. 139.

p. 59 Description: New York, New York, NYC Municipal Archives tax photo, 113 West 13th Street, circa 1939.

p. 59 Financing: AAA/DTG, 113 West 13th Street Cashbook and Ledger 1925–1950. Unmicrofilmed.

p. 59 "First modern-era gallery": The author made every effort to determine if the Downtown Gallery was the first bonafide commercial art gallery in Greenwich Village. Searching old directories, newspapers, and art magazines suggested the Downtown might hold the claim for the 20th century though there was at least one 19th century venture when Manhattan was centered on the lower parts of the island. Information on the Apollo Gallery, which operated in the 1830s at 410 Broadway, can be found in Goldstein, p. 20.

p. 60 "Not lost on Edith": AAA OH EGH, p. 131.

p. 60 Description: AAA/DTG, photo of opening exhibition at "Our Gallery" 1926 (reel 5654, frame 748).

p. 60 Polly's: Watson, p. 214.

p. 61 "Sheridan Square Gallery": Holladay had hung art at Polly's, also known as the Greenwich Village Inn, at its first location at 147 West 4th Street. Watson; SDCR. In 1917 she moved to 5 Sheridan Square.

p. 61 "Edith's competition": SDCR; Bowdoin, "Modern Work of Stuart Davis in Village Show," New York Evening World, December 13, 1917.

p. 61 "Just down the block": Watson, p. 214.

p. 62 Whitney Museum of American Art: According to Avis Berman, Whitney and Force did make a brief foray into selling with the short-lived Whitney Studio Gallery which operated from 1928–1930. (Berman p. 254 and "Juliana Force and American Art," 1949, p. 65.)

p. 62 "That was terribly important": AAA OH EGH, p. 142.

p. 62 Description of Our Gallery credos and policies: AAA/DTG (reel 5640, frame 197) and draft press release November 6, 1926 (reel 5641, frame 291).

p. 63 "Such good pay!": Montross's reaction: AAA/DTG, EGHUK (reel 5637, frame 639).

p. 63 Obituary for Marie Sterner, "Mrs. E. B. Lintott, Art Dealer Here," NYT, July 2, 1953.

p. 63 Sterner as precedessor: AAA OH EGH, p. 256.

p. 64 "They didn't have systems": AAA OH EGH, p. 249.

p. 64 Commissions: Melby interview.

p. 65 Gallery announcement: AAA/DTG (reel 5640, frame 197).

p. 65 Pitch for gallery: AAA/DTG, EGH to Mr. Hays, March 2, 1927 (reel 5640, frame 196).

p. 65 Newspaper reviews of opening: AAA/DTG (reel 5640, frame 200).

p. 66 "Artistic richness": AAA/DTG, *New York Evening Post Literary Review*, November 20, 1926 (reel 5598, frame 148).

p. 66 "Old-fashioned hospitality": AAA/DTG, "New 'Our Gallery' Offers Attractive Exhibition Quarters," *Christian Science Monitor* (reel 5596, frame 145).

p. 66 "Attract them with ideas": AAA OH EGH, p. 357.

p. 66 "A real piece of art": AAA OH EGH, p. 379.

p. 67 "The idea": AAA OH EGH, p. 357.

p. 67 Harrison donated his three collections to the Los Angeles Museum of Art in 1934 and died the following year.

p. 67 "Readily judge": AAA/DTG, EGH to Preston Harrison, December 24, 1926, (reel 5490, frames 672–673).

p. 68 "Mere copyists": AAA/DTG, Preston Harrison to EGH, December 30, 1926, (reel 5490, frame 675).

p. 68 "More vital to say": AAA/DTG, EGH to Preston Harrison, January 12, 1927 (reel 5490, frames 679–680).

p. 68 "Rather embarrassing": AAA/DTG, EGH to Preston Harrison, January 28, 1927, (reel 5490, frame 705).

p. 69 "'Very learned' letters": AAA OH EGH, p. 685.

p. 69 "throw my weight around": Ibid.

p. 69 "Downtown Gallery": Zorach, p. 89.

Chapter 4: Art for the Electric Icebox

p. 71 "Pictures leaning against garbage cans": AAA OH EGH, p. 143.

p. 71 "I own the joint": AAA OH EGH, p. 181.

p. 71 "It was illegal": See Caplow et al., p. 72, for facts and figures on cohabitating couples during the twentieth century.

p. 72 Biographical information on Cahill comes from AAA, Holger Cahill Papers; in 1961, his wife Dorothy Miller complied "Notes on Life of Holger Cahill." Addition information comes from the archives at the Newark Museum and Wendy Jeffers, who is writing a biography on Miller.

p. 72 "Sam used the gallery": Zorach, p. 89.

p. 74 "You prude": AAA/DTG, EGHJB (reel 5637, frame 676).

p. 74 "Invitation": Werner, p. 24.

p. 74 "Poses taken from life": AAA/DTG, EGHJB (reel 5637, frame 677).

p. 75 Sketched with him": AAA OH SD, p. 147.

p. 76 "A time": Davidson, p. 182.

p. 76 "Nationalist fixation": Haskell, p. 166.

p. 76 "No doubt": AAA/DTG, EGH to Walter Kuhn, June 15, 1929 (reel 5548, frame 1093).

p. 76 "Artistically": Haskell, p. 166.

p. 77 "I paint what I see": Ibid., p. 170.

p. 77 *Lucky Strike* is now at the Museum of Modern Art in New York.

p. 77 "A product": Berman, p. 173.

p. 77 "Critics' reactions": Ibid., p. 237.

p. 78 "stipend": AAA OH SD p. 151.

p. 78 "Beer mostly": AAA OH SD, p. 36.

p. 79 "exclusive subject matter": Sweeney, p. 16.

p. 79 "Not wandering the streets": Ibid.

p. 79 "Based on that": Ibid., pp. 17–18, and Hughes, p. 475.

p. 79 According to SDCR, *Egg Beater No. 1*, now in the collection of the Whitney Museum of American Art, was exhibited at the Downtown Gallery as *Egg Beater*, November 26–December 9, 1927.

p. 79 "These crazy pictures": AAA OH EGH, p. 161.

p. 80 Davis quotation: AAA/DTG, Stuart Davis to EGH, November 18, 1927 (reel 5546, frames 592–594).

p. 80 Reviews of Davis's one-man show: SDCR, *Art News*, December 10, 1927.

p. 81 "Don't you touch my drawings": AAA OH EGH, p. 63.

p. 81 "My taste may stink": Ibid., p. 319.

p. 81 "Rain today": Ibid., p. 332.

p. 81 "Not a single sale": Information provided by SDCR editors.

p. 82 "I painted it the other way around": SDCR, "Upside Down Art Pains Artist Only: Visitors to Exhibition Greatly Praise Painting They Don't Know Is Hung Wrong: Picture of an Egg Beater," *Evening Bulletin* (Philadelphia), May 3, 1928.

p. 82 This painting is now known as *Egg Beater No. 4* of 1928 and is owned by The Phillips Collection, Washington, D.C.

p. 83 "Dome'ites": AAA/DTG, EGH to Stuart Davis, May 4, 1928 (reel 5546, frame 608).

p. 83 Copy of signed contract between Halpert and Davis dated October 1, 1930. AAA/DTG (reel 5546, frames 615–616).

p. 83 "Brutal arrangement": AAA OH SD, p. 177.

Chapter 5: The Richest Idiot in America

p. 86 "Sleep with the Homer": AAA/DTG, EGHJB (reel 5637, frame 653).

p. 86 "Landscape Experiment": Edward Alden Jewell, NYT, January 29, 1928.

p. 86 "the newer men": Clipping, "Gallery Notes," name and date of publication unknown, AAA/DTG Papers (reel 5598, frame 170).

p. 86 "shocked Edith": AAA/DTG, EGHUK (reel 5637, frame 653).

p. 86 "Wouldn't want to sell": Ibid.

p. 87 "Least like a client": AAA OH EGH, p. 160.

p. 88 "Not for sale": AAA/DTG, EGHUK (reel 5637, frame 653).

p. 88 Purchase of Marin/Zorach: These purchases are recorded in AAR's art ledger dated February 13, 1928, the day after the exhibition closed. RAC, Series II, Personal Papers, Ledger 1927–34. Box 13, (Marin folder 180 purchased for $750; Zorach folder 181 purchased for $250).

p. 88 "Probably the richest man": "53rd Street Patron," *Time*, January 27, 1936, pp. 28–29.

p. 88 "$30 million fortune": Ibid.

p. 90 "A chance to express themselves": Kert, p. 238. Kert explores the reasons why EGH appealed to AAR, which serves as the basis for this section.

p. 90 "she had sex appeal": Ibid., p. 66.

p. 90 "Checks appeal": AAA OH EGH, p. 38.

p. 90 "Your father is afraid": Saarinen, p. 360.

p. 90 "Babs 'bored stiff'": Kert, p. 217.

p. 90 "Surrogate daughter": Ibid.

p. 91 "Race prejudice": Ibid., p. 208.

p. 92 "Duccios, Goyas, and Chardins": Saarinen, p. 349.

p. 92 "Duveen": RAC, AAR Papers, Series III, Art Collections, Record Group 2, OMR, Box 16, Folder 173, lists French fifteenth-century Gothic stone chimney piece, purchased from Duveen Brothers.

p. 92 "Meeting place": Kert, p. 100.

p. 92 Rockefeller mansion décor: Interior photos of Rockefeller home from RAC, series 1005, box 39.

p. 93 "My only hobby": Saarinen, p. 345.

p. 93 *Hunt of the Unicorn:* Saarinen, p. 361.

p. 93 "$15,400": Ibid., p. 351.

p. 93 "$500,000 play house": Ibid., p. 359.

p. 94 "John D. Jr. Outlines Good Citizenship," NYT, November 13, 1922.

p. 94 "Mere pittance": Cholly Knickerbocker, *New York Journal-American*, December 27, 1931.

p. 94 "Another journalist": *New York Journal-American*, April 1938, RAC, Series II, Personal Papers, AAR Clippings Misc, Box 11, Folder 133.

p. 94 *Landscape:* Kert, p. 220.

p. 94 "Detroit Museum of Art": Later renamed the Detroit Institute of Arts.

p. 94 "Buying smaller works": Author interview with Deborah Wye.

p. 95 "Condolence note": AAR to Mr. Davies, son of artist, December 18, 1928. Kert, p. 272.

p. 95 "Dear Ma": Kert, p. 290.

p. 96 "He gave her $25,000": Ibid., p. 252.

p. 96 "Tiny fraction": Ibid., p. 253.

p. 97 Mrs. Rockefeller's spending at the Downtown Gallery: These figures come from AAR's art-buying records. The ledger is available at the RAC.

p. 97 Information on AAR's art buying from RAC, Series II, Personal Papers, Ledger 1927–34. Box 13, folder 48. I cross-referenced the information from AAR's art buying ledger with DTG records.

p. 97 Nightgown below her dress: AAA OH EGH, pp. 534–535.

p. 98 "It just isn't done": AAA OH EGH, p. 540.

p. 98 Marie's prophecy: AAA/DTG, EGHFG (reel 5637, frame 435).

p. 99 1883 gift to WCTU: "A Prohibition Campaign Fund," NYT, September 27, 1883.

p. 99 "Keep liquor away": "Rockefeller Prohibitionist," NYT, March 13, 1908.

p. 99 "List of donors": "Rockefellers Lead in Dry League Gifts," NYT, July 7, 1926.

p. 99 "Illegal speakeasies": *Encyclopedia of NYC*, ed. Kenneth T. Jackson, 1995, Yale University Press. Quote on speakeasies in 1920s "Police Commissioner Grover Whales estimates that the city has 32,000 speakeasies, twice the number of legal saloons in the city before Prohibition."

p. 99 "Just bursting": AAA OH EGH, p. 403.

p. 100 Julius's is still in operation in Greenwich Village, located at 159 West 10th Street. The bar's Web site claims Julius's is the oldest gay bar in the Village.

p. 100 "Don't worry": AAA OH EGH, p. 403.

p. 100 "I don't know": AAA OH EGH, p. 404.

p. 100 Raid on Julius's: "Arrest 49 in Liquor Raid," NYT, July 26, 1928.

p. 101 "No one would believe you": AAA/DTG, EGHJB (reel 5637, frame 658).

p. 101 "What are you girls up to now?": AAA OH EGH, p. 405.

Chapter 6: One Very Wide-Awake Art Operator

p. 103 "Publishing art books": Per author phone interview with Peter Kraus, March 25, 2005, owner of Ursus Books and Prints in New York City.

p. 104 "Hart pictures . . . terrible beyond words": Kert, p. 252.

p. 104 "Giving the name": AAA/DTG to George Overbury Hart, July 11, 1928, (reel 5490, frame 300).

p. 105 Bee Goldsmith's lament: AAA/DTG, Berthe Goldsmith to Mrs. Guggenheim, May 1928 (reel 5490, frames 863–864).

p. 105 "The afternoon was drizzly": Edward Alden Jewell, "Vagabonding Genius," NYT, December 23, 1928.

p. 106 "You don't know me": AAA/DTG, EGHJB (reel 5637, frame 668).

p. 106 "Low altitude slap": Ibid.

p. 106 "Not widely known": *Herald Tribune*, December 28, 1928, Rockefeller Family Archive, RAC, Series II, Clippings.

p. 106 "Original opinions": Kert, p. 252.

p. 107 Harrison's humiliation: Preston Harrison, "Collector's Fun," *Space* 1, no. 3 (June 1930), p. 15.

p. 107 "Art of embalming": Stuart Davis, "The Audience," *Space* 1, no. 3
(June 1930), p. 22.

p. 108 "Three issues": TEPDIS, p. 64.

p. 108 Metropolitan purchase: AAA/DTG; business records lists sale to Metro-
politan Museum of Art in June 1932: Karfiol's *Hills* for $1,200 and
Glenn Coleman's *Speakeasy* for $700.

p. 109 William Ivins: Calvin Tomkins, p. 240.

p. 109 "I have never been able to see": AAA/DTG, William Ivins to EGH, Feb-
ruary 14, 1933 (reel 5491, frames 1101–1102).

p. 109 "Under the greatest debt": Ibid.

p. 109 "Edith accepted": AAA/DTG, EGH to William Ivins, February 23, 1933
(reel 5491, frame 1119).

p. 109 "Depends on museums": Ibid.

p. 110 "Logical art center": AAA/DTG, EGH to AAR, June 5, 1929 (reel 5490,
frames 976–977).

p. 110 "Ten women art collectors": Ibid.

p. 110 "Edith shaped her scheme": Ibid.

p. 110 Rona Roob's article in *Art in America* reports that Rockefeller and
Bliss may have briefly discussed a museum in Haifa on March 7 and
that Abby Rockefeller also discussed the idea with Mary Sullivan dur-
ing the ocean passage back to New York.

p. 111 "About 8 percent": Caplow et al., p. 39.

p. 111 "Even well into the 1930s": Ibid., p. 40. Caplow and his colleagues
report that a Gallup poll in 1936 asked a national sample, "Should a
married woman earn money if she has a husband capable of support-
ing her?" The vast majority of men and women said no.

p. 111 "single women": Ibid., pp. 42–43. Caplow and his colleagues include
information on women's occupations during the twentieth century. In
1900, 75 percent of women working were in domestic service or fac-
tory work. The only professions open to women were teaching and
nursing. Women managers were rare.

p. 111 "Fueled her desire": AAA OH EGH, p. 186.

p. 112 "Produced": C. J. Bulliet, AAA/DTG, *Chicago Post*, October 27, 1928
(reel 5598, frame 184).

p. 113 Louis E. Stern: Stern died in 1962 and bequeathed his collection of
more than 250 French nineteenth- and twentieth-century paintings,
sculptures, prints, and drawings to the Philadelphia Museum of Art.

p. 113 Information on history and events at Atlantic City Boardwalk Hall
provided by Atlantic City Convention Center.

p. 113 "American art has definitely arrived": Introduction, Municipal Art
Gallery Exhibition Catalog, Atlantic City, Summer 1929, AAA/DTG
(reel 5600, frames 405–449).

p. 115 "You will see": AAA/DTG, EGH to Louis E. Stern, June 4, 1929 (reel 5490, frame 974).

p. 115 "This exhibition has cost me": Ibid.

p. 115 "Lost your temper": AAA/DTG, Louis E. Stern to EGH, June 6, 1929 (reel 5490, frame 974).

p. 116 Donald Deskey: Gilbert Seldes, "Profiles: The Long Road to Roxy," *New Yorker*, February 25, 1933, pp. 22–26.

p. 117 "A hospital": Edward Alden Jewell, "Contemporary American Art Joins Boardwalk Parade," NYT, June 23, 1929.

p. 117 "Much thought": Ibid.

p. 117 "Serving as a foil": Walter Rendell Storey.

p. 117 "I must tell you": AAA/DTG, Max Weber to EGH, July 8, 1929 (reel 5556, frame 286).

p. 118 Divorce rate: Caplow et al., pp. 78–79. Caplow and his colleagues chart the divorce rate over the twentieth century. In 1900, four out of every 1,000 marriages ended in divorce. By 1996, the rate had increased to approximately four of ten marriages ending in divorce.

p. 118 "Edith knows": Sam Halpert to Max Weber, February 3, 1929. TEPHAL, p. 106.

p. 118 "She won't mind waiting": Ibid., TEPHAL, p. 107.

p. 118 "My wife no longer": Sam Halpert to Max Weber, February 3, 1929, TEPHAL, p. 107.

p. 119 Information on Sonia Watter provided in author phone interview on April 21, 2006, by Sonia's granddaughter, Patricia Vanderbes.

p. 119 "Art feast daily": AAA/DTG, EGH to AAR, July 14, 1929 (reel 5490, frame 987).

p. 119 "Chorus girl": AAA/DTG, EGH to Preston Harrison, August 1, 1929 (reel 5490, frame 989).

p. 119 "Sip Chocolate Sodas": AAA/DTG, EGH to Wiliam Zorach, Carlsbad, July 1, 1929, (reel 5557, frame 10).

p. 119 "As for myself": AAA, Leon Kroll Papers, Sam Halpert to Leon Kroll, January 29, 1930 (reel D363, frames 1176–1177).

p. 120 "After I am unmarried": Sam Halpert to Max Weber, March 15, 1929, TEPHAL, p. 108.

p. 120 "Not feeling so strong": Last letter from Sam to Edith: AAA/DTG, Sam Halpert to EGH, March 25, 1930 (reel 5490, frame 1065).

p. 120 "Your old friend, Sam": Ibid.

p. 120 Divorce granted: TEPHAL, p. 88; and TEPDIS, p. 275.

p. 120 Sam dies: TEPHAL, p. 88.

p. 121 "I could see": AAA/DTG, Harold Goodman to Edith Halpert, April 9, 1930 (reel 5490, frames 1070–1075).

p. 121 Obituary: *Detroit News*, April 8, 1930.

p. 121 "Then moved on": Phone interview with Myrna Davis, Sam Halpert's niece, April 1, 2005.

p. 121 Halpert works: AAA/DTG, EGH to Nathan Lieberman, Halpert family lawyer, May 14 and 16, 1930 (reel 5490, frames 1092–1093).

p. 121 "Most unwise": AAA/DTG, Edmund Gurry to EGH, May 1, 1930 (reel 5490, frames 1083–1084).

p. 122 "Benjamin and Irving": This story was told to me by Myrna Davis and Wesley Halpert.

p. 122 "Special Promise": AAA/DTG, catalog of the Twenty-Fifth Annual Exhibition of Selected Paintings by American Arts and A Memorial Group of the Work of Samuel Halpert, April 26–June 22, 1931 (reel 5572, frame 847).

p. 122 "Sold to another dealer": Today one of the biggest collections of Sam Halpert paintings is displayed at the Ritz-Carlton Hotel in New York City, on Central Park South.

Chapter 7: Packaging the Primitives

p. 123 "After the crash": AAA/DTG, EGH to Preston Harrison, May, 30, 1930 (reel 5490, frame 1095).

p. 123 "Cheapest imitation": AAA/DTG, Preston Harrison to EGH, June 17, 1930 (reel 5490, frame 1104).

p. 124 "Very suspicious": AAA/DTG, EGH to AAR, June 13, 1930 (reel 5490, frames 1102–1103).

p. 125 "Thought and trouble": AAA/DTG, AAR to EGH, June 26, 1930 (reel 5490, frame 1108).

p. 125 "Buy, buy, buy": AAA/HCP, EGH to Cahill, undated, circa July 1930 (reel 5285, frame 732).

p. 125 "Scared and old": AAA/HCP, EGH to Cahill, undated, circa summer 1930 (reel 5285, frames 689–690).

p. 125 "You must not": AAA/HCP, EGH to Cahill, undated, circa summer 1930 (reel 5285, frame 732).

p. 126 "Try to get started": AAA/HCP, EGH to Cahill, circa summer 1930 (reel 5285, frame 734).

p. 126 Sam died intestate: According to author phone conversation with Wayne County Probate Court, Detroit, Michigan.

p. 126 "That damned Lieberman": AAA/HCP, EGH to Cahill, date unknown, summer 1930 (reel 5285, frame 738).

p. 126 Edith at Pocantico: AAA/HCP, EGH to Cahill, July 5, 1930 (reel 5285, frame 741).

p. 127 "Extremely careful": AAA/DTG, Duncan Phillips to EGH, November 4, 1930 (reel 5490, frame 1165).

p. 127 Karfiol painting: AAA/DTG, EGH to Arthur Allen, November 8, 1930 (reel 5490, frame 1171).

p. 127 "'You can't hold good art down'": AAA/DTG, EGH to Preston Harrison, January 5, 1931 (reel 5491, frame 15).

p. 127 Dudensing: AAA/DTG, EGH to Janina Liskowska, Galerie Jeune Peinture, January 16, 1931 (reel 5491, frame 36).

p. 127 Plea for money: AAA/DTG, Preston Dickinson to EGH, undated October–November 1930 (reel 5547, frame 18).

p. 128 "Preston Dickinson Dies," NYT, December 7, 1930.

p. 128 Daniel Gallery closed: Goldstein, p. 127.

p. 128 "shocked:" AAA/DTG, EGH to Harry L. Braxton, September 17, 1931 (reel 5491, frame 318).

p. 128 "Occasionally:" AAA/DTG, EGH to Preston Harrison, February 18, 1931 (reel 5491, frames 73–74).

p. 129 Painting of AAR's horse at Pocantico: AAA/DTG, EGH to AAR, April 23, 1931 (reel 5491, frame 155).

p. 129 "Had a very nice visit:" AAA/DTG, Marguerite Zorach to EGH, undated, probably August 1930 (reel 5556, frame 1211).

p. 129 Zorach tapestry: There is some discrepancy on the final price for the tapestry. According to Edith's records, AAA/DTG, Downtown Gallery Accounts Receivable file unmicrofilmed and available at AAA Washington, D.C. branch: Mrs. John D. Rockefeller, Tapestry Account, shows $500 monthly payments starting September 1, 1930, until October 3, 1932, equaling $13,000. Edith's business records (reel 5635, frame 48) record a total of $18,000. *Time* magazine ran a story listing the final price at $20,000.

p. 130 Force and early American primitives: Berman, p. 145.

p. 130 "Edith's offer": AAA/DTG, EGH to AAR, April 9, 1931 (reel 5491, frame 136).

p. 131 "Some of the paintings": AAA/DTG, EGH to AAR, April 30, 1931 (reel 5491, frame 172). Frame 193 is an invoice for purchase, and the items are listed on frame 194.

p. 131 Re: John Cotton Dana: Newark Museum Library, Exhibit Files.

p. 132 Information on Cahill and his folk art shows at the Newark Museum Library were obtained from the museum's archive. Exhibit files box 20: catalog, correspondence and notes pertaining to organization of "American Primitives Paintings," November 3 to February 1, 1931; box 21: correspondence, catalog and notes pertaining to organization of "American Folk Sculpture," October 20, 1931 to January 31, 1932.

p. 132 "standard masters": Holger Cahill, "American Primitive Paintings," November 3, 1930–February 1, 1931, Newark Museum and Library, Newark, New Jersey.

p. 132 "Anonymous": Rumford, p. 25.

p. 133 "I made a business": AAA OH EGH, pp. 474 and 478.

p. 134 Rockefeller art purchases: AAR Art Ledger, series II, personal papers, ledger 197–1934, box 13, folder 148, Rockefeller Family Archives, RAC.

p. 134 "Old furniture and bric-a-brac": Kert, p. 326.

p. 134 AAR's charities: Ibid., p. 312.

p. 134 Re: Williamsburg restoration: Saarinen, p. 354.

p. 134 "This other aspect": Kert, p. 326.

p. 135 "Break their hearts": AAA OH EGH, p. 494.

p. 136 Weathervane acquisition: AAA OH EGH, pp. 485–486.

p. 136 Two weathervanes: AAA/DTG, EGH to AAR, July 15, 1931 (reel 5491, frame 243).

p. 136 "Exorbitant": Ibid.

p. 137 "Amateurish stuff": Ibid.

p. 137 "Black as a fireman": "Reminiscences of Holger Cahill," interview by Joan Pring, Oral History Research Office, Columbia University, 1957, p. 208. AAA/HCP (reel 5285, frames 27–653).

p. 137 "Reduction": AAA/DTG, EGH to Irving Lyon, July 15, 1931 (reel 5491, frame 241).

p. 137 "Present conditions": AAA/DTG, E. Hickey, for Irving Lyon of Charles Woolsey Lyon, Inc., to EGH, July 17, 193 (reel 5491, frame 245).

p. 138 "Contact with fine works": AAA/DTG, EGH to AAR, August 17, 1931 (reel 5491, frame 278).

p. 138 "Good looking": AAA/DTG, AAR to EGH, July 18, 1931 (reel 5491, frame 246).

p. 138 Rockefeller sales: AAA/DTG, *American Folk Art Gallery Journal and Ledger*, 1931–1940 (unmicrofilmed), p. 4 indicates sales of $11,486.60 by October 1931. TEPDIS, p. 171 quotes statement on Rockefeller primitive account $11,268.

p. 139 Shares: AAA/DTG, *American Folk Art Gallery, Inc.* (AFA) *By-Laws and Stock Certificates* (reel 5635, frames 861–883).

p. 139 Salaries: AAA/DTG, *AFA Journal and Ledger* (unmicrofilmed), p. 17.

p. 139 "Remarkable discrimination": EGH to Isabel Carleton Wilde, October 23, 1931 (reel 5491, frame 388).

p. 139 "Historical interest": AAA/DTG, EGH to Harry duPont (Henry F., nickname), October 23, 1931 (reel 5491, frame 387).

p. 140 Press release: AAA/DTG, Press release for "American Ancestors," dated December 9, 1931, December 14–December 31, 1931 (reel 5641, frames 324–325).

p. 140 "Fill in the gaps": AAA/DTG, Press release for "American Ancestors," dated December 9, 1931, December 14–December 31, 1931 (reel 5641, frames 324–325).

p. 140 Orozco and Léger: AAA/DTG, EGH to Fiske Kimball, Director, Philadelphia Museum of Art, December 18, 1931 (reel 5491, frame 463).

p. 140 "Most thrilling": Ibid.

p. 140 "Treasures": According to *The Kingdoms of Edward Hicks* by Carolyn Weekly, AAR bought the painting from Halpert in 1932 and

donated it to the Museum of Modern Art, who transferred it to the Metropolitan Museum of Art-along with other folk art donated by Mrs. Rockefeller. David Rockefeller then repurchased the painting and donated it to the Abby Aldrich Rockefeller Folk Art Collection at Colonial Williamsburg.

p. 141 "Sixty-seven items": Notebooks, Folk Art Exhibitions Lists, 1935–1961, Downtown Gallery Papers (reel 5564, frames 1009–1011). List of objects sent to Newark Museum, September 22, 1931.

p. 141 "Added mirror": AAA/DTG, H. I. Brock, "America Discovers a Neglected Folk Art of Its Own," NYT, November 8, 1931, p. SM7 (reel 5602, frames 367–368).

p. 142 Folk art at Dearborn: AAA/DTG, Robert H. Tannahill to EGH, undated 1932 (reel 5491, frame 515).

p. 142 Conversations with Edsel Ford: AAA OH EGH, p. 505.

p. 142 "Offer me pictures": AAR to Nelson Rockefeller, July 16, 1932. Box 4, Series I, AAR Correspondence, Record Group 2, OMR, Folder 63, Rockefeller Family Archive, RAC.

Chapter 8: The Palace of Virtue

p. 146 "Some have vision": Mrs. Rockefeller gift book, December 1931, Folder 146, Box 12, Series II: Personal Papers, Rockefeller Family Archive, RAC.

p. 146 Sales: AAA/DTG, accounting worksheet, probably annual sales records, give $42,831.83 for 1927–1928 and $83,850.14 for 1929–1930 (reel 5632, frame 1083).

p. 147 "Sales exceeded $100,000": AAA/DTG, accounting worksheet, probably annual sales records, lists $102,466.33 for 1930–1931, which matches Edith's recollection of her revenue for that year. That was the most she grossed until 1946, when gallery sales totaled $124,517.64.

p. 147 "Another $12,000": AAA/DTG, accounting chart listing annual proceeds for the period 1928–1937. For 1931, the total is $124,105.83, and AFA (American Folk Art) is $11,699 (reel 5632, frame 1085).

p. 147 "More than $38,000": AAA/DTG, Accounting chart listing annual proceeds 1928–1937. For 1932, AFA total is $39,078. Downtown Gallery revenues are $37,883.

p. 148 "Financially embarrassed": AAA/DTG, EGH to Edmund Gurry, September 23, 1932 (reel 5491, frame 832).

p. 148 Rockefeller net worth: Chernow, p. 667.

p. 148 "Particularly valuable": AAA/DTG, Announcement from Lincoln Kirstein, member of Museum of Modern Art Advisory Committee, April 1932 (reel 5491, frame 636).

p. 149 "Nelson's club": Letter, AAR to Nelson Rockefeller, June 4, 1929, folder 63, box 4, Rockefeller Family Archives, RAC. In 1935, when Mrs. Rockefeller made a series of folk art donations, Dartmouth College was among the beneficiaries.

p. 150 "Improved 'elbow room'": AAA/DTG, "Museum of Modern Art Is 'At Home,'" NYT, Edward Alden Jewell, May 8, 1932, p. X8.

p. 150 "Art Review: The Museum of Modern Art Gives Private Showing Today of Murals by American Painters," NYT, Edward Alden Jewell, May 3, 1932, p. 9.

p. 150 "Touches bottom": Quoted in Okrent, p. 225.

p. 151 "Modern artists": AAA/DTG, EGH to H. W. Corbett, June 6, 1932 (reel 5491, frame 690).

p. 151 "New streamlined looks": Highlights of the Paris Art Deco show were exhibited at the Metropolitan Museum of Art in 1926.

p. 151 "Cork walls": Gilbert Seldes, New Yorker, "Profiles" pp. 22–26.

p. 152 Meeting Deskey: There are many variations on the story of Mrs. Rockefeller meeting Deskey. Abby Rockefeller's biographer Berenice Kert quotes Deskey's own recollection that Mrs. Rockefeller saw his Saks window and asked Edith Halpert to introduce them. This is highly unlikely given Mrs. Rockefeller's generally conservative taste. Edith said she discovered Deskey at 57th Street designer showroom, which is plausible. Their first documented connection appears to be the 1929 show at the Newark Museum.

p. 153 The description of the gallery draws from the author's personal visit to the Daylight Gallery, now converted to a restaurant called Spain Restaurant, in Greenwich Village.

p. 153 "Daylight quarters": AAA/DTG, no byline or headline, Herald Tribune, April, 20, 1930 (reel 5598, frame 251).

p. 153 "Pilgrims": AAA/DTG, "Daylight Art Gallery Houses American Work," New York World, circa April 1930 (reel 5598, frame 259).

p. 153 "Stroke of genius": AAA/DTG, Edward Alden Jewell, "Moving Day in Order: Gallery Changes Are a Present Epidemic-Montross, Arthur V. Newton, Downtown," NYT, April 27, 1930 (reel 5598, frame 254).

p. 153 "Three months": Kert, p. 297.

p. 153 "My gallery": AAR to Nelson Rockefeller, January 17, 1931, folder 63, box 4, Series One AAR Correspondence, Record Group 2, OMR, Rockefeller Family Archives, RAC.

p. 154 For the relationship between Radio City and the Daylight Gallery and biographical background on Deskey, the author acknowledges design historian David Hanks and Jennifer Tober, who wrote about the Daylight Gallery in their book on Deskey: "Here Deskey saw the integration of artists, designers and architecture that he was to use to great advantage on a larger scale at Radio City Music Hall," p. 29.

p. 157 "So called brain": AAA/DTG, EGH to Robert Laurent, July 15, 1932 (reel 5549, frame 292).

p. 158 "The controversy": AAA/DTG, EGH to Robert Laurent, undated, summer 1932 (reel 5549, frame 294).

p. 158 "Without panels": AAA/DTG, Robert Laurent Radio City Contract for $850.

p. 158 "Hard boiled procrastinators": AAA/DTG, EGH to Robert Laurent, undated, circa June 1932 (reel 5549, frame 295).

p. 158 "Ridiculous": Zorach, p. 91. Zorach's dates regarding the founding of the Downtown Gallery and the Rockefeller Center commissions are incorrect.

p. 158 In May 2006 the Metropolitan Museum offered the Zorach for sale at auctions with a top pre-sale estimate of $500,000. The piece failed to sell.

p. 160 "Davis was devastated": Author interview with Ani Boyajian and Mark Rutkoski, editors, SDCR, February 28, 2006.

p. 160 "Ten shows": Stuart Davis exhibition history provided by Ani Boyajian and Mark Rutkoski, editors, SDCR.

p. 160 "Can't hurt anyone": AAA/DTG, EGH to Stuart Davis, September 9, 1932 (reel 5546, frame 631).

p. 160 "Feel that way": AAA/DTG, Stuart Davis to EGH, September 9, 1932 (reel 5546, frames 635–636).

p. 161 "Fine work you have done": AAA/DTG, EGH to Stuart Davis, September 14, 1932 (reel 5546, frames 637–638).

p. 161 "McSorley's Ale": Letter from Stuart Davis to Robert Carlton Brown, October 2, 1932. Robert Carlton Brown Papers, Special Collections, Morris Library, Southern Illinois University at Carbondale. Quoted in Sims, p. 221.

p. 162 "In its shelter": AAA/DTG, Stuart Davis to EGH, October 24, 1932 (reel 5546, frames 654–655).

p. 162 "Taken over": Sims, p. 221.

p. 162 "Paint it big": Letter, Georgia O'Keeffe to Blanche Matthias, circa April 1929. Collection of American Literature, Beinecke Rare Book and Manuscript Library, Yale University, New Haven. Quoted in Robinson, p. 371.

p. 163 "It was fear": Robinson, p. 379. Robinson, Daniel Okrent, and Hunter Drohojowska-Philp provided background about O'Keeffe's Radio City episode.

p. 164 "Interested visitors": Hugh Blake, "A Reporter at Large: The New Roxy," New Yorker, December 17, 1932, pp. 48–56.

p. 164 "She's been hanged": Ibid.

p. 165 "Floor was bare": New York Evening Journal, December 14, 1932, "Nude 'Ladies' Mysteriously Vanish After Roxy Ban," AAA/DTG (reel 5557, frame 56). There are several accounts of Zorach's discovering

his sculpture had disappeared. In his autobiography, he reports having received a phone call from Edith. Since that account was written more than thirty years after the events, I depended on contemporaneous news accounts.

p. 165 "Negative": December 17, 1932, *Daily News*, AAA/DTG (reel 5557, frame 57).

p. 166 "The nudity isn't emphasized": "Even Sumner Can't See Roxy's Art Ban," December 17, 1932, *Daily News*, AAA/DTG (reel 5557, frame 57).

p. 166 "Field of culture": AAA/DTG, letter to Rockefeller Center officials signed Robert Laurent and William Zorach, written by EGH, December 15, 1932 (reel 5491, frames 966–967).

p. 167 "As good as dead": AAA/DTG, Downtown Gallery press release, 1932 (reel 5557, frame 48).

p. 167 "With the artist": "Zorach's Rejected Statue Revealed," *New York Sun*, December 31, 1932. AAA/DTG (reel 5557, frame 59).

p. 167 "Mr. Zorach's figure": Edward Alden Jewell, NYT, "Art in Review: Plaster Cast of Zorach's 'Spirit of the Dance,' Banned in Radio City, Is Shown Downtown," December 28, 1932. AAA/DTG (reel 5557, frame 58).

p. 167 "Big, new thing": Columbia Broadcasting System, Edwin Hill, *The Human Side of the News*, December 27, 1932, Record group III, 2C, Box 88, Folder 661, Rockefeller Family Archives, RAC.

p. 168 "Life of vice": AAA/DTG, EGH to Edmund Gurry, January 3, 1932 (reel 5491, frame 1005).

p. 168 "Greediest of playgoers": Quoted from NY Landmarks Commission Report, p. 18.

p. 169 "For all of us": AAA/DTG, EGH to Janina Liszkowska and Martin Baer, December 31, 1932 (reel 5491, frame 996).

p. 169 "Not sales hokum": AAA/DTG, EGH to George Gershwin, November 1, 1932 (reel 5491, frame 902).

p. 169 Armitage: AAA/DTG, EGH to Merle Armitage, November 3, 1932 (reel 5491, frame 904).

p. 170 "Things *are* different": AAA/DTG, Merle Armitage to EGH, November 19, 1932 (reel 5491, frame 919).

p. 170 "If it were proposed": AAA/DTG, H. E. Winlock to EGH, February 16, 1933 (reel 5491, frame 1011).

p. 170 "Acclaim and notoriety": Zorach, p. 92.

Chapter 9: A New Deal for Artists

p. 171 "Brilliant idea": AAA OH EGH, p. 558.

p. 171 "La Guardia Bars Inaugural Fete," NYT, December 5, 1933.

p. 172 Quota of 400,000 civil works jobs in New York State: reported in "225,000 In State Now on Civil Work," NYT, December 7, 1933.

p. 172 "Greatest asset—culture": AAA/DTG, Plan for All-American Exhibition submitted to Mayor Fiorello LaGuardia by Edith Halpert, December 5, 1933 (reel 5492, frames 461–465).

p. 172 "Officially": Ibid.

p. 173 Prohibition repeal festivities described: "City is Set to End Dry Era Amid Song," NYT, December 3, 1933.

p. 173 "Carefully crafted proposal": AAA/DTG, report submitted March 25, 1933, "Rockefeller Center Galleries of American Art" (reel 5492, frame 63); expenses, revenues, floor plan and capital structure (reel 5492, frame 66); "Proposal for Further Procedure of the Organization of the Rockefeller Center Gallery of American Art" (5492, frame 57).

p. 173 "At a later period": AAA/DTG, Nelson Rockefeller to EGH, July 25, 1933 (reel 5492, frame 267).

p. 174 Time reviews: "Citadel Taken," February 10, 1930, p. 44. "33 Moderns," January 28–February 15, 1931.

p. 175 "$45,000": AAA/DTG, EGHJB (reel 5637, frame 688).

p. 176 "Several women at once": April 28, 2006, email from Wendy Jeffers, who is working on a biography of Dorothy Miller, states that "there is evidence that there were a number of other women in Cahill's life— probably throughout the time he was seeing Halpert." She also notes, "I think Cahill was something of a ladies' man." Cahill's papers include several ardent 1929 letters from Marguerite Gates of Newark, N.J., which say, "I miss you greatly" and "my love to you." AAA/HCP (reel 5285, frames 720–728).

p. 176 "My rackets": AAA OH EGH, p. 595.

p. 178 Rivera and Kahlo: AAA OH EGH, p. 627.

p. 178 "If Lenin's head were removed": Okrent, p. 312.

p. 178 Statement by eleven artists printed in "Artists Quit Show in Rivera Protest: Eleven Refuse to Exhibit at Rockefeller Center After Destruction of Mural," NYT, February 14, 1934.

p. 178 "Harmony party": Ibid.

p. 178 "Definite protest": "Art Group Drops Protest on Rivera," NYT, February 17, 1934.

p. 179 "Right to do so": "Artists Quit Show," NYT, February 14, 1934.

p. 179 "In its entirety": Ibid.

p. 179 "His sponsorship": AAA/DTG, EGH to Lester Stone, February 19, 1934 (reel 5492, frame 682).

p. 180 "RCA building": Installation and opening night photos obtained from Rockefeller Center Archives.

p. 180 "Forged forward": "City Art Exhibit Opened By Mayor," NYT, February 28, 1934.

p. 180 "Trailed Davis inside": AAA OH EGH, p. 621.

p. 182 "First Georgia O'Keeffe": Sales ledger for First Municipal Art Exhibition is located at AAA, Mildred Baker papers (reel 4982). TEPDIS, p. 205, says the O'Keeffe painting is now called *Black Flower, Blue Larkspur*.

p. 182 "Regulating device": Henry McBride, "Municipal Exhibition Vast but Entertaining Show," *New York Sun*, March 3, 1934.

p. 182 "Much about painting": AAA/DTG, William Carlos Williams to EGH, March 13, 1934 (reel 5492, frame 743).

p. 182 "Selling pictures": Edward Alden Jewell, "In the Realm of Art: First Municipal Art Exhibition," NYT, March 4, 1934.

p. 182 "Biggest art show": Edward Alden Jewell, "Pedestrian Critic Views 'Mile of Art,'" NYT, February 28, 1934.

p. 183 "Setting suns": "A Mile of Art," NYT, March 4, 1934.

p. 183 "Vulgar and revolting": AAA/DTG, publicity announcement of "Art Feud," March 12, 1934, broadcast on NBC radio (reel 5492, frame 750).

p. 183 "Bad art": Ibid.

p. 184 "Short duration naturally": AAA OH EGH, p. 570.

p. 184 "Her lawyer": AAA/DTG, EGH to Philip Wittenberg, May 14, 1934, (reel 5492, frame 926).

p. 184 *From the Garden*: This work is now owned by the Fine Arts Museums of San Francisco.

p. 185 "Scout southern folk art": AAR's Art Ledger, Series II, Personal Papers, Ledger 1927–1934, Box 13, Folder 148, Rockefeller Family Archive, RAC.

p. 185 "Appreciate this": AAA/DTG, AAR to EGH, April 11, 1934 (reel 5492, frame 833).

p. 185 Gorky "reached his limit": AAA/DTG, EGH to AAR, November 14, 1933 (reel 5492, frame 402).

p. 186 "Murals in government buildings": McKinzie, p. 5; Berman, p. 332.

p. 186 "Architecture and barrels": AAA/DTG, EGH to Alfred H. Barr, Jr., October 3, 1935 (reel 5493, frame 519).

p. 186 "Embellish public property": "City Art Exhibit Opened by Mayor," NYT, February 28, 1934.

p. 187 "Another winter": Quoted in Berman, p. 335.

p. 187 "In need of jobs": Ibid., p. 340.

p. 187 "Before I knew why": Ibid., p. 340.

p. 187 "At once": Ibid., p. 340.

p. 189 "Retire from the picture": AAA/DTG, minutes of gallery meeting held April 28, 1934 (reel 5635, frames 1039–1045).

p. 190 "For the time being": AAA/DTG, EGH to Sheldon Cheney, April 17, 1934 (reel 5492, frame 850).

p. 191 *After the Bath*: Edith claimed she sold *After the Bath* for $5,000 (AAA EGH OH p. 465), however, a memo dated February 1, 1934, from the registrar's file at the Nelson-Atkins Museum of Art (copy provided by Lauren Lessing and Margaret Conrads) indicates Edith came down on her asking price considerably. The memo from the American Folk Art Gallery lists a "special cash price" of $2,500.

p. 191 "Resold things": Art historian Dorinda Evans says the Peale was discovered by William A. Gough, a Connecticut book and picture dealer in 1931 and sold to Edith Halpert. "Raphaelle Peale's Venus Rising from the Sea: Further Support for a Change in Interpretation," Dorinda Evans, *American Art Journal*, Vol. 14, No. 3 (Summer 1982), pp. 62–72.

p. 191 "Paid $75 for it": AAA OH EGH, p. 468. Edith says she paid $75. The Downtown Gallery *AFA Journal and General Ledger*, 1931–1940, p. 3., lists a payment in September 1931 to "Gough" of $265. There is no indication if this was for one or several pieces. Gough was a frequent supplier of folk art and other eighteenth- and nineteenth-century artworks.

p. 191 "Broke my heart": AAA/DTG, EGH to Paul Gardner at Nelson Gallery, February 19, 1934 (reel 5492, frame 683).

p. 191 Peale worth $10 million: Estimated value provided by John Driscoll, director, Babcock Galleries. The painting is now known as "Venus Rising From the Sea: A Reception" circa 1822.

p. 192 *Time* article: "$100 Works," *Time*, May 21, 1934.

p. 192 "Finding new channels": Exhibition brochure, Edith Gregor Halpert, "Practical Manifestations in American Art," December 13–31, 1934 (reel 5598, frames 411–413).

p. 193 "Revere Copper and Brass Company": Edith worked on the show with Samuel Kootz, who had an industrial design company and who opened a gallery eleven years later and became an important postwar dealer and champion of Abstract Expressionist artists.

p. 193 "Even more abstract": Information provided to author by Ani Boyajian/SDCR.

p. 193 *Seine Cart Composition:* That painting is missing, according to Ani Boyanjian/SDCR, phone interview, March 22, 2006.

p. 193 "More superficial type of art": AAA/DTG, EGH to Mrs. S. R. Guggenheim, May 29, 1934 (reel 5492, frame 957).

p. 194 "25 percent commission": AAA/DTG, Alfred Stieglitz to EGH, outlining terms of their agreement, October 16, 1934 (reel 5555, frame 590).

p. 194 "Under the same terms": AAA/DTG, Receipt dated October 25, 1934, listing names, sale price, and insurance value of Marin consignment (reel 5555, frame 592).

p. 194 "Very amusing": AAA/DTG, EGH to Robert Tannahill, July 3, 1935 (reel 5492, frame 997).

p. 195 "Take up dancing": AAA/DTG, EGH to Mildred Lamb, January 8, 1935 (reel 5493, frame 37).

p. 195 Rental fee: AAA/DTG, American Society of Painters, Sculptors, and Gravers letter sent to museums, dated May 14, 1935 (reel 5638, frame 811).

p. 195 "Straighten out the matter" with Fiene: AAA/DTG, EGH to Ernest Fiene, February 22, 1935 (reel 5547, frame 965).

p. 196 "Recent chill" with Laurent: AAA/DTG, EGH to Robert Laurent, February 21, 1935 (reel 5549, frame 316).

p. 196 Davis letter: AAA/DTG, Stuart Davis to EGH, September 20, 1933 (reel 5546, frame 660).

p. 196 "NRA program": AAA/DTG, EGH to Stuart Davis, September 29, 1933 (reel 5546, frame 661).

p. 197 "Recouped just $1,185": AAA/DTG, EGH to Stuart Davis, May 29, 1935 (reel 5546, frame 662).

p. 197 "Any resentment involved": AAA/DTG, EGH to Stuart Davis, May 29, 1935 (reel 5546, frame 662).

p. 197 Lawsuit: AAA/DTG, Jacob Grossman, Counselor at Law, to Edith G. Halpert and Berthe K. Goldsmith, October 10, 1935 (reel 5493, frame 531).

p. 198 "Pushing other exhibitors out": AAA/DTG, Stuart Davis to EGH, December 8, 1935 (reel 5546, frames 667–669).

p. 198 "Misunderstanding": AAA/DTG, EGH to Stuart Davis, January 2, 1936 (reel 5546, frame 673).

p. 199 "A great debt": Zorach, p. 93.

p. 199 "He couldn't work": AAA/DTG, Marguerite Zorach to EGH, September 15 (no year), probably 1935 (reel 5556, frame 1010).

p. 200 "Think your effects out": Nicoll, p. 44.

p. 200 Artworks by Marguerite: AAA/DTG, December 18, 1935, partial list of Marguerite Zorach sales, excluding prints 1929–1936 (reel 5557, frame 92).

p. 200 "$8,150 a year": AAA/DTG, December 19, 1938, partial list of William Zorach sales, (about 1929–1936) (reel 5557, frame 104).

p. 201 "It is hopeless": AAA/DTG, William Zorach to EGH, undated, probably fall 1935 (reel 5556, frames 1222–1223).

p. 201 "I love you": AAA/DTG, Nathaniel Uhr to EGH, undated circa 1933 (reel 5490, frame 246).

p. 202 Edith and Charles Sheeler: AAA/DTG, Nathaniel Uhr to EGH, undated, probably 1934 (reel 5490, frame 253).

p. 202 "Trip to jail": Theodore E. Stebbins, Jr. "Sheeler and Photography," *The Photography of Charles Sheeler,* p. 9.

p. 203 "Icons of modern photography": Ibid., p. 19.

p. 203 "No longer interested in photography": AAA/DTG, EGH to Edsel Ford, March 7, 1934 (reel 5492, frame 729).

p. 203 "Hope to do": AAA/DTG, Charles Sheeler to EGH, January 22, no year, probably 1935 (reel 5554, frame 202).

p. 203 "As ever, Charles": AAA/DTG, Charles Sheeler to EGH, undated, probably 1935 (reel 5554, frame 209).

p. 203 "Gallery's address": Private Papers, courtesy Charles Alan's family, p. 305.

p. 204 "Don't you?": AAA/DTG, Charles Sheeler to EGH, July 19, no year, probably 1935 (reel 5493, frames 447–448).

p. 204 "Ideal friendship": AAA/DTG, EGH to Charles Sheeler, undated, located by Tepfer in box 136–137, and quoted in TEPDIS, p. 104.

p. 204 "One-way ticket": AAA/DTG, Charles Sheeler to EGH, November 7, no year, probably 1935 (reel 5554, frame 214).

p. 205 "Your letter": AAA/DTG, EGH to Charles Sheeler, November 13, 1935 (reel 5493, frame 560).

p. 205 $20,000: Sale price recollected by John Driscoll, who worked as the curator of the William H. Lane Foundation from 1978–1982.

p. 205 "The right thing": AAA/DTG, William Lane to EGH, November 1, 1967 (reel 5538, frame 653).

p. 206 "All they were worth": "Art: In the Business District," *Time*, September 5, 1938, p. 36.

p. 206 "I went over the thing": AAA OH EGH, pp. 1–2. On January 20, 1965 Halpert and Harlan Phillips convened for a final interview—this time focusing on the Federal Arts Project. Halpert, less than lucid, makes accusations against Holger Cahill and Dorothy Miller whom she believes have stolen credit for various exhibitions and minimized Edith's contributions to ascertaining AAR's folk art collection.

p. 207 "Never ultimately produced": AAA OH, Dorothy Miller, p. 14.

p. 207 "Paul Klee": *Time*, September 5, 1938, p. 35.

p. 207 "Never saw an original": AAA OH EGH, p. 2 (Interview dated January 20, 1965).

p. 208 "Sense of failure": AAA/DTG, EGH to Marguerite Zorach, August 2, 1936 (reel 5556, frame 1033).

p. 208 "Ridiculous": AAA/DTG, EGH to Cahill, August 13, 1936 (reel 5493, frames 764–766).

p. 209 "Swell job": AAA/DTG, Cahill to EGH, August 21, 1936 (reel 5493, frame 768).

p. 209 "High standard of achievement": AAA/DTG, Downtown Gallery brochure, undated, circa fall 1936 (reel 5598, frames 508–527).

p. 210 "Has been reached": Ibid.

p. 211 "Inclination to buy pictures": AAA/DTG, AAR to EGH, January 7, 1938 (reel 5494, frame 8).

p. 212 "It ain't so": AAA/DTG, EGH to Anna Kelly, March 4, 1938 (reel 5494, frame 61).

p. 212 "Purchase fund": Bee and Elligot, *Art in Our Time*, p. 42.

p. 212 "Buy the best wares": Author phone interview with art historian Wendy Jeffers, May 8, 2006.

p. 212 "Grey-haired Edith Halpert": "53rd Street Patron," *Time*, January 27, 1936.

p. 212 The Nadelman collection was eventually sold to the New York Historical Society for $50,000 in 1937, nine years before Nadelman committed suicide.

p. 213 "Represents the cream": AAA/DTG, EGH to Blanchette Rockefeller, February 28, 1938 (reel 5494, frame 58).

p. 213 "Delivery": AAA/DTG, sales slip, March 12, 1938 (reel 5623, frame 554).

p. 213 "Duplicitous": Berman, p. 331.

p. 213 Krystalnacht: BBC Web site "War and Conflict," timeline for "Genocide under the Nazis."

p. 214 "Most unusual canvas": AAA/DTG, according to stock book for American Folk Art Gallery: *The Faithful Colt* was sold to Edith in April 1935 from a seller listed as "Weiss." The cost price is listed in code "IS," and the selling price is $300 to the Wadsworth Atheneum (reel 5609, frame 586). Frankenstein, in his book on Harnett, describes the seller as a "'runner' from Philadelphia," on p. 3.

p. 214 "Aside from the Peale": AAA/DTG, EGH to Everett Austin, director, Wadsworth Atheneum, April 13, 1935 (reel 5493, frame 321).

p. 214 Harnett background: Frankenstein, p. 3.

p. 215 "Lower East side": AAA/DTG, EGH to A. Everett Austin, Jr., June 12, 1935 (reel 5493, frame 417).

p. 216 "Need I say more?": AAA/DTG, EGH to J. C. Nichols, March 14, 1939 (reel 5494, frame 396).

p. 216 "Reductions in price": AAA/DTG, EGH to Alfred H. Barr, Jr., April 8, 1939 (reel 5494, frame 433).

p. 216 Donation to MoMA: In 1948, art historian Alfred Frankenstein reattributed this work to Frederick Peto. It was subsequently sold by MoMA and was listed in the collection of Detroit collector Richard Manoogian. It is now titled "Old Time Letter Rack."

p. 216 "Retirement gift": This painting was also reattributed by Frankenstein to Frederick Peto.

p. 217 "Make Dali die": Edith quotes from *New York Sun* article in her April 27, 1939, letter to Nelson Rockefeller.

p. 217 "Remarkable painter": Edward Allen Jewell, "Works by Harnett Put on Exhibition," NYT, April 19, 1939.

p. 217 "Bar in Carmel": Private Papers, Charles Alan, p. 308. According to Alan, Edith met Davis at a bar in either Carmel or Monterey.

p. 218 "Great fun": AAA/DTG, EGH to Mildred Lamb, August 7, 1939 (reel 5494, frame 626).

p. 218 "They wed soon": I was unable to locate a marriage certificate for Edith Halpert (or Fein) and Raymond Davis in New York City or Newtown, CT. Searches in California near where they had met (San Francisco, Alameda, Monterey) were also unsuccessful.

p. 218 "Cardboard roll": Private Papers, courtesy Charles Alan's family, p. 308.

p. 219 "Divorce had not been finalized": Information on Raymond Davis from California State Archives, State Prison of San Quentin, California, copies of file for convict 64437, which included inmate statement on entering prison; probation officer's report; transcripts of trial in Superior Court of State of California, Orange County, December 27, 1939; and letters from Davis to prison warden regarding parole.

p. 219 "Damned foolishness": Quoted from statement on form, "Statement of Inmates on Entering Institution."

p. 220 So have our spirits": AAA/EGH, EGH to Mildred Lamb, November 28, 1939 (reel 5494, frame 798).

p. 220 "Masterpieces . . . plucked from obscurity": AAA/DTG, sales slips October 1939 (reel 5623, frames 796, 805, 806, 807).

p. 220 "Three watercolors": AAA/DTG, Museum of Fine Arts, Boston, sales slip dated October 18, 1939, for *Sea, Island, Tree, Maine* (1923), *Small Point, Maine*, (1928), and *Mountain Form*, (circa 1918), for $1,500 (reel 5623, frame 799).

Chapter 10: Uptown at the Downtown

p. 222 The title of this chapter, "Uptown at the Downtown" was the title Edith and a ghost writer used for their chapter title in the 1961 outline for Edith's unpublished book.

p. 223 Mortgages: AAA/DTG, A. B. Benedict, treasurer, Vanderbilt University, to 113 West 13th Street Corporation, January 9, 1940 (reel 5494, frame 910).

p. 224 "Consigned to Edith": AAA/DTG, EGH to Samuel Cooper, January 11, 1940. In this letter Edith writes her accountant with details of her plan to dissolve the American Folk Art Gallery partnership between herself and Cahill (reel 5494, frame 915).

p. 224 Moving sale: AAA/DTG, EGH to Alfred H. Barr, Jr., April 12, 1940 (reel 5494, frame 1078).

p. 225 "Two minor oils": AAA/DTG, Series 4: Business records (reel 5623, frame 951); list of paintings sold at Plaza Art Galleries, receipt dated May 13, 1940, Stuart Davis, *Downtown Street*, $17.50; and *Landscape with Red Spotlight*, $17.50 (reel 5623, frame 951). Receipt from Plaza Art Galleries indicates sale held April 11.

p. 225 "Almost menacing proportions": Frank Crowninshield, "Child Portraiture and Folk Painting in America's Age of Innocence," *Vogue,* December 15, 1939, p. 32.

p. 225 "Governor's Palace": AAA, EGH OH, p. 434.

p. 225 "Cost plus ten per cent": AAA/DTG, James Cogar to EGH, April 27, 1940 (reel 5494, frame 1115).

p. 226 "For the collection": AAA/DTG, EGH to James Cogar, April 30 (reel 5494, frame 1123).

p. 226 "Or elsewhere": AAA/DTG, EGH to B. W. Norton, March 8, 1939 (reel 5494, frame 385).

p. 227 "Unpleasant connotations": AAA/DTG, Norton to EGH, April 28, 1949 (reel 5494, frame 1118).

p. 227 "Prepared to make": AAA/DTG, AAR to EGH, July 8, 1940 (reel 5495, frame 13).

p. 227 "Classical touches": New York City Municipal Archives, tax photo records, 43 East 51 Street, circa 1939 (1287–29 M).

p. 227 "More fashionable areas": I thank architectural historian Francis Morrone for his insights on the block in the 1940s.

p. 227 "Ghost town": AAA OH EGH, p. 381.

p. 228 "Uptown big": AAA/DTG, EGHUK (reel 5637, frame 408).

p. 229 "Absence of ultra red": AAA/DTG, Edward Alden Jewell, "Downtown to Open Its New Gallery," NYT, October 16, 1940 (reel 5598, frame 745).

p. 229 "Reported *Art Digest*": AAA/DTG, "Downtown Gallery Reopens Uptown," *Art Digest,* October 15, 1940 (reel 5598, frame 743).

p. 229 "*New York Times*": AAA/DTG, Edward Alden Jewell, "Downtown to Open Its New Gallery," NYT, October 16, 1940 (reel 5598, frame 745).

p. 229 Exhibidor: AAA/DTG, Elizabeth Sacartoff, "Downtown Gallery Moves Uptown," *PM Weekly,* October 20, 1940 (reel 5598, frame 752).

p. 230 *New York Sun:* AAA/DTG, *New York Sun,* May 17, 1941 (reel 5598, frame 817).

p. 230 In 1942 the Metropolitan Museum of Art acquired *South of Scranton; Americana* was donated to the Metropolitan in 1991, a gift from Edith Lowenthal who had bought the painting, together with her husband, Milton, for $1,800 in 1946.

p. 231 "Strengthen the black community": This idea comes from Jeffrey C. Stewart, "(Un)Locke(ing) Jacob Lawrence's Migration Series," in *Jacob Lawrence: The Migration Series,* edited by Elizabeth Hutton Turner (Washington, D.C.: Rappahannock Press, 1993), p. 43.

p. 232 "Interesting event": AAA/DTG, EGH to Anna Kelly, Mrs. Rockefeller's secretary, November 12, 1934 (reel 5492, frame 1161).

p. 232 "200,000 citizens": Fogelson, p. 41.

p. 232 "Social affairs": Ibid., p. 88.

p. 233 "Little money to promote it": AAA/DTG, Dr. Alain Locke to Halpert, June 5, 1929 (reel 5490, frame 975).

p. 233 "Chicago artist": "One-Man Show of Art by Negro, First of Kind Here, Opens Today," NYT, February 25, 1928.

p. 233 "Self-taught artist": Edward Alden Jewell, "Pippin Has Display at Bignou Gallery," NYT, October 1, 1940.

p. 234 "Woefully ignorant": AAA/DTG, EGH to Dr. Alain Locke, June 8, 1941 (reel 5495, frame 736).

p. 234 "My resources": AAA/DTG, Dr. Alain Locke to EGH, June 16, 1941 (reel 5495, frame 765).

p. 234 "Two weeks later": In Locke's June 16 letter to Halpert, he proposes meeting her on June 23, and it is likely they met on or just after that date.

p. 234 "In the flesh": Diane Tepfer, "Edith Gregor Halpert: Impresario of Jacob Lawrence's Migration Series," essay in *Jacob Lawrence: The Migration Series*, Washington, D.C.: Rappahannock Press, in association with the Phillips Collection, 1993. Tepfer states that Halpert probably joined Locke to view the Migration Series at the Harlem Community Art Center, as suggested by a telegram from Halpert to Locke proposing the visits. Tepfer's essay was instrumental in my understanding of Halpert's involvement with Lawrence.

p. 235 "*Migration of the Negro*": Later renamed "The Migration Series."

p. 236 "Reticent mask": Selden Rodman, *Conversations with Artists*, Introduction by Alexander Eliot, New York: Devin-Adair, 1957.

p. 237 "Believe in and do best": Rodman, p. 206.

p. 237 "Possible spread": AAA/DTG, Dr. Alain Locke to EGH, July 5, 1941, "Mrs. Caulkins writes that he will come in to the office sometime next week" (reel 5495, frame 816).

p. 238 "À la 19th century": AAA/DTG, EGH to Dorothy Miller, July 17, 1941 (reel 5495, frame 837).

p. 238 "Psychotic": AAA/DTG, Locke to EGH, August 5, 1941 (reel 5495, frame 878).

p. 239 "Locke wrote": Ibid.

p. 239 "Marked up fancy": Ibid.

p. 239 "Declined to send work": Ibid.

p. 240 "Original plans": AAA/DTG, Locke to EGH, August 5, 1941 (reel 5495, frame 879).

p. 241 "Discussed the matter": AAA/DTG, EGH to Deborah Caulkins, August 12, 1941 (reel 5495, frame 900).

p. 241 "I appreciate your offer": AAA/DTG, Lawrence to EGH, undated, but probably August 1941 (reel 5549, frame 382).

p. 242 "Art in all its phases": AAA/DTG, EGH to La Guardia, July 10, 1941 (reel 5495, frame 829).

p. 242 "During the past year": EGH to Lester Stone, executive secretary to the mayor, July 11, 1941 (reel 5495, frame 831).

p. 243 "Water heating": AAA/DTG, EGH to Consolidated Edison Company of New York, October 7, 1941 (reel 5495, frame 1005).

p. 244 "Social content in America": AAA/DTG, Press Release, "Migration of the Negro," October 28, 1941 (reel 5549, frames 387–388).

p. 245 "Corrugated subconscious": AAA/DTG, EGH to Nathaniel Uhr, November 3, 1941 (reel 5495, frames 1091–1092).

p. 245 "Color patterns": "Picture Story of the Negro's Migration," *Art News*, November 15–30, 1941, no byline.

p. 245 "Until December": AAA/DTG, EGH to Lawrence, November 8, 1940 (reel 5549, frame 390).

p. 245 "Talented members of his race": ". . . And the Migrants Kept Coming: A Negro Artist paints the Story of the Great American Minority," *Fortune*, November 1941.

p. 247 "Work was created": AAA/DTG, Downtown Gallery press release, "American Negro Art," December 9–31, 1941 (reel 5598, frame 840).

p. 247 "Other public institutions": Ibid.

p. 247 "Through it all": AAA/DTG, Dr. Alain Locke to EGH, undated but circa December 4, 1941 (reel 5495, frame 1230).

p. 248 "Opposing emotions": The exhibition catalog describes Crichlow's piece as *Lovers*, a tempera dated 1940. The work was priced at $300. In 1938, Crichlow had made lithographs with the same title and subject.

p. 248 "Because of the war": Author phone interview with Ernest Crichlow, April 2003.

p. 248 "More unconventional": *Art News* review, James W. Lane, December 15–31, 1941.

p. 248 "The pieces contain": "The Art Galleries: Negro Art," *New Yorker*, December 27, 1941.

p. 249 "Gotten out": AAR to EGH, January 7, 1942 (reel 5496, frame 12).

p. 251 "$33 per panel": AAA/DTG, EGH to Mrs. David H. Levy, January 17, 1942 (reel 5496, frame 38).

p. 251 "Urgent request": AAA/DTG, EGH to Marjorie Phillips, February 5, 1942 (reel 5496, frame 86).

p. 252 "Best treatment": "Stanzas from a Black Epic," Robert Hughes, *Time*, November 22, 1993.

p. 252 "Great American dealers": AAA OH, Jacob Lawrence, p. 15.

Chapter 11: Edith's Victory Garden

p. 253 "Attack from both sides": "Text of Mayor La Guardia's Radio 'Chat' on War Front at Home," NYT, December 15, 1941.

p. 254 "spirit of the time": AAA/DTG, Downtown Gallery press release, "Battles and Symbols of the U.S.A.," February 24, 1942 (reel 5602, frame 146).

p. 254 "Most irreplaceable objects": "Museum Prepared to Evacuate Art,"
 NYT, December 16, 1941.

p. 254 "Safekeeping": AAA, The Phillips Collection Records.

p. 255 "The help of all our friends": AAA/DTG, EGH to Nelson Rockefeller,
 January 20, 1942 (reel 5496, frame 48).

p. 255 "Maintain buying interest": AAA/DTG, EGH to AAR, January 23, 1942
 (reel 5496, frame 55).

p. 256 "Her own mortality": See Kert for information on AAR during the
 war, pp. 429–439.

p. 256 "Deep sensuous vitality": AAA/DTG, Draft undated memorial tribute to
 Kuniyoshi by Lloyd Goodrich, circa 1953 (reel 5548, frame 1108).

p. 257 "Brush pyrotechnics": Edward Alden Jewell, "Kuniyoshi, in New
 One-Man Exhibit at Downtown Gallery, Shows Considerable
 Progress," NYT, February 8, 1933.

p. 257 "Difference to him": AAA OH, Schmidt, p. 38.

p. 257 "Slightly morbid interpretation": AAA/DTG, "New England Was
 Rather Sad Drama to Yasuo," Art Digest, March 15, 1941 (reel 5549,
 frame 29).

p. 258 "My being here": AAA/DTG, Yasuo Kuniyoshi to EGH, undated letter,
 circa 1941 (reel 5549, frame 22).

p. 258 "Art and life in a democracy": AAA/DTG, Downtown Gallery press
 release dated April 22, 1942: "A Retrospective Loan Exhibition of
 Paintings by Yasuo Kuniyoshi," May 5–29, 1942 (reel 5549, frames
 35–36).

p. 258 "Japanese militarism": AAA/DTG, "A Kuniyoshi Retrospective," New
 Yorker, May 16, 1942 (reel 5549, frame 48).

p. 258 Self-Portrait as a Golf Player, 1927, was acquired by the Museum of
 Modern Art in 1938, Abby Aldrich Rockefeller Fund.

p. 259 "Evidence of trouble": AAA OH EGH, p. 631.

p. 259 "In their midst": Levin, p. 11.

p. 259 "For the war effort": EGH to Lawrence Allen, July 28, 1942 (reel
 5496, frame 390).

p. 260 "Towards their success": AAA/DTG, EGH to AAR, October 15, 1942
 (reel 5496, frame 480).

p. 260 "New acquisitions": AAA/DTG, EGH to Electra Havemeyer Webb, June
 19, 1950 (reel 5501, frames 337–338).

p. 261 "Yours and mine": AAA/DTG, Electra Havemeyer Webb to EGH, July
 27, 1951, quoted in Joyce, p. 188.

p. 261 "Mrs. Halpert": AAA/DTG, Electra Havemeyer Webb to EGH, July 15,
 1950 (reel 5501, frames 406–407).

p. 261 "Stay in bed period": AAA OH EGH, p. 115.

p. 261 "For their workers": AAA/DTG, EGH to Edsel Ford, October 16, 1942
 (reel 5496, frame 487).

p. 262 "Shift for ourselves after the war": AAA/DTG, EGH to Nathaniel Uhr, November 16, 1942 (reel 5496, frames 538–540).

p. 262 "One less thing to fret about": Ibid. (reel 5496, frames 538–540). Edith writes "Mother is in a nursing home. This arrangement is ideal, particularly for me." It was not a permanent arrangement: Frances lived until 1956, and Edith's grand-niece does not remember Frances in a nursing home in the 1940s.

p. 262 "My sole benefit": Ibid.

p. 263 "Deemed a good fit": AAA/DTG, Stuart Davis to EGH, August 31, 1942 (reel 5546, frame 703).

p. 263 "Much longer period": AAA/DTG, EGH to Robert Carlen, June 20, 1942 (reel 5496, frame 354).

p. 263 "Own kind of dash": Author interview with Jack Levine, July 11, 2003.

p. 264 Camouflage exhibition: "Art of Camouflage Is Demonstrated As Army Men Open Department Store Show," NYT, February 6, 1943.

p. 265 "Natural way for me to be happy": AAA/DTG, Louis Guglelmi to EGH, April 2, 1943 (reel 5548, frames 80–82).

p. 266 "What you have done": AAA/DTG, Jacob Lawrence to EGH, undated (reel 5549, frames 372–374).

p. 266 "This is war": AAA/DTG, EGH to Jacob Lawrence, January 20, 1944 (reel 5549, frame 424).

p. 266 "How so soon": AAA/DTG, Alfred H. Barr, Jr. to EGH, November 17, 1942 (reel 5496, frame 544).

p. 266 "Also declined": AAA/DTG, a receipt and note in her client records show that Edith sold the series to Edith and Milton Lowenthal on December 3, 1945 for $1,700 (reel 5624, frame 1055). In 1955, the Lowenthals donated "The Life of John Brown" series to the Detroit Institute of Arts.

p. 267 "Good strong ones": AAA/DTG, Jacob Lawrence to EGH, undated (reel 5549, frames 426–427).

p. 267 "Valuable propaganda": AAA/DTG, EGH to Jacob Lawrence, March 1, 1944 (reel 5549, frame 431).

p. 268 "Auction block": "Boom in Old Masters," *Time*, August 17, 1942.

p. 268 *L'Amour:* Ibid. The article reports Dr. Barnes paid $175,000 for Renoir's *Mussel Fishers at Berneval.*

p. 269 "East 50s": In *De Kooning: American Master,* Mark Stevens and Annalyn Swan describe the surrealist artists as "cliquish" and "snobbish," p. 169.

p. 269 "East River": Ibid., p. 170.

p. 270 "American art": AAA/DTG, Alain Locke to EGH, February 12, 1944 (reel 5497, frame 263).

p. 270 "Fit to copy": AAA/DTG, Esther Isabel Seaver, Wheaton College chair of Art Department, to EGH, February 3, 1944 (reel 5497, frame 239).

p. 270 "Library item": AAA/DTG, Henry Clifford to EGH, February 8, 1944 (reel 5497, frame 251).

p. 270 "Canvas and stone": Messenger, p. 4.

p. 270 "Forty-six paintings": Ibid., p. 5.

p. 271 *Americana, Rockport*: Both donated to Metropolitan Museum of Art, Edith and Milton Lowenthal Collection, Bequest of Edith Abrahamson Lowenthal, 1991. *Report from Rockport* by Stuart Davis, 1940, oil on canvas, 24 by 30 inches (1992.24.1); and *Americana* by Charles Sheeler, 1931, oil on canvas, 48 by 36 inches (1992.24.8).

p. 271 "Most of the time": Neuberger, p. 64.

p. 271 "Not an easy person": Author interview with Roy Neuberger, June 17, 2003.

p. 271 "Never consummated": AAA/DTG, Agreement between Miller Company and the Downtown Gallery, undated circa 1947 (reel 5499, frames 7–14).

p. 272 "Progressive outlook": AAA/DTG, EGH to Lester D. Longman, head of the Department of Art, State University of Iowa, June 1, 1945 (reel 5497, frame 767).

p. 273 "Everyone is happy": AAA/DTG, EGH to Harry Warner, January 27, 1944 (reel 5497, frame 212).

p. 273 "Spend it on": Emily Genauer, "Enter—the Fabulous New Collector!" *New York World-Telegram*, June 10, 1944. AAA/DTG (reel 5600, frame 1088).

p. 273 "No doubt about it": AAA/DTG, "Bull Market in Art," *Newsweek*, March 10, 1944 (reel 5600, frame 1089).

p. 274 $150: Sale price confirmed by Renée Mauer, curatorial coordinator for The Phillips Collection. Davis had originally priced the painting at $750, according to SDCR.

p. 274 "Gouaches": AAA/DTG, unmicrofilmed stock book, Stuart Davis, 1930–1935.

p. 274 "Indication of conspiracy": AAA/DTG, Stuart Davis to EGH, July 18, 1941 (reel 5546, frames 685–686).

p. 275 "New subject": AAA/DTG, Copy of Downtown Gallery exhibition program, "Stuart Davis: Selected Paintings, February 2–29, 1943" (reel 5546, frames 720–723).

p. 275 "Refused to be assimilated": AAA/DTG, Downtown Gallery press release, "Stuart Davis: Selected Paintings, February 2–29, 1943," dated January 25, 1943 (reel 5546, frames 714–715).

p. 275 "Wasted effort": AAA/DTG, Clyde Burroughs, the Detroit Institute of Arts, to EGH, May 11, 1942 (reel 5496, frame 290).

p. 275 "Shown here": AAA/DTG, March 25, 1943 (reel 5496, frame 763).

p. 276 Record price: AAA/DTG, Downtown Gallery sales slip, December 2, 1943, lists buyer as Jan de Graaff (reel 5624, frame 566).

p. 277 *She-Wolf* price: Gill, p. 328.

p. 277 Guggenheim to "shut up shop": Ibid., p. 332.

p. 277 Sales from Art of This Century: Ibid., p. 333.

p. 277 Downtown Gallery sales: AAA/DTG, Downtown Gallery sales records for fiscal years 1941–1948, listing gross sales and profits (reel 5632, frame 1092).

p. 277 "Pollacks [sic] progress": AAA/DTG, EGH to Peggy Guggenheim, March 20, 1947 (reel 5499, frame 331).

p. 278 "New pram": Author interview with Earl Davis.

p. 278 "Stimulating show": AAA/DTG, EGH to Donald Baer, July 12, 1945 (reel 5497, frame 841).

p. 278 Information on prices and provenance from SDCR.

p. 278 "Smiling on numerous occasions": AAA/DTG, EGH to Elizabeth Sacartoff, December 13, 1945 (reel 5497, frame 1249).

p. 281 "In hock": AAA/DTG, EGH to David Rosen, July 26, 1945 (reel 5497, frame 875).

p. 282 "Producing so little": AAA/DTG, EGH to Thomas C. Parker, September 26, 1944 (reel 5497, frame 588).

p. 282 "Leaps and bounds": AAA/DTG, EGH to Samuel C. Waugh, First Trust Company, January 5, 1945 (reel 5497, frame 350).

p. 283 *"The Old Cupboard Door"*: This painting is now titled *Old Models*.

p. 283 "Placed by the gallery": AAA/DTG, Downtown Gallery Exhibit Program, "Loan Exhibition," October 15–November 3, 1945 (reel 5598, frames 995–999).

p. 283 "One of the musts": AAA/DTG, NYT, October 21, 1945 (reel 5598, frame 1003).

p. 283 "Pioneering paths": AAA/DTG, Ben Wolf, "Edith Halpert, Art Crusader, Marks Two Decades of Success," *Art Digest*, October 15, 1945 (reel 5598, frame 1001).

Chapter 12: Inheriting Stieglitz, Courting O'Keeffe

p. 285 "Do it?": Private papers, courtesy of Charles Alan's family, p. 304.

p. 285 "Satin draperies": Aline (née Bernstein) and Eero Saarinen Papers, 1857–1972, AAA (reel 2075, frame 1235).

p. 285 Charles Alan background: "Charles Alan Dies; Art Dealer was 66," NYT, January 13, 1975.

p. 286 "Don't disappointment me": Private papers, courtesy of Charles Alan's family, p. 305.

p. 288 "Protect myself": AAA/DTG, Alfred Stieglitz to Duncan Phillips, July 3, 1946 (reel 5498, frame 591).

p. 288 "Seven days later": Whelan, p. 572, says Stieglitz is comatose by July
 10 and dies July 13.

p. 288 "Hypnotic monologues": AAA/DTG, EGHFG, p. 4 (reel 5637, frame
 415).

p. 288 "Practical": Author interview with Doris Bry, November 2, 2005.

p. 288 "Long period of time": AAA OH EGH, p. 798.

p. 288 "Most important thing": Ibid., p. 799.

p. 289 "Pay his rent": Ibid., p. 800.

p. 289 "Very little": Ibid., p. 800.

p. 290 "After the visit": AAA/DTG, Stieglitz to EGH, January 15, 1931 (reel
 5555, frame 549).

p. 290 "Behalf of culture": Lowe, p. 300.

p. 290 "On art matters": AAA/DTG, Stieglitz to EGH, February 11, 1931 (reel
 5555, frames 557–559).

p. 290 "Spending $4,500": AAA/DTG, Sales slip lists Mrs. J. D. Rockefeller,
 Jr., February 10, 1931, $4,500 (reel 5621, frame 746).

p. 290 "Inspiring": AAA/DTG, EGH to Stieglitz, February 10, 1931 (reel 5555,
 frame 556).

p. 290 "To see Dove": AAA OH EGH, p. 812.

p. 291 "More seriously": Author phone interview with Sarah Greenough,
 February 23, 2006.

p. 291 $5,000: Lowe, p. 244.

p. 291 "Lose his pictures": AAA/DTG, Stieglitz to EGH, March 24, 1932 (reel
 5555, frame 569).

p. 292 "Get into the newspapers": AAA/DTG, EGH to Tannahill, January 10,
 1934 (reel 5492, frame 565).

p. 292 "If it is to come": AAA/DTG, Stieglitz to EGH, June 8, 1934 (reel 5555,
 frame 580).

p. 292 "Do something with them": AAA/DTG, Stieglitz to EGH, April 18, 1934
 (reel 5555, frame 576).

p. 293 "One tiny bit": AAA/DTG, Stieglitz to EGH, May 7, 1936 (reel 5555,
 frame 617).

p. 293 "Early visit . . . recommended": AAA/DTG, Downtown Gallery
 announcement, "20 Watercolors by John Marin, All Priced at $500,"
 October 16 to November 4, 1939 (reel 5550, frame 226).

p. 294 "Seventy-two-year-old": AAA/DTG, Stieglitz to EGH, July 11, 1935 (reel
 5555, frames 605–606).

p. 294 "Willed the artists": AAA OH EGH, p. 282.

p. 294 "On the lease": According to phone interview with Doris Bry, April 5,
 2006.

p. 295 "Gifts from artists": Georgia O'Keeffe, "Stieglitz: His Pictures Col-
 lected Him," NYT, December 11, 1949.

p. 295 $64,425: AAA/DTG, Draft of EGH appraisal of Alfred Stieglitz property, September 13, 1946 (reel 5690, frame 726).

p. 295 "Loss of Stieglitz": AAA/DTG, EGH to Elizabeth Sacartoff, an art reporter whom Edith befriended, September 27, 1946 (reel 5498, frame 840).

p. 296 "With sound": AAA/DTG, Dove quoted from exhibition program for Arthur G. Dove Paintings; 1927, The Intimate Gallery, Room 303, December 12–January 11, 1927–1928 (reel 5547, frame 541).

p. 296 "An artist like him": Turner, *In the American Grain*, p. 25.

p. 296 "Accepted symbols": Murdock Pemberton, "The Art Galleries: Dove Comes to Terms—A Bursting Week of First-Class Things," *New Yorker*, December 24, 1927, p. 57, AAA/DTG (reel 5547, frame 543).

p. 296 "Can admire it": Murdock Pemberton, "The Art Galleries: New Doves—Mr. Kootz Picks Eleven, One of those Necessary Evils," *New Yorker*, March 21, 1931, p. 68, AAA/DTG (reel 5547, frame 561).

p. 296 "He resented": Turner, p. 29. "Dove's pride was as prickly as Stieglitz's, and there were many times when he resented Phillips."

p. 296 "Keep Dove out of the limelight": Carol Troyen, curator of painting, Art of the Americas, Museum of Fine Arts, Boston, interview with author, September 30, 2005: "Dove looked too much like O'Keeffe . . . Stieglitz kept him out of the public eye to avoid competition with O'Keeffe."

p. 297 "Marvelous as he has been": AAA/DTG, Arthur Dove to EGH, undated letter circa 1946 (reel 5547, frame 573).

p. 297 "Forty years ago": AAA/DTG, Downtown Gallery press release, dated December 30, 1946: Arthur Dove Retrospective, January 7–25, 1946 (reel 5547, frame 613).

p. 297 "Importance as a precursor": AAA/DTG, memo from Alfred H. Barr, Jr., January 2, 1951 (reel 5547, frame 635).

p. 298 "Outstanding original artists": Howard Devree, "Personal Modern: Arthur Dove's Work Takes on Stature Through Whitney Museum Show," NYT, October 5, 1958, AAA/DTG (reel 5547, frame 757).

p. 299 "Why does one": AAA/DTG, quoted from letter from John Marin to Stieglitz, October 10, 1941 (reel 5550, frame 228).

p. 300 "First living artist": AAA/DTG, Downtown Gallery press release, July 30, 1948 (reel 5550, frame 235).

p. 300 Information on John Marin, Jr. from author interview with his widow, Norma Marin, September 30, 2005.

p. 300 "My entire career": AAA/DTG, August 8, 1949, EGH to Marin (reel 5550, frame 251).

p. 300 "Tomorrow into today": AAA/DTG, John Marin, Jr. to EGH, September 5, 1948, AAA/DTG (reel 5550, frame 253).

p. 301 "Once Edith retired": From author interview with Norma Marin, widow of John Marin, Jr., September 30, 2005.

p. 301 "Meant a great deal": AAA OH, Charles Alan, p. 14.

p. 303 "Ford Roadster": Doris Bry, phone interview with author, April 5, 2006.

p. 303 "General store": Details about Abiquiu provided to author by Ibid.

p. 304 "Very pleasant": AAA/DTG, O'Keeffe to EGH, November 12, 1947 (reel 5550, frame 874).

p. 304 "Infatuations with adolescent girls": Whelan, pp. 200, 557.

p. 304 "Worst of times": Author phone interview with Greenough, February 23, 2006.

p. 305 "It had been done": Robinson, p. 78.

p. 306 "Casual young man": AAA/DTG, O'Keeffe to EGH, June 23, 1948 (reel 5550, frame 875).

p. 306 "Stieglitz's efforts": Author phone interview with Lynes, May 9, 2006.

p. 306 "She had inherited": Drohojowska-Philip, p. 424. Doris Bry disputed the claim that Stieglitz's death made O'Keeffe wealthy.

p. 307 "Symbolic value": Author interview with Doris Bry, November 2, 2005.

p. 307 "Can't say yet": AAA/DTG, O'Keeffe to EGH, September 27, 1949, (reel 5550, frame 892).

p. 307 "Woman opinion": AAA/DTG, O'Keeffe to EGH, August 31, 1949 (reel 5550, frame 887).

p. 307 "Unorganized stuff": Bry, April 5, 2006.

p. 308 "Get queer": AAA/DTG, O'Keeffe to EGH, June 12, 1950 (reel 5550, frames 959–960).

p. 308 "Will be put": AAA/DTG, EGH to O'Keeffe, June 20, 1950 (reel 5550, frame 961).

p. 308 "You yourself select": Ibid.

p. 308 "Better than the money": AAA/DTG, O'Keeffe to EGH, July 2, 1950 (reel 5550, frames 966–970).

p. 308 "Without Stieglitz": AAA/DTG, EGH to O'Keeffe, July 9, 1950 (reel 5550, frames 971–972).

p. 309 "Better than I do": AAA/DTG, O'Keeffe to EGH, July 13, 1950 (reel 5550, frame 974).

p. 309 "Part of my life": AAA/DTG, O'Keeffe to EGH, August 2, 1950 (reel 5550, frames 978–979).

p. 309 "Restimulate . . . interest": AAA/DTG, EGH to O'Keeffe, August 1, 1951 (reel 5550, frame 1016).

p. 309 "As most artists do": AAA/DTG, O'Keeffe to EGH, September 10, 1951 (reel 5550, frame 1020).

p. 309 "Abstract school": AAA/DTG, Downtown Gallery press release, February 11, 1952, "O'Keeffe Paintings in Pastel," 1914–1945, February 19–March 8, 1952 (reel 5550, frame 1033).

p. 310 "Other Work": AAA/DTG, O'Keeffe to EGH, September 10, 1951 (reel 5550, frame 1021).

p. 310 "Only representative": Exhibit catalog (reel 5550, frame 1057).

p. 310 "Plexiglass covering": AAA/DTG, O'Keeffe to EGH, September 18, 1952 (reel 5550, frames 1062–1066).

p. 311 "The boys": AAA/DTG, EGH to O'Keeffe, October 22, 1952 (reel 5550, frame 1067).

p. 311 "Stability in my life": AAA/DTG, O'Keeffe to EGH, November (day illegible) 1952 (reel 5550, frames 1068–1069).

p. 311 "And I don't": O'Keeffe, p. 24.

p. 312 "Very female parts": AAA OH EGH, p. 807.

p. 312 "Please": AAA/DTG, O'Keeffe to EGH, January 19, 1955 (reel 5550, frames 1180–1183).

p. 312 "In no humor": Ibid.

p. 312 "Superior sex": AAA/DTG, EGH to O'Keeffe, March 10, 1955 (reel 5550, frame 1198).

p. 313 "Before me": AAA/DTG, EGH to O'Keeffe, February 14, 1955 (reel 5550, frame 1189).

p. 313 "Other things": AAA/DTG, O'Keeffe to EGH, February 26, 1955 (reel 5550, frame 1197).

p. 313 "Three new paintings": Ibid. (reel 5550, frame 1193).

p. 313 "If I die": Ibid. (reel 5550, frame 1195).

p. 313 "Stated in your letter": AAA/DTG, EGH to O'Keeffe, December 4, 1952 (reel 5550, frame 1074).

p. 314 "Necessary evil": AAA/DTG, O'Keeffe to EGH, May 7, 1955 (reel 5550, frame 1214).

p. 314 "Good for nothing": AAA/DTG, O'Keeffe to EGH, April 11, 1956 (reel 5551, frames 106–110).

p. 314 "Any minute": EGH to O'Keeffe, April 24, 1956 (reel 5551, frame 114).

p. 315 "Masses of color": Press release for "O'Keeffe Exhibition, Watercolor 1916–1917," February 25–March 22, 1958 (reel 5551, frame 143). (Emphasis in original.)

p. 315 "Please": AAA/DTG, O'Keeffe to EGH, March 3, 1961 (reel 5551, frames 267–268).

p. 315 "Record sales": AAA/DTG, EGH to O'Keeffe, list of payments made during 1961 totalling $49,837 (reel 5551, frame 329).

p. 315 "Interest you": AAA/DTG, O'Keeffe to EGH, June 22, 1961 (reel 5551, frame 296).

p. 316 "Police force": AAA/DTG, EGH to O'Keeffe, June 16, 1961 (reel 5551, frame 295).

p. 316 "Give me up": AAA/DTG, O'Keeffe to EGH, September 16, 1961 (reel 5551, frame 302).

p. 316 O'Keeffe's agent: Bry worked as O'Keeffe's private dealer from 1965–1977.

Chapter 13: Art for Mr. and Mrs. America

p. 319 "Provocative and shocking": Edward Alden Jewell, "A Crisis," NYT, April 13, 1947.

p. 320 *Still Life with Flowers:* The painting sold at Christie's auction house in December 2005 for $3.125 million. The seller was the New Trier School board in Chicago, which paid $62.50 for the work at the government auction. In the 1990s, the painting was appraised at $200,000.

p. 320 *Times* review: Edward Alden Jewell, "Eyes to the Left: Modern Painting Dominates in State Department and Pepsi-Cola Selections," NYT, October 6, 1946.

p. 321 "Left-wing painters": Littleton and Sykes, p. 26.

p. 321 "Nightmare": Ibid., p. 27.

p. 321 "Establish ill-will": Letter from John Taber to George C. Marshall, February 4, 1947, AAA, Advancing American Art Papers (reel 7769, frame 444).

p. 322 "I'm a Hottentot": Littleton and Sykes, p. 55.

p. 322 "Therefore worthless": "Modern art violated the American work ethic," wrote Lisa Phillips in "The American Century: Art and Culture 1950–2000," The Whitney Museum of American Art, New York: W. W. Norton, 1999, p. 36.

p. 322 "Communist ideals": Littleton and Sykes, p. 29, quotes Reid and explains his role.

p. 323 "Stifled": "Artists Protest Halting Art Tour," NYT, May 6, 1947.

p. 323 EGH's notes from a talk given at the Hotel Capital, May 5, 1947, AAA/DTG(reels 5637, frames 579–584).

p. 323 "Stifled": "Artists Protest Halting Art Tour," NYT, May 6, 1947.

p. 323 "Embarrassing episode": Office Memorandum, U.S. Government memo to Ken Holland, September 9, 1947: "the Secretary thought it a wonderful idea to sell the pictures at a profit if we could." AAA, Advancing American Art papers (reel 3769, frame 519).

p. 324 Auction prices: Sales information from Littleton and Sykes, pp. 60–61.

p. 324 "Integrity of the living artist": "A Statement on Modern Art by the Institute of Contemporary Art, Boston, the Museum of Modern Art, New York, and the Whitney Museum of American Art, New York,"

March 1950. AAA, Advancing American Art papers (reel 3769, frame 398).

p. 324 "Art Dealers Elect," NYT, November 21, 1947. Other members included Associated American Artists, ACA, Babcock, Ferargil, Grand Central, Kraushaar, Midtown, Macbeth, Milch, and Rehn galleries.

p. 325 "Hardship": Press Release, "Art for 13,000,000," May 29, 1950, AAA/DTG records (reel 5599, frame 321).

p. 326 "Proper order": Press Release, "Art for the 67%," May 26, 1952, AAA/DTG (reel 5599, frame 417).

p. 326 "Copy of a detective story": Aline B. Louchheim, "Art Show Is Set Up for Business Men," NYT, November 17, 1953, p. 44.

p. 327 "Wondered what we had done": Author interview with Barbara Fleischman, March 15, 2003.

p. 327 "Who wants this": Ibid.

p. 327 "Owed $18,467": AAA/DTG, Lawrence Fleischman to EGH, February 10, 1953 (reel 5504, frame 718).

p. 327 "Pattern of collecting": EGH to Lawrence Fleischman, March 20, 1953 (reel 5504, frame 1082).

p. 327 "Bought twenty-one": Author interview with Barbara Fleischman, March 15, 2003. Lawrence Fleischman was one of the founders of the Archives of American Art, where Edith donated her gallery records. The Fleischmans moved to New York City in 1966, and Lawrence bought a half-share in the old-line American art gallery, Kennedy Galleries. He died in 1997.

p. 328 "Learn from her": AAA OH Interview with Lawrence Fleischman, conducted by Gail Stavitsky, April 18, 1994, p. 7.

p. 328 "Blue sky": Now in the collection of the National Gallery of Art in Washington, D.C. Sold as *Jack-in-the-Pulpit #6* according to Downtown Gallery sales records.

p. 329 "We don't know what we say": Author interview with Helen Boigon, February 11, 2006.

p. 329 "Narrow border of her life": Private papers, courtesy of Charles Alan's family, p. 314.

p. 329 "Nightgowns": Ibid., p. 314.

p. 329 "Pain of loss again": Author interview with Helen Boigon, February 11, 2006.

p. 330 "Beyond one's depth": AAA/DTG, EGH to Lawrence Allen, July 23, 1950 (reel 5501, frame 414).

p. 330 "House I want": AAA/DTG, Lawrence Allen to EGH, July 25, 1950 (reel 5501, frame 417).

p. 331 "Discussing her home": Private Papers, courtesy of Charles Alan's family, pp. 308–309.

p. 331 "Not detrimental to the gallery": Ibid., p. 309.

p. 331 "Brought her back": Ibid., p. 318.

p. 332 "Tax deductible": AAA OH, Charles Alan, pp. 6 and 7.

p. 332 "Extraordinary ability": AAA/DTG, EGH to Charles Alan, July 6, 1951 (reel 5502, frame 241).

p. 332 "Their experiments": AAA/DTG, EGH to Charles Alan, July 6, 1951 (reel 5502, frame 242).

p. 333 "Worked with Edith": AAA OH, Charles Alan, p. 7.

p. 333 Jean Arthur: Private papers, courtesy of Charles Alan's family, p. 309.

p. 333 "Pep talks to myself": AAA/DTG, EGH to Charles Alan, July 6, 1951 (reel 5502, frame 241).

p. 334 "accept the offer": Sale price reported by Edith. Author unable to verify price. Numerous calls to real estate office of Catholic Archdiocese not returned and no records found at New York Department of Finance archives.

p. 334 "Greatest living painter" *Life*, August 8, 1949.

p. 334 "extinguishing the object": Rosenberg, p. 26.

p. 334 "Make more obvious": Greenfeld, p. 220.

p. 337 "Signal the independence": AAA OH, Charles Alan, p. 22; and author interview with Jack Levine, July 11, 2003.

p. 337 "His contract ran out": Author phone interview with Luise Ross, April 16, 2006 and Don Madger, July 28, 2006.

p. 338 Obituary: "Charles Alan Dies; Art Dealer Was 66," NYT, January 13, 1975. The circumstances of Alan's death were described to me by Chris Wohler, Raymond Saroff, and Don Madger.

p. 339 "Only thing I really do hate": Greenfeld, p. 73.

p. 340 "Wealthy people": Author interview with Bernarda Shahn, June 30, 2003.

p. 340 "Disturbers of the peace": Greenfeld, p. 232.

p. 340 "Fire in Chicago": Shahn, *The Shape of Content*, pp. 25–27.

p. 340 "Next ten years": Greenfeld, p. 277.

p. 341 "While you do not": AAA/DTG, EGH to Ben Shahn, April 17, 1956, (reel 5553, frame 847–848).

p. 341 "I couldn't": AAA/DTG, Ben Shahn to Edith Halpert, September 27, 1954 (reel 5553, frame 738).

p. 341 "Superimposed ideas": AAA/DTG, EGH to Ben Shahn, April 17, 1956 (reel 5553, frame 848).

p. 341 "Two years": Greenfeld, pp. 281–282.

p. 342 "The show never made it": Jerome K. Crossman, Gerald C. Mann, and Waldo Stewart, Letter to Editor, "Dallas Trustees Take a Stand," NYT, February 19, 1956.

p. 343 "Cancelled": Anthony Lewis, "Red Issue Blocks Europe Art Tour," NYT, June 21, 1956.

p. 344 "Non-typical": Franklin Watkins, "U.S. Art to Moscow," *Art in America* (Summer 1959).

p. 346 "Hot water *and* toilet paper": EGH to Virginia Gilbert, July 7, 1958, (reel 5637, frame 216).

p. 346 "Slogans": EGH lecture at the Brooklyn Museum, October 19, 1959, p. 3. Transcript at AAA.

p. 346 "The moment I left": AAA/DTG, EGH notes on first visit, July 6, 1958, (reel 5637, frame 201).

p. 346 "On all sides": AAA/DTG, EGH notes on Russian travels (reel 5637, frame 214).

p. 347 "Duc de Richelieu": EGH OH AAA, p. 2.

p. 347 "Just rubble": Ibid., p. 3.

p. 347 "Mr. and Mrs. America": Francis G. Walter, July 1, 1959, transcript of public hearings, "The American National Exhibition, Moscow, July 1959"; U.S. House of Representatives, Sub-committee of the Committee on Un-American Activities, Washington, D.C.; AAA/DTG (reel 5645, frame 835).

p. 348 "Hydrogen bomb": Wheeler Williams, June 3, 1959, *Congressional Record*, p. 896, AAA (reel 5645, frame 833). The American National Exhibition, Moscow, July 1959, Hearings Before the Committeee on Un-American Activities, House of Representatives, Congress, First Session, U.S. Printing Office, Washington, D.C., 1959.

p. 348 "Ought to be shown": "President Favors Art Liked by U.S." NYT, July 1, 1959.

p. 348 "In the army": "Ike's Role as an Art Critic Is Given a Fast Brush-Off," *Milwaukee Journal*, July 2, 1959. AAA (reel 5645, frame 289).

p. 349 "Convert us to Communism": Transcript given by EGH, October 1959, at Brooklyn Museum of Art. AAA (frames 520–525), pp. 11–20.

p. 350 "Verge of tears": Transcript of talk given by EGH, October 19, 1959, at the Brooklyn Museum of Art, AAA.

p. 350 "Expression in a democracy": Ibid.

p. 351 "This kind of equipment": Ibid., p. 13.

p. 351 "Couldn't move": Ibid., p. 7.

p. 352 "I mean today": AAA/DTG, Copy of note from EGH to Donald McClellan, July 28, 1959 (reel 5489, frame 394).

p. 352 "Satisfied": Draft of lecture, 1962, AAA/DTG (reel 5637).

p. 352 "Impetus for continuity": EGH Lecture, Women's City Club, February 25, 1960 (reel 5637, frame 522), p. 3.

p. 353 Andrew Wyeth, *Children's Doctor*, 1949, tempera on panel, Brandywine River Museum, Chadds Ford, Pennsylvania.

p. 353 "Closed society": George V. Allen, director of USIA, quoted in "Russians Flock to Painting Disliked by Eisenhower," NYT, August 13, 1959.

p. 353 "To prove it": Max Frankel, "Ivan Appears to Like the Way the Joneses Live," NYT, August 7, 1959.

Chapter 14: Dealer Descending

p. 354 "Art lovers": Ross Gelbspan, "Halpert Collection Premieres at Gallery," *Washington Post*, September 28, 1962, AAA/DTG (reel 5642, frame 991).

p. 355 "Last 60 years": Ibid.

p. 356 "American art history": Leslie Judd Ahlander, "Halpert Paintings at the Corcoran," *Washington Post*, September 30, 1962. AAA/DTG (reel 5642, frames 987–988).

p. 356 "Technicality": Gelbspan, "Halpert Collection Premieres."

p. 356 Vigtel worked at the Corcoran Gallery from 1954 to 1963 and was director at the High Museum of Art in Atlanta, Georgia, from 1963 to 1991.

p. 356 "End of the year": Ibid.

p. 357 "Still on top": AAA OH EGH, p. 635.

p. 358 "Some great examples": AAA/DTG, notes for lecture, undated (reel 5636, frames 969–971).

p. 358 "Pop Art": AAA OH EGH, p. 638.

p. 358 "Indeed": Ibid., p. 640.

p. 359 "National scene": Author phone interview with Gudmund Vigtel, January 24, 2006.

p. 359 "Edith's artists": Charles Alan, private papers, courtesy of Charles Alan's family, p. 322.

p. 359 "Sensationalism exclusively": AAA/DTG, EGH to Mr. and Mrs. William Moise, art collectors in Sarasota, Florida, March 1, 1967 (reel 5541, frame 395).

p. 359 "Turnover valuations": AAA/DTG, EGH to James Schramm, February 17, 1959 (reel 5517, frame 1121).

p. 360 "I may not sell securities": AAA OH EGH, p. 204.

p. 360 "Increasingly paranoid": Private papers, courtesy of Charles Alan's family, p. 321.

p. 361 Deaths of Frances and Sonia: Information provided by Patricia Vanderbes.

p. 361 "Litigation": AAA/DTG, EGH to Barry Peril, September 26, 1967 (reel 5542, frames 708–709).

p. 362 "Ever be developed": AAA/DTG, EGH to Maurice Chase, August 31, 1960 (reel 5522, frame 263).

p. 362 "These matters": AAA/DTG, Lawrence Allen signed statement, August 23, 1960 (reel 5522, frame 186).

p. 363 Western Union Telegram, Lawrence Allen to Mrs. Edith G. Halpert, October 27, 1960, AAA/DTG (reel 5522, frame 809).

p. 363 "Faithful to you": O'Keeffe to EGH, August 8, 1960, AAA.

p. 363 "Time to get out": Author interview with Doris Bry, November 2, 2005.

p. 363 "He was innocent": Author phone interview with Bernard Heineman, Jr., February 7, 2006.

p. 364 "Psychotic visitors": AAA/DTG, EGH to Frederick Wright, March 10, 1960, (reel 5520, frame 1028).

p. 364 "Modern art in America": AAA/DTG, EGH to Frederick Wight, October 19, 1961 (reel 5525, frame 665).

p. 364 "Whirly gig": AAA/DTG, EGH to Frederick Wight, April 21, 1959 (reel 5518, frame 536).

p. 365 "Concussion": AAA/DTG, EGH to Edwin Gilbert, March 9, 1961 (reel 5523, frames 869–871).

p. 365 "My 'heir'": AAA/DTG, EGH to Bernard Heineman, Jr., March 18, 1960, (reel 5520, frame 1106).

p. 366 "Utterly dull": AAA/DTG, EGH to Boris Mirski, April 12, 1960, (reel 5521, frame 121).

p. 366 "Details": AAA/DTG, EGH to Frederick Baum, January 26, 1962, (reel 5526, frame 689).

p. 366 "Back on the market": "Halpert Collection and Its Owner Both Are Part of U.S. History," Donald H. Louchheim, Washington Post, August 20, 1961.

p. 367 "For days": AAA EGH OH, p. 104.

p. 368 "360 museums and galleries": Stebbins and Troyen, p. 7.

p. 368 "No purchase funds": AAA/DTG, "A Survey of the Current Activities and Major Needs of the Corcoran Gallery of Art," September 1960 (reel 5638, frames 746–753).

p. 369 "Eclectic patronage": Leslie Judd Ahlander, "American Art in Microcosm," Washington Post, January 17, 1960, p. E7.

p. 369 "Commemorated": Draft of speech given at Corcoran Gallery, AAA/DTG, (reel 5636, frames 987–988).

p. 370 "No appeal to them": Author phone interview with Gudmund Vigtel, January 24, 2006.

p. 370 "Drawing rooms of Washington": Ibid.

p. 371 "Annually": AAA/DTG, 1962 draft of gift agreement (reel 5526, frames 355–376).

p. 371 "Disintegrate": AAA EG OH, p. 450–452.

p. 372 "More fakes": Grace Glueck, "It's More Uptown at the Downtown," NYT, June 13, 1965.

p. 372 "Tired of it": Ibid.

p. 373 "Her lawyer": According to author interview with Linden, Halpert had a benign tumor and asked Linden to take her to the hospital.

p. 373 "Ideal space": AAA/DTG, EGH to Frederick Baum, November 26, 1965 (reel 5538, frame 320).

p. 373 "Money they cared about": Author interview with Bella Linden, April 30, 2006.

p. 374 "Residual property": Edith G. Halpert's will, signed and dated December 13, 1965, obtained from Surrogate's Court, New York City.

p. 374 "All plugged up now": AAA/DTG, Nathaly Baum to EGH, December 16, 1965 (reel 5538, frame 531).

p. 374 "New version": AAA/DTG, EGH to Bill Williams, March 12, 1966 (reel 5536, frame 120)..

p. 375 "Couldn't pry": Author phone interview with Donelson Hoopes, September 21, 2005. Hoopes died in 2006.

p. 375 "Understand": AAA/DTG, EGH to Bill Williams, March 19, 1966 (reel 5539, frame 76).

p. 375 "Any legal document": AAA/DTG, EGH to Francis Biddle, April 19, 1966 (reel 5539, frame 296).

p. 376 "Interested accordingly": AAA/DTG, EGH to Hermann Warner Williams Jr., director of the Corcoran Gallery, October 19, 1966, AAA (reel 5540, frame 528)

p. 376 "Contribution there": EGH, October 6, 1967. AAA/DTG, EGH to Martin Bush, assistant dean, Syracuse University, October 6, 1967 (reel 5542, frame 788).

p. 376 "Be really happy": Author interview and phone interview with Elaine Weitzen, February 7, 2006.

p. 376 "Asked for a doctor": Author phone interview with Martin Bressler, January 6, 2005.

p. 377 "I understood why": Author phone interview with Marvin Sadik, November 4, 2002.

p. 378 *They All Sang My Songs:* When the author interviewed Lawrence at his Connecticut home, he gave me a copy of a draft from his forthcoming memoir where this text appears.

p. 379 "Dropped the case": Author phone interview with David Ellenhorn, January 13, 2006.

p. 379 "Drunk by late afternoon": Among those interviewed who observed evidence of a drinking problem were George Perutz, and Maria and Marvin Sadik.

p. 379 "Not quite straight": private papers, p. 300, courtesy Charles Alan's family.

p. 380 "Nothing but scribbles": Author interview with Jack Lawrence, July 29, 2003.

p. 380 "a small group gathered": List of funeral attendees recollected by Bernard Heinenman, Jr.

Epilogue

p. 382 Auction catalog: *The Edith G. Halpert Collection of American Painting*, Sotheby Parke Bernet, March 14 at 8 p.m. and March 15 at 2 p.m., 1973.

p. 382 $2 million: Author interview with Charles Benenson, May 2003.

p. 383 "Cancel that will": Author interview with Helen Boigon, February 11, 2006.

p. 383 "Took the proceeds": Jack Lawrence, quoted from manuscript draft of his memoir that Lawrence gave the author, *They All Sang My Songs*.

p. 383 "Car accident": According to Patricia Vanderbees.

p. 383 "Prophetic": Sanka Knox, "Halpert Art Collection Brings $3.6 Million," *NYT*, March 16, 1975.

p. 384 "Didn't happen": Author interview with James Maroney, November 20, 2002.

p. 384 $100 million: Author phone interview with Peter Rathbone, May 15, 2006.

p. 384 *Hot Still-Scape for Six Colors—7th Avenue Style* is now owned by the Museum of Fine Arts, Boston, and exhibited in the William H. and Saundra P. Lane Gallery.

p. 384 Nadelman's *Tango* changed hands several times after the auction and is now at the Whitney Museum of American Art.

p. 384 "Until her death": Nancy L. Ross, "Record Art Prices," *Washington Post*, March 15, 1973.

p. 384 Estate value: Surrogate's Court County of New York, Accounting of Nathaly Baum as administratrix of the estate of Edith G. Halpert, file no. 6114–1970. Accounting covers period from October 6, 1970, to February 28, 1975.

p. 385 "never caught": An Oct. 18, 1974, estate tax application for the estate of Edith G. Halpert states that ". . . almost the entire contents of the decedent's property . . . had been stolen" Losses were estimated at $11,345. Robert Tvardzik, a Newtown Police Dept. detective sergeant, told the author the case was never solved.

p. 385 "Casts for resale": Author interview with Maroney. *Tango* was later auctioned at Christie's and eventually ended up the Whitney Museum of American Art.

Bibliography

Selected Interviews and Conversations with Author

Benenson, Charles. Interview, May 7, 2003.

Berkman, Barry. Phone interview, January 13, 2006.

Boigon, Helen. Interviews, June 14, 2003; February 11, 2006.

Bowman, Ruth. Conversation, January 16, 2006.

Boyajian, Ani, and Mark Rutkoski. Interviews, August 5, 2005; February 28, 2006.

Bressler, Martin. Phone interview, January 6, 2005.

Brown, Irving. Interview, May 8, 2003.

Bry, Doris. Interview and various phone interviews, November 2, 2005, and others.

Crawford, John. Conversations, 2003.

Critchlow, Ernest. Phone interview, April 2003.

Culver, Michael. Phone interview, October 12, 2004.

Davis, Earl. Interview, January 14, 2003.

Davis, Myrna. Phone interview, April 1, 2005.

Dintenfass, Terry. Interview, June 19, 2003.

Dorfman, Bob. Interview, April, 24, 2005.

Doyle, Margaret. Phone and emails. May-June, 2006.

Dubois, Michelle. Interview, June 20, 2003.

Edelson, Gilbert. Interview, January 27, 2006.

Fleischman, Barbara. Interview, March 15, 2003.

Goldstein, Malcolm. Interview, April 12, 2005.

Greenough, Sarah. Phone interview, February 23, 2006.

Grieve, Victoria. Phone interview, April 13, 2005.

Griffiths, Marien. Interview, March 16, 2003.

Haskell, Barbara. Interview, May 18, 2006.

Heineman, Jr., Bernard. Interviews, June 18, 2003, and others.

Hyman, Linda. Conversation, November 12, 2002.

Halpert, Wesley, and Carolyn Halpert. Interview, August 20, 2004.

Hanks, David A. Phone conversation, February 22, 2005.

Hoopes, Donelson. Phone interviews, September 21, 2005; January 11, 2006.

Icpar, Dahlov. Interview, July 10, 2005.

Jeffers, Wendy. Emails and phone conversations, February 26, 2005, and others.

Kunin, Myron. Conversation, November 13, 2002.

Kraus, Peter. Interview, March 25, 2005.

Lansing, Gerrit. Phone interview, April 27, 2006.

Lawrence, Jack. Interview, July 29, 2003.

Levine, Jack. Interview, July 15, 2003.

Linden, Bella. Interviews, July 11, 2003; April 30, 2006.

Lynes, Barbara Buhler. Phone interview, May 9, 2006.

Marin, Norma. Interviews and conversations, September 30, 2005; October 9, 2005.

Maroney, James. Interview and phone interviews, December 2, 2003; May 15, 2006.

Melby, Julie. Phone interview, March 3, 2006.

Munroe, Alexandra. Phone interview, May 10, 2006.

Neuberger, Roy. Interview, June 17, 2003.

Nicoll, Jessica. Conversation, July 7, 2005.

Patterson, Laura. Conversation, March 3, 2006.

Perutz, George. Phone interview, July 23, 2003.

Pesner, Carole. Interview, November 2, 2002.

Rathbone, Peter. Phone interview, May 15, 2006.

Richardson, Sarah. Various conversations, 2004–2006.

Rose, Marie. Phone interview, December 19, 2005.

Rosenfeld, Michael, and Halley K. Harrisburg. Conversation, April 14, 2005.

Ross, Luise. Interview and various conversations, June 12, 2006.

Sadik, Marvin. Phone interview, November 11, 2002.

Salander, Larry. Interview, May 8, 2003.

Saroff, Raymond. Interview, January 18, 2006.

Schroeder, Dave. Phone interview and emails, December 31, 2004; April 17, 2006.

Shahn, Bernarda. Interview, June 30, 2003.

Shahn, Jonathan. Phone interview, June 11, 2003.

Shahn, Judith. Interview, July 1, 2003.

Shaw, Kendall. Interview, January 9, 2003.

Smith, Scudder. Phone conversation, May 12, 2005.

Szarkowski, John. Phone interview, May 8, 2006.

Troyen, Carol. Interview, September 30, 2005.

Vanderbes, Patricia. Interview, May 2, 2006.

Vigtel, Gudmund. Phone interview, January 24, 2006.

Wax, Murray. Interview, July 2003.

Weber, Joy. Phone Interviews, March 2005; February 27, 2006.

Weinberger, Michael. Phone Conversation, May 24, 2006.

Weitzen, Elaine. Interview and phone interviews, February 7, 2006.

Wohler, Chris. Phone interview, April 30, 2006.

Wye, Deborah. Interview, April 11, 2005.

Zabriskie, Virginia. Interview, January 7, 2006.

Zipperstein, Stephen. Conversation, August 16, 2004.

Interview Transcripts, the Archives of American Art, Smithsonian Institution

Alan, Charles. AAA OH interview with Paul Cummings, August 20, 1970.

Bacon, Peggy. AAA OH interview with Paul Cummings, May 8, 1973.

Bishop, Isabel. Nov. 12–Dec. 11 1987 with Cynthia Nadelman.

Cahill, Holger. AAA OH interview with John Morse, April 12, 1960.

Carlen, Robert. AAA OH interview with Catherine Stover, June 28, 1985 and with Marina Pacini, March 17, 1988.

Crichlow, Ernest. AAA OH interview with Henri Ghent, July 20, 1968.

Davis, Stuart. AAA OH interview with Harlen Phillips, May–June 1962.

Dintenfass, Terry. AAA OH interview with Paul Cummings, December 2 and 18, 1974.

Fleischman, Lawrence. AAA OH interview with Paul Cummings, February 28, 1970; with Gail Stavitsky, April 18, 1994.

Halpert, Edith. AAA OH interview with Harlan Phillips, April 1963 and January 20, 1965.

Kootz, Samuel. AAA OH interview with Dorothy Seckler, April 13, 1964.

Lawrence, Jacob. AAA OH interview with Carroll Greene, October 26, 1968.

Levi, Julian. AAA OH interview with Colette Roberts, October 7, 1968.

Miller, Dorothy. AAA OH interview with Paul Cummings, 1970–1971.

Nakian, Ruben. AAA OH interview with Avis Berman, June 9, 1981.

Schmidt, Katherine. AAA OH interview with Paul Cummings, December 8 and 16, 1969.

Shahn, Ben. AAA OH interview with Richard Dowd, April 14, 1964; Harlan Phillips, October 3, 1965; and Forrest Selvig, September 27, 1968.

Shahn, Bernarda Bryson. AAA OH interview with Lisa Kirwin, April 29, 1983.

Sheeler, Charles. AAA OH interview with Martin Friedman, June 18, 1959, and Bartlett Cowdrey, December 9, 1958.

Other Papers at the Archives of American Art, Smithsonian Institution

Abel Warshawsky Papers. Draft of unpublished biography.

Charles Daniel papers, 1950–1967.

The Phillips Collection Records, 1920–1960.

Holger Cahill papers, 1910–1993.

John Weichsel papers, 1905–1922.

Leon Kroll papers, 1916–1976.

Wood and Adelaide Lawson Gaylor papers, 1866–1986.

City Directories and Municipal Archives

California State Archives, State Prison at San Quentin, California.

Covington, Kentucky. Phone directory, 1916–1917.

New York, New York. Marriage certificate, Edith G. Fein and Samuel Halpert.

———. Marriage certificate, Sonia Fine and Maurice Chase.

———. Tax photo, 32 East 51st Street (1286–45 C799).

———. Tax photo, 43 East 51st Street (1287–29, G1973).

———. Tax photo, 113 West 13th Street (609–52, F1572).

———. Deed to 113 West 13th Street, September 27, 1926.

———. Deed to 113 West 13th Street, December 2, 1942.

Unpublished Sources

Bolger, Doreen A. "Hamilton Easter Field and the Rise of Modern Art in America." Master's thesis, University of Delaware, 1973.

Cassidy, Stephanie. Letter and e-mail to author about student registration at Art Students League, February 14, 2005 (letter) and March 26, 2006 (e-mail).

Falk, Peter. E-mail to author about student registration at National Academy of Design, December 28, 2004.

Hadley, Kate. E-mail to author providing information on the history of Atlantic City Boardwalk Hall.

Kohn, Harry, Jr. Letter to author about New York department stores in early twentieth century.

Landmarks Preservation Commission, March 28, 1978. Designation List No. 114, report on Radio City Music Hall.

Lassette, Leslie A. "Covington's Schule: The Temple of Israel," December 3, 1976. Kenton County Historical Society.

Mitchell, Mark. E-mail to author about history of National Academy of Design.

Morrone, Francis. E-mail to author about 51st Street in 1940s.

Newark Museum Library, Museum Archives.

Oral History Research Office, Columbia University. "Reminiscences of Holger Cahill," interview by Joan Pring, 1957.

Rockefeller Archive Center, Sleepy Hollow, New York.

Rockefeller Center Archive, New York, New York.

Schramm, James S. Papers. Special Collections Department, University of Iowa Libraries, Iowa City, Iowa.

Tepfer, Diane. "Edith Gregor Halpert and the Downtown Gallery 1926–1940: A Study in American Art Patronage." Ph.D. diss., University of Michigan, 1989.

Books on or by Artists Associated with the Downtown Gallery

Drohojowska-Philip, Hunter. *Full Bloom: The Art and Life of Georgia O'Keeffe*. New York: W. W. Norton, 2004.

Frankel, Stephen Robert, ed., with Jack Levine and Milton Brown. *Jack Levine*. New York: Rizzoli, 1989.

Goosen, E. C. *Stuart Davis*. New York: George Braziller, 1959.

Greenfeld, Howard. *Ben Shahn: An Artist's Life*. New York: Random House, 1998.

O'Keeffe, Georgia. *Georgia O'Keeffe*. New York: Penguin Books, 1977.

Peters, Sarah Whitaker Peters. *Becoming O'Keeffe: The Early Years*. New York: Abbeville Press, 2001.

Robinson, Roxana. *Georgia O'Keeffe: A Life*. New York: Harper and Row, 1989.

Rourke, Constance. *Charles Sheeler: Artist in the American Tradition*. New York: Harcourt, Brace and Company, 1938.

Shahn, Ben. *The Shape of Content*. Cambridge: Harvard University Press, 1985.

Tepfer, Diane. *Samuel Halpert: Art and Life, 1884–1930*. New York: Millennium Partners, 2001.

Werner, Alfred. *Pascin*. New York: Harry N. Abrams, 1959.

Zorach, William. *Art Is My Life: The Autobiography of William Zorach*. Cleveland: World, 1967.

———. *Zorach Explains Sculpture: What It Means and How It Is Made*. New York: Tudor, 1960.

Museum Catalogs

Brock, Charles. *Charles Sheeler: Across Media*. National Gallery of Art, Washington, D.C. Berkeley, Los Angeles, London: University of California Press, 2006.

Chevlowe, Susan. *Common Man, Mythic Vision: The Paintings of Ben Shahn.* The Jewish Museum, New York. Princeton: Princeton University Press, 1998.

The Edith Gregor Halpert Collection. Corcoran Gallery of Art, September 28–November 11, 1962.

Fillin-Yeh, Susan. *Charles Sheeler: American Interiors.* New Haven, Connecticut: Yale University Art Gallery, 1987.

Fine, Ruth. *The John Marin Collection at the Colby College Museum of Art.* Waterville, Maine: Colby College, 2003.

Friedman, Martin, Barlett Hayes, and Charles Millard. *Charles Sheeler.* National Collection of Fine Arts. Washington, D.C.: Smithsonian Institution Press, 1968.

Goodrich, Lloyd. *Yasuo Kuniyoshi: Retrospective Exhibition.* New York: Whitney Museum of Art, 1948.

Haskell, Barbara. *The American Century: Art and Culture, 1900–1950.* Whitney Museum of American Art. New York: W. W. Norton, 1999.

Henning, Robert. *Wright S. Ludington: Four Decades of Gifts to the Santa Barbara Museum of Art.* Santa Barbara Museum of Art, 1982.

Hood, Graham, ed. *The Robert Hudson Tannahill Bequest to the Detroit Institute of Arts.* Detroit: The Detroit Institute of Arts, 1970.

Kirstein, Lincoln. *The Sculpture of Elie Nadelman.* New York: Museum of Modern Art, 1948.

A Loan Exhibit from the Edith Gregor Halpert Collection. Corcoran Gallery of Art, January 16–February 28, 1960.

Mayor, Hyatt A. "Introduction." *Artists for Victory: An Exhibition of Contemporary American Art.* New York: The Metropolitan Museum of Art, 1942.

Nesbett, Peter T., and Michelle Dubois, eds. and intro. *Over the Line: The Art and Life of Jacob Lawrence.* Seattle: University of Washington Press, 2001.

Nicoll, Jessica. "To Be Modern," *Marguerite and William Zorach: Harmonies and Contrasts.* Portland Museum of Art, 2001.

Owens, Gwendolyn. *The Dr. and Mrs. Milton Lurie Kramer Collection.* Herbert F. Johnson Museum of Art, Cornell University, 1981.

Phillips, Lisa. *The American Century: Art and Culture 1950–2000.* New York: W. W. Norton in association with the Whitney Museum of American Art, 1999.

Richardson, E. P. *American Art: An Exhibition from the Collection of Mr. and Mrs. John D. Rockefeller, III.* San Francisco: The Fine Arts Museum of San Francisco, 1976.

Richardson, Edgar P., intro. *American Paintings in the Ferdinand Howald Collection*. Catalog prepared by Marcia Tucker. Columbus: Columbus Gallery of Fine Arts, 1969.

Sadik, Marvin S. *Edith Halpert and the Downtown Gallery*. Storrs-Mansfield: Museum of Art, University of Connecticut, 1968.

Sims, Lowery Stokes. *Stuart Davis: American Painter*. Metropolitan Museum of Art. New York: Harry N. Abrams, 1991.

Stebbins, Jr., Theodore E., Gilles Mora, and Karen E. Haas. *The Photography of Charles Sheeler: American Modernist*. Boston: Bulfinch Press, 2002.

Stebbins, Jr., Theodore E., and Carol Troyen. *The Lane Collection: Twentieth-Century Paintings in the American Tradition*. Boston: Northeastern Press, Museum of Fine Arts, 1983.

Sweeney, James Johnson. *Stuart Davis*. New York: Museum of Modern Art, 1945.

Turner, Elizabeth Hutton. *In the American Grain: Arthur Dove, Marsden Hartley, John Marin, Georgia O'Keeffe, and Alfred Stieglitz*. Washington, D.C.: Counterpoint, in association with the Phillips Collection, 1995.

———, ed. *Jacob Lawrence: The Migration Series*. Washington, D.C.: Rappahannock Press, in association with The Phillips Collection, 1993.

Williams, William Carlos, intro. *Charles Sheeler: Paintings, Drawings, Photographs*. New York: The Museum of Modern Art, 1939.

Wye, Deborah, and Isselbacher, Audrey. *Abby Aldrich Rockefeller and Print Collecting: An Early Mission for MoMA*. Museum of Modern Art, 1999.

Gallery Catalogs

Leon Kroll: Revisited. Gerald Peters Gallery. New York, 1998.

Recent Paintings by Samuel Halpert. Daniel Gallery. 2 West 47th St., New York. Undated (circa 1915).

Articles on Edith Halpert and Halpert Collection

Ahlander, Leslie Judd. "American Art in Microcosm." *Washington Post*, January 17, 1960.

———. "The Corcoran Gallery's Problems." *Washington Post*, July 23, 1961.

———. "Halpert Paintings at the Corcoran." *Washington Post*, September 30, 1962.

Berman, Avis. "Pioneers in American Museums: Edith Halpert." *Museum News* (Nov/Dec 1975): pp. 34–37, 61–64.

Casey, Phil. "Corcoran Plans New Art Wing in Meeting Gift Requirements." *Washington Post,* August 8, 1961.

Donihi, Rosemary. "Private Collectors to Unveil Pictures." *Washington Post,* January 16, 1960.

Glueck, Grace. "The Corcoran's Coup: After Much Ado, Washington Museum Bags a Major American Collection." *NYT,* July 26, 1964.

Louchheim, Donald H. "Halpert Collection and Its Owner Both Are Part of U.S. Art History." *Washington Post,* August 20, 1961.

———. "Modern Art Collection Is Offered to Corcoran." *Washington Post,* September 8, 1961.

Richard, Paul. "Deciding the Corcoran's Future." *Washington Post,* March 4, 1973.

Seacrest, Meryle. "Abstracts Face Concrete Problems: Corcoran Caught in a Cost Squeeze?" *Washington Post,* July 16, 1961.

———. "The Halpert Collection." *Washington Post,* April 8, 1972.

White, Jean. "'Separate Entrance' Gallery Offered by Corcoran for $2 Million Art Gift." *Washington Post,* August 4, 1961.

Willenson, Kim. "Agreement Reached for Corcoran to Acquire Halpert Art Collection." *Washington Post,* September 13, 1962.

Articles on the Downtown Gallery

Bulliet, C. J. "Current American Paintings Salable." *Chicago Post,* October 27, 1928.

Jewell, Edward Alden. "Moving Day in Order: Gallery Changes Are a Present Epidemic—Montross, Arthur V. Newton, Downtown." *NYT,* April 27, 1930.

———. "Downtown to Open Its New Gallery." *NYT,* October 16, 1940.

———. "Landscape Experiment: Modern and Early Work on Friendly Terms." *NYT,* January, 29, 1928.

Bragazzi, Olive. "The Story Behind the Rediscovery of William Harnett and John Peto by Edith Halpert and Alfred Frankenstein." *American Art Journal,* Spring 1984.

Sacartoff, Elizabeth. "Downtown Gallery Moves Uptown." *PM Weekly,* October 20, 1940.

Wolf, Ben. "Edith Halpert, Art Crusader, Marks Two Decades of Success." *Art Digest*, October 15, 1945.

Articles on the Downtown Gallery Artists

Bowdoin, W. G. "Modern Work of Stuart Davis at Village Show." *New York Evening World*, December 13, 1917.

Devree, Howard. "Personal Modern: Arthur Dove's Work Takes on Stature Through Whitney Museum Show." *NYT*, October 5, 1958.

Jewell, Edward Alden. "Kuniyoshi, in New One-Man Exhibit at Downtown Gallery, Shows Considerable Progress." *NYT*, February 8, 1933.

———. "Works by Harnett Put on Exhibition." *NYT*, April 19, 1939.

———. "Vagabonding Genius." *NYT*, December 23, 1928.

Levin, Gail. "Between Two Worlds: Folk Culture, Identity, and the American Art of Yasuo Kuniyoshi." *Archives of American Art Journal* 43, nos. 3–4.

Pemberton, Murdock. "The Art Galleries: Dove Comes to Terms—A Bursting Week of First-Class Things." *New Yorker*, December 24, 1927.

———. "The Art Galleries: New Doves—Mr. Kootz Picks Eleven, One of Those Necessary Evils." *New Yorker*, March 21, 1931.

Articles on Downtown Gallery Customers

Jeffers, Wendy. "Abby Aldrich Rockefeller: Patron of the Modern." *Magazine Antiques*, November 2004.

Joyce, Henry. "Electra Havemeyer Webb and Edith Gregor Halpert: A Collaboration in Folk Art Collecting." *Magazine Antiques*, January 2003.

Knickerbocker, Cholly. *New York American*. December 27, 1931. Series II, Personal Papers, AAR clippings MISC, Box 11 Folder 133, Rockefeller Family Archives, RAC.

Messinger, Lisa Mintz. "American Art: The Edith and Milton Lowenthal Collection." *Metropolitan Museum of Art Bulletin*, 1996.

Wilson, P. W. "John D. Jr.: The Man and His Background." *NYT*, June 19, 1932.

Published by the Downtown Gallery

Cahill, Holger, ed. and intro. *George O. 'Pop' Hart: Twenty-Four Selections from His Work*. New York: Downtown Gallery, 1928.

————. *Max Weber.* New York: Downtown Gallery, 1930.

Space 1, no. 1, January 1930. New York: Space Publishing.

Space 1, no. 3, June 1930. New York: Space Publishing.

Unsigned Articles

"A Mile of Art." *NYT*, March 4, 1934.

". . . And the Migrants Kept Coming." *Fortune*, November, 1941.

"Anti-Saloon League Spent $13,000,000." *NYT*, March 28, 1927.

"Art Group Drops Protest on Rivera." *NYT*, February 17, 1934.

"Art: In the Business District." *Time*, September 5, 1938.

"Artists Quit Show in Rivera Protest." *NYT*, February 14, 1934.

"Art of Camouflage Is Demonstrated Here as Army Men Open Department Store Show." *NYT*, February 6, 1943.

"Boom in Old Masters." *Time*, August 17, 1942.

"Busy Man Is Booster, Has Eventful Career." *Kentucky Post*, January 25, 1915.

"City Art Exhibit Opened by Mayor." *NYT*, February 28, 1934.

"City Is Set to End Dry Era Amid Song." *NYT*, December 3, 1933.

"Daylight Art Gallery Houses American Work." *New York World*, circa April 1930.

"Downtown Gallery Reopens Uptown." *Art Digest*, October 15, 1940.

"Even Sumner Can't See Roxy's Art Ban." *Daily News*, December 17, 1932.

"53rd Street Patron." *Time*, January 27, 1936.

"Halpert Collection." *Washington Post* editorial, September 16, 1962.

"John D. Jr. Outlines Good Citizenship." *NYT*, November 13, 1922.

"A Kuniyoshi Retrospective." *New Yorker*, May 16, 1942.

"La Guardia Bars Inaugural Fete." *NYT*, December 5, 1933.

"Museum Prepared to Evacuate Art." *NYT*, December 16, 1941.

"Museum to Show American Murals." *NYT*, February 1, 1932.

"Mrs. E. B. Lintott, Art Dealer Here." *NYT*, July 2, 1953.

"New Crop of Painting Protéges." *Life*, March 17, 1952.

"New England Was Rather Sad Drama to Yasuo." *Art Digest*, March 15, 1941.

"New 'Our Gallery' Offers Attractive Exhibition Quarters." *Christian Science Monitor* (date not clipped, about November 1926).

"New York Artists to Have Own Show." *NYT*, January 29, 1934.

"Nude 'Ladies' Mysteriously Vanish After Roxy Ban." *N.Y. Evening Journal*, December 14, 1932.

"$100 Works." *Time*, May 21, 1934.

"One-Man Show of Art by Negro, First of Kind Here, Opens Today." *NYT*, February 25, 1928.

"Our Gallery [headline illegible]." *New York Evening Post Literary Review*, November 20, 1926.

"Picture Story of the Negro's Migration." *Art News*, November 15–20, 1940.

"Rockefellers Lead in Dry League Gifts." *NYT*, July 7, 1926.

"Rockefeller Prohibitionist." *NYT*, March 15, 1908.

"Text of Mayor La Guardia's Radio 'Chat' on War Front at Home." *NYT*, December 15, 1941.

"20,000 in Week See City Art Exhibition." *NYT*, March 7, 1934.

"225,000 in State Now on Civil Work." *NYT*, December 7, 1933.

"Upside Down Art Pains Artist Only: Visitors to Exhibition Greatly Praise Painting They Don't Know Is Hung Wrong: Picture of an Egg Beater." *Evening Bulletin* (Philadelphia), May 3, 1928. Article provided by SDCR.

"Want Native Art in Rockefeller City." *NYT*, January 20, 1932.

"Zorach's Rejected Statue Revealed." *NY Sun*, December 31, 1932.

Related Books

Bee, Harriet S., and Michelle Elligott, eds. *Art in Our Time: A Chronicle of the Museum of Modern Art*. New York: Museum of Modern Art/DAP, 2004.

Berman, Avis. *Rebels on Eighth Street: Juliana Force and the Whitney Museum of American Art*. New York: Atheneum, 1990.

Bernet, Sotheby Parke. *The Edith G. Halpert Collection of American Paintings*, 1973.

Brown, Milton. *American Painting from the Armory Show to the Depression*. Princeton: Princeton University Press, 1955.

Cahill, Holger. *Look South to the Polar Star*. New York: Harcourt, Brace, 1947.

Cahill, Holger, and Alfred H. Barr, Jr. *Art in America, A Complete Survey*. New York: Reynal and Hitchcock, 1935.

Caplow, Theodore, Louis Hicks, and Ben J. Wattenberg. *The First Measured Century: An Illustrated Guide to Trends in America, 1900–2000*. Washington, D.C.: AEI Press, 2001.

Chernow, Ron. *Titan: The Life of John D. Rockefeller, Sr.* New York: Random House, 1998.

Clark, Eliot. *History of the National Academy of Design, 1825–1953.* New York: Columbia University Press, 1954.

Davidson, Abraham A. *Early American Modernist Painting: 1910–1935.* New York: Da Capo, 1994.

Feininger, Andreas, and John von Hartz. *New York in the Forties.* New York: Dover, 1978.

Ferry, John William. *History of the Department Store.* New York: Macmillan, 1960.

Fogelson, Robert M. *Mass Violence in America: The Complete Report of Mayor La Guardia's Commission on the Harlem Riot of March 19, 1935.* New York: Arno Press and *New York Times*, 1969.

Frankenstein, Alfred. *After the Hunt: William Harnett and Other American Still Life Painters, 1870–1900.* Berkeley: University of California Press, 1953.

Gaines, Catherine Stover, and Lisa Lynch. *A Finding Aid to the Records of the Downtown Gallery.* Washington, D.C.: Archives of American Art, Smithsonian Institution.

Gill, Anton. *Art Lover: A Biography of Peggy Guggenheim.* New York: HarperCollins, 2002.

Goldstein, Malcolm. *Landscapes with Figures: A History of Art Dealing in the United States.* New York: Oxford University Press, 2000.

Hanks, David A., and Jennifer Tobcr. *Donald Deskey: Decorative Designs and Interiors.* New York: E. P. Dutton, 1987.

Harris, Leon. *Merchant Princes: An Intimate History of Jewish Families Who Built Great Department Stores.* Harper and Row, 1977.

Hendrickson, Robert. *The Grand Emporiums: The Illustrated History of America's Great Department Stores.* New York: Stein and Day, 1980.

Hower, Ralph. *History of Macy's New York, 1858–1919.* Cambridge: Harvard University Press, 1943.

Hughes, Robert. *American Visions: The Epic History of Art in America.* New York: Knopf, 1997.

Kantor, Sybil Gordon. *Alfred H. Barr, Jr. and the Intellectual Origins of the Museum of Modern Art.* Cambridge: MIT Press, 2002.

Kert, Bernice. *Abby Aldrich Rockefeller: The Woman in the Family.* New York: Random House, 2003.

Kramer, Michael, and Sam Roberts. *I Never Wanted to Be Vice-President of Anything! An Investigative Biography of Nelson Rockefeller.* New York: Basic Books, 1976.

Landgren, Marchal E. *Years of Art: The Story of the Art Students League of New York*. New York: Robert M. McBride, 1940.

Levy, Julien. *Memoir of An Art Gallery*, Boston: MFA Publications, 2003.

Lowe, Sue Davidson. *Stieglitz: A Memoir/Biography*. Boston: MFA Publications, 2002.

Lynes, Russell. *Good Old Modern: An Intimate Portrait of the Museum of Modern Art*. New York: Atheneum, 1973.

Marquis, Alice Goldfarb. *Alfred H. Barr, Jr.: Missionary for the Modern*. Chicago: Contemporary Books, 1989.

McKinzie, Richard D. *The New Deal for Artists*. Princeton: Princeton University Press, 1973.

Mulvey, Kate, and Melissa Richards. *Decades of Beauty: The Changing Image of Women, 1890s to 1990s*. New York: Reed Consumer Books, 1998.

Neuberger, Roy R., with Alfred and Roma Connable. *The Passionate Collector: Eighty Years in the World of Art*. New York: John Wiley and Sons, 2003.

Norman, Dorothy. *Alfred Stieglitz: An American Seer*. New York: Aperture, 1973.

Okrent, Daniel. *Great Fortune: The Epic of Rockefeller Center*. New York: Viking, 2003.

Rose, Barbara. *Twentieth-Century American Painting*. New York: Rizzoli, 1986.

Rosenberg, Harold. *The Tradition of the New*. New York: Grove Press, 1961.

Roussel, Christine. *The Art of Rockefeller Center*. New York: W. W. Norton, 2006.

Saarinen, Aline B. *The Proud Possessors: The Lives, Times and Tastes of Some Adventurous American Art Collectors*. New York: Random House, 1958.

Tomkins, Calvin. *Merchants and Masterpieces: The Story of the Metropolitan Museum of Art*. New York: Henry Holt, 1989.

Tragard, Louise, Patricia E. Hart, and W. L. Copithorne. *Maine's Art Colony: A Century of Color, 1886–1986*. Ogunquit, Maine: Barn Gallery Associates, 1987.

Traub, Marvin. *Like No Other Store: The Bloomingdale's Legend and the Revolution in Marketing*. New York: Three Rivers Press, 1994.

Watson, Steven. *Strange Bedfellows: The First American Avant-Garde*. New York: Abbeville Press, 1991.

Wetzsteon, Ross. *Republic of Dreams: Greenwich Village, the American Bohemia, 1910–1960*. New York: Simon and Schuster, 2002.

Whelan, Richard. *Alfred Stieglitz: A Biography*. Boston: Little, Brown, 1995.

Zurier, Rebecca. *Art for the Masses: A Radical Magazine and its Graphics, 1911–1917.* : Temple University Press, 1988.

Books on Odessa, Immigration, and/or Harlem

Gurock, Jeffrey S. *When Harlem Was Jewish.* New York: Columbia University Press, 1979.

Herlihy, Patricia. *Odessa: A History, 1847–1914.* Cambridge: Harvard University Press, 1986.

———. "Odessa Memories," in Nicholas Iljine, ed., *Odessa Memories.* Seattle: University of Washington Press, 2004.

Howe, Irving, with Kenneth Libo. *The World of Our Fathers: The Journey of the East European Jews to America and the Life They Found and Made.* New York: Harcourt Brace Jovanovich, 1976

How We Lived: A Documented History of Jews in America, 1880–1930. Ed. Irving Howe and Kenneth Libo. New York: Richard Marek, 1979.

Joselit, Jenna Weissman. "'A Set Table': Jewish Domestic Culture in New York," in Susan L. Braunstein and Jenna Weissman Joselit, eds., *Getting Comfortable in New York: The Jewish American Home, 1880–1950.* New York: Jewish Museum.

Kaufman, Bel. "My Odessa," in Nicholas Iljine, ed., *Odessa Memories.* Seattle: University of Washington Press, 2004.

Weinberg, Robert. *The Revolution of 1905 in Odessa: Blood on the Steps.* Bloomington: Indiana University Press, 1993.

Folk Art Articles, Books, and Catalogs

Brock, H. I. "America Discovers a Neglected Folk Art of Its Own," *NYT,* November 8, 1931.

Brown, Carter J. Introduction. *An American Sampler: Folk Art from the Shelburne Museum.* Washington, D.C.: National Gallery of Art, 1987.

Cahill, Holger. Introduction. An Exhibition of American Folk Sculpture, October 20, 1931–January 31, 1932. Newark: The Newark Museum, 1931.

———. Introduction. Beatrice Winser Foreword. An Exhibition of American Primitive Painitngs, November 3, 1930–February 1, 1931. Newark, NJ: The Newark Museum, 1930.

———. Introduction. *American Folk Art: The Art of the Common Man in America: 1750–1900.* Museum of Modern Art, New York: W. W. Norton, 1932.

Christensen, Erwin O. *The Index of American Design*. New York: MacMillan Company with the National Gallery of Art, Washington D.C., 1950.

Greene, Richard Lawrence, and Kenneth Edward Wheeling. *A Pictorial History of the Shelburne Museum*. Shelburne, VT: Shelburne Museum, 1947.

Halpert, Edith Gregor, and James L. Cogar. *American Folk Art: A Collection of Paintings and Sculpture Produced by Little-Known and Anonymous American Artists of the Eighteenth and Nineteenth Centuries*. Williamsburg, VA: Colonial Williamsburg, 1940.

———. *A Catalogue of the American Folk Art Collection of Colonial Williamsburg*. Williamsburg, VA: Colonial Williamsburg, 1947.

Jeffers, Wendy. "Holger Cahill and American Folk Art." *Magazine Antiques* September 1, 1995.

Jewell, Edward Alden. "Contemporary and Folk." *NYT*, October 25, 1931.

———. "Art in Review: Works of 18th and 19th Centuries on View at Exhibition Called 'The Art of the Common Man in America.'" *NYT*, November 29, 1932.

———. "Our American Folk Art: Impressive Group of Paintings and Sculpture Shown at the Museum of Modern Art." *NYT*, December 4, 1932.

Jacobs, Joseph. *A World of Their Own: Twentieth-Century American Folk Art*. Newark, NJ: Newark Museum, 1995.

Kimball, Fiske. "The Restoration of Colonial Williamsburg in Virginia." *Architectural Record*, Volume 78, Number 6, Issue of December, 1935.

Lipman, Jean. *American Primitive Painting*. New York: Dover, 1969.

Muller, Nancy C. *American Folk Art in Wood Metal and Stone*. New York: Dover, 1972.

———. *Paintings and Drawings at the Shelburne Museum*. Burlington, VT: Shelburne Museum, 1976.

Muller, Nancy, and Alice Winchester. *The Flowering of American Folk Art, 1776–1876*. New York: Viking Press in cooperation with the Whitney Museum of American Art, 1974.

Rose, Howard. *Unexpected Eloquence: The Art in American Folk Art*. New York: Raymond Sarnoff, 1990.

Rumford, Beatrix T. "Uncommon Art of the Common People: A Review of Trends in the Collecting and Exhibiting of American Folk Art." In Ian M. G. Quimby and Scott T. Swank, eds., *Perspectives on American Folk Art*. New York: W. W. Norton, 1980.

Schorsch, Marjorie H., David A. Schorsch, and Margaret R. Schorsch. *American Folk Art: Selected Examples from the Private Collection of the Late Edith Gregor Halpert, A Private Sale*. New York: David A. Schorsch, 1994.

Weekley, Carolyn J. *The Kingdoms of Edward Hicks*. New York: Abrams, in association with Abby Aldrich Rockefeller Folk Art Center, Colonial Williamsburg, Virginia, 1999.

Weekly, Carolyn J., and Beatrix T. Rumford. *Treasures of American Folk Art from the Abby Aldrich Rockefeller Folk Art Center*. Boston: Little, Brown/Bulfinch Press in association with The Colonial Williamsburg Foundation, 1989.

Related Museum Catalogs

Du Bois, Guy Pene. *Juliana Force and American Art: A Memorial Exhibition Sept. 24–October 1949*. Whitney Museum of American Art.

Harrison, Preston. *A Catalogue of the Mr. and Mrs. William Preston Harrison Galleries of American Art: A Gift to the People*. Los Angeles: Saturday Night Publishing Company, 1934.

William Rockhill Nelson Collection. Kansas City, Missouri, circa 1940.

Related Articles

Alsop, Joseph W., Jr. "Mile of Art Hung in New Galleries of Rockefeller Center." *N.Y. Herald-Tribune*, February 26, 1934.

Blake, Hugh. "A Reporter at Large: New Roxy." *New Yorker*. December 17, 1932.

Brigman, Annie. "What '291' Means to Me." *Camera Work*, July 1914. Online: Purdue University, Women Artists of the American West.

Genauer, Emily. "Enter—the Fabulous New Collector!" *New York World-Telegram*, June 10, 1944.

Jewell, Edward Alden. "Art Amid Icebergs: Mr. and Mrs. William Preston Harrison Have Been Doing Pioneer Work in California." *NYT*, July 7, 1929.

———. "Art in Review: The Museum of Modern Art Gives Private Showing Today of Murals by American Painters." *NYT*, May 3, 1932.

———. "Art in Review: Plaster Cast of Zorach's 'Sprit of the Dance,' Banned in Radio City, Is Shown Downtown." *NYT*, December 28, 1932.

———. "Contemporary American Art Joins Boardwalk Parade." *NYT*, June 23, 1929.

———. "In the Realm of Art: First Municipal Art Exhibition." *NYT*, March 4, 1934.

———. "Museum of Modern Art is 'At Home.'" *NYT*, May 8, 1932.

———. "Pedestrian Critic Views 'Mile of Art.'" *NYT*, February 28, 1934.

———. "Pippin Has Display at Bignou Gallery." *NYT*, October 1, 1940.

McBride, Henry. "Municipal Exhibition Vast but Entertaining Show." *New York Sun*, March 3, 1934.

O'Keeffe, Georgia. "Stieglitz: His Picture Collected Him." *NYT*, December 11, 1949.

Reich, Sheldon. "The Halpert Sale: A Personal View." *American Art Review*, September 10, 1973.

Roob, Rona. "A Noble Legacy." *Art in America*, November 2003.

Seldes, Gilbert. "Profiles: The Long Road to Roxy." *New Yorker*, February 25, 1933.

Storey, Walter Rendell. "Harmonizing Our Art and Furnishings." *NYT*, November 24, 1929.

Credits

Chapter Four

p. 73: Courtesy Downtown Gallery records, 1824–1974, in the Archives of American Art, Smithsonian Institution. Photographer: Soichi Sunami.

Chapter Five

p. 89: Courtesy of the Rockefeller Archive Center.
p. 93: Courtesy of the Rockefeller Archive Center.

Chapter Six

p. 114: Courtesy Downtown Gallery records, 1824–1974, in the Archives of American Art, Smithsonian Institution.
p. 116: Courtesy Downtown Gallery records, 1824–1974, in the Archives of American Art, Smithsonian Institution.

Chapter Seven

p. 144: Courtesy Downtown Gallery records, 1824–1974, in the Archives of American Art, Smithsonian Institution.

Chapter Eight

p. 155: Courtesy of the Rockefeller Archive Center.
p. 158: Rockefeller Center Archives, © Rockefeller Group, Inc. 2006.
p. 161: © Earl Davis, Courtesy VAGA.

Chapter Nine

p. 180: Rockefeller Center Archives, © Rockefeller Group, Inc. 2006.
p. 181: Rockefeller Center Archives, © Rockefeller Group, Inc. 2006.

Chapter Ten

p. 235: Library of Congress, Prints and Photographs Division, Carl van Vechten Collection, [reproduction # LC—USZ62–95743 DLC].

Chapter Eleven

p. 267: Corbis.
p. 276: © Earl Davis, Courtesy VAGA.
p. 279: Courtesy Downtown Gallery records, 1824–1974, in the Archives of American Art, Smithsonian Institution.

p. 282: Courtesy Downtown Gallery records, 1824–1974, in the Archives of American Art, Smithsonian Institution.

Chapter Twelve

p. 287: Collection Center for Creative Photography, University of Arizona, © Ansel Adams Publishing Rights Trust.

p. 302: Courtesy Downtown Gallery records, 1824–1974, in the Archives of American Art, Smithsonian Institution.

Chapter Thirteen

p. 336: Digital files courtesy Getty Images/Time Life Archive; © Louis Faurer Estate.

p. 351: Franz Goess/Black Star.

Chapter Fourteen

p. 355: © *The Washington Post*; reprinted by permission of the Washington, D.C., Public Library.

Photo Insert

p. 1, top: Edsel Williams Fine Art—The Millennium Partners Collection.

p. 1, bottom: Palmer Museum of Art, The Pennsylvania State University, Gift of Joseph M. Erdelac.

p. 2, top: From the Collection of Barney A. Ebsworth, © Estate of Marguerite Zorach.

p. 2, bottom: National Portrait Gallery, Smithsonian Institution, © Estate of Marguerite Zorach.

p. 3, top: The Phillips Collection, Washington, D.C. © Estate of Stuart Davis, Licensed by VAGA, New York.

p. 3, bottom: © Earl Davis, Courtesy VAGA.

p. 4, top: Courtesy Downtown Gallery records, 1824–1974, in the Archives of American Art, Smithsonian Institution. Photographer: Max Yavno.

p. 4, bottom: Yasuo Kuniyoshi, *Self Portrait as a Golfer*, 1927. Oil on canvas, 50.25 x 40.25 inches. Abby Aldrich Rockefeller Fund. (293.1938) The Museum of Modern Art, New York, U.S.A. Digital images © The Museum of Modern Art/Licensed by Scala/Art Resource, © Estate of Yasuo Kuniyoshi/ Licensed by VAGA, New York.

p. 5, top left: Abby Aldrich Rockefeller Folk Art Museum, The Colonial Williamsburg Foundation, Williamsburg, VA. Gift of Abby Aldrich Rockefeller.

p. 5, top right: © 2006 Museum of Fine Arts, Boston.

p. 5, bottom: Courtesy Shelburne Museum.

p. 6, top: Edward Steichen. Charles Sheeler, West Redding, Connecticut, c. 1932. Gelatin silver print, 17 1/2 x 13 7/8 inches. Gift of Samuel M. Kootz. (110.1987) The Museum of Modern Art, New York, U.S.A. Photo credit: Digital Image © The Museum of Modern Art/Licensed by Scala/Art Resource, New York, Joanna T. Steichen.

p. 6, bottom: Charles Sheeler 1883–1965, *River Rouge Plant*, 1932, Oil on Canvas, 20 x 24 1/8 in. (50.8 x 61.28 cm), Whitney Museum of American Art, New York, Purchase 32.43.

p. 7, top: Harmon Foundation Collection, National Archives, College Park, Maryland. Photographer J. Feierbaucher.

p. 7, bottom: The Phillips Collection, Washington, D.C., © 2006 The Jacob and Gwendolyn Lawrence Foundation, Seattle/Artists Rights Society (ARS), New York.

p. 8, top: Collection Walker Art Center, Minneapolis. Gift of the T. B. Walker Foundation, Gilbert M. Walker Fund, 1944, © Estate of Ben Shahn/ Licensed by VAGA, New York.

p. 8, bottom: Hulton Archive/Getty Images.

Acknowledgments

This book would not have been possible without a number of people, first among them Edith Gregor Halpert herself, who kept a record of her life and was prescient and generous enough to preserve it for future generations.

Another person deserving special thanks is Dale Pollock, my mother, who has an overwhelming reserve of great ideas. It was she who first suggested I write about Edith.

I must also acknowledge the vast and astonishing resources at the Archives of American Art, Smithsonian Institution, where I was welcomed and assisted by Joy Weiner at the New York branch and Judy Throm in Washington, D.C. Thanks are also due to Wendy Baker Hurlock in assembling the photos to help illustrate Edith's colorful world.

My enthusiasm for Edith Halpert was shaped into a book proposal with the inspirational guidance of Professor Samuel Freedman at Columbia University's Graduate School of Journalism, who believed in the importance of this book and gave me the confidence and skills to write it.

My agent, David Kuhn, was enthusiastic about Edith from the very start. He understood the significance of Edith's life and marketed her story with the same verve, originality, and style as Edith had used to market art. Billy Kingsland, at Kuhn Projects, has been a charming and helpful force throughout.

Edith could not have hoped for a better publisher than PublicAffairs. My editor, Kate Darnton, guided me every step of the way. Her skillful editing and constant support were indispensable in getting this story down on paper. I was always comforted by the team of excellent minds and hearts at PublicAffairs. Thanks to Peter Osnos, Susan Weinberg, Clive Priddle, Lindsay Jones, and Jaime Leifer for ushering Edith back to life.

I am grateful to Joan K. Davidson and the Furthermore Foundation for a generous grant that provided me with time to focus on Edith. I also thank my colleagues at *Bloomberg News*, my former editors at the *New York Sun,* and the late Brad Swett. Shira Boss, my unofficial writing buddy, gave me regular counsel and moral support. Abel Polese searched the archives in Odessa.

There are dozens of people who generously gave of their time and shared personal stories about Edith. They are listed in the bibliography. Some require special mention. Patricia Vanderbes, Edith's grandniece, generously shared private papers and memories. Charles Alan's family gave me access to Alan's private papers, providing a remarkable window into the Downtown Gallery.

Edith's surviving circle of artists, friends, clients, and acquaintances agreed that Edith had been unjustly neglected and were eager to speak about her. They include: Marian Griffiths, Jack Levine, Dr. Wesley and Carolyn Halpert, Dr. Helen Boigon, Barbara Fleischman, Bernard (Jack) Heineman, Jr., Bella Linden, Elaine Weitzen, Gudmund Vigtel, Roy Neuberger, Doris Bry, Jack Lawrence, Norma Marin, George Perutz, Joy Weber, Raymond Saroff, Barney Ebsworth, and Murray Wax.

Sadly, several of the people who provided me with rich material through their interviews have since passed away. They include

Charles Benenson, Irving Brown, Bernarda Bryson Shahn, Donelson Hoopes, and Terry Dintenfass.

This book also depends on the art historical scholarship of a number of brilliant and devoted thinkers. I am grateful to the following curators and scholars who submitted to my queries and interviews: Ani Boyajian, Mark Rutkoski, Avis Berman, Karen Haas, Michael Culver, Carol Troyen, Michelle Dubois, Barbara Buhler Lynes, Sarah Greenough, Sarah Richardson, and Barbara Haskell.

Diane Tepfer, who wrote an illuminating dissertation on Edith and a monograph on Sam Halpert also stands out among critical sources for the art historical underpinnings of this narrative.

Special thanks to my neighbor and art history guru Phyllis Tuchman, who reviewed the manuscript and shared her humor, insights, and observations.

In the course of writing this book I was fortunate to come in contact with the decedents of several Downtown Gallery artists. I am enormously grateful to John Crawford, Earl Davis, Jonathan Shahn, Dahlov Ipcar, and Jonathan Zorach for sharing their memories of the Downtown Gallery days and for their enthusiasm for this project.

A book on an art dealer would not be possible without the kind help extended by dealers of today. Thanks to Carole Pesner and Katherine Degn, James Maroney, David Schorsch, Larry Salander, Michael Rosenfeld, Halley K. Harrisburg, Virginia Zabriskie, Don Magner, Peter Rathbone, John Driscoll, Linda Hyman, and Luise Ross.

There are numerous others who went out of their way to help me research this book. Lauren Gioia at Sotheby's, Eileen Kinsella at *Art News,* and Margaret Doyle at MoMA enthusiastically attended to my endless stream of requests. Diane Jaust, the Radio City Museum Hall historian, and Christine Roussel at Rockefeller Center Archive provided me with cheer and invaluable materials as did Michele Hiltzik at the Rockefeller Archive Center in Pocantico Hills, New York.

There is a long list of people to whom I owe thanks for supporting my passion for art and writing. Joe Swayze and Vincent Broderick

were among my earliest mentors. Thanks to Barbara Novak, whose college lectures sparked my interest in American art and who guided me in writing my college thesis. Joachim Pissarro gave me my first art-world job. I would not be a writer without the unstinting support of Inger and Osborne Elliott.

My dear friends Sabrena Tufts, Lisa Meadowcroft, Maria Daou, and Nadine Lerner always asked about Edith. Maria Elena Baerga magically brought order to my home.

The memory of my grandfather, Arthur Smith, gave me confidence that I possessed a writing gene. Thanks to my loving father, who raised me to believe I could do whatever I set my mind to. I am forever grateful to my sister, Justine, who always picked up her phone, no matter how many times I called, no matter how annoying my questions. And I do not know what I would have done without Andrew Zarnett, who was always there for me.

Index

accomplishments, 385

avoidance of close personal attach-
ments, 329, 333

career over children, 54–56

devotion to her artists, 328

good taste and executive skill, 283

inability to be traditional, nurtur-
ing wife, 122

precociousness and resourceful-
ness, 31

puritanism, 218

relating to people of power, 28–29

Roy Neuberger describes, 271

salesmanship/lying skills, 25

self-esteem, 18

sexual charms, 90

similarities to O'Keeffe, 304–305

temper, 259

worries, 262

Halpert, Edith Gregor (childhood)

apartment house of, 7

art school, 19–20

behavior of, 7

early flair for business, 17–18

on family decision to leave
Odessa, 3–4

father of, 5, 9

Harlem home of, 12–13

immigration to America, 11–12

impressed with wealth of America,
14

mother of, 5, 9

moves in with married sister,
20–22

poverty of, 16–19

schooling in America, 14–16

setting interview parameters on, 2

shedding Russian Jewish identity,
13–14

sister of, 4–5

striking appearance of, 4–5, 8

talents of, 15

Halpert, Elias, 42

Halpert, Irving, 122

Halpert, Masha, 42

Halpert, Samuel

art style of, 45

congeniality of, 43

death of, 120–122

divorce from Edith, 118, 120–121

exhibits in Europe and America,
43

failure to succeed, 119–121

Harrison purchases, 68

marriage to Edith, 40–42, 45–50

patrons of, 44

summer at Ogunquit, 51–55

talent and training of, 42–43

as Whitney Studio artist, 38

Hamilton, Juan, 304

Harlem

conditions for blacks in, 232

Jacob Lawrence grows up in, 236

Russian Jews settling in, 12–13

Harnett, William, 214–217, 220–221,
360

Harriman, Marie, 184

Harrison, Preston

affect of Great Depression, 123,
127

contributing to *Space* publication,
107

Edith's cultivation of, 67–69

Hart, George Overbury (Pop), 38,
104–105

Hart, Moss, 224

Hartley, Marsden, 129, 291

Harvard Contemporary Art Society,
149

Hassam, Childe, 85–86

Heckel, Erich, 94

Heineman, Bernard, Jr., 365, 383

Henri, Robert, 78

Hicks, Edward, 140

Hirshhorn, Joseph, 376

Holladay, Polly, 60